→ p.036 → p.038 → p.040 → p.042 → p.044 → p.046 → p.048 → p.050
→ p.068 → p.070 → p.072 → p.074 → p.076 → p.078 → p.080 → p.082
→ p.100 → p.102 → p.104 → p.106 → p.108 → p.110 → p.112 → p.114
→ p.132 → p.134 → p.136 → p.138 → p.140 → p.142 → p.144 → p.146
→ p.164 → p.166 → p.168 → p.170 → p.172 → p.174 → p.176 → p.178
→ p.196 → p.198 → p.200 → p.202 → p.204 → p.206 → p.208 → p.210
→ p.228 → p.230 → p.232 → p.234 → p.236 → p.238 → p.240 → p.242
→ p.260 → p.262 → p.264 → p.266 → p.268 → p.270 → p.272 → p.274
→ p.292 → p.294 → p.296 → p.298 → p.300 → p.302 → p.304 → p.306
→ p.324 → p.326 → p.328 → p.330 → p.332 → p.334 → p.336 → p.338
→ p.356 → p.358 → p.360 → p.362 → p.364 → p.366 → p.368 → p.370
→ p.388 → p.390 → p.392 → p.394 → p.396 → p.398 → p.400 → p.402
→ p.420 → p.422 → p.424 → p.426 p.432 → p.434
→ p.452 → p.454 → p.456

The graphic on the cover is made up of many colored bands, each of which represents a section of a book page and uses the section's colors, which have also been sorted by grade. In addition, the three main sections of the book are exported as PNGs, read into Processing, and evaluated as "Color palettes from images." → Ch.P.1.2.2

On the front page of the book the bands run along a Bézier curve toward the font outlines. The way points can be fixed set to a font is described in "Font outlines." → Ch.P.3.2

The bands on the back cover transform into a list of keywords (tag cloud). The tags that correspond to the book pages are saved in an XML file that is read similarly to the example in "Dynamic data structures." → Ch.M.6

The program → Cover.pde, which was used to generate the graphic on the cover, is part of the code package that can be downloaded from www.generative-gestaltung.de.

This program, however, is not intended to be a didactic example and will only make sense to experienced users. Nonetheless, it demonstrates how a complicated graphic image can be created out of many individual techniques. It also is intended to serve as a repository for smaller code snippets.

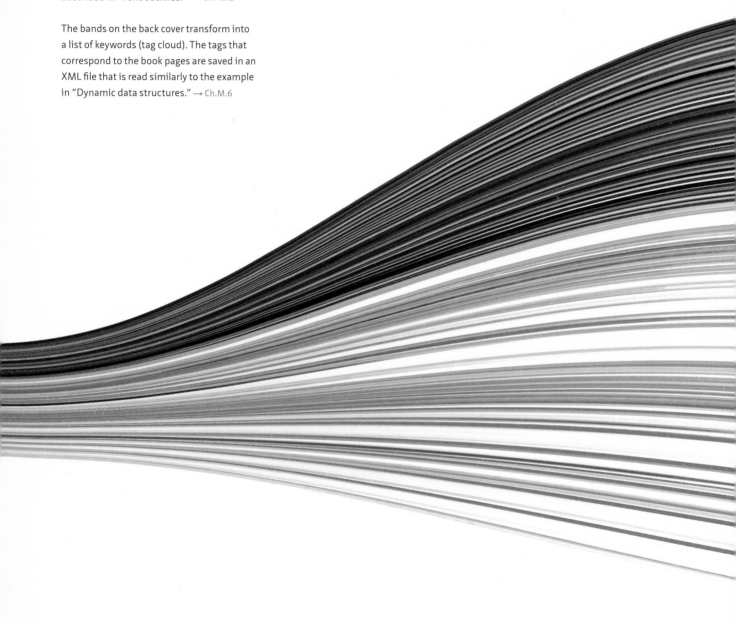

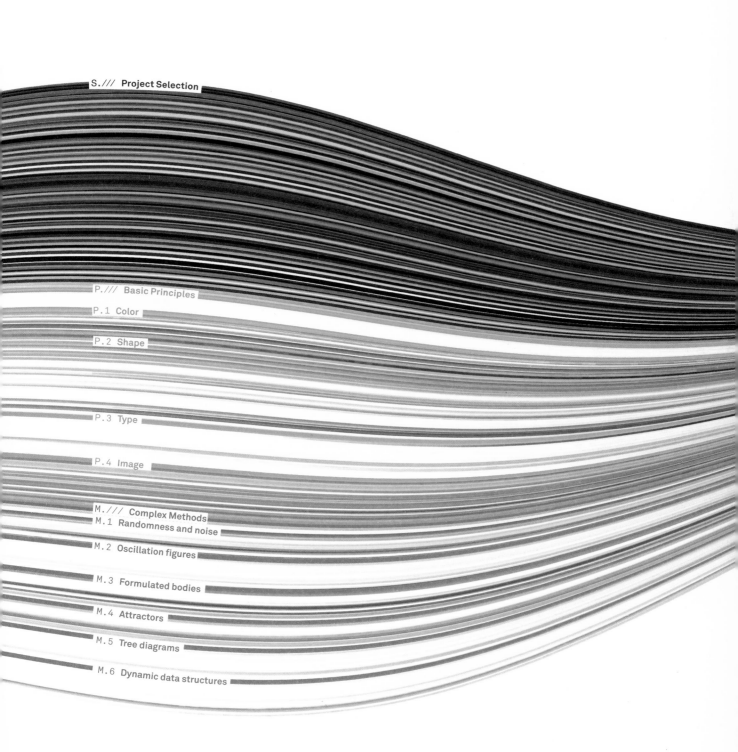

S./// **Project Selection**

P./// **Basic Principles**

P.1 Color

P.2 Shape

P.3 Type

P.4 Image

M./// **Complex Methods**
M.1 **Randomness and noise**

M.2 **Oscillation figures**

M.3 **Formulated bodies**

M.4 **Attractors**

M.5 **Tree diagrams**

M.6 **Dynamic data structures**

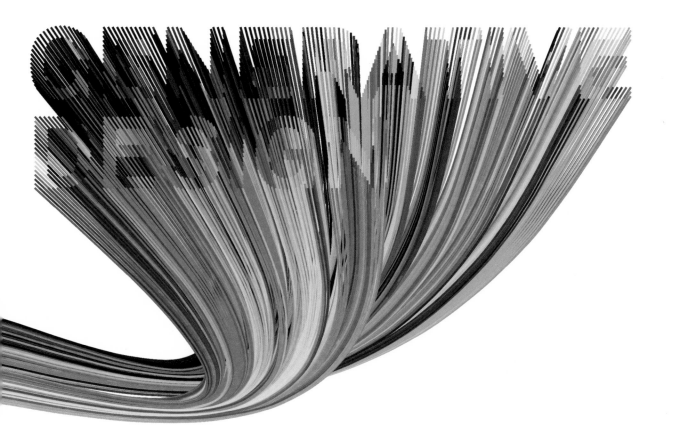

GENERATIVE DESIGN

Visualize, Program, and Create with Processing

Hartmut Bohnacker
Benedikt Groß
Julia Laub

Editor
Claudius Lazzeroni

Translated by Marie Frohling

Princeton Architectural Press
New York

I.1
Contents

I./// Introduction →p.008

I.1 Contents →p.008
I.2 Preface →p.010
I.3 Image overview →p.012
I.4 How to read this book →p.014
I.5 How to use www.generative-gestaltung.de →p.016
I.6 How to use the programs →p.018

Project
S./// Selection →p.020

These thirty-five works by various media artists, designers, and architects active in the field of generative design are intended to serve as a representative overview of the subject and as a source of inspiration.

Basic
P./// Principles →p.164

In this section the basic principles of generative design are demonstrated using the four main aspects of design: color, shape, type, and image.

P.0 Introduction to Processing →p.166
 P.0.0 Processing—an overview →p.168
 P.0.1 Language elements →p.170
 P.0.2 Programming beautifully →p.178

P.1 Color →p.180
 P.1.0 Hello, color →p.182
 P.1.1 Color spectrum →p.184
 P.1.1.1 Color spectrum in a grid →p.184
 P.1.1.2 Color spectrum in a circle →p.186
 P.1.2 Color palettes →p.188
 P.1.2.1 Color palettes through interpolation →p.188
 P.1.2.2 Color palettes from images →p.190
 P.1.2.3 Color palettes from rules →p.194

P.2 Shape →p.200
 P.2.0 Hello, shape →p.202
 P.2.1 Grid →p.206
 P.2.1.1 Alignment in a grid →p.206
 P.2.1.2 Movement in a grid →p.210
 P.2.1.3 Complex modules in a grid →p.214
 P.2.2 Agents →p.218
 P.2.2.1 Dumb agents →p.218
 P.2.2.2 Intelligent agents →p.220
 P.2.2.3 Shapes from agents →p.224
 P.2.2.4 Growth structure from agents →p.228
 P.2.2.5 Structural density from agents →p.232
 P.2.3 Drawing →p.236
 P.2.3.1 Drawing with animated brushes →p.236
 P.2.3.2 Relation and distance →p.240
 P.2.3.3 Drawing with type →p.242
 P.2.3.4 Drawing with dynamic brushes →p.244
 P.2.3.5 Drawing with the pen tablet →p.248
 P.2.3.6 Drawing with complex modules →p.252

P.3 Type →p.256
 P.3.0 Hello, type →p.258
 P.3.1 Text →p.260
 P.3.1.1 Writing time-based text →p.260
 P.3.1.2 Text as blueprint →p.262
 P.3.1.3 Text image →p.266
 P.3.1.4 Text diagram →p.272
 P.3.2 Font outline →p.276
 P.3.2.1 Dissolving the font outline →p.276
 P.3.2.2 Varying the font outline →p.280
 P.3.2.3 Font outline from agents →p.284

P.4 Image →p.286
 P.4.0 Hello, image →p.288
 P.4.1 Image cutouts →p.290
 P.4.1.1 Image cutouts in a grid →p.290
 P.4.1.2 Feedback of image cutouts →p.294
 P.4.2 Image collection →p.296
 P.4.2.1 Collage from image collection →p.296
 P.4.2.2 Time-based image collection →p.300
 P.4.3 Pixel values →p.302
 P.4.3.1 Graphic from pixel values →p.302
 P.4.3.2 Type from pixel values →p.308
 P.4.3.3 Real-time pixel values →p.312

Complex
M./// Methods → p.318

This section extends the repertoire of generative design by introducing and explaining more complex methods in the form of six comprehensive tutorials.

M.1 Randomness and noise → p.320

M.1.0 **Randomness and noise—an overview** → p.322

M.1.1 **Randomness and starting conditions** → p.324

M.1.2 **Randomness and order** → p.325

M.1.3 **Noise vs. randomness** → p.326

M.1.4 **Noisy landscapes** → p.330

M.1.5 **Noisy motion** → p.332

M.1.6 **Agents in space** → p.342

M.2 Oscillation figures → p.346

M.2.0 **Oscillation figures—an overview** → p.348

M.2.1 **Harmonic oscillations** → p.350

M.2.2 **Lissajous figures** → p.351

M.2.3 **Modulated figures** → p.353

M.2.4 **Three-dimensional Lissajous figures** → p.354

M.2.5 **Drawing Lissajous figures** → p.356

M.2.6 **A drawing tool** → p.364

M.3 Formulated bodies → p.368

M.3.0 **Formulated bodies—an overview** → p.370

M.3.1 **Creating a grid** → p.372

M.3.2 **Bending the grid** → p.373

M.3.3 **Mesh class** → p.377

M.3.4 **Deconstructing the mesh** → p.378

M.3.5 **Defining custom shapes** → p.388

M.3.6 **Mesh class—a short reference** → p.389

M.4 Attractors → p.390

M.4.0 **Attractors—an overview** → p.392

M.4.1 **Nodes** → p.394

M.4.2 **Attractor** → p.396

M.4.3 **The attractor tool** → p.400

M.4.4 **Attractors in space** → p.404

M.4.5 **Node class—a short reference** → p.408

M.4.6 **Attractor class—a short reference** → p.409

M.5 Tree diagrams → p.410

M.5.0 **Tree diagrams—an overview** → p.412

M.5.1 **Recursion** → p.414

M.5.2 **Reading data from the hard drive** → p.415

M.5.3 **Sunburst diagrams** → p.417

M.5.4 **Sunburst trees** → p.422

M.5.5 **The sunburst tool** → p.423

M.6 Dynamic data structures → p.432

M.6.0 **Dynamic data structures—an overview** → p.434

M.6.1 **Force-directed layout** → p.436

M.6.2 **Data from the Internet** → p.440

M.6.3 **Force-directed layout with data** → p.443

M.6.4 **Visualizing proportions** → p.445

M.6.5 **Semantic text analysis** → p.448

M.6.6 **Fish-eye view** → p.454

A./// Appendix → p.458

The appendix is a kind of reflection. In it we summarize our thoughts about the changing design process and the new possibilities generative design offers. We link these thoughts with our sample programs and give a perspective on future developments.

A.0 **Reflections** → p.460

A.1 **Index** → p.466

A.2 **Bibliography** → p.468

A.3 **The authors** → p.470

A.4 **We thank** → p.471

A.5 **Address index** → p.472

A.6 **Copyright** → p.474

I.2
Preface

For the last several years generative design has created considerable excitement among insiders at media art festivals and conferences. Through the interplay of complex information with graphic design and programming, new and fascinating visual worlds are emerging where the coincidental is shaped to help correlations become visible.

The possibilities of programming languages such as Processing will change the role of the designer. We are experiencing a paradigm shift in design that will lead to new realms of visual imagery. Knowledge of this change, however, has been somewhat inaccessible. Until now, designers have used the tools that programmers have developed for them, which has forced designers to adjust to their systems.

With generative design, the user of fabricated digital tools becomes the programmer of an individualized digital toolbox. This fundamentally changes the design process. The technical aspect moves into the background and is replaced by abstraction and information as the meta level is realized. Generative design begins not with formal questions but with the recognition of phenomena.

Before we met Hartmut Bohnacker, Benedikt Groß, Julia Laub, and Claudius Lazzeroni, we observed the products of generative design with enthusiasm and fascination; it was only after lengthy conversations with the authors that these paradigm shifts in design became truly clear. We never wanted to make a book with formulas or code—but never say never. Such books are needed to understand generative design and not just marvel at it. Rarely have we learned so much working on a book, and for that, we thank the authors.

We encourage you to use their clear and comprehensive introduction to this emerging field. The authors have taken even the most complex source code and illuminated its key components in an intelligible way. They have structured their guide around classic design principles of color, shape, type, and image, as well as the website www.generative-gestaltung.de. The authors invite both designers and programmers to expand their horizons by sharing their own contributions to the rapidly expanding base of knowledge about generative design.

Generative design has emerged from its niche existence in the last few years and deserves to be available to a broader public. Hartmut Bohnacker, Benedikt Groß, Julia Laub, and Claudius Lazzeroni have created the foundation for such accessibility with this book and its companion website.

We are pleased that we can provide readers with the opportunity to learn about generative design and how to use it, and we wish you a fascinating journey into a new world of design.

Karin and Bertram Schmidt-Friderichs
Publishers, Verlag Hermann Schmidt Mainz

I.3
Image overview

P./// **Basic Principles** → p.164

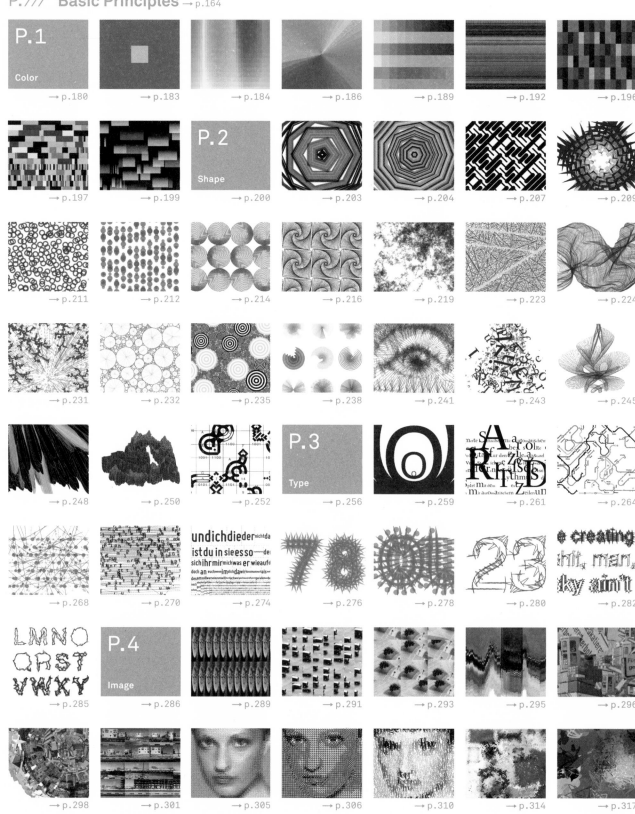

P.1 Color
→ p.180 → p.183 → p.184 → p.186 → p.189 → p.192 → p.196

→ p.197 → p.199 P.2 Shape → p.200 → p.203 → p.204 → p.207 → p.209

→ p.211 → p.212 → p.214 → p.216 → p.219 → p.223 → p.224

→ p.231 → p.232 → p.235 → p.238 → p.241 → p.243 → p.245

→ p.248 → p.250 → p.252 P.3 Type → p.256 → p.259 → p.261 → p.264

→ p.268 → p.270 → p.274 → p.276 → p.278 → p.280 → p.282

→ p.285 P.4 Image → p.286 → p.289 → p.291 → p.293 → p.295 → p.296

→ p.298 → p.301 → p.305 → p.306 → p.310 → p.314 → p.317

M./// Complex Methods → p.318

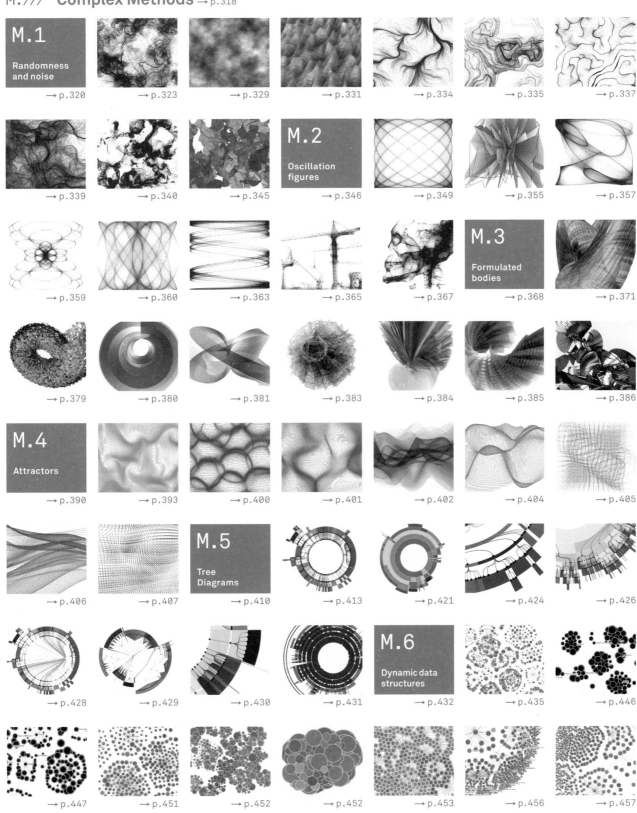

M.1
Randomness and noise
→ p.320

→ p.323

→ p.329

→ p.331

→ p.334

→ p.335

→ p.337

→ p.339

→ p.340

→ p.345

M.2
Oscillation figures
→ p.346

→ p.349

→ p.355

→ p.357

→ p.359

→ p.360

→ p.363

→ p.365

→ p.367

M.3
Formulated bodies
→ p.368

→ p.371

→ p.379

→ p.380

→ p.381

→ p.383

→ p.384

→ p.385

→ p.386

M.4
Attractors
→ p.390

→ p.393

→ p.400

→ p.401

→ p.402

→ p.404

→ p.405

→ p.406

→ p.407

M.5
Tree Diagrams
→ p.410

→ p.413

→ p.421

→ p.424

→ p.426

→ p.428

→ p.429

→ p.430

→ p.431

M.6
Dynamic data structures
→ p.432

→ p.435

→ p.446

→ p.447

→ p.451

→ p.452

→ p.452

→ p.453

→ p.456

→ p.457

I.4
How to read this book

The header

The code link leads directly to the corresponding program on which this chapter is based → p.016, "Downloading the programs for Processing." Explanations are only provided for the basic version of the program, which ends in _01. In the code folders there are often additional versions (_02, _03, etc.), which are variations of the first program and are often more complex.

A list of the interactive possibilities indicates which key and/or mouse action can be used to carry out an action. For instance, it is almost always possible to save a created image as a PNG by clicking on the S key. Parameters are often linked to the position of the mouse cursor → p.019, "Using a program."

The code block

In order to better understand the code, which ideally should also be opened on the computer while reading the book, important parts of the code are listed and accompanied by explanations → p.019, "Using a program."

The most important parts in a code are highlighted so that it is easier to classify the explanations.

Keywords can be recognized by their special color.

The ellipsis signifies that code has been omitted here.

The arrow signifies that the code block is continued on the next page.

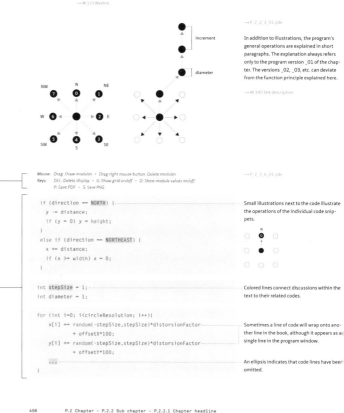

P.2.2.1
Chapter headline

This brief introductory text describes what the chapter is about and what can be learned from it. The text may contain references to other chapters in the book to external weblinks .
→ W.123 Weblink

increment

diameter

→ P.2.2.1_01.pde

In addition to illustrations, the program's general operations are explained in short paragraphs. The explanation always refers only to the program version _01 of the chapter. The versions _02, _03, etc. can deviate from the function principle explained here.

→ W.345 link description

```
Mouse:  Drag: Draw modules  ·  Drag right mouse button: Delete modules
Keys:   DEL: Delete display  ·  G: Show grid on/off  ·  D: Show module values on/off
        P: Save PDF  ·  S: Save PNG
```
→ P.2.3.6_01.pde

```
if (direction == NORTH) {
    y -= distance;
    if (y = 0) y = height;
}
else if (direction == NORTHEAST) {
    x += distance;
    if (x >= width) x = 0;
}

int stepSize = 1;
int diameter = 1;

for (int i=0; i<circleResolution; i++){
    x[i] += random(-stepSize,stepSize)*distorsionFactor
            + offsetX*100;
    y[i] += random(-stepSize,stepSize)*distorsionFactor
            + offsetY*100;
    ...
}
```

Small illustrations next to the code illustrate the operations of the individual code snippets.

Colored lines connect discussions within the text to their related codes.

Sometimes a line of code will wrap onto another line in the book, although it appears as a single line in the program window.

An ellipsis indicates that code lines have been omitted.

456 P.2 Chapter – P.2.2 Sub chapter – P.2.2.1 Chapter headline

The composition of program names

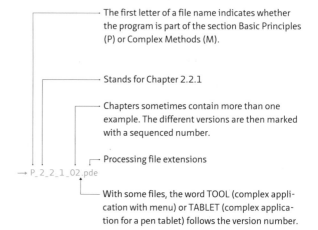

The first letter of a file name indicates whether the program is part of the section Basic Principles (P) or Complex Methods (M).

Stands for Chapter 2.2.1

Chapters sometimes contain more than one example. The different versions are then marked with a sequenced number.

Processing file extensions

→ P_2_2_1_02.pde

With some files, the word TOOL (complex application with menu) or TABLET (complex application for a pen tablet) follows the version number.

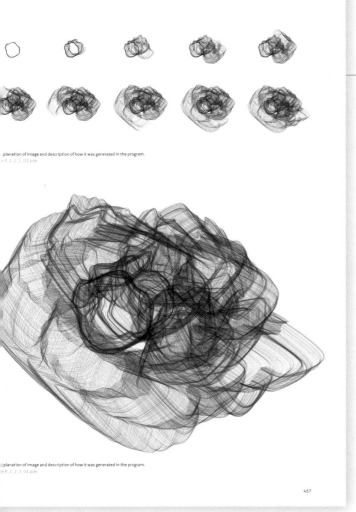

...planation of image and description of how it was generated in the program.
→ P_2_2_1_01.pde

...planation of image and description of how it was generated in the program.
→ P_2_2_1_01.pde

457

Images

In many examples, time sequence is depicted by a series of smaller images.

The image caption contains both a short explanation and a reference to the program with which the image was created.

Different kinds of reference links

→ P_1_1_01.pde	Refers to a program file in the program package → p.018, "Download program and library"
→ p.123	Refers to a page
→ Ch.P.1.1.2	Refers to a chapter
→ W.345	Refers to a website At → www.generative-gestaltung.de, the number code can be directly entered into a search field without typing in long URLs → p.017, "Weblinks"

I.5
How to use www.generative-gestaltung.de

Downloading the programs for Processing

You can download all programs addressed in the book in one package (for Processing 1.x or 2.x) or download every program individually on its code detail page, if you do not want to download the entire code package.

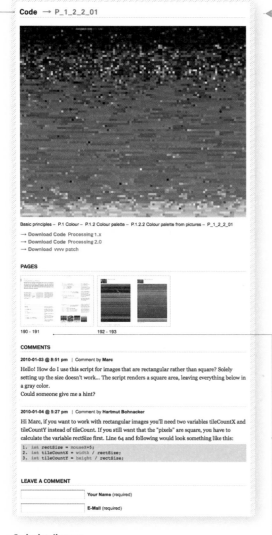

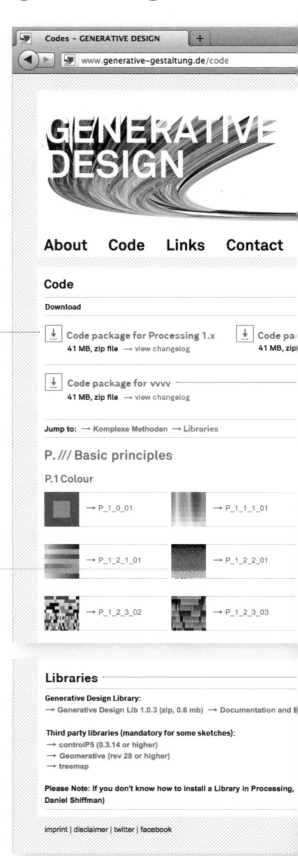

Code detail pages

When you click on a program on the code overview page, you land on a code detail page that shows you an image or video generated by that program, as well as the corresponding page in the book on which the program is explained.

Comments

Because it is possible to post comments, you will be able to network with other people reading this book and exchange applications with them. You can also give or get advice and present your further developments to a broad public.

→ W. 300

Weblinks

The quick link search is there for your convenience (by entering the code number of the desired link in the search field, you are immediately forwarded to the right website). This also ensures that the link collection is up to date if URLs evolve.

In the "Links" menu item all website references included in this book are listed according to the chapter in which they appear. The weblink is followed by a short description and the corresponding book chapter in which it appears.

Links EN / DE / FR

Jump to: → Basic principles → Complex methods → **Appendix** → **Common links**

S. /// Project selection

→ **W.101** Website Sanch [P.001]
→ **W.102** Website Andreas Fischer [P.002/003/004]
→ **W.103** Wikipedia: Mercator Projektion [P.004]

The vvvv code package

You can also download all the programs in another programming language called vvvv.

vvvv is a graphical programming environment for easy prototyping and development. It is designed to facilitate the handling of large media environments with physical interfaces, real-time motion graphics, audio, and video that can interact with many users simultaneously. → vvvv.org

We don't refer to them in the book, but if you are more familiar with visual programming, you might prefer to work with the vvvv patches instead of Processing. They work analog to the Processing sketches addressed in the book and have detailed explanations written directly in the patches.

Downloading the libraries

For some of the programs you need specific libraries, which you can download in this area. The Generative Design library was developed exclusively for this book. Three additional libraries, which were developed by others, are mandatory for some programs. You can download them on the specific websites of each developer. (We didn't include them in our library download package, to ensure that you always get the latest version of each library.)

For the installation of the libraries see → p.018 "How to Install Processing" or the tutorial of Dan Shiffman.

I.6
How to use the programs

How to install Processing

1. Download the newest version of Processing. The programs for this book were created with version 2.0, but newer versions should also work.
→ www.processing.org

2. Download the 2.0 code package and libraries from www.generative-gestaltung.de/code.
→ p.016, "Downloading the programs for Processing"

The libraries you will need for this book are:
· Generative Design Lib
· controlP5
· Geomerative
· treemap

With Processing 2.0, libraries can be added easily from within the program via the menu items "Sketch > Import Library… > Add Library…"

If you are using an older version of Processing, you will need to download the libraries from www.generative-gestaltung.de. Put all libraries in the folder "Documents > Processing > libraries." (The Processing program will have created this Processing folder automatically the first time you started it.) The code package can be stored anywhere on your computer.

3. Via "File > Open…" you can now open any of the programs in the code package. Processing programs (also called "sketches") have the file extension ".pde." Many PDE files can be part of a given program (in this example, "M_3_4_03_TOOL").
It is sufficient to open just one of these; the other parts of the program open automatically and appear as tabs in the editor. Sometimes there are folders with the name "Data" in the program folder. These contain files (texts, images, etc.) that the program also requires. A PNG file provides a simple preview of the elements of a program.

▼ 📁 M_3_4_03_TOOL
 📄 GUI.pde
 📄 M_3_4_03_TOOL.pde
 📄 M_3_4_03.png
 📄 Mesh.pde
 📄 TileSaver.pde

4. The program is started with "Sketch > Run" or with the "play" button. A new window (the display window) opens in which the program runs. The interactions described in the book and in the pde header are now available.

5. The program is ended by closing the display window or by hitting the stop button. The changes you have made in the display window will then be lost. The program begins with the same initial settings the next time it starts. The changes that have been made and saved in the program code will be kept.

6. Warning: Some of our programs require a lot of storage space, especially when saving high-resolution images. Therefore, the Processing setting "Increase maximum available memory" should be activated and set at 512 MB or more. In some cases it may take a bit longer to save images.

7. More information can be found in
→ Ch.P.0.0 Processing—an overview

The corresponding program to every chapter can be easily found using the file name. The programs are named after the chapters.
→ p.014, "The composition of program names."

In many programs, this section (the Processing console) is used to display status information. (This example notes the progress of the PDF edition.)

This number indicates in which line of code the cursor is located. This is especially important when looking for mistakes.

We released the programs in this book under the Apache license. This essentially means the programs can be freely used, modified, and distributed in any context.

Using a program

Generally speaking, one does not have to be able to program in order to benefit from this book, since every program can simply be used as is. In the Basic Principles section, a series of interactive projects is available with which a created image can be modified and saved.

In the Complex Methods section, the final programs have a parameter menu with controls and buttons. Using this menu, extremely varied images can be created and saved as high-quality images without having to deal with the code.

Program output

Depending on the program, high-resolution images or vector data can be saved. These are saved in the same folder that also contains PDE files. The saved files are given final names comprised of dates and times, making it easy to see in what order the images were created.

Color palettes can also be saved in ASE format for Adobe applications, using the programs contained in the chapter on color palettes.

Vector data can usually be saved (as an editable PDF) simply by pressing the P key. In some programs it may be necessary to quasi-record the PDF (recording is started by pressing R and ended with E); all elements created after the start of recording are saved live in a PDF that is finalized when the recording process ends.

Modifying a program

As a small introduction to programming, you can simply change certain parameters. This allows the creation of more variations than those that are possible with mouse and keyboard interaction. The lines in which it makes sense to change parameters are indicated with //// and followed by a reasonable range of values.

Creating new programs

We encourage users to alter existing programs or create new ones using their elements.

The Generative Design library, which provides many useful functions and classes, can be a great help in this respect.

Library documentation can be found at → www.generative-gestaltung.de. There are also short references for the classes at the end of the chapter in which they can be used.

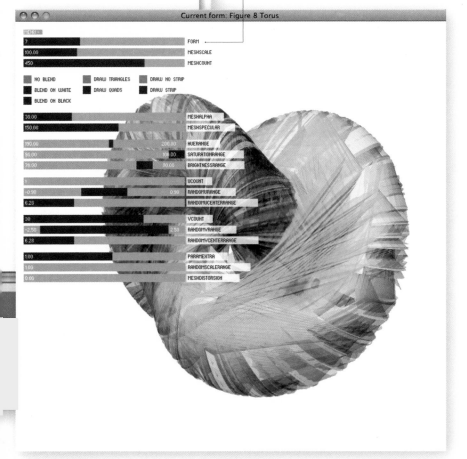

S.///

These thirty-five works by various media artists, designers, and architects active in the field of generative design are intended to serve as a representative overview of the subject and as a source of inspiration. In the project descriptions you will also find references to related chapters in the Basic Principles and Complex Methods sections of the book.

S.01 Superformula →p.024

S.02 extracts of local distance →p.028

S.03 10,000 Digital Paintings →p.032

S.04 Reflection →p.036

S.05 A Week in the Life →p.040

S.06 Gestalt →p.044

S.07 Aperiodic Symmetries →p.048

S.08 Recursive Growth →p.052

S.09 Platonic Solids →p.056

S.10 Subdivided Pavilions →p.060

S.11 Der Wirklichkeitsschaum →p.064

S.12 Red Ambush →p.068

S.13 Subjektbeschleuniger →p.072

S.14 Growing Data →p.076

S.15 Similar Diversity →p.080

S.16 Generative Lamps →p.084

S.17 Segmentation and Symptom →p.088

S.18 Footfalls →p.092

S.19 Poetry on the Road →p.096

S.20 Actelion Imagery Wizard →p.100

S.21 Talysis II, Autotrophs →p.104

S.22 Delaunay Raster →p.108

S.23 Tile Tool →p.112

S.24 Process Compendium →p.116

S.25 con\texture\de\structure →p.120

S.26 Being not truthful →p.124

S.27 Casa da Música Identity →p.128

S.28 Type & Form Sculpture →p.132

S.29 Faber Finds →p.136

S.30 genoTyp →p.140

S.31 Evolving Logo →p.144

S.32 _grau →p.148

S.33 well-formed.eigenfactor →p.152

S.34 Cyberflowers →p.156

S.35 Stock Space →p.160

S.01
Superformula

Superformula is generative art in the classic sense. The project explores abstract, three-dimensional compositions; its creative aim is purely aesthetic. An artistic space of forms and rich colors is generated out of various experiments with random values, algorithms, and interactive processes.

Each composition consists of numerous individual forms that have been distorted into three dimensions by using mathematical formulas and then further manipulated. Depending on the parameters employed, the results range from shell-like, opulent figures to aggressive, technical structures.

In 2004 David Dessens began using the so-called Superformulas (cf. J. Gielis) in combination with vvvv software, a graphic programming language known for its speed; the graphic card executes many computations without having to use the main processor. Different mathematical formulas are converted into pixel and vertex shaders and then used on geometric grids. In the process the vertex shaders rapidly influence the existing objects' geometry.

David Dessens (Sanch)

2008
Superformula

→ W.101
Website: Sanch

Related chapter:
→ Ch.M.3
Formulated bodies

extracts of local distance

Members of the studio FELD came up with the initial idea for *extracts of local distance* while exploring the archive of an architectural photographer. Looking at the thousands of images revealed some overall common aspects of image composition, including very prominent perspective foreshortening and vanishing points.

This realization led to experiments with those visual features. In the early stages, various algorithms for image analyzation and segmentation were tested and combined. The simple layering of small snippets of different photographs, aligned to a common vanishing point, created small collages of architectural spaces with a common perspective. Fascinated by the outcome of the experiments, the designers ran the algorithms through software tools that could be used to create much bigger collages.

The final process uses two separate tools. The high-resolution source images are initially analyzed and categorized according to their vanishing points and the shapes they contain. Based on this analysis, the images are digitally sliced into many pieces that retain the information of their positions in relation to the vanishing point and the lines of perspective. For this purpose, an algorithm was developed that handles the analysis in a semiautomatic process. It also manages the slicing of the pictures into smaller fragments, resulting in a large pool of pieces, ready to be applied to new perspectives and shapes within new images. Those pieces, together with the information about their original perspective, form the repertoire for the creation of new collages.

A second tool provides an interface for the composition of new collages. To make a collage, a coarse geometry is defined and a covering of matching image segments is applied. The segments are never altered to match the frame, but instead appropriate ones are chosen from the mass of possible pieces. By defining additional keywords that describe the content of the original photographs, the selection of segments used for the final composition can be influenced. Thus, the semantic linking with the source material adds a contextual layer.

The recompositions mix and match the views and perspectives of both the architect and the photographer with a third, newly chosen frame. Each resulting fine-art print is unique. The method bears the potential for further experimentation and can be considered a work in progress.

FELD

2009
extracts of local distance
Collage generator

→ W.144
Website: extracts of local distance

Related chapter:
→ Ch.P.4.2.1
Collage from image collection

S.03
10,000 Digital Paintings

Invited to educate the design community about the possibilities of digital print and generative design, FIELD created a series of unique cover artworks for this 2011 Print Test brochure for legendary British paper manufacturer GF Smith. Generated through a process combining generative coding with creative intuition, each sleeve features a different view of a hypercomplex sculpture. The energy of a dynamic process is caught in a timeless medium. The team at SEA Design originally created this work as an impromptu artistic response to a music track, then recognized its similarities to the microfiber structure of paper and invited FIELD to elaborate on the project for the Print Test brochure.

Hand-drawn 3D curves form the basic structure of the object, several of them encompassed by convex hulls. A surface generator breaks up the hull based on randomly generated noise textures—like crumpling a sheet of paper. Every image explores a different close-up view of the sculpture, while the bulk of it remains hidden in a vast virtual space: its actual shape, touch, and materiality is left to the viewer's imagination.

FIELD

2011
10,000 Digital Paintings

Commissioned by:
SEA Design

Client:
GF Smith

→ W.145
Documentation video on field.io

Related chapters:
→ Ch.M.3
Formulated bodies
→ Ch.M.1.4
Noisy landscapes

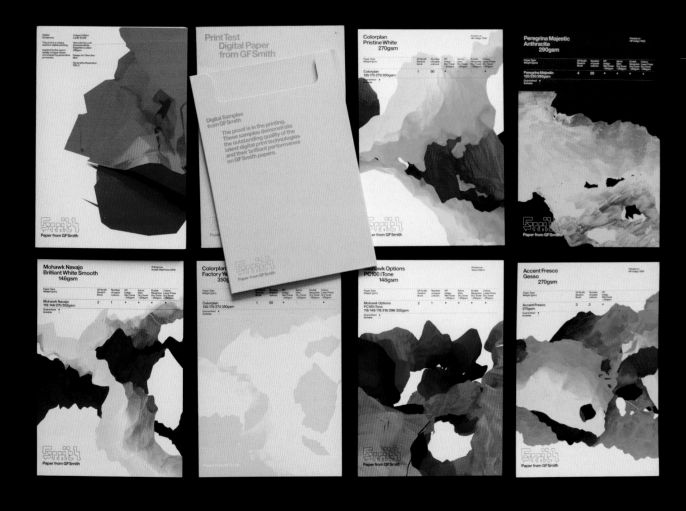

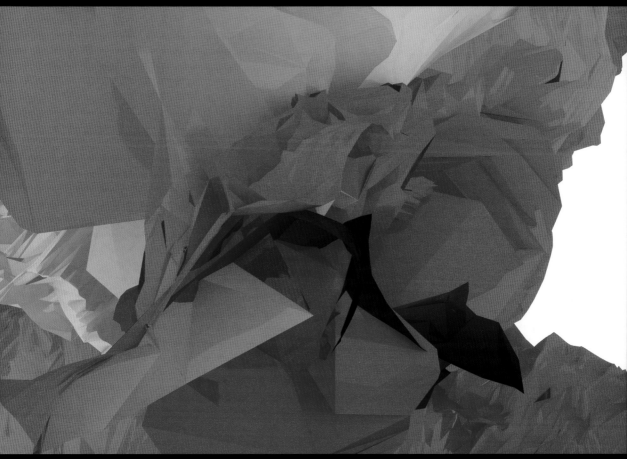

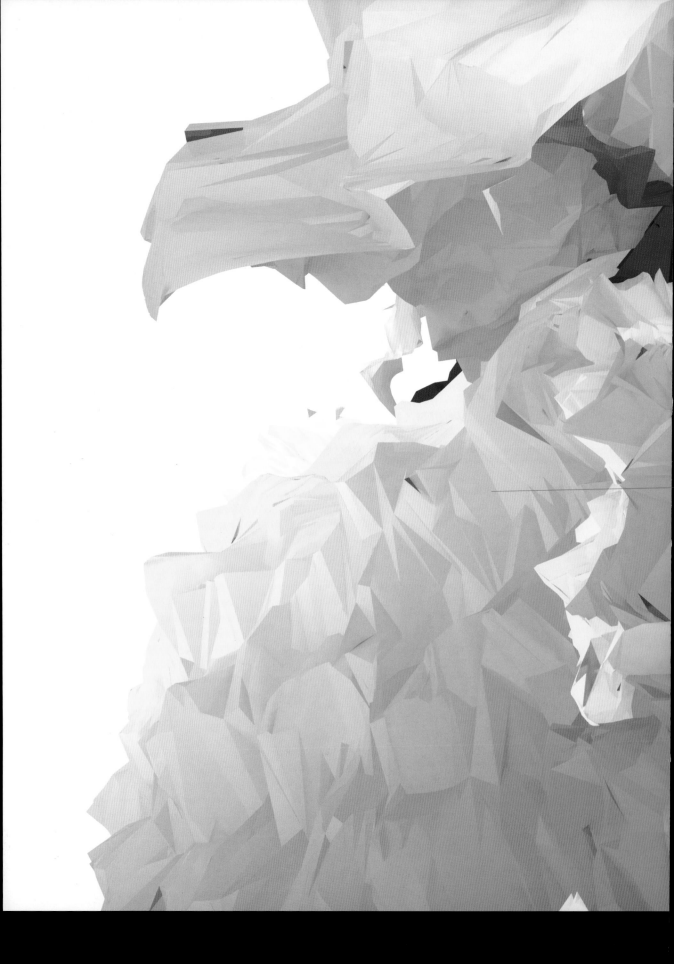

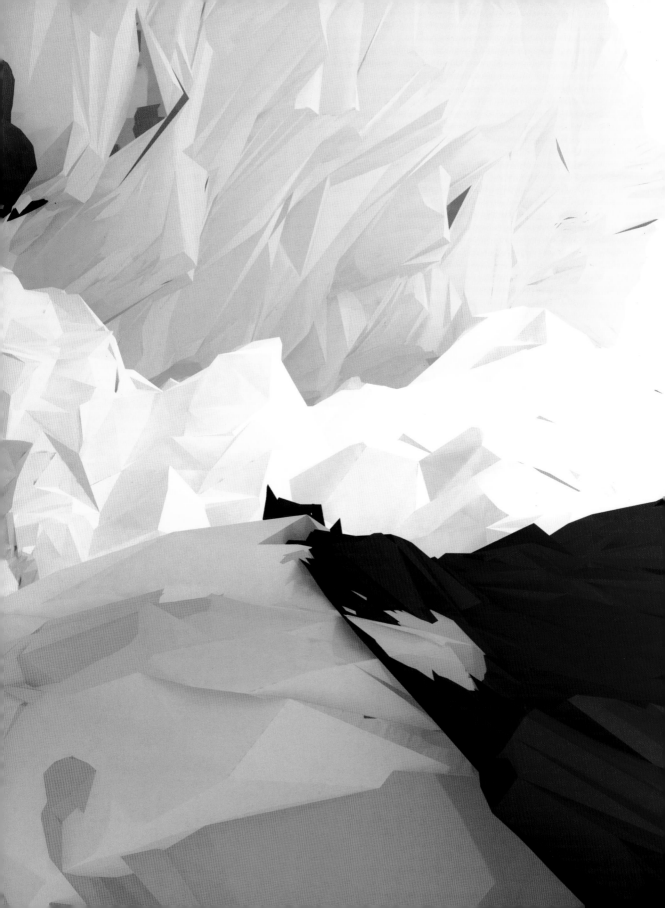

Reflection

Reflection is a data sculpture based on an analysis of the eponymous piece of music by Dutch artist Frans de Waard. The sculpture was commissioned by the 5 Days Off Festival in July 2008 in Amsterdam for the exhibition *Frozen*.

Reflection is an approximately sixteen-minute-long piece of electronic music characterized by twelve musical motives, which appear in almost linear succession. The wave forms and spectrum analysis clearly demonstrate the repetitive structure. The motives were reduced to their smallest repeated elements.

The distinctive elements extracted from the piece of music were analyzed by software created expressly for this purpose and then transferred onto a spatial coordinate system. Fast Fourier transform (FFT) analysis is a common method of investigating sound, in which the frequency spectrum of the audio signals are represented over the temporal course of a piece, making the structure of the musical motif visible. The resulting intensity forms were arranged according to their frequency in the piece.

Andreas Fischer
Benjamin Maus

2008
Reflection
Sculpture

CNC-milled MDF
90 × 72 × 12 cm

→ W.102
Website: Andreas Fischer

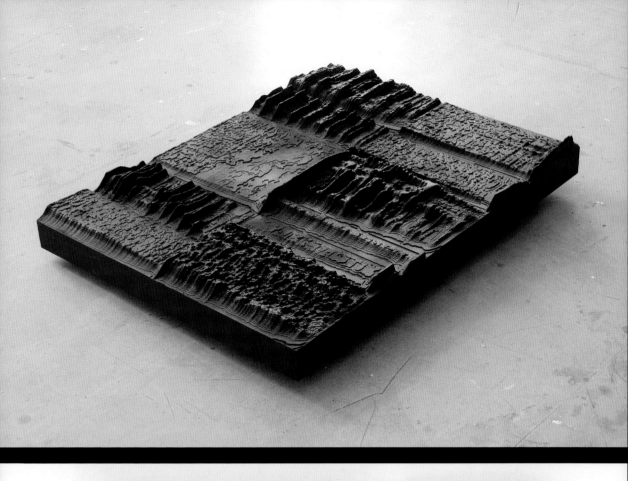

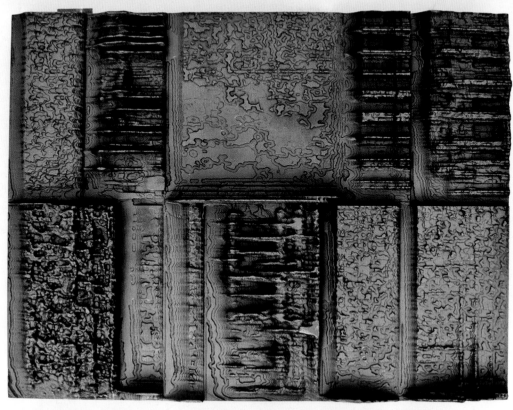

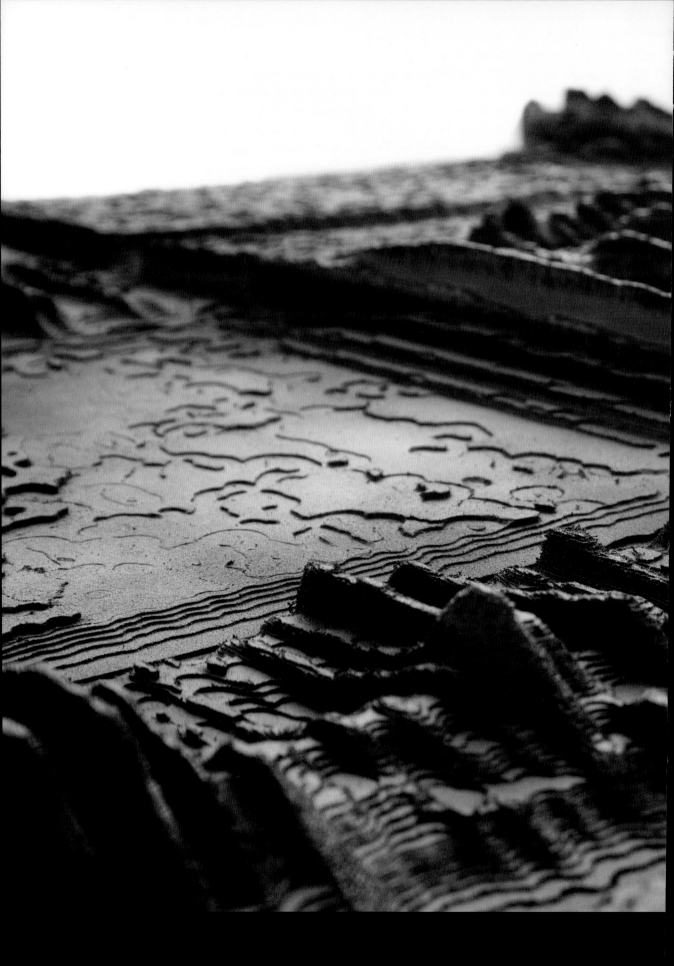

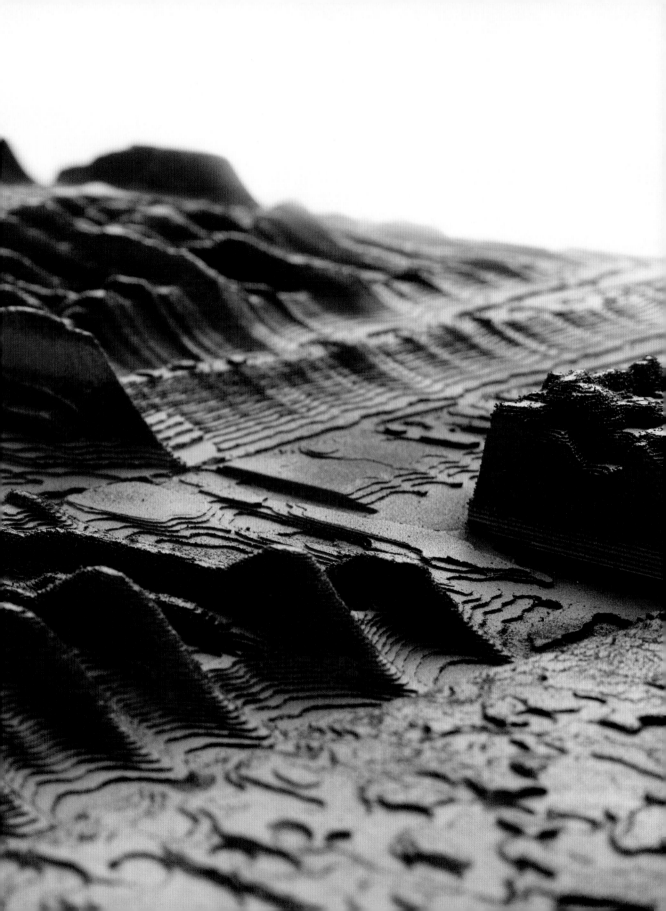

S.05
A Week in the Life

A Week in the Life is based on Germany's Law on the Revision of Telecommunications Monitoring and other Covert Investigation Measures and on the Implementation of Directive 2006/24/EC (the EU Data Retention Directive), which stipulates that all telecommunication providers are obliged to save customers' connection data for six months. This sculpture, a visualization of telecommunication data, depicts Andreas Fischer's movements in Berlin over the course of a week; the data was collected using software written expressly for this purpose. The space though which Fischer moved was measured using the radius of the radio waves. The distribution of radio cells is determined by their signal strength and position; their coordinates are transmitted with their signal and can be converted into longitude and latitude, which results in the sculpture's form.

Andreas Fischer

2005
A Week in the Life
Sculpture

Laser-cut cardboard
120 × 70 × 20 cm

→ W.102
Website: Andreas Fischer

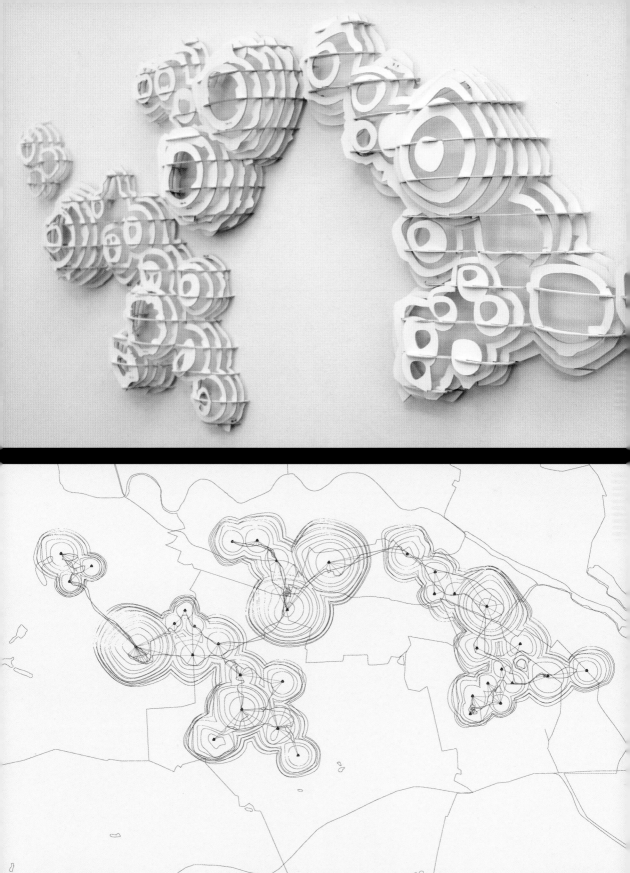

GPS motion path

Antenna range

S.06
Gestalt

Gestalt is an experimental short film that explores the visual space of a mathematical formula. The work is based upon Thorsten Fleisch's analysis of Mandelbrot set fractals and the geometry of the fourth dimension as well as his interest in the spiritual component of science.

This concern for spirituality is part of a long tradition: the Pythagoreans regarded science and mathematics as an expression of divine order. Numbers—already mystical in nature because of their immateriality—were not just tools, but the manifestation of divine power. The spirit of the Pythagoreans lives on today as a research branch of elementary physics that deals with superstring theory. With this theory researchers hope to unite the universe's four basic forces (gravity, electromagnetic force, weak nuclear force, and strong nuclear force) in one elegant formula. Building on the work of these theorists, Fleisch displays the strange universe of a much simpler mathematical theory.

Four-dimensional *quaternions* (a special group of fractals) are visualized by projection into three-dimensional space. The mathematical body in the movie *Gestalt* is the visualization of the formula $(x[n+1] = x[n]\,p - c)$. To familiarize himself with the forms of mathematical bodies, Fleisch spent nearly a year manipulating variables and close to another year rendering the selected sequences at a higher resolution.

Thorsten Fleisch

2003
Gestalt
Film

Rendering:
Timo Fleisch, Bernarda Fleisch,
Jan Weingarten, Thorsten Fleisch

→ W.104
 Website: Thorsten Fleisch

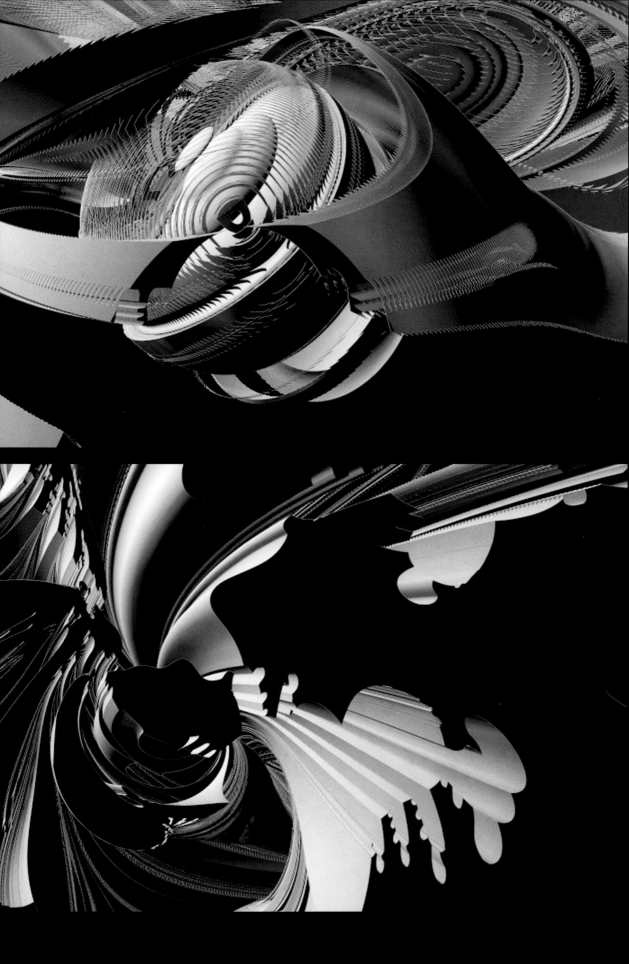

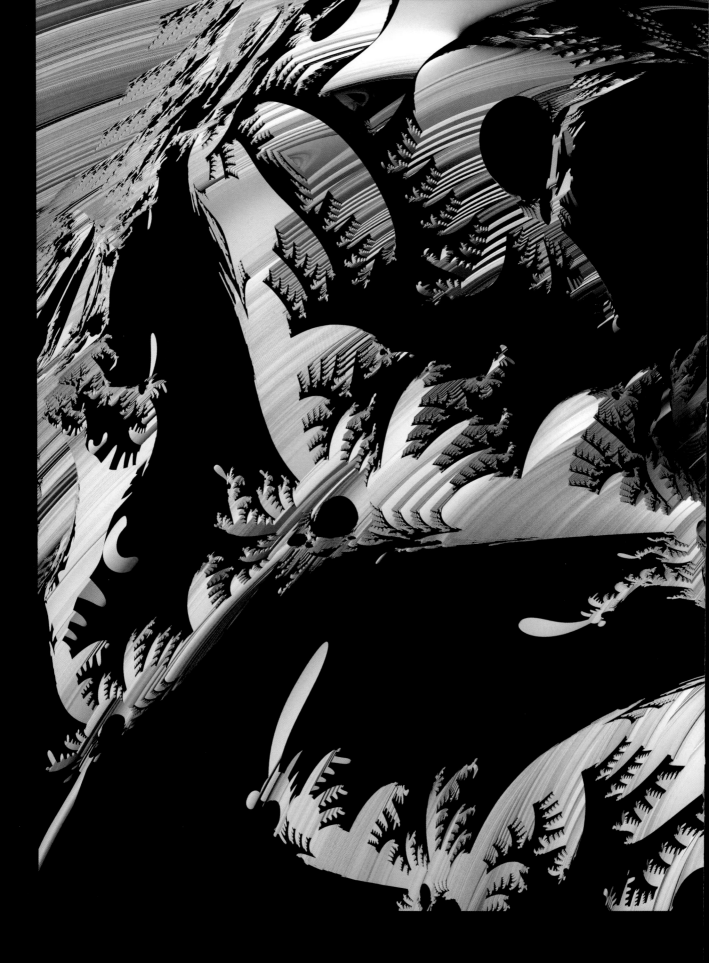

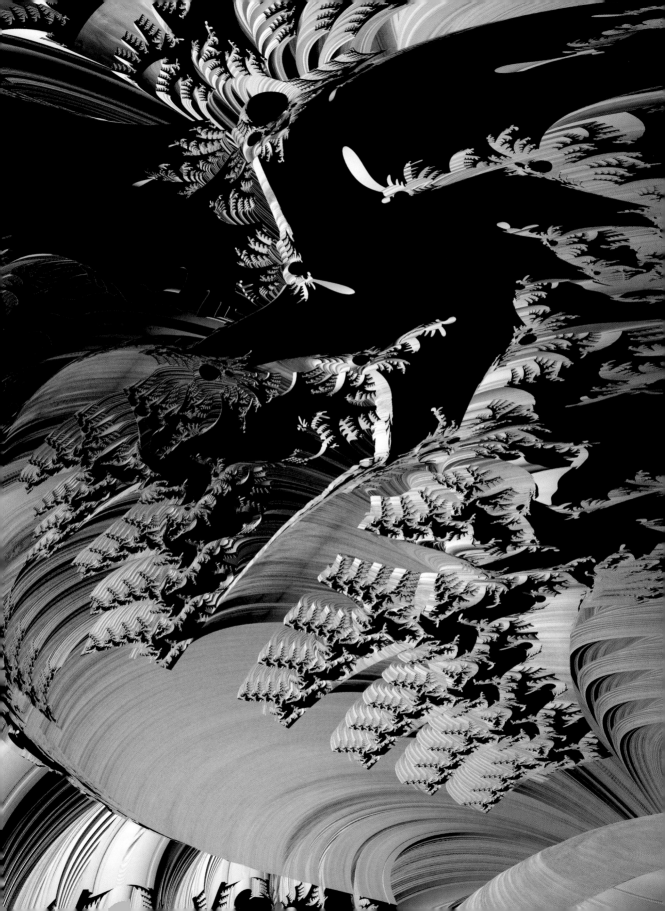

Aperiodic Symmetries

Aperiodic Symmetries is part of a series of experiments conducted by the collective THEVERYMANY. These projects explore complex spatial structures that are generated using optimization algorithms. This approach to architectural form aims to optimize, within the design process itself, structural features such as engineering, cost, air circulation, light transmission, and—not least—aesthetic quality.

A total of 757 star-shaped connections and 883 formal elements—each unique—unite to create an abstract and expansive structure 6.3 × 2.5 × 3 meters in size. The individual elements are made of polyethylene sheets and were produced within five days using CNC milling machines, which enable the automated fabrication of large numbers of custom-molded freeform shapes. The machines are programmed using RhinoScript, a scripting language for Rhino 3D modeling software based on Microsoft's VBScript.

THEVERYMANY
Marc Fornes
Skylar Tibbits

2009
Aperiodic Symmetries
Permanent installation

Programming (RhinoScripting):
Marc Fornes

Sponsored by:
Sturgess Architecture
Zeidler Partnership Architects
RJC Consulting Engineers

Supported by:
Faculty of Environmental Design,
University of Calgary, Canada
Jason S. Johnson, Josh Taron

Student assistants:
Frazer Van Roeckel, Dolores Bender-Graves,
Matt Knapic, Bradena Abrams Reid, Carmen
Hull, Peter MacRea, Adam Onulov, Tiffany
Whitnack

Gallery assistants:
Jordan Allen, Ryan Palibroda

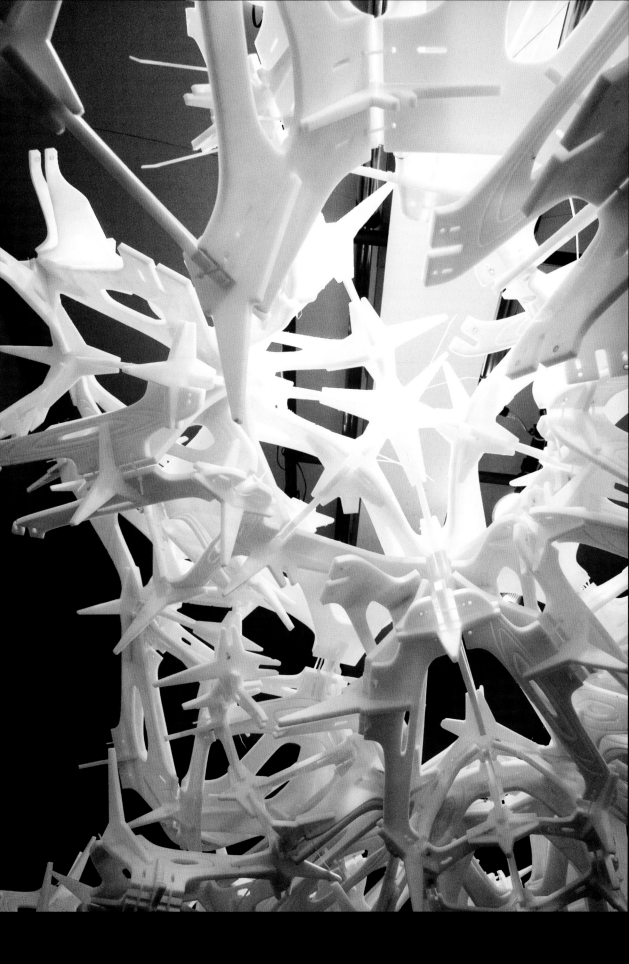

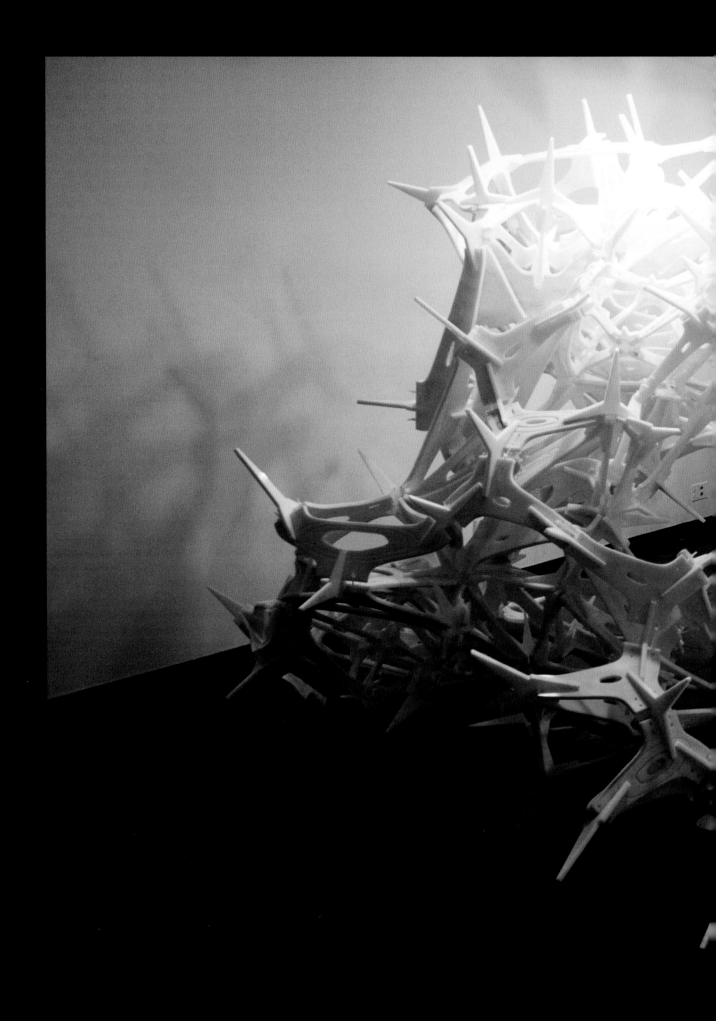

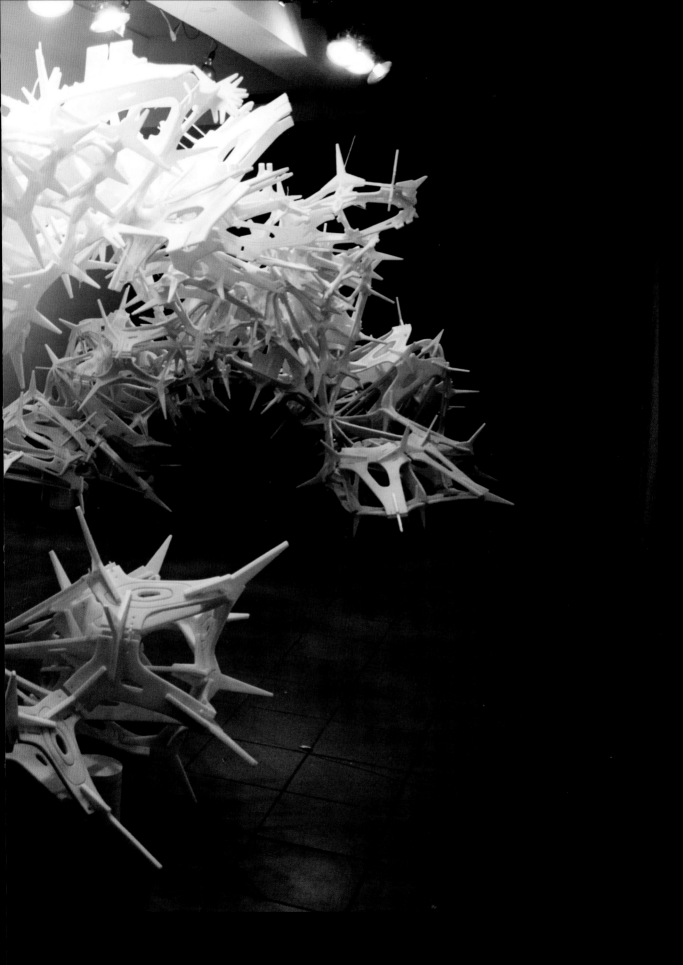

Recursive Growth

In mathematics and the sciences, recursion refers to a method in which a function is defined by itself. In a broader sense, the term is also used to describe processes in which objects repeat themselves. Two mirrors that almost directly face each other reflect their images in an infinite recursion.

The project *Recursive Growth* is an examination of growth processes resulting from the recursive subdivision of surfaces. In combination with simulated physical forces, this process offers the possibility of structural form-finding. Pressure in the form of a vector is applied to the center of a surface in order to break it up. Depending on the direction of the force and the shape of the surface, which breaks into different numbers of pieces according to defined rules, each force can create an additional force in each generation. The process is then continuously repeated.

This series of experiments ranges from problem-solving to design research and is driven by the quest for efficiency. The designer can observe all steps in the process and selectively incorporate asymmetries, fractures, and limitations. The qualities of a structure created in this way can then be considered when handling similar problems in the future.

THEVERYMANY
Marc Fornes

2007
Recursive Growth
Research project

Programming (RhinoScripting):
Marc Fornes

→ W.105
Website: THEVERYMANY

Related chapter:
→ Ch.M.5.1
Recursion

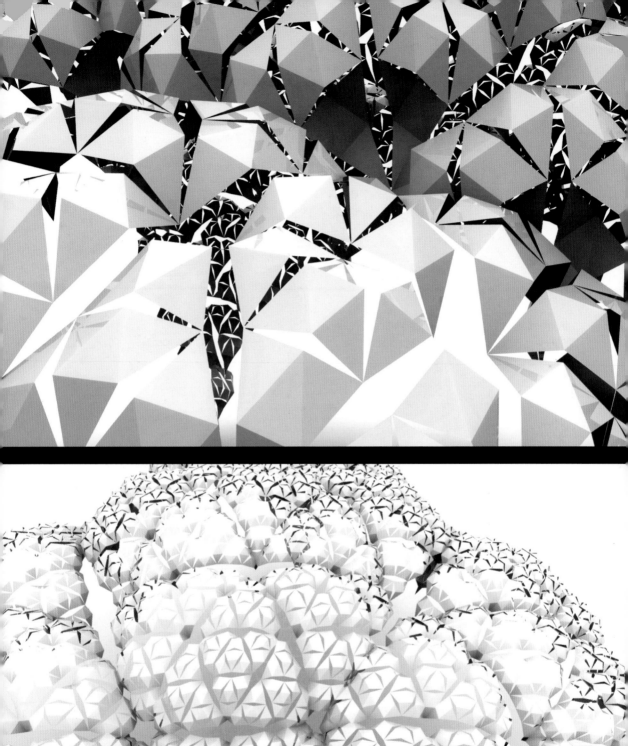

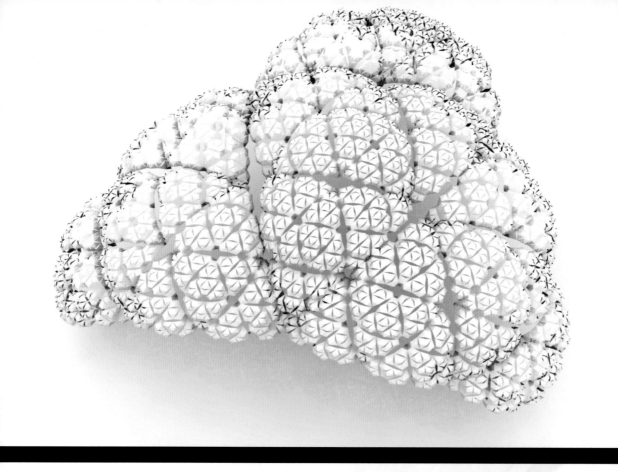

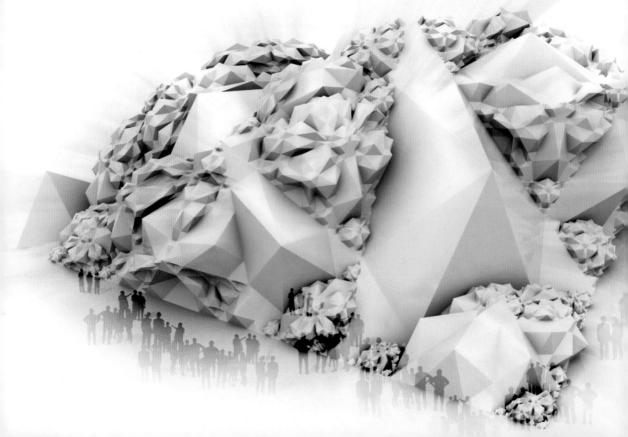

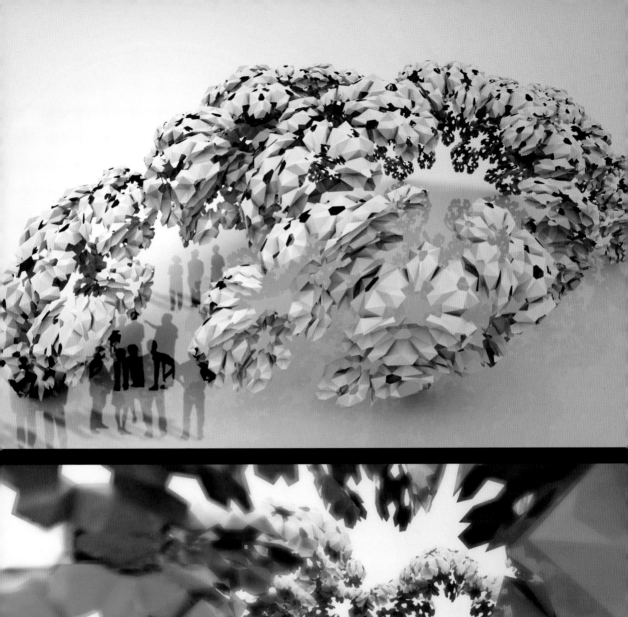
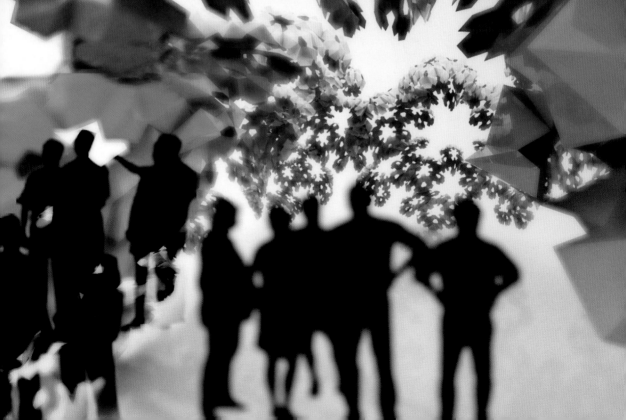

S.09
Platonic Solids

This project explores the use of three-dimensional subdivision algorithms and demonstrates that heterogeneous and rich forms can be generated using a single, simple approach. These algorithms originally came from the field of computer graphics and were employed to calculate round, soft shapes out of rough polygons. The subdivision processes are applied recursively to simple Platonic solids. This allows designers to concentrate on the range of possible outcomes of the individual generative processes. Changes made to the parameters directly affect form attributes such as branching, curvature, structure, and surface properties. Many forms look organic and resemble living creatures, such as the radiolarians from Ernst Häckel's *Kunstformen der Natur* (Art Forms in Nature). Other parameter combinations, in contrast, yield completely different results not found in nature. In both cases, however, the forms are generated by a simple process. Hence, they are easy to retrace and can be deformed without restraint.

In recent years discussions about generative art have often focused on complex, agent-based models capable of creating fascinating results. In contrast, this project focuses on simple, deterministic, and comprehensible generative processes. The results are predictable and controllable, and therefore can be readily developed and refined.

The subdivision algorithms used in this design are based on the work of Daniel Doo and Malcolm Sabin; Edwin Catmull and Jim Clark; and Jörg Peters, Ulrich Reif, and Charles Loop. The forms are created in Processing with OpenGL and rendered using the DXF exchange format. The illustrated works are in the seventh to tenth generation of the process and consist of 200,000 to 1,800,000 surfaces. The rendering has a resolution of 8,000 × 8,000 pixels.

Michael Hansmeyer

2008
Platonic Solids

→ W.106
Website: Michael Hansmeyer

Related chapters:
→ Ch.M.3
Formulated bodies
→ Ch.M.5.1
Recursion

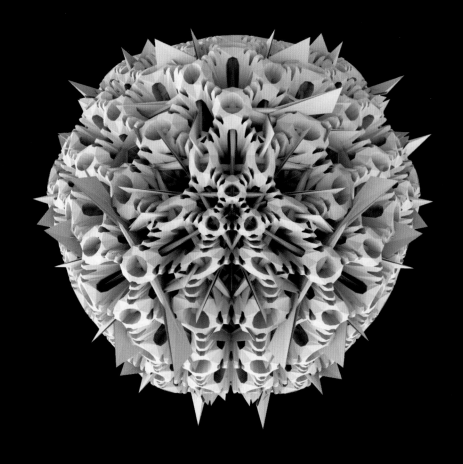

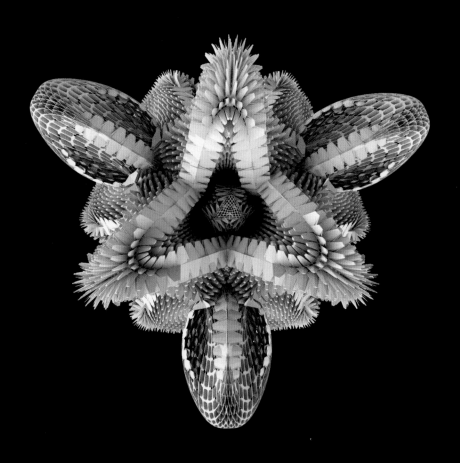

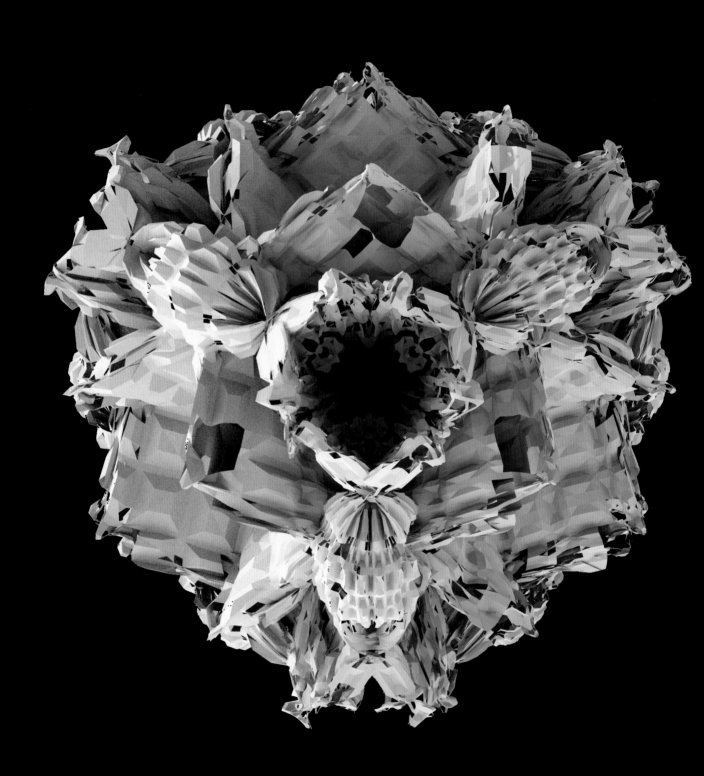

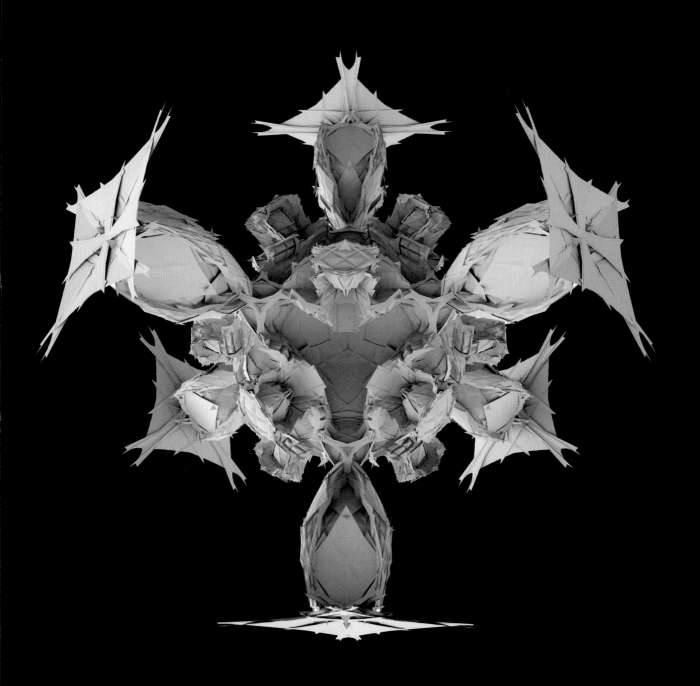

Subdivided Pavilions

This project examines three-dimensional subdivision processes as generators of architectural forms. In this work, the source data consists of simple rectangular abstractions of buildings, often composed of only a few dozen polygons. Space and context determine the subdivision processes applied to the meshes. Both the measurements and depths of the divisions are variable. The change in these values affects the space and the shell of the generated building. On another level, the given edge of the meshes can impact the structural system of the building. Finally, surface properties such as softness, porosity, and formation patterns are influenced. The resulting pavilions are generated by a single, predetermined division process. While the process makes no formal distinction between volumes and shell, structural conditions and surface—it is completely blind to the semantics—the viewer can clearly differentiate between such qualities. It is precisely this contrast that makes further exploration of the generative processes worthwhile.

The project uses variations of the Catmull-Clark and Doo-Sabin algorithms. The forms were generated in Processing and exported to Maya via MEL scripts. The initial forms have between eight and thirty-two faces, while finished objects consist of an average of 500,000 faces. Faces smaller than 10 cm^2 are not included in the division process.

Michael Hansmeyer

2006
Subdivided Pavilions

→ W.106
Website: Michael Hansmeyer

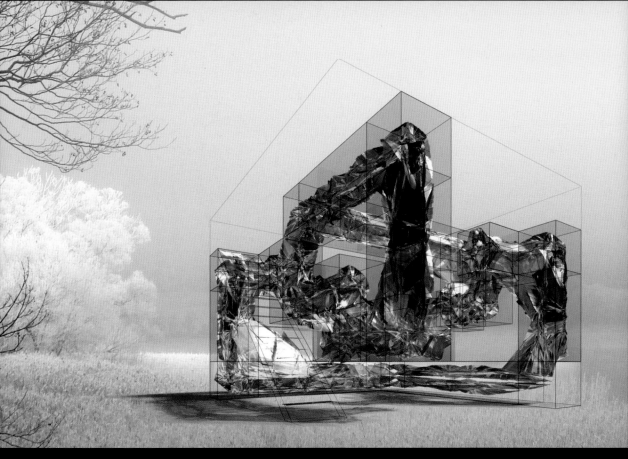

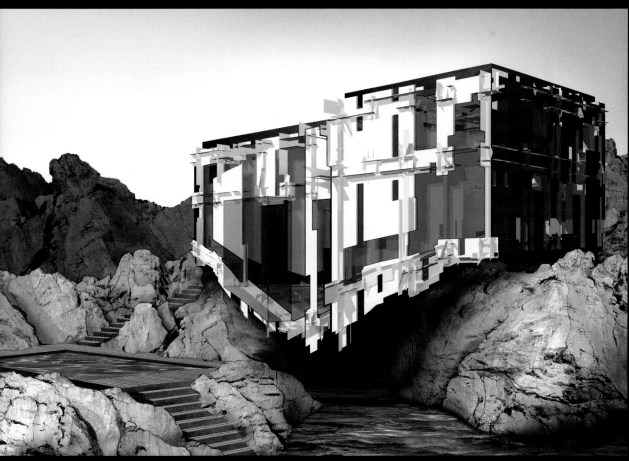

Der Wirklichkeitsschaum

In *Der Wirklichkeitsschaum* (Reality Foam), Eno Henze attempts to depict the structure of objects as we see them, assuming that all things in reality appear as multi-dimensional spheres. Objects should not be reduced to elements of meaning but rather manifest themselves as a network of relationships, references, and demarcations. Imaginary layers and wrappings render the objective qualities of a thing inaccessible. Like an atom, each core contains a volume enclosed by a shell, which engages in a relationship of exchange and delimitation with its surroundings. Seen from a distance, the matter of reality forms a sea of bubbles: reality foam.

These spheres of meaning are depicted mathematically as attractors that do not allow particles to penetrate their center. Particles swirl about in areas where the influences of neighboring attractors merge. The structure of the attractors is scanned or sampled by particles, and the particles' paths of movement then become visible as a line network. The work, consisting of 288 colored laser prints on A3 paper, was mounted as wallpaper in the installation *My Vision* in the Zephyr Room for Photography and the Reiss-Engelhorn Museums in Mannheim.

Eno Henze

2007
Der Wirklichkeitsschaum

→ W.107
Website: Eno Henze

Related chapters:
→ Ch.M.1
Randomness and noise
→ Ch.M.4
Attractors

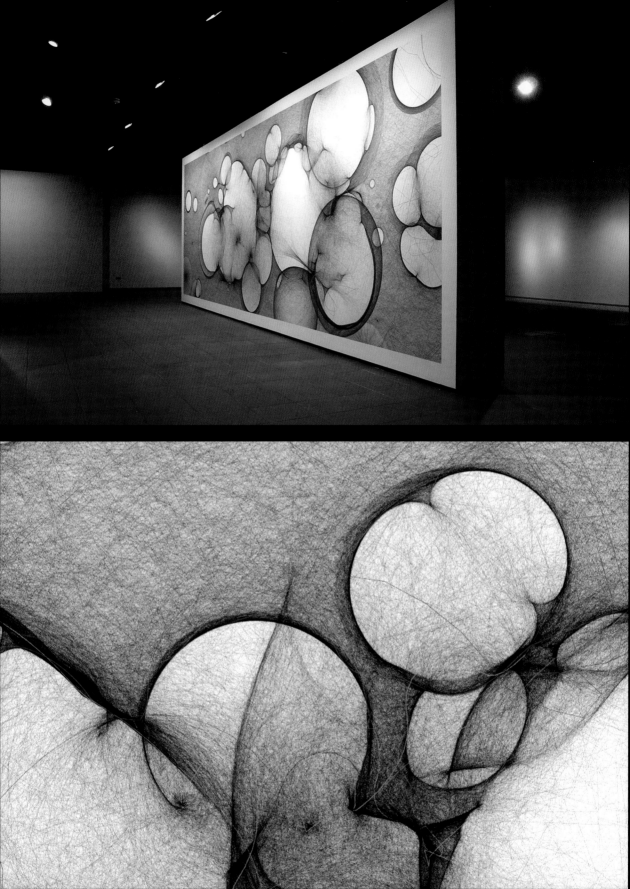

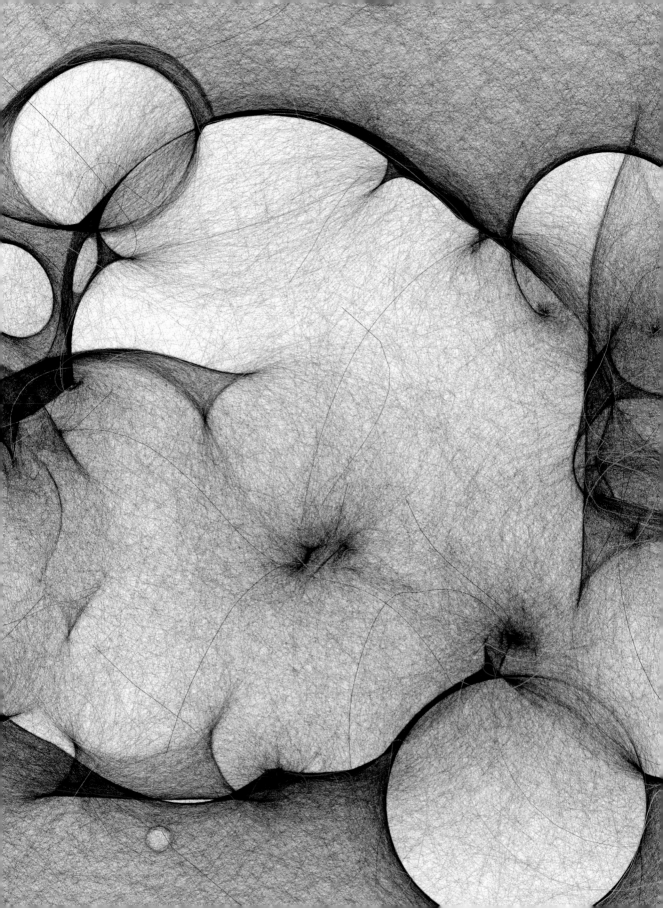

Red Ambush

Red Ambush is part of a series of images in which Eno Henze attempts to teach a computer to draw like a human. What succeeds at the detail level is destroyed on a larger scale: the individual line is so wobbly, erratic, and arbitrary that it could have been drawn by hand. Collectively, however, the lines are so evenly and precisely arranged that they could come only from a machine.

The large structure of the images is created by scanning a surface generated by a Perlin noise function. Perlin noise is superimposed noise of various frequencies. It creates random structures similar to those of a natural phenomenon such as a water surface with waves of different sizes. Lines crisscross over the surface to define the piece's amorphous structure. Individual identifiable strands form a loosely woven cloth.

Red Ambush was commissioned by MAXALOT Gallery, Amsterdam.

Eno Henze

2008
Red Ambush

→ W.107
Website: Eno Henze

Related chapters:
→ Ch..P.2.2.3
Shapes from agents
→ Kap.M.1
Randomness and noise

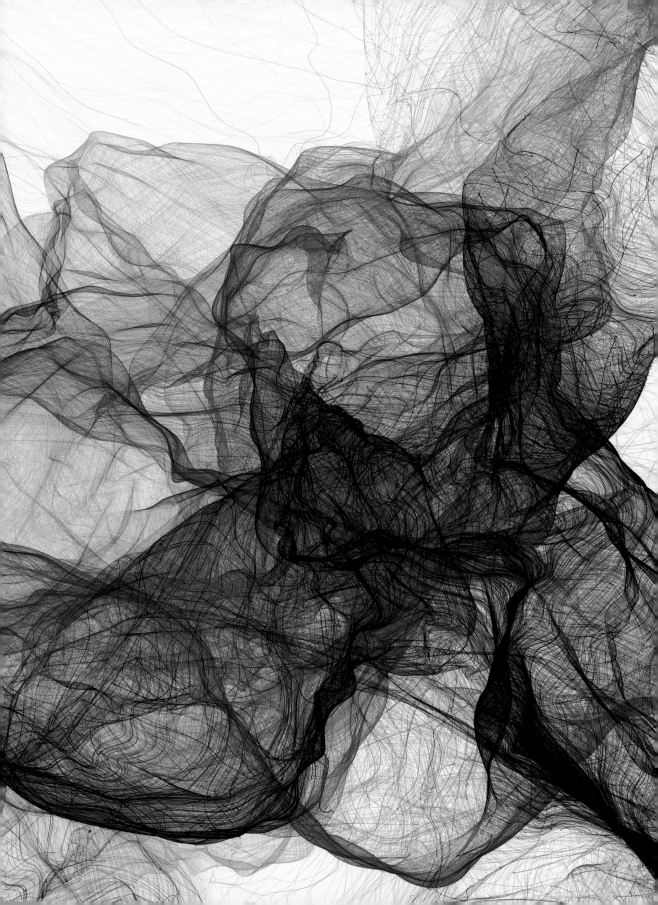

S.13
Subjektbeschleuniger

This drawing is based on the signatures left by subatomic particles in detectors like those used, for example, at CERN (the European Organization for Nuclear Research) in Geneva. By interpreting these signatures, scientists try to explain how all matter is composed and how our world functions on a fundamental level. Eno Henze has always been fascinated by the contrast between the simplicity and beauty of the external of these markings and their invisible meaning. The topic accelerator uses these signatures and strips them of their function as scientific evidence. The impenetrable thicket of signs becomes a symbol of the attempt to explain the world using scientific reason. Henze has approximated the forms of the real signatures using his own frame-based algorithm that reproduces the essential characteristics of the real signatures—fork-shaped connected spirals, drifts, long and short forms, changes in the signs of the motion vector. The scientific formulas that describe the models are not used.

The project is executed using a drawing machine Henze developed. Two computer-controlled mirrors with a focused laser beam expose plates coated with a light-sensitive emulsion, which are then developed. The drawing and the laser control are implemented using the same software (vvvv), so that the lines are calculated and drawn virtually simultaneously.

Eno Henze

2008
Subjektbeschleuniger (Subject Accelerator)
Installation

Subjektbeschleuniger I
Exhibited at Node08: Forum for Digital Arts
in Frankfurt am Main
32 panels, each 68 × 68 cm
280 × 560 cm total dimensions

Subjektbeschleuniger III
Part of the exhibition
Von Dunkler Materie und Grauer Masse (Of Dark Matter and Gray Mass)
at the Marion Scharmann gallery,
Cologne, 2009
20 panels, each 60 × 60 cm
240 × 300 cm total dimensions

→ W.107
Website: Eno Henze

Related chapters:
→ Ch.P.2.3
Drawing
→ Ch.M.1
Randomness and noise

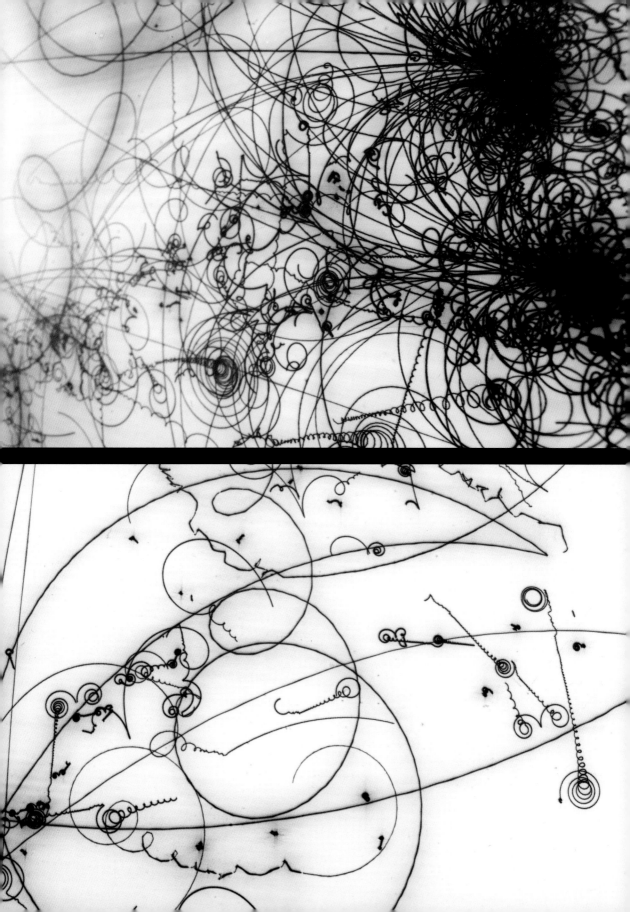

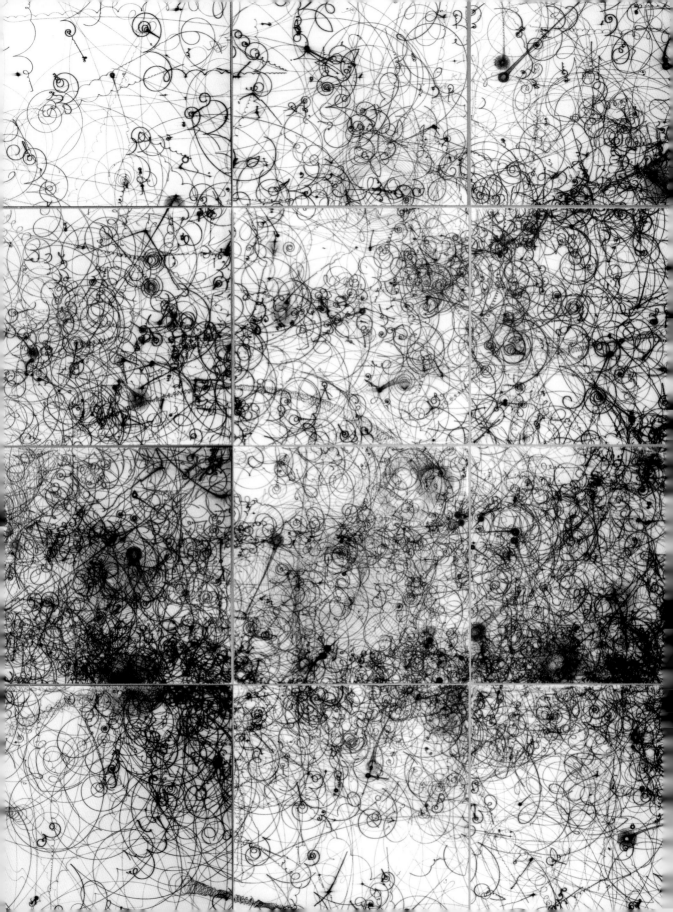

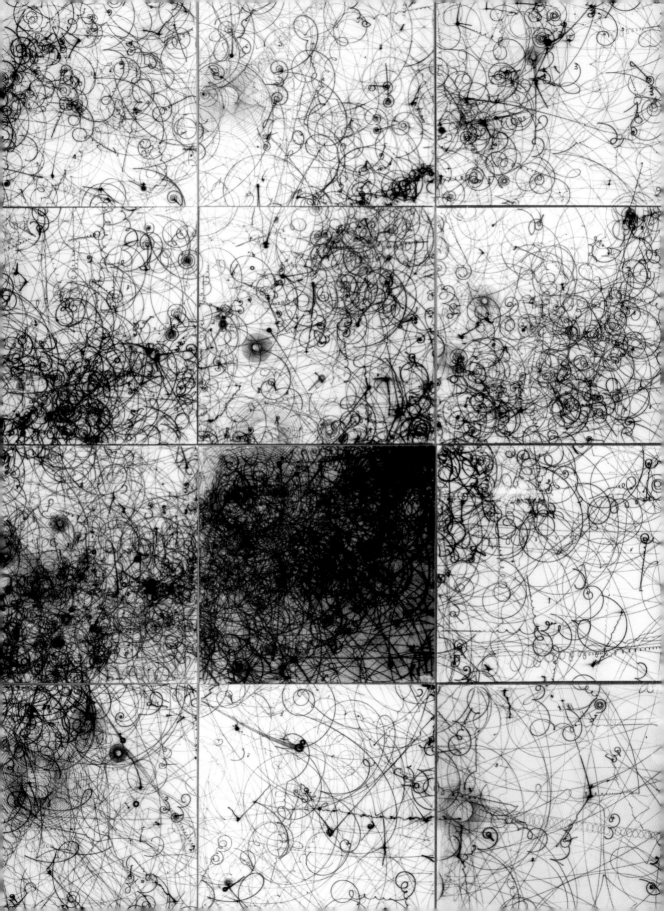

Growing Data

Growing Data is a research project that explores the question of how real processes and structures can be used to generate a new form of data visualization, in comparison with classical statistical charts. Formal aspects of various natural phenomena are translated into visual systems. Generative strategies are especially well suited for creating visual patterns and textures, while the human brain is extremely adept at quickly interpreting such patterns and piecing them together into an overall picture. The primary aim here is to avoid using abstract forms of data visualization, in order to allow images to evolve that do not prescribe the accuracy of data, but rather tell a story and provide a quick overview.

The project *Growing Data* is part of this series and it explores—using virtual plant growth—the possibility of visualizing the air quality in various major cities. The growth of plants or other life forms provides an obvious metaphor for changes in data. Just as external influences determine the growth of plants, data that varies can control aspects of digital growth. This data is assigned to variables responsible for life span, density, and speed, for example. Names, words, or symbols that are slowly generated out of the growing structures add an additional level of information.

Connected to different data interfaces and databases, current information for various cities, as well as the comparative figures from previous years, can be impressively visualized. The program itself is based primarily on a more complex version of the "agent model," in which agents are controlled by Brownian motion and influenced by variables in their movement.

Cedric Kiefer

2008/2009
Growing Data
Research project

In cooperation with
Christopher Warnow

→ W.109
Website: Cedric Kiefer

Related chapter:
→ Ch.P.2.2
Agents

Similar Diversity

Similar Diversity is an information graphic that visualizes parts of the holy scriptures of the five main world religions. It opens a new perspective on issues of religion and faith by shedding light on similarities and differences between Christianity, Islam, Hinduism, Buddhism, and Judaism. The objective analysis of texts—without interpretation by their authors—provides the basis for this work. In addition to the abstract informational level, the work is intended to make people reflect on their own prejudices and current religious conflicts at the emotional level.

The x-axis represents, in alphabetical order, the forty-one figures who appear most frequently in the different scriptures. The size of each name and its arc corresponds to its number of occurrences in all five scriptures, each of which is assigned a specific color. The bar graphs below break down each character's activity, listing the verbs that directly follow each name. The height of each bar and its font size corresponds to the frequency of that combination of name and verb in the text. The numerous arcs on top depict similarities in the subject-verb compounds of each pair of linked figures.

The work lays no claim to absolute accuracy and completeness. The Buddhist Pali canon, for example, has not yet been translated in its entirety, and some of the faiths, such as Hinduism and Buddhism, are based on several books, only the most well-known of which were used here.

Similar Diversity is a work created by Andreas Koller and Philipp Steinweber under the direction of Stefan Sagmeister during his professorship in Salzburg. It was first presented in June 2007 as part of the exhibition *Is it possible to touch someone's heart with design?* by Sagmeister's class in Hanger 7, in Salzburg.

Various tools were used for the text analysis. The evaluation was executed using xxxx software and the data then visualized in Processing.

Andreas Koller
Philipp Steinweber

2007
Similar Diversity

Canvas print: 7 × 3 m
Total number of analyzed words: 2,903,611
(15,625,764 characters)

→ W.110
Website: Andreas Koller
→ W.111
Website: Philipp Steinweber
→ W.112
Website: Similar Diversity

Related chapters:
→ Ch.P.3.1.3
Text image
→ Ch.P.3.1.4
Text diagram
→ Ch.M.6
Dynamic data structures

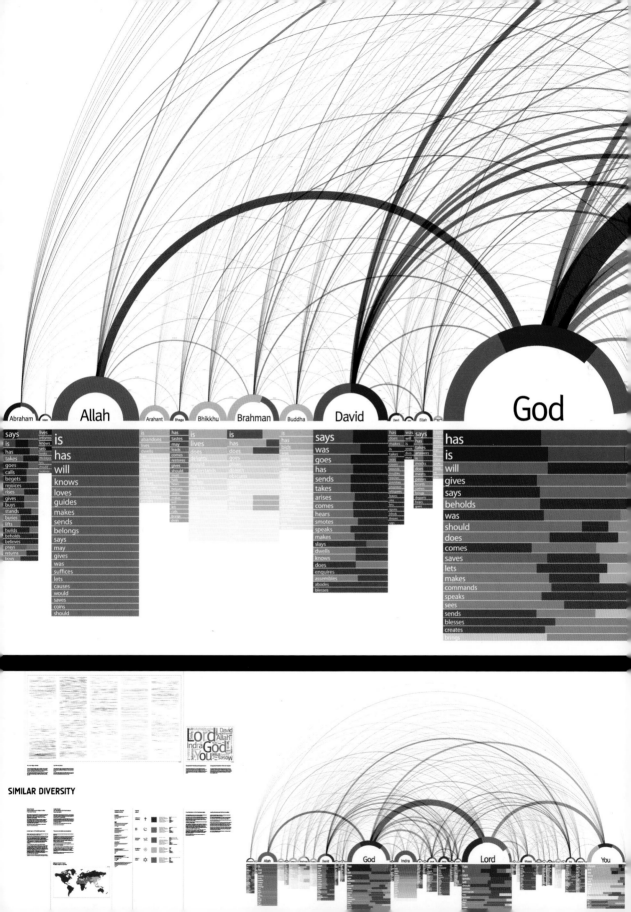

Abraham Adam Allah Arahant Bhaga Bhikkhu Brahman Buddha David David Elijah God

SIMILAR DIVERSITY

Allah David God Indra Lord Moses You

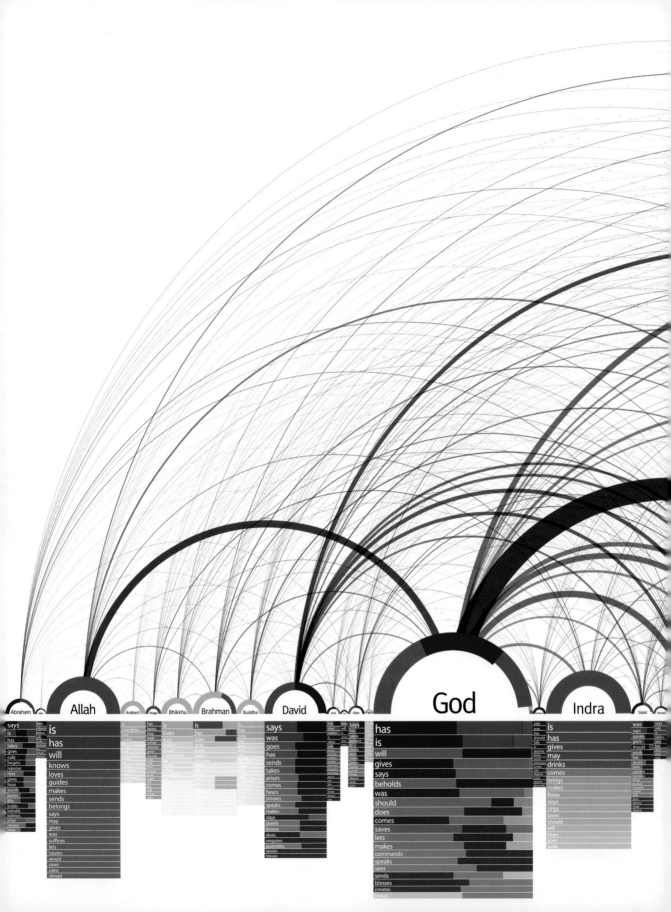

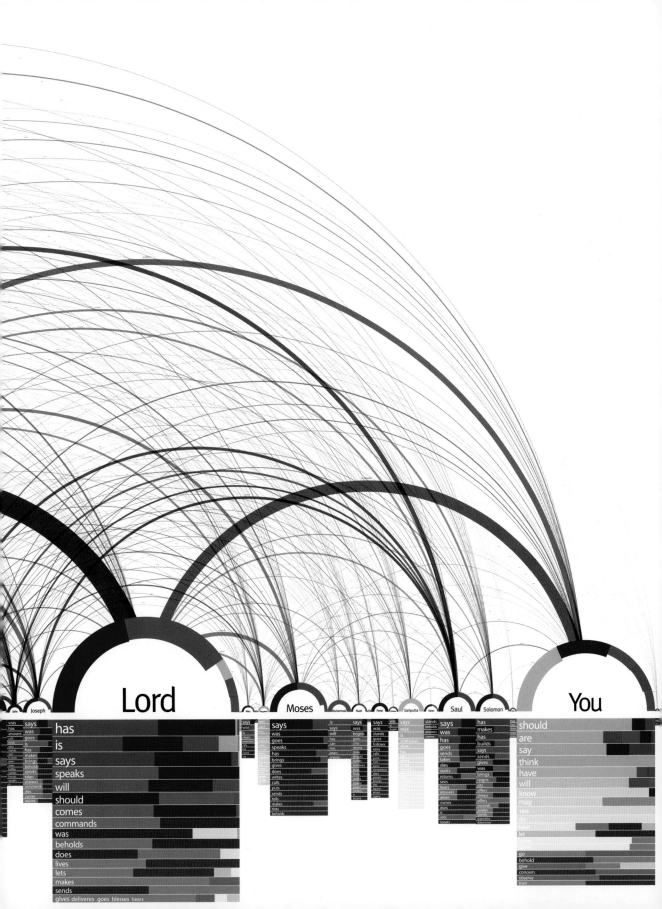

Generative Lamps

The light objects *Dahlia*, *Vasarely*, and *610* are part of the portfolio of the Amsterdam design firm FOC (Freedom of Creation). The work of the designer and cofounder Janne Kyttänen is characterized by a close resemblance to natural structures.

The dahlia—the petals of which have a geometrical arrangement—was the model for the light *Dahlia* (opposite, top). As with the plant itself, the individual forms are layered and rely on the mathematics of nature.

Vasarely (opposite, bottom) is a tribute to Victor Vasarely, the famous artist and practitioner of Op Art. A vibrant, geometric structure bulges out from a perfect square. The light object corresponds physically to what Vasarely's graphical structures purport as optical illusions.

The table lamp *610* (on the next page) is based on the Fibonacci sequence, a numerical sequence that is ubiquitous in nature. The form of *610* was inspired by coneflowers, with their characteristic central cone.

Janne Kyttänen

2007
Generative Lamps
Light objects

Dahlia
Laser-sintered polyamide
Diameter 16, 32, and 50 cm

Vasarely
Laser-sintered polyamide
30 × 30 × 8,5 cm

610
Laser-sintered polyamide
Height 51 cm, diameter 16 cm

→ W.113
Website: FOC

Related chapter:

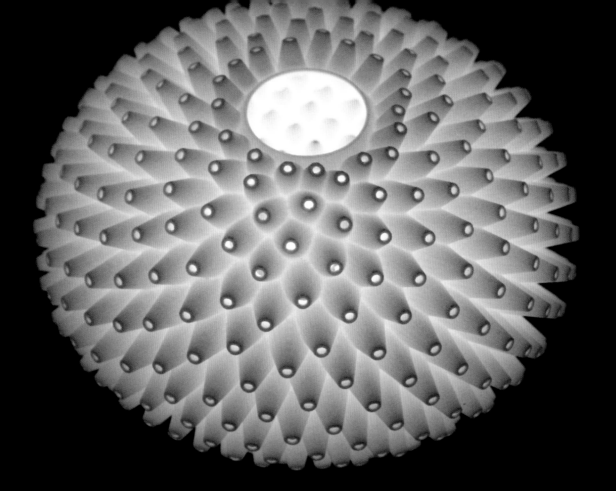

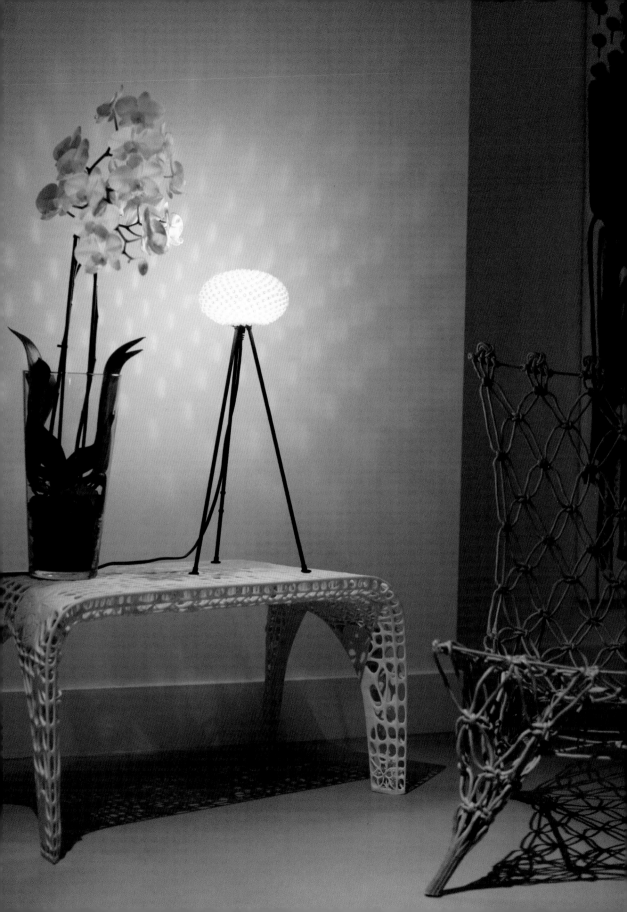

Segmentation and Symptom

The concept of image filtering has long been part of computer art. Famous examples such as Ken Knowlton and Leon Harmon's alphabetic nude *Studies in Perception I* from 1966–1967 and, more recently, Jim Campbell's dynamic LED displays and Daniel Rozin's interactive pixelated mirrors attest to its popularity, as does the long list of Photoshop filters. The application of a filter is often the starting point for students who wish to use computerized calculations.

It was against this background that *Segmentation and Symptom* was created as an investigation of the imaging capabilities of Voronoi diagrams. The geometric structures of Voronoi diagrams often appear in nature: in cells, air bubbles, and crystals. They occur in pressurized spatial structures, creating characteristic balance-seeking boundaries.

In this series created for the *British Zoo Quarterly*, Golan Levin used the Voronoi algorithm as an image filter on photographs of displaced and homeless people, creating portraits from numerous vector lines. Their fragile condition is echoed in the delicate structures of the Voronoi diagram.

To achieve this result, several thousand dots were placed in the image based on the brightness of the original photographs. The gray values in the image acted as reference points for distribution—the darker areas were given more points, lighter areas fewer. This structure served as a basis for calculations using the Voronoi algorithm, which generated images with tens of thousands of lines that were output as a PostScript file. The project was implemented entirely in Java.

Golan Levin

2000
Segmentation and Symptom

→ W.114
Website: Segmentation and Symptom

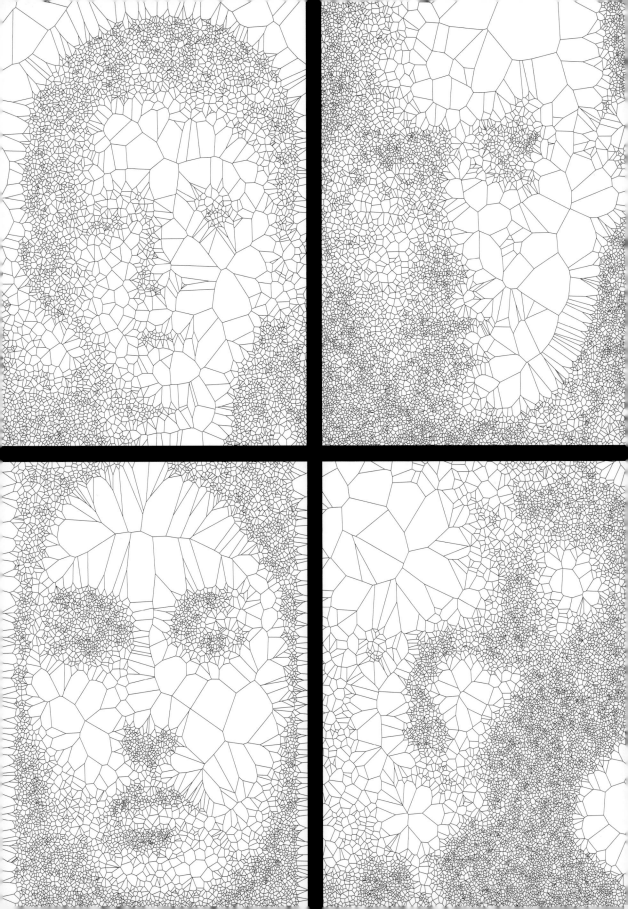

S.18
Footfalls

Footfalls is an interactive audiovisual projection in which the viewer's stomping sets off an avalanche of bouncing virtual objects. It was part of an exhibition on TMEMA projections by NTT InterCommunication Center (ICC), Tokyo, in July 2006.

Golan Levin and Zachary Lieberman developed this installation from another collaboration, *Messa di Voce*. Microphones in the floor registered visitors' walking and stomping sounds. The intensity of the noise controlled the size and number of balls that fell from above onto the six-meter-high projection screen. The more vigorously the viewer stomped, the more objects fell.

Visitors could use their silhouettes to catch, rearrange, and throw objects. Each collision between two objects produced a minimal percussion sound. If a number of balls collided simultaneously, the noise level increased abruptly, creating a piece of jarring music. Visitors could perform this piece of music, both visually and musically, by generating a fast-paced audiovisual spectacle with their entire bodies.

Footfalls was developed in C++ with the openFrameworks toolkit, a cross-platform open-source library. Visitors' silhouettes were tracked using infrared light, converted into geometric representations, and—with the help of a physics simulation—integrated into the logic of the installation. Thousands of virtual particles collided with the invisible contours to create the silhouettes.

TMEMA
Golan Levin
Zachary Lieberman

2006
Footfalls
Interactive installation

→ W.117
Website: TMEMA
→ W.118
Website: Footfalls
→ W.119
Website: Messa di Voce

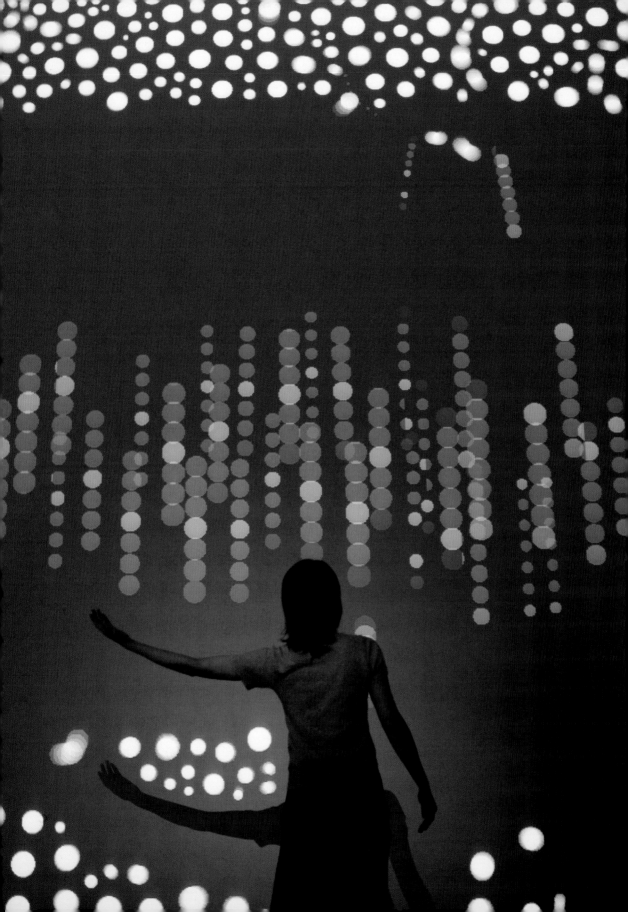

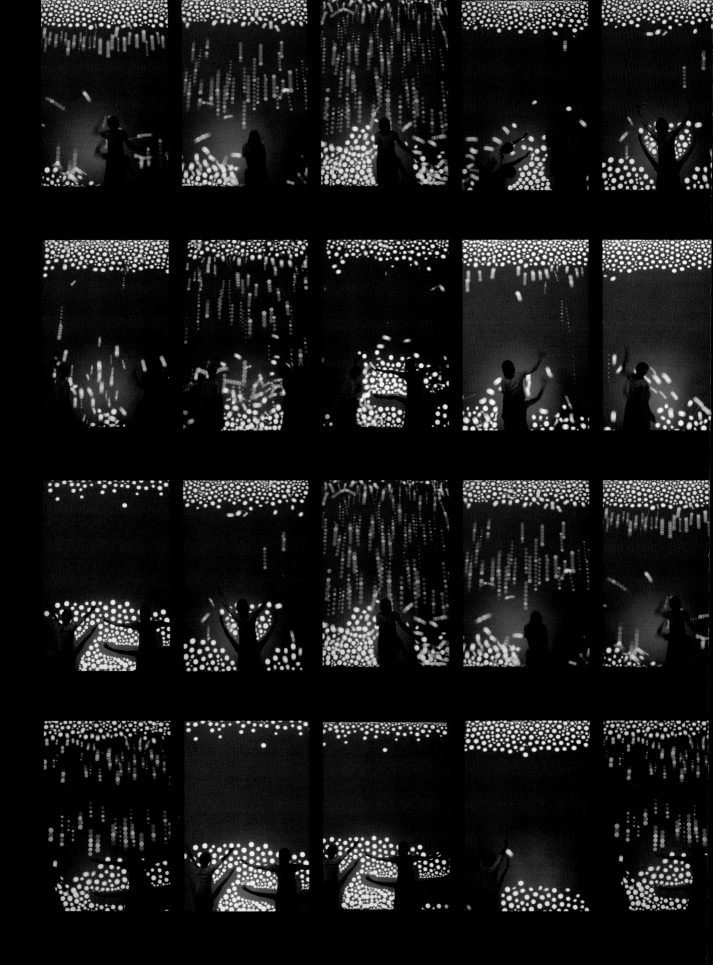

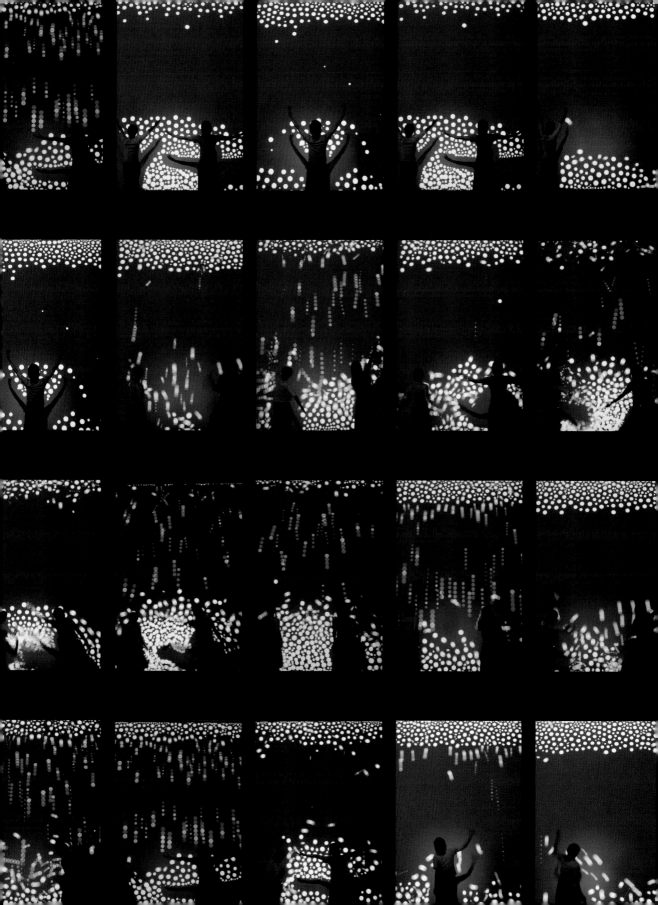

S.19
Poetry on the Road

Poetry on the Road is an international literature festival that takes place annually in Bremen. Together with Florian Pfeffer of the design studio Jung and Pfeffer, Boris Müller has been developing the festival's graphics since 2002.

Although the visual motifs are very different from year to year, they all are united by one underlying process: a computer program analyzes the festival's poetry and transforms it into an abstract image. This flexible computer program can produce a number of variations for different media. Because the program follows clearly defined rules, the visualization of the poems is neither emotional nor arbitrary; rather, it is a direct reflection of the underlying text.

What makes this approach so original is that the core of the design identity for Poetry on the Road is not formalistic (logo, font, color scheme), but conceptual. It is not visual consistency that produces continuity but rather the idea of turning texts into images with the help of algorithms. Although Boris Müller developed the computer program for the text-image conversion, he has no influence on the graphics' final appearance. With the help of the program and a selection of poems, the designers at Jung and Pfeffer develop the images they need for the project.

The first versions of the graphics (2002–2005) were developed using the scripting language Python, which provided a number of advantages when working with text. One problem, however, persisted: for each image, a Web demonstrator was developed that allowed online users to understand the concepts behind the artwork. Because Python scripting is unsuitable for web applications, the demonstrators were programmed using Flash. This issue was addressed in 2006 with Processing, which has been used ever since. It allows the same program to appear in print and online.

Boris Müller
Florian Pfeffer

2002–2007
Poetry on the Road

→ W.120
Website: Boris Müller
→ W.121
Website: one/one

Related chapters:
→ Ch.P.3.1.2
Text as blueprint
→ Ch.P.3.1.3
Text image

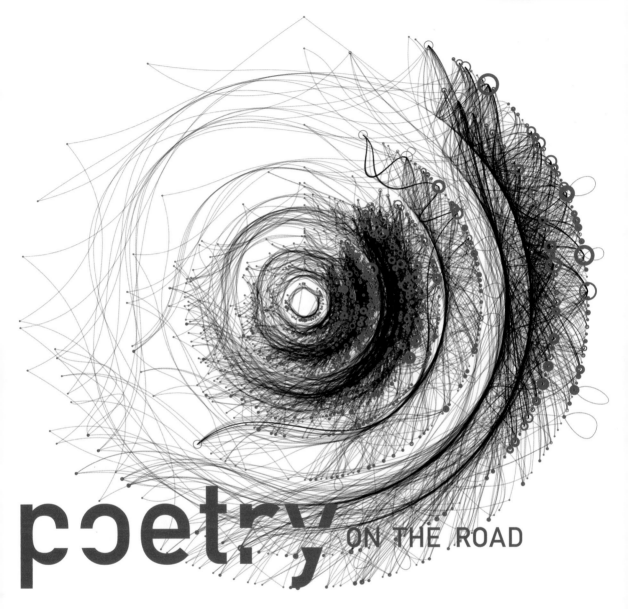

poetry ON THE ROAD

7. INTERNATIONALES LITERATURFESTIVAL BREMEN

11. – 19. MAI 2006

VERANSTALTET VON:

 HOCHSCHULE BREMEN
UNIVERSITY OF APPLIED SCIENCES

radiobremen

Goethebund in Bremen e.V.

GEFÖRDERT VON: Bremen Marketing, Senator für Kultur, Karin und Uwe Hollweg Stiftung, Bernd und Eva Hockemeyer Stiftung, Wolfgang-Ritter-Stiftung, DAAD, Waldemar Koch Stiftung, Bremer Literaturstiftung, pro helvetia

WWW.POETRY-ON-THE-ROAD.COM | Programmheft und Karten bei: Buchladen im Ostertor, Fehrfeld 60, Fon: 0421-785 28 | Die Sparkasse Bremen

GESTALTUNG: jung und pfeffer : visuelle kommunikation Bremen, Amsterdam | mit Boris Müller, esono.com

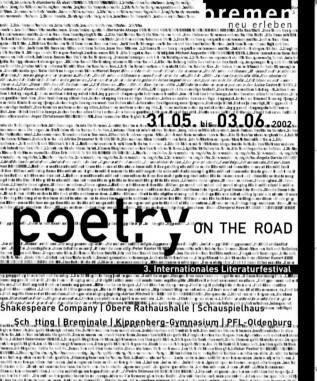

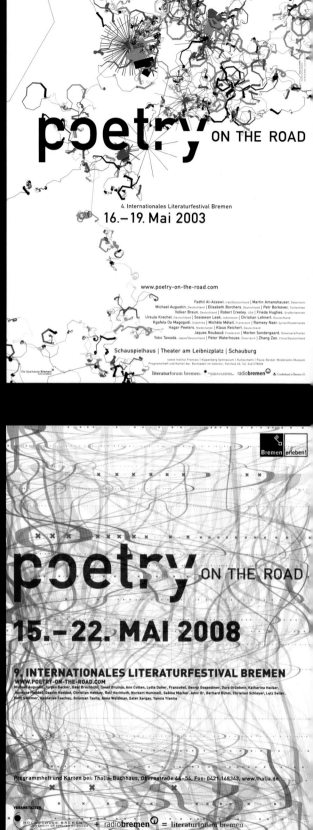

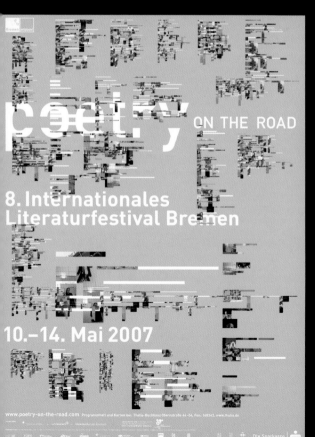

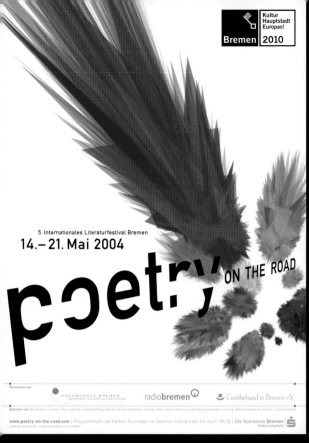

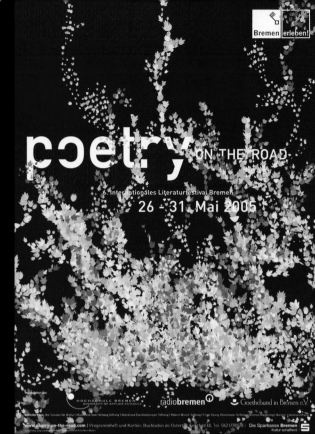

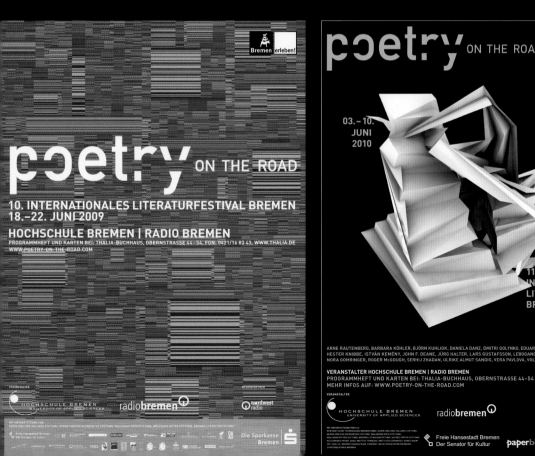

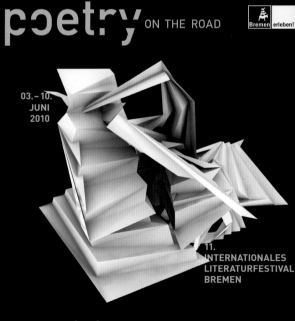

Actelion Imagery Wizard

Actelion is a biopharmaceutical company that researches, develops, and markets medicines for diseases that still lack adequate treatments. "Create a new identity for the Actelion brand. Don't touch the logo, but create something the world of pharma has not seen before." Following this directive from Actelion, the brand consultancy Interbrand in Zurich conducted an initial review of the client's existing identity system and discovered a portfolio of generic scientific images that were difficult to distinguish from those of the competition. Developed around the slogan "From medical industry to medical magic," a new visual identity was created that uncovers the invisible magic of medicine.

The new imagery is based on the smallest possible unit: the digital molecule. It represents the magical moment when new medicine arises from molecules—innovative design for a company that supplies the world with innovations. Onformative worked closely with Interbrand in creating the graphic imagery and developed a tool for automatic image generation that enables the creation of a unique, homogeneous graphic image world out of heterogeneous visual material. The new visual identity was featured in the 2010 annual report and continues to evolve on Actelion's updated website.

The Processing-based software was developed especially for Actelion. It enables the targeted creation of images based on photographs, whose visual information is interpreted by the tool and is translated into graphic elements such as points, lines, and curves using special algorithms. There are a number of presets, as well as countless possibilities—through expanded editing and settings—for making fine adjustments to individual graphical elements. It is even possible to edit the underlying photographic template later on without having to switch to other image-processing programs. The software allows both the print vector data and the information for digital media to be exported. Extensive adjustment possibilities for the animations are also available in a separate animation menu. Thanks to its modular construction, the software can easily be expanded in years to come, permitting the corporate design to be continually revived.

onformative

2011
Actelion Imagery Wizard
Corporate imagery tool

Client:
Actelion Pharmaceuticals

In cooperation with:
Hartmut Bohnacker

→ W.146
Website: onformative

Related chapters:
→ Ch.P.4.3.1
Graphic from pixel values
→ Ch.M.2.6
A drawing tool
→ Ch.M.5.1
Recursion
→ Ch.M.6.1
Force-directed layout

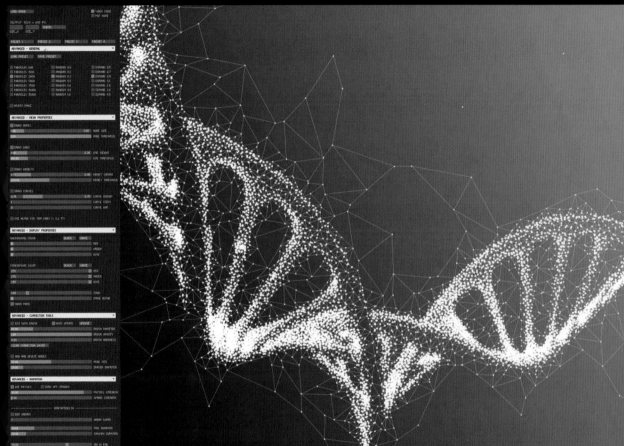

Talysis II, Autotrophs

The figures in this work were created using a complex process that mimics the functioning of autotrophic organisms. In biology the term *auto-trophic* refers to organisms that nourish themselves. This project stems from an interest in artworks and performances that emerge from auto-catalytic, self-reinforcing processes. Digital video feedback serves as a recursive function simulator. With its strict symmetry, *Talysis II* conjures memories of the Op Art movement of the 1960s. The *Autotrophs* image series uses similar geometry and combines it with computerized models of the morphogenesis of organisms.

Autotrophs mimics this process with video signals that act as morphogens. The video signals replicate themselves, thereby generating complex, organic crystalline forms. In mythology, this process is symbolized by the ouroboros, a snake that bites itself in the tail, and thus is the embodiment of self-sustaining repetition and "output as input."

Talysis II and the *Autotroph* sequence were generated using programmed simulations of the classical structure for analog feedback, in which a camera is pointed at a monitor that then displays the output signal of the camera.

The computerized version consists of interconnected renderers—in this case virtual monitor screens. Each renderer passes its output onto the next. The video signal is transformed in various ways during the transfer. In this infinite loop, numerous variants of self-similar figures are created. The work was programmed using yyy software.

Paul Prudence

2007
Talysis II, Autotrophs

→ W.122
Website: Paul Prudence
→ W.123
Website: Transphormetic
→ W.124
Blog: dataisnature

Related chapter:
→ Ch.P.4.1.2
Feedback of image cutouts

S.22
Delaunay Raster

The Delaunay Raster is the result of a long effort to create customized image grids. In the traditional printing process, the computer rasterizes an image automatically. It is a deterministic process that is always executed in the same manner; for example, a user can change some parameters when applying an image filter, but the consequences are always predictable.

In contrast, the Delaunay Raster permits the intervention of the human hand. After scanning the image, the user sets grid points on the image by clicking the mouse and, in so doing, learns how the tool works, since its effects are immediately visible. This feedback allows the user to respond to changes in the image and influence the process directly. The resulting image will vary according to how the points are set; hundreds of quick user decisions determine the result.

This tool is based on the Delaunay triangulation, invented in 1934 by the Russian mathematician Boris Delaunay. This system creates a set of optimal triangles out of a group of points. The *Delaunay Raster* converts the triangles into paths in Illustrator. The color is determined by dividing the triangle in two parts and creating a profile of the average colors of the respective halves.

The tool was implemented with Scriptographer, a scripting environment for Adobe Illustrator developed by Jürg Lehni.

Jonathan Puckey

2008/2009
Delaunay Raster

→ W.125
Website: Jonathan Puckey/Delaunay Raster

Related chapter:
→ Ch.P.4.3.1
Graphic from pixel values

Tile Tool

The intention of this experiment was to obtain varied results using a simple principle. Users of Tile Tool can draw free-form shapes with so-called tiles. The logic is visible in the results, yet the control remains with the user, who significantly influences the appearance of the final product. The tool provides a connection between the automation of work and the individual ideas and energy of the designer; it strives for balance between opportunities and constraints. The results remain dependent on the commitment and the ideas of the user.

This tool simplifies time-consuming design work that employs small-scale geometric shapes and requires great precision. It makes use of small building blocks that serve as horizontal, vertical, or corner elements. Tile Tool places these building blocks in the image according to the drawing direction and generates precise abstract structures.

Tile Tool was developed using Scriptographer, a scripting environment for Adobe Illustrator. Scriptographer makes the Illustrator API accessible for JavaScript, which usually can only be used by plugin developers. Tile Tool is available online and can be downloaded for free.

Jonathan Puckey

2006
Tile Tool

→ W.126
Website: Jonathan Puckey/Playtime
→ W.127
Website: Scriptographer/Tile Tool

Related chapters:
→ Ch.P.2.3.6
Drawing with complex modules
→ Ch.P.4.3.1
Graphic from pixel values

Graphic Design students from the Rietveld Academy present their games
Ringmaster: Klaas Kuitenbrouwer · Starts at 20:00 · April 6th 2006 · SMCS/11

THE CLASSROOM

The Classroom is a monthly lecture series
organised by Lectoraat Kunst en Publieke
Ruimte with speakers proposed by the 13
departments of the Rietveld Academy

Information/reservation
esther.deen@rietveldacademie.nl

Speaker
Jean Marc
Bustamente

Location
Gerrit Rietveld
Academy

Proposed by
The Photography
Department

Date & Time

THE CLASSROOM

The Classroom is a monthly lecture series
organised by Lectoraat Kunst en Publieke
Ruimte with speakers proposed by the 13
departments of the Rietveld Academy.

Speakers:
Jan van Toorn &
Camiel van Winkel

Proposed by:
The Graphic
Design Dept.

Location:

Date & Time:

Information/reservation:
esther.deen@rietveldacademie.nl

Process Compendium

The *Process Compendium* consists of two editions of fifteen prints that document *Process 4* to *Process 18*. In each case, two static images have been selected from an infinite number of potential variations. A catalog documents these prints, alternate software interpretations, and the emergence of the forms through a series of time-lapse images.

In the framework of this project, an Element is a simple machine that is comprised of a Form and one or more Behaviors. A Process defines an environment for Elements and determines how relationships among Elements are visualized. For instance, *Element 1* takes the form of a circle, and one of its behaviors is moving along a straight line at a constant speed. *Process 4* fills a surface with *Element 1* and draws lines between elements while they overlap. Each Process is a short text that defines a space to explore through multiple interpretations. A Process interpretation in software is a kinetic drawing machine with a beginning but no defined end. It proceeds one step at a time, and at each discrete step, every Element modifies itself according to its Behaviors. The corresponding visual forms emerge as the Elements change; each adjustment adds to the previously drawn shapes.

Over the course of seven years, Casey Reas has continuously refined the system of Forms, Behaviors, Elements, and Processes. The phenomenon of emergence is the core of the exploration, and each artwork builds on previous works and informs the next. The system is idiosyncratic and pseudoscientific, containing references ranging from the history of mathematics to the generation of artificial life.

The first three *Process* works are named *Structure 1, 2,* and *3*.

Casey Reas

2004–2010
Process Compendium

→ W.148
Website: Casey Reas

Related chapter:
→ Ch.P.2.2
Agents

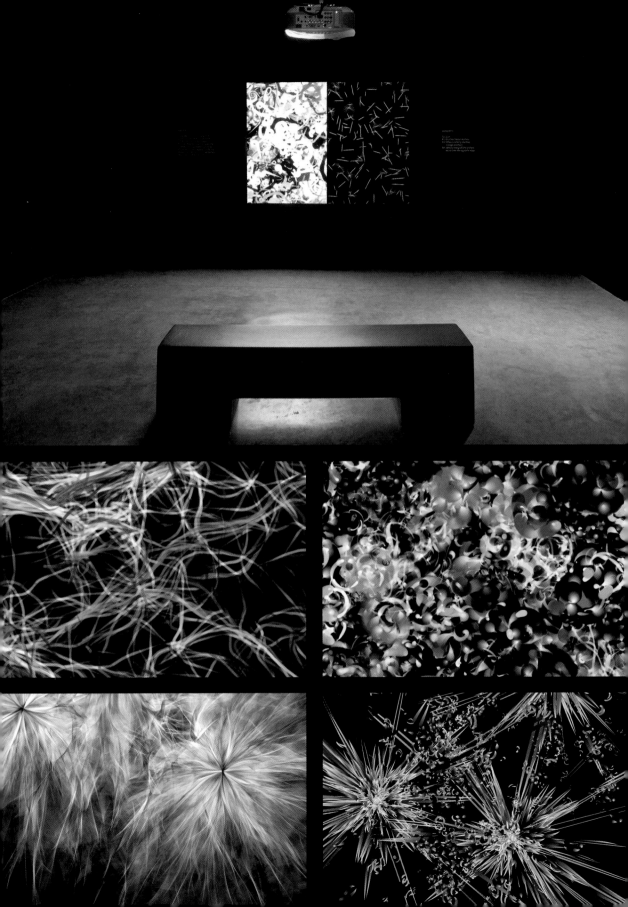

con\texture\de\structure

The artwork itself demonstrates... how the contingent creation, which is in itself not necessary, ultimately appears to be necessary, because, in a kind of self-limitation, it robs itself of every opportunity to be different.

—Niklas Luhmann

Based on the idea of contingency, Niklas Luhmann's work *con\texture\ de\structure* uses a drafting machine and the program controlling it to carry out a self-referential process for creating an image that is neither representational nor abstract.

The resulting artwork loses its status as an object that is valuable because it is unique. If the artwork is contingent, it loses its claim to originality. Structural elements of art—the composition or color of a visual work, the tonality or rhythm of a musical piece—often refer to traditional forms, justifying a work in its relationship to the past. *Con\texture\de\structure* does not conceal its contingent character, but rather deliberately displays it.

Programming was intentionally kept simple, allowing the viewer to understand the machine's actions and underlying program simply by observing them.

The pen moves along the x- and y-axes, from minimum to maximum and back. The pen maintains its direction of movement until it reaches the minimum or maximum value. Whenever it hits a line, however, the ratio of the velocities of the x- and y-axes changes, as does the angle of the drawn line. The machine's program follows only two rules: when you hit the end of the image, change the direction and speed; and when you hit a point that you already visited, change the speed.

Tim Riecke

2006
con\texture\de\structure
Installation

→ W.129
Website: Tim Riecke

Related chapter:
→ Ch.P.2.2.2
Intelligent agent

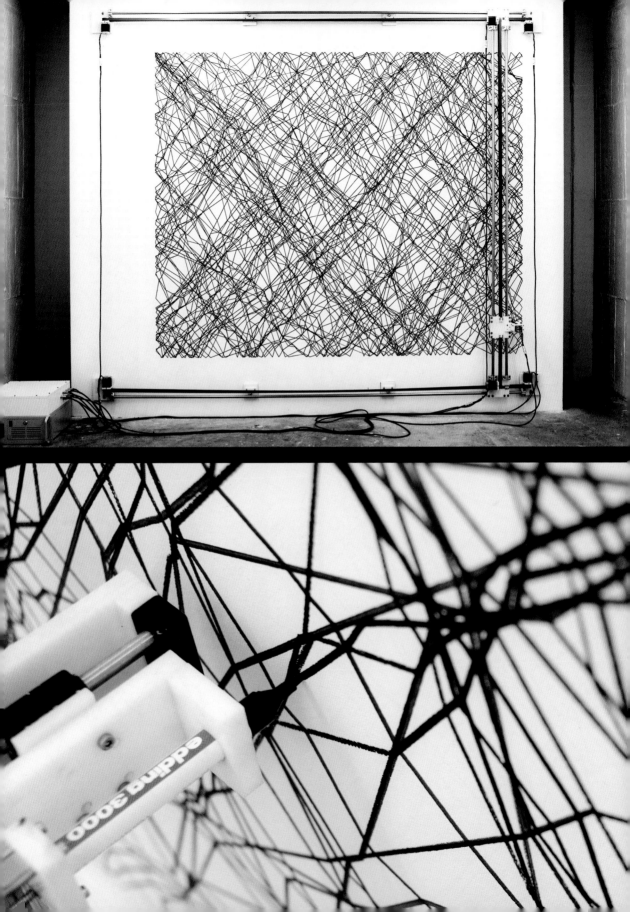

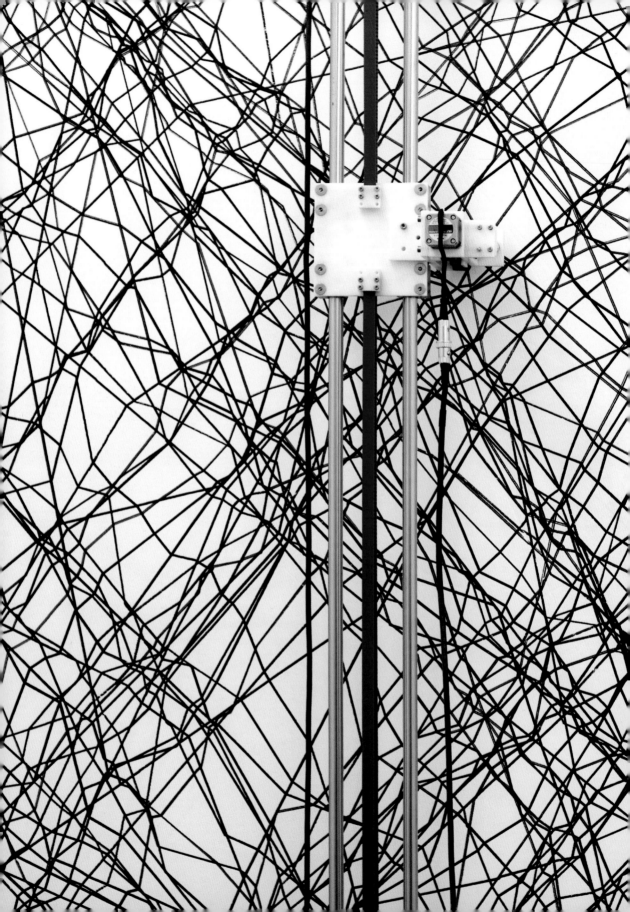

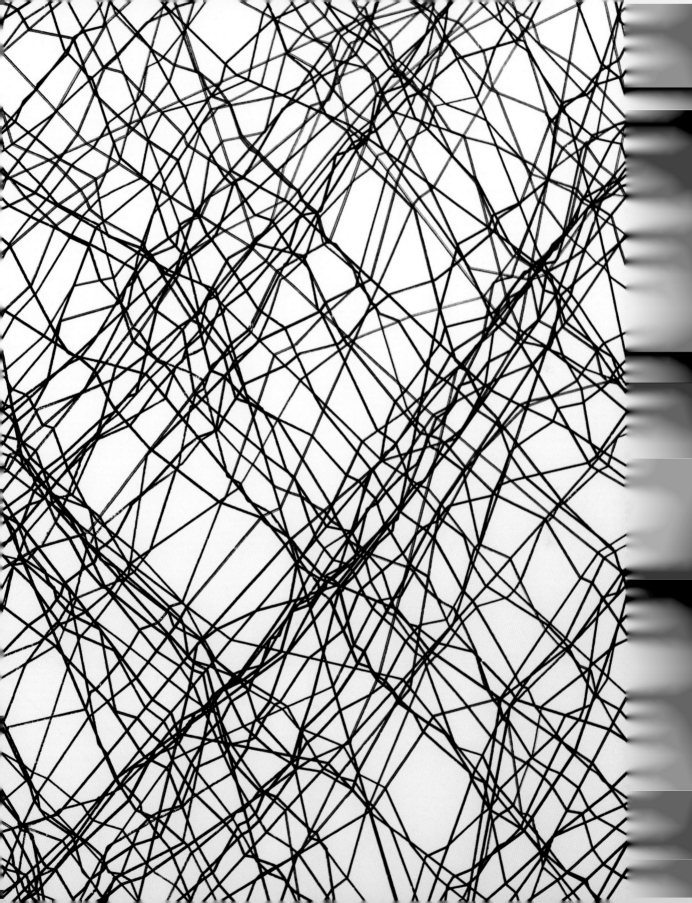

"Being not truthful works against me" is part of a list in Stefan Sagmeister's diary entitled "Things I have learned in my life so far." In the installation *Being not truthful*, this maxim is woven into a virtual spiderweb, which rips if a viewer's shadow touches it; then, bit by bit, the web reconstructs itself. This fragile construction serves as a metaphor for the vulnerability of Sagmeister's aphorism and the effort required to follow it, raising questions about the nature of truth and the value of sincerity.

The technical structure consists of a computer connected to a camera and a projector. The camera photographs the viewer; then, software integrates this video input into the simulated physics of the spiderweb and projects the shadowy image of the viewer onto the net.

**Ralph Ammer
Stefan Sagmeister**

2006
Being not truthful
Interactive installation

Programming:
Ralph Ammer
Technical support:
Stephan Huber
Design support:
Matthias Ernstberger

→ W.130
Website: Ralph Ammer
→ W.131
Website: Stefan Sagmeister

Related chapter:
→ Ch.P.4.3.3
Real-time pixel values

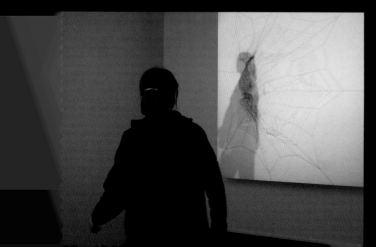

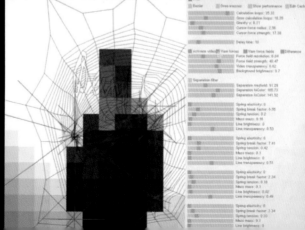

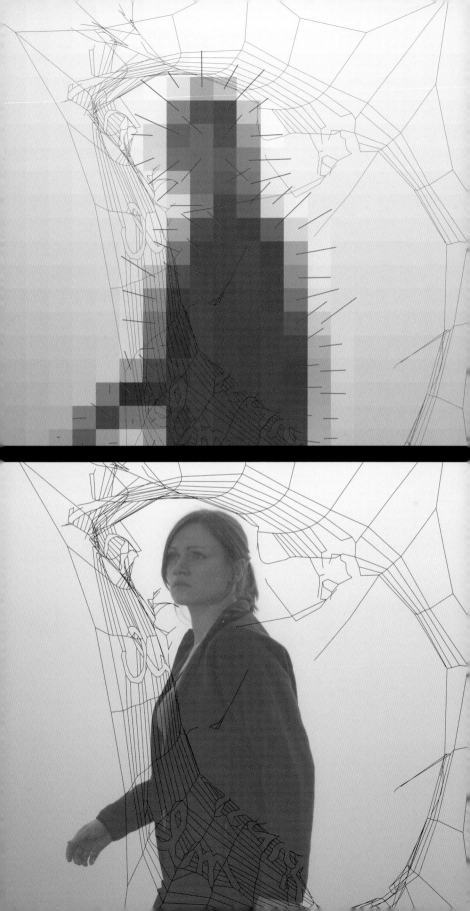

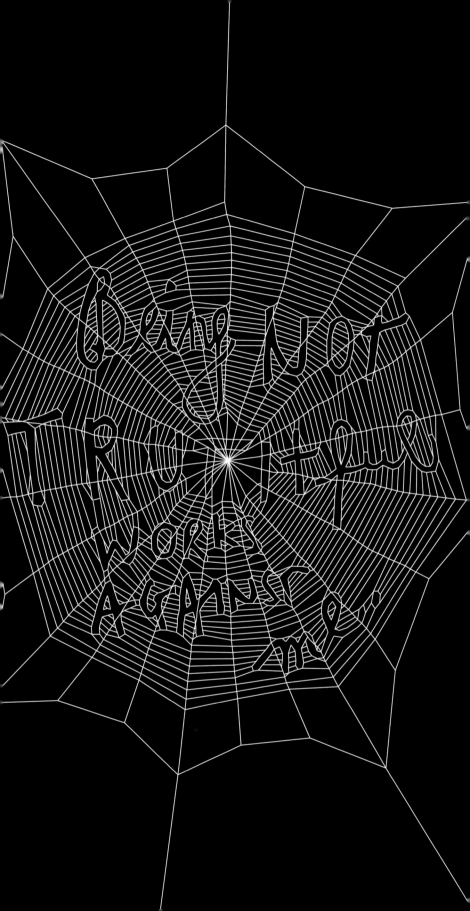

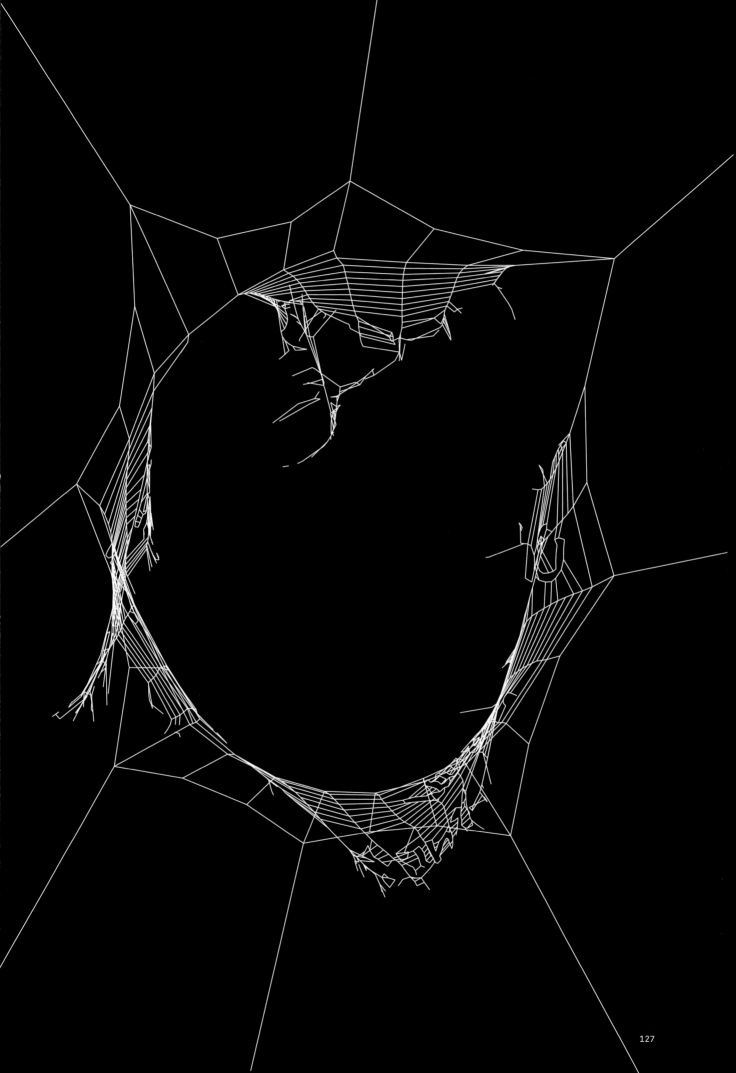

Casa da Música Identity

For *Casa da Música*, a concert hall designed by Rem Koolhaas that is situated on the harbor of Porto, Stefan Sagmeister designed a comprehensive, modular brand identity. The project's original goal was to create a logo for the hall that did not refer to the building, but this turned out to be unfeasible. Research revealed that the building itself was a logo. Koolhaas aptly called this "the organization of the interests of symbolism."

The image needed to be more than just an illustration of a building, and the designers developed a chameleonlike system that transforms the concert hall's distinctive form from application to application. A high-resolution rendering of the structure appears as the unifying element in all the concert hall's publications. The logo's character changes to reflect the genre of music being performed, so that the brand image maintains harmony among the concert hall's various types of musical offerings.

Stefan Sagmeister

2007
Casa da Música Identity
Corporate design

Art direction:
Stefan Sagmeister
Design:
Matthias Ernstberger, Quentin Walesh
Logo generator:
Ralph Ammer
Client:
Casa da Música, Portugal

→ W.130
Website: Ralph Ammer
→ W.131
Website: Stefan Sagmeister

Related chapter:
→ Ch.P.1.2.2
Color palettes from images

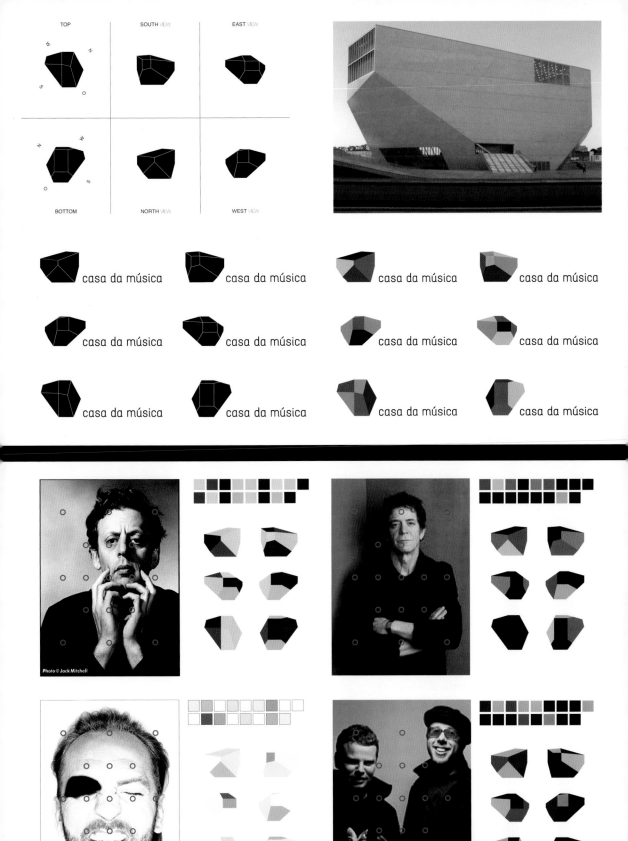

TOP
SOUTH VIEW
EAST VIEW
BOTTOM
NORTH VIEW
WEST VIEW

casa da música
casa da música
casa da música
casa da música
casa da música
casa da música
casa da música
casa da música
casa da música
casa da música
casa da música
casa da música

Photo © Jack Mitchell

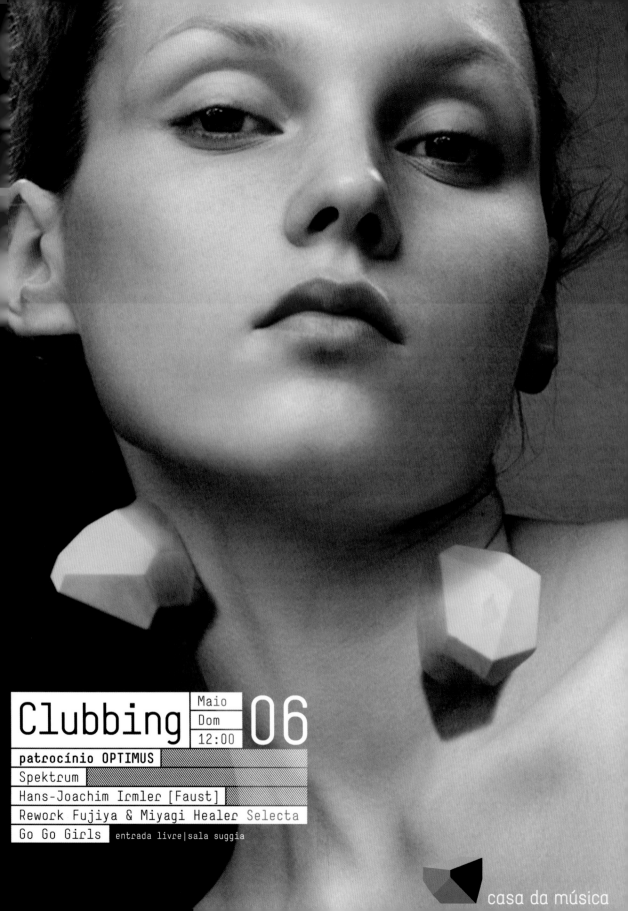

Clubbing

Maio
Dom
12:00

06

patrocínio OPTIMUS

Spektrum

Hans-Joachim Irmler [Faust]

Rework Fujiya & Miyagi Healer Selecta

Go Go Girls entrada livre|sala suggia

casa da música

SERVIÇO EDUCATIVO

Patrocínio **Superbock**

Patrocínio **Superbock**

01 Junho | Sex

António Victorino d'Almeida
Concerto para tuba e orquestra
Richard Strauss:
Till Eulenspiegels lustige Streiche
Destinatários: Público geral,
escolas (a partir do 2º ciclo
e cidadãos séniores
11:00 Ensaios Abertos

Filme/Concerto | Space Ensemble
As Aventuras Do Príncipe Achmed
Destinatários: Escolas do
Ensino Básico e Secundário
11:00 e 15:00 Outros Concertos

02 Junho | Sáb

Ritmos Urbanos Jorge Queijo
11:00 Workshops (ConstruSom)

Narrativas Sonoras Rui Penha
11:00 Workshops (CyberSom)
Sonoridades Líquidas João Ricardo
de Barros Oliveira
14:00; 15:30 Workshops (ConstruSom)

Ritmos Do Mundo Jorge Queijo
14:30 Workshops (ConstruSom)

Digital Jam | Rui Penha
14:30 Workshops (CyberSom)

Filme/Concerto | Space Ensemble As
Aventuras Do Príncipe Achmed
15:00 (Outros Concertos)

Compor Com Hyperscore Rui Penha
16:00 Workshops (CyberSom)

De Festivais Dos Anos 60
Álvaro Costa
16:00 (Breve Dicionário de Ouvir)

03 Junho | Dom

Orquestra Nacional Do Porto
Marc Tardue, direcção musical
António Rosado, piano Obras de
Maurice Ravel, Ernst von Dohnanyi,
Richard Strauss
12:00 Sala Suggia
(Concertos Comentados)

GUDGIGUDGI DADA Ana Paula Almeida,
Katarzyna Pereira
Concerto comentado por Fátima Pombo
(Primeiros Sons)
Destinatários: 11:30 (0-18 meses)
15:00 (18 meses-3 anos)
16:15 (3-5 anos)

SONORIDADES LÍQUIDAS João Ricardo
Barros de Oliveira
Destinatários: Famílias com crianças
a partir dos 4 anos
14:00; 15:30 Workshops (ConstruSom)

DJ Classic: audição musical com
crianças e jovens Jorge Ribeiro
14:30-17:30 (Formação Música na
Sala de Aula)

casa da música

Type & Form Sculpture

This typographic sculpture was commissioned by *Print* magazine. It grew virtually through a generative process that was based on a biochemical reaction. The sculpture clearly embodies the genuine development process out of which it emerged.

The contours of a custom font served as the basis for this sculpture and generated its initial crystals. Over time the simulation decomposed the original structure in an increasingly delicate pattern.

Using a process frequently used in MRI scans in medicine, the two-dimensional frames of the different process phases were combined into a detailed 3D model consisting of several million polygons. A 3D printer then produced the model. The raw material used was grainy and resembled the structure of bone, reinforcing the synthetically biological aesthetics of this seemingly natural, dripstone-like object.

Karsten Schmidt

2008
Type & Form Sculpture
Cover, *Print* magazine

Concept, type design,
generative design, photography:
Karsten Schmidt (PostSpectacular)
Client, art direction:
Kristina Di Matteo / Lindsay Ballant
(*Print* magazine)
3D printing:
Anatol Just (ThingLab)

→ W.132
Website: Type and Form
→ W.133
Website: Karsten Schmidt

Related chapter:
→ Ch.P.3.2.3
Font outline from agents

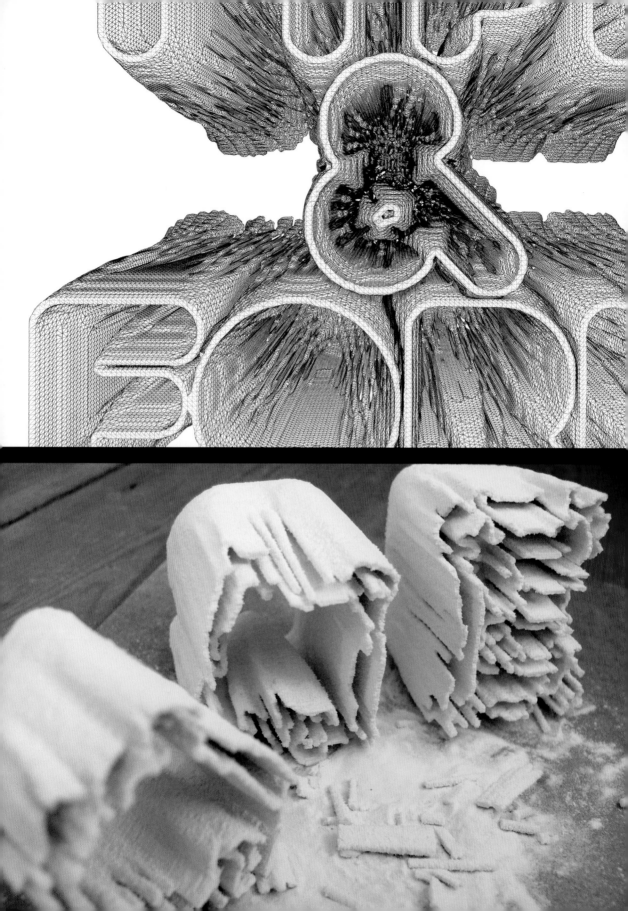

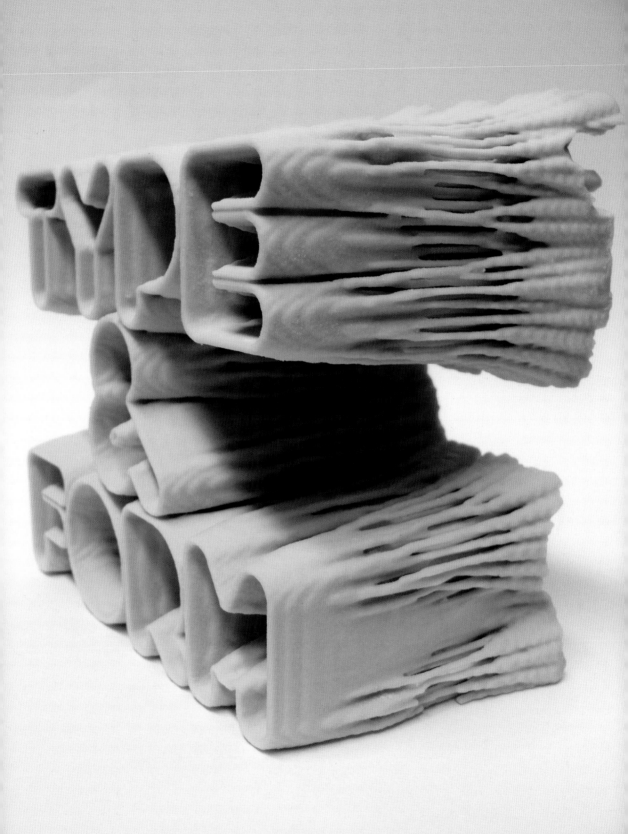

Faber Finds

Faber Finds is an innovative print-on-demand service that was established in 2008 by Faber & Faber publishers in London. It specializes in resurrecting out-of-print titles, making them available to a broader public.

For Faber Finds, a fully automated generative design for book covers was developed that could create a potentially infinite number of variations. Every book that is ordered and printed receives its own unique cover. All designs follow the same strict aesthetic format that combines highly detailed ornamental frames with a typeface designed especially for Faber Finds by Michael C. Place.

Sketches by typographer Marian Bantjes provided the initial inspiration for the look and feel of the decorative frame. These were abstracted and broken down into their smallest formal components and then, using software, reassembled repeatedly in new configurations. In a lengthy iterative process, the software follows thirty-five layout rules that correspond to the generated design. Based on these rules, the program calculates two hundred to three hundred variants until it creates a valid design that can be used in production.

Karsten Schmidt

2008
Faber Finds
Generative book covers

Design, programming:
Karsten Schmidt
Client, art direction:
Faber & Faber / Darren Wall
Illustrations:
Marian Bantjes
Type design:
Michael C. Place and Corey Holms
Photography:
Karsten Schmidt

→ W.133
Website: Karsten Schmidt
→ W.134
Website: Faber Finds

Related chapter:
→ Ch.P.2.3.6
Drawing with complex modules

Jacob
Bronowski
—
The Common
Sense of
Science

Adrian Be[...]
—
Cordurо[...]

Faber F[...]

John Cowper
Powys
—
Rodmoor

S[...]

Faber Finds

Calcutta

...verell
...well

—

British
...hitects and
Craftsmen

Taste, Design and Style
1600 to 1830

F. R. L.
Q. D.

Dicke...
Nove...

genoTyp

GenoTyp is an experimental software that unites typography and genetics. Fonts can be paired and bred using the genetic information contained in individual letters and the generative capabilities of computers.

Using principles of genetics, genoTyp draws up a framework in which a design develops generatively. It creates room for variation and new, unanticipated results that reflect the process of emergence.

In order for different fonts to mate, their genetic codes must be compatible. A special format had to be developed that was valid for all the letters. GenoTyp uses a skeletal structure; a letter consists of its basic structure, which describes the average shape, and its ridges, which define the line thickness. Another skeleton describes any serifs. This results in three genes per character that are stored on a chromosome.

The fonts are then loaded into a family tree, and the user pairs them. A laboratory screen allows the user to examine the resulting copies and compare them to other variations, thus making it possible to track the transfer and mutation of genes.

Michael Schmitz

2004
genoTyp
Experiment in generative typography

→ W.135
Website: genoTyp
→ W.136
Website: Michael Schmitz

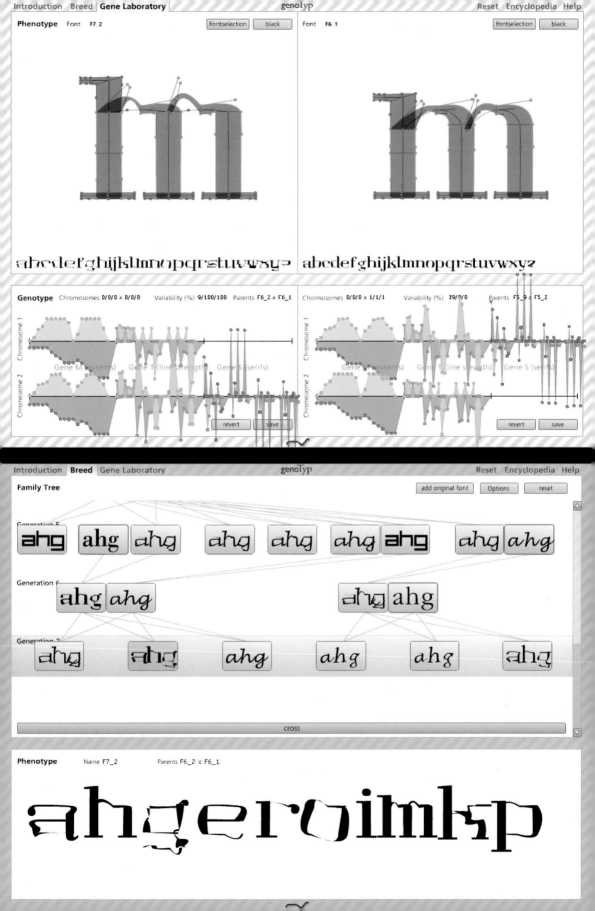

Evolving Logo

Evolving Logo is a system in which the trademark of a company is refined according to principles of evolution. It is subject to recombination and random mutation, is constantly changing, and is not target oriented. Whether one of the logo's elements remains alive and can pass on its genes depends on how well adapted it is to its habitat.

The quality of the resulting logos is judged by a so-called fitness function, which determines the attributes of individual logos and compares them with the company's current situation. The best logos mate, and the offspring resulting from this recombination of genetic material replace older individuals. This updated population is reevaluated so that a constant process of renewal takes place. The individual with the most adaptive qualities then becomes the current logo and the one the company presents to the public.

The logo's appearance is based on a familiar model used to simulate cell systems: the cellular automaton, whose components follow simple rules and show emergent behavior in its entirety. This is therefore not an arbitrary exercise; the dynamics and activity visualized in this manner actually relate to the development of the company and its employees and thus ensure a logo that accurately reflects the condition of the company. The system was programmed in Java.

Michael Schmitz

2006
Evolving Logo

→ W.136
Website: Michael Schmitz

 Max Planck Institute
of Molecular Cell Biology and Genetics

 Max Planck Institute
of Molecular Cell Biology and Genetics

 Max Planck Institute
of Molecular Cell Biology and Genetics

 Max Planck Institute
of Molecular Cell Biology and Genetics

 Max Planck Institute
of Molecular Cell Biology and Genetics

grau

The experimental short film _grau is a personal confrontation with memories created during a car accident, in which an irreversible development consolidated into synaptic afterimages in a split second. This "living painting," reminiscent of figurative tableaux vivants, branches out over the course of ten minutes one second (10:01)—a length based on Leibniz's binary system, in which God equals one and darkness zero. The shape and movement aesthetics are based on the infinite detail of nature within an autonomous memory universe. It draws from scientific visualization, which—with the disenchantment of reality—creates picture and knowledge structures of great complexity. Their evolutionary filtering allows the derivation of both sculptural and pictorial patterns as emotional essences of concrete experiences. These add up to a torrent, from the prismatic light veils of splintered glass to the faded-memory sculptures, all culminating in the "decision fur," in which each hair is part of the preceding chain of events.

The work is a vibrant collection of structures, spaces, movement, and time levels. Initially, it consisted of countless sketches, objects, and body parts that were recorded using 3D scans, MRIs, X-rays, and motion capture. The simulation of dynamic processes is based on this convolution, which is fused with L-systems, particles, fractals, and digital artifacts. Using scripting, After Effects, and 3ds Max, new possibilities for bridging the gap between the contrasting representations and architectures were explored, with the aim of dissolving the sharp boundaries between individual ideas and creating a system whose cool beauty wrests memories from the beholder.

Robert Seidel

2004
_grau

Duration:
00:10:01 min
Direction, production, animation:
Robert Seidel
Music:
Heiko Tippelt, Philipp Hirsch

→ W.137
Website: Robert Seidel

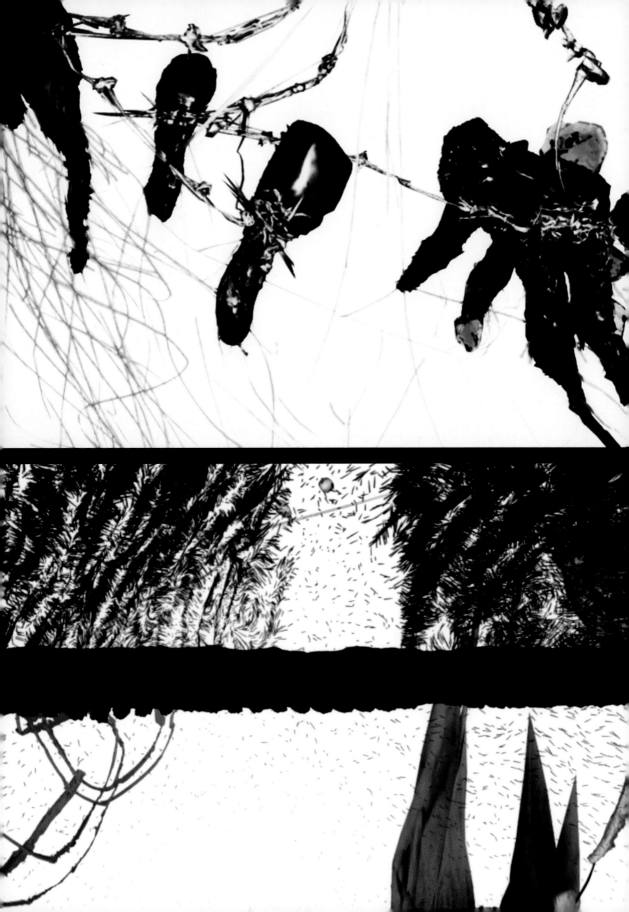

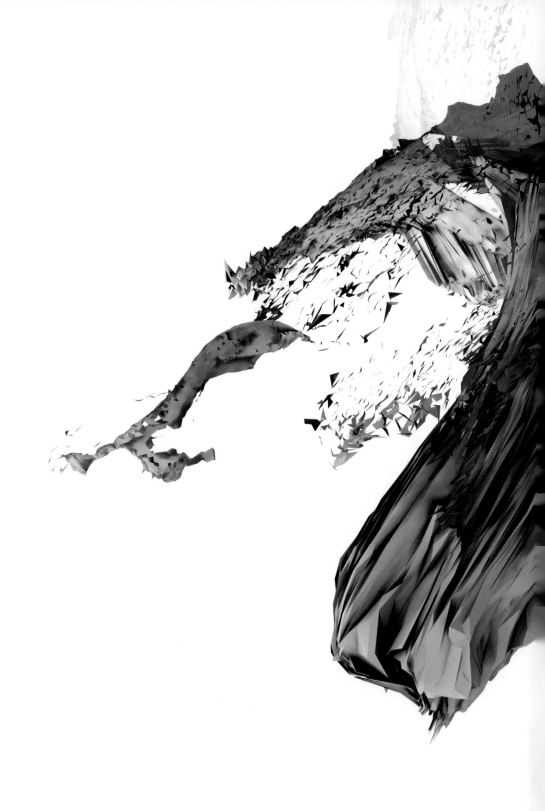

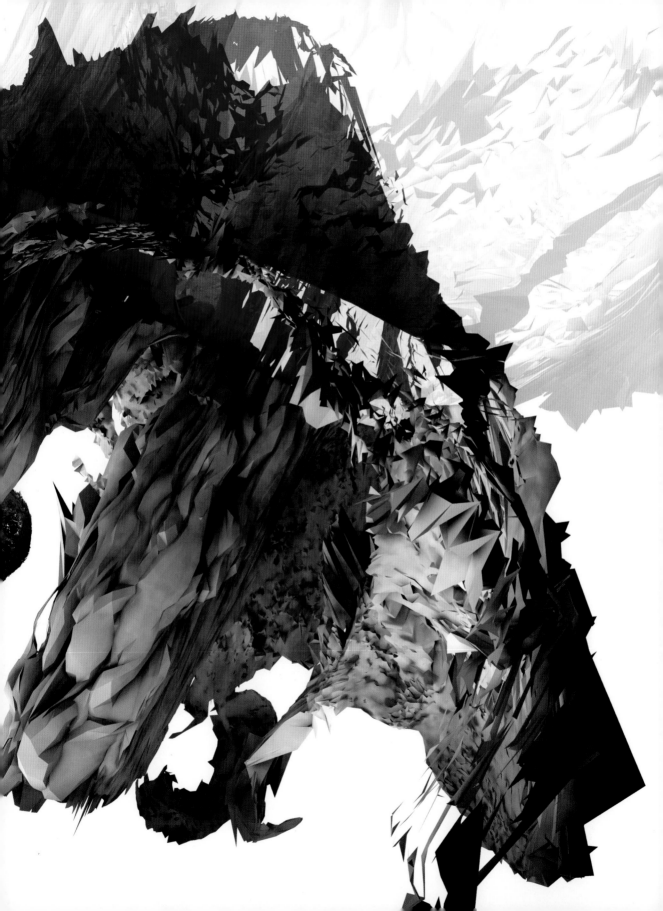

well-formed.eigenfactor

Well-formed.eigenfactor visualizes the information flow in the ecosystem of science. The goal is to create a map of the sciences that is not based on how the disciplines fit together a priori but rather on how they are grouped together and influence each other in actual scientific work.

The Bergstrom Lab at the University of Washington calculated a measurement of the influence of scientific journals (the "Eigenfactor Score"), weighted network graphs, and, based on these factors, determined a hierarchical clustering. Moritz Stefaner transformed this extensive data into four visualizations, each of which reveals different aspects of the information.

The project expands the vocabulary of network visualization: on the one hand by changing the function of existing technologies, such as hierarchical edge bundling and treemaps, and on the other hand through new approaches such as using magnetic needles as influence indicators and a new flow chart for representing changes in the cluster structure over time.

The data set was drawn from Thomson Reuters's Journal Citation Reports, 1997–2005. The top 400 journals, with approximately 13,000 citation connections, were selected.

Moritz Stefaner
Martin Roswall
Carl Bergstrom

2008
well-formed.eigenfactor
Visualizing information flow in science

→ W.138
Website: well-formed.eigenfactor
→ W.139
Website: Moritz Stefaner

Related chapters:
→ Ch.M.5
Tree diagrams
→ Ch.M.6
Dynamic data structures

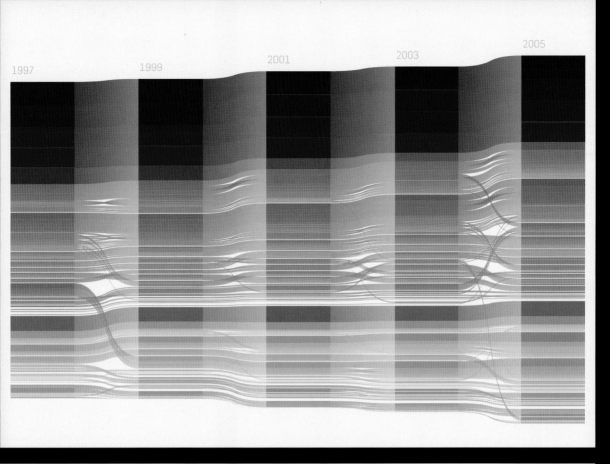

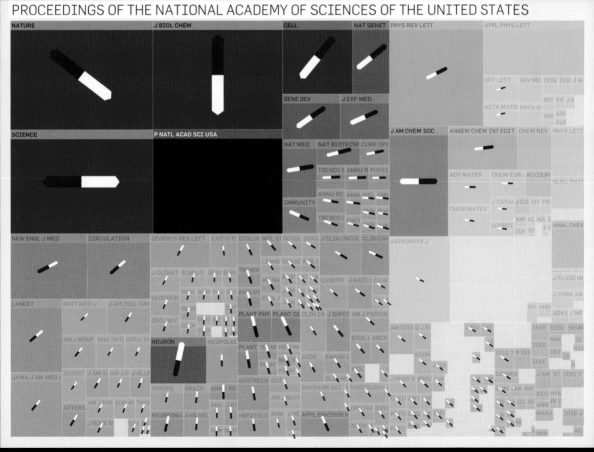

PROCEEDINGS OF THE NATIONAL ACADEMY OF SCIENCES OF THE UNITED STATES

NATURE

J BIOL CHEM

CELL

NAT GENET

PHYS REV LETT

APPL PHYS LETT

OPT LETT

REV MO

IEEE IEEE J AP

GENE DEV

J EXP MED

REP PH J N

ACTA MATER

PHYS R

MR

ADV

SUR

SCIENCE

P NATL ACAD SCI USA

NAT MED

NAT BIOTECH

CURR OPI

J AM CHEM SOC

ANGEW CHEM INT EDIT

CHEM REV

PHYS ST

TRENDS

ANNU R

PHYSI

IMMUNITY

ANNU RE

ANN

TIC

ADV MATER

CHEM-EUR

ACCOUN

NUCL PHY

CHEM MATER

J CATA

J CO

CH PR

COORDI

ANY

AC

NA

CUR

TO

ANAL CHEM

NEW ENGL J MED

CIRCULATION

GEOPHYS RES LETT

EARTH P

ECOLOG

MOL E

OECOL

OIKO

J CLIN ONCOL

CLIN CAN

ASTROPHYS J

LIMNO

CONSE

SOIL

J CLIMAT

ICARUS

QUAT

N

TRENDS

J FLUID M

ARCH

EC

SCI

CANCER

J NATL

CANC

J COM

AN

GEOCHIM

MON

PR

EVOLUT

ECOL J

ADV

J ME

LANCET

BRIT MED J

J AM COLL CAR

GEOLOGY

PLANT PHY

PLANT CE

CLIN IN

J INFEC

AM PSYCHI

SP

ANN

AM J RESP

ANN INT

ARCH I

NEURON

NEUROLDE

PLANT TR

NE PH

BIOL

ARCH

AM ECO

Q J E

IEEE

IEEE

NEUR

PLANT

M

MA

IE

JAMA-J AM MED A

DIABET

J AM SC

AM J C

J ALLE

STROKE

BRAIN

ANN

RE

GASTROEN

GUT

AIDS

EMERG

VOL

ECON

IEEE

P IEE

INT

IEEE

J AM BI

IEEE T

AM J EPI

EUP HI

TH

ARTERI

NEUROIMA

ANN NE

HEPATOLO

ANN

J ME

APPL ENVIRON M

J PHY

PSYCO

BIO

STA

PH

ANK

MANA

IEEE J

J BOFE M

ENVIRON SCI

RADIOLOGY

OPHTHA

ENVI

AC

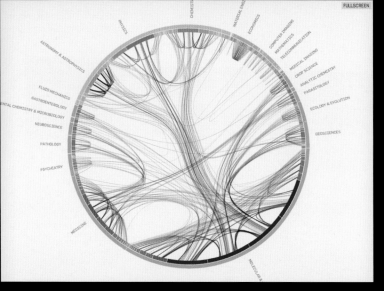

PHYSICAL REVIEW LETTERS

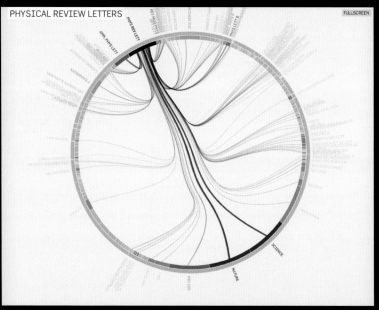

GEOPHYSICAL RESEARCH LETTERS

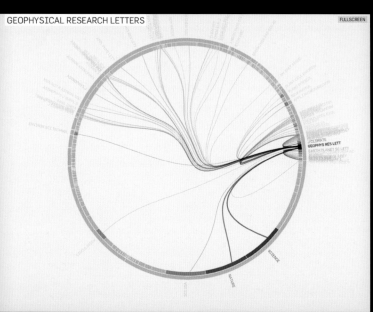

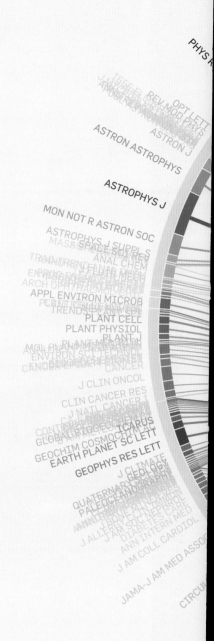

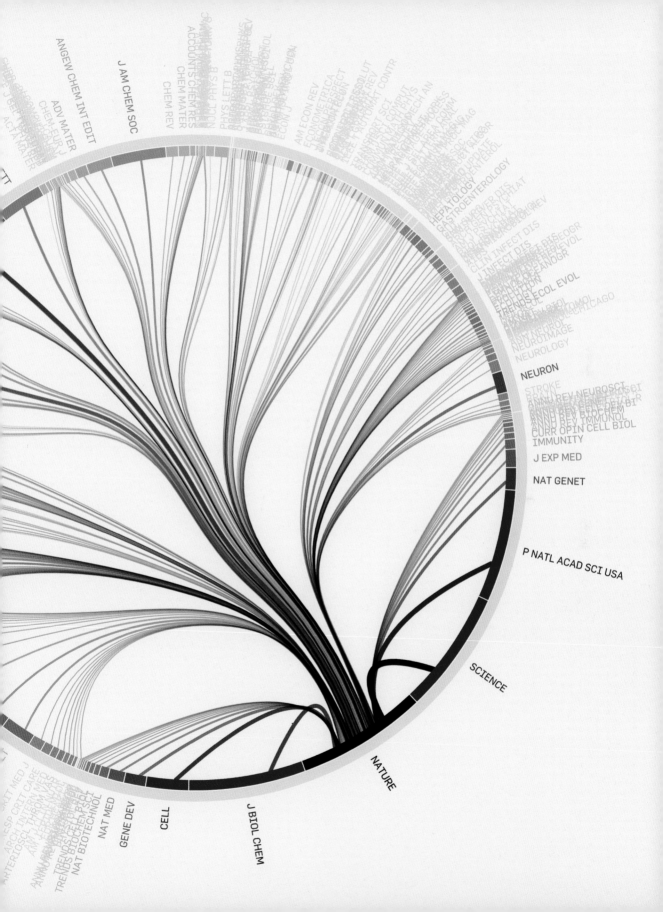

Cyberflowers

Since the 1960s Roman Verostko has been exploring the creation of purely formal-aesthetic works using modified pen plotters. Code is transmitted to a drawing machine, which translates the instructions into motion and draws directly on the paper.

Years of working with this method and countless experiments eventually led to the use of algorithms that revealed colorful shapes, on which the *Cyberflowers* are based. They evolved out of recent works by the artist, such as *Pearl Park Scriptures* and *Flowers of Learning*. The *Cyberflowers* are based as well on the efforts of early twentieth-century pioneers who wished to create an art of pure form. Influences from artists like Piet Mondrian and Kazimir Malevich also came into play.

The visualizations are based on algorithms derived from ubiquitous digital technologies. Each drawing makes manifest the code with which it was generated and, in its subtlety, transcends the seemingly rigid logic of the program.

Roman Verostko

2009
Cyberflowers
Imaging the unseen

→ W.140
Website: Roman Verostko

Related chapters:
→ Ch.P.2.3
Drawing
→ Ch.M.2
Oscillation figures

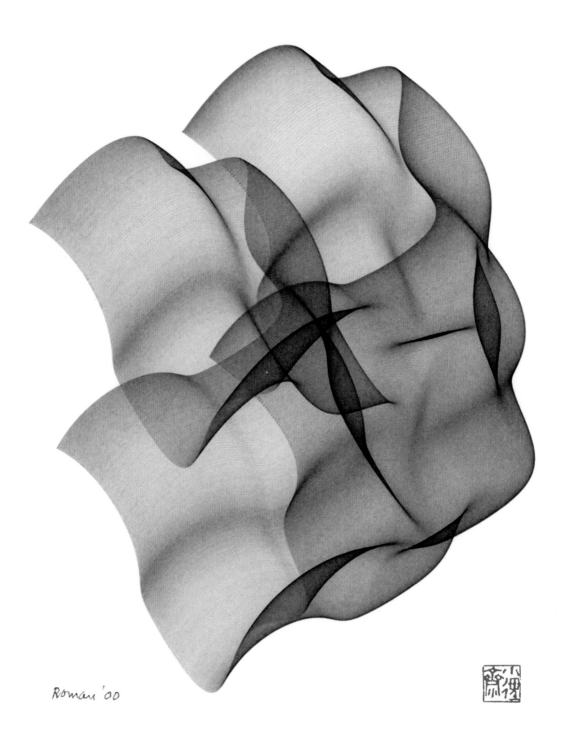

Roman '00

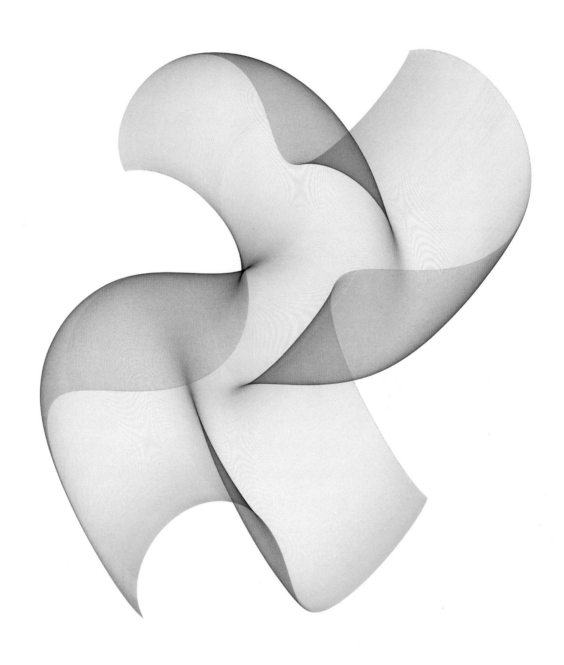

Stock Space

Stock Space is a work commissioned for the firm Knight Capital Group, one of the largest providers of electronic trading systems in the financial sector. Securities trading is a complex, fast-paced business in which the flow of information in real time is essential. Time is measured in milliseconds, and the trading floor is increasingly dissolving into decentralized networks.

The goal of this project was to treat the business as a virtual space and to develop a series of data landscapes. The visualization accentuates certain characteristics of the data and thus creates forms that illustrate the complexity of the information stream in which securities traders move every day. The semantic meanings are deliberately ignored; instead, the work illuminates the spatial structures that are normally hidden in the information flows.

The visualization was developed in Processing with OpenGL. Tile-based rendering was used for the print edition of the pictures in high resolution. Knight Capital Group made data available showing all the trading transactions that were handled by the Knight network during one entire day. This information was augmented with older stock prices from the online service Yahoo! Finance.

Marius Watz

2008
Stock Space
Visualizing data

→ W.141
Website: Marius Watz
→ W.142
Blog: GeneratorX
→ W.143
Website: evolutionzone

Related chapters:
→ Ch.M.3
Formulated bodies
→ Ch.M.6
Dynamic data structures

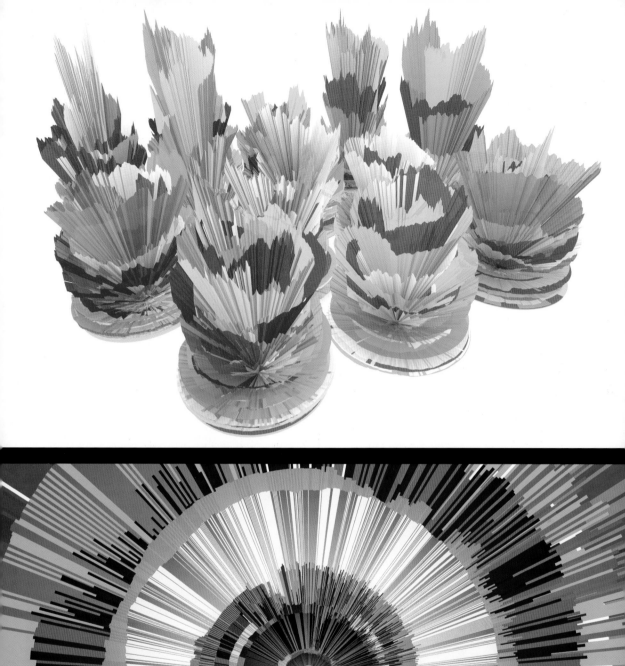
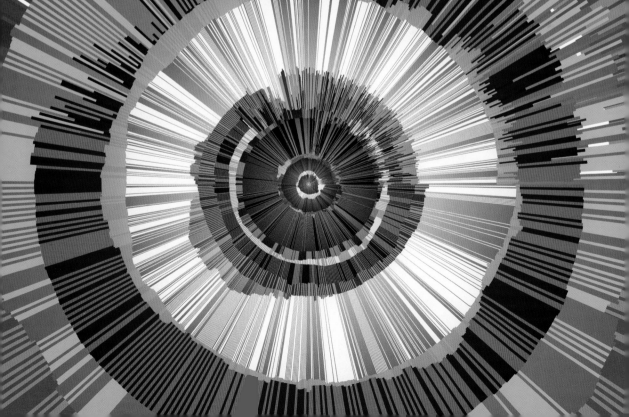

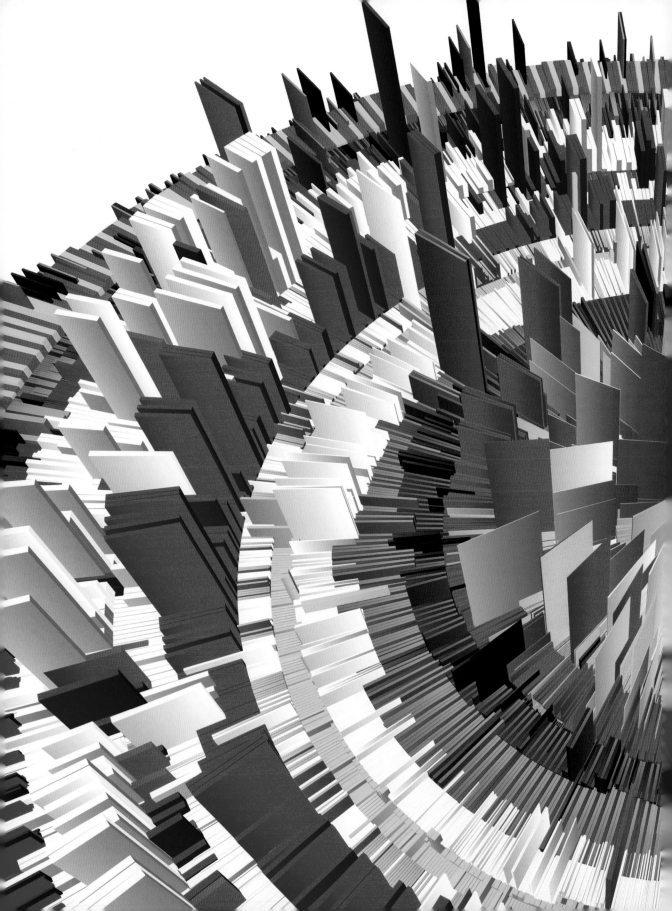

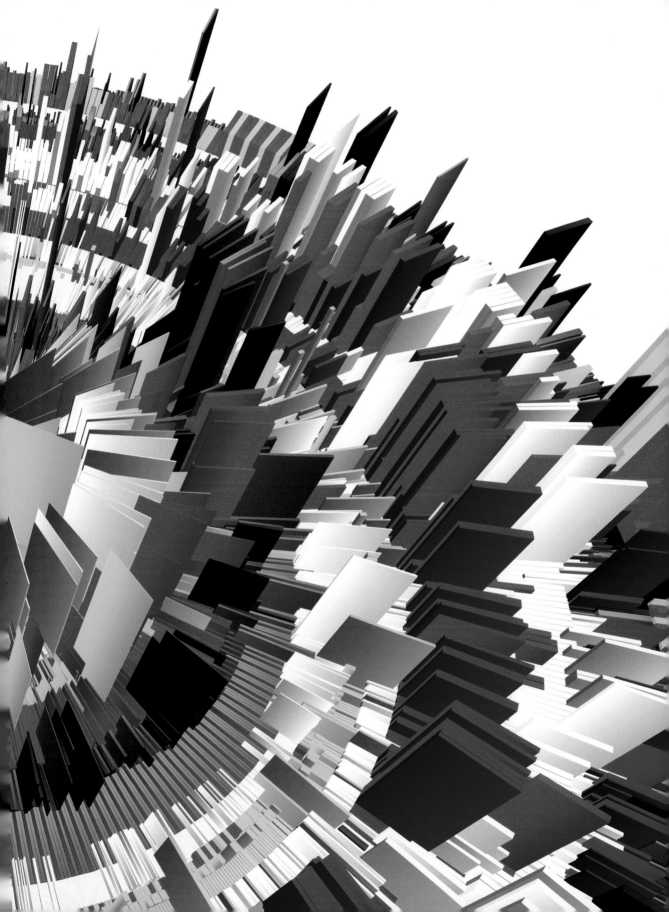

P.///

Basic Principles

In this part of the book, various basic design principles are explored in the generative context. Users can become acquainted with new possibilities in the design process by generating color palettes, using shapes, constructing type, or changing image structures. We present design principles and explain their corresponding programs. These programs are simple to understand; users can create their own variations by changing the code or experiment with parameters to create their own images. The following introduction to Processing will provide a basic technical understanding.

P.0

Introduction
to Processing

P.0.0
Processing—an overview

This book uses the programming language Processing as a way of introducing the concept of generative design; its basic features and functions will be presented on the following pages. This chapter lays no claim to completeness, which would be far beyond the realm of the book. A very good and detailed introduction to programming with Processing can be found in the book *Processing: A Programming Handbook for Visual Designers and Artists* by Casey Reas and Ben Fry.

→ W.201
Processing book

The Processing project was initiated in the spring of 2001 by Ben Fry and Casey Reas and has continually grown and been developed since then with a small group of collaborators. The main goal of Processing is to provide visually oriented people with simple access to programming.

Processing programs are called "sketches." Hence, Processing can be understood as an environment for the quick creation of digital sketches. The main folder where user-created programs are stored is called the "sketchbook" folder.

Processing is an open-source project; users can download it for free and use it for their own projects. Since Processing uses textual notation that consists of up to ninety-five percent Java syntax (with Java considered one of the main standards of the software industry), it is easy to transfer the code and examples to the majority of other textual development environments. Processing is cross-platform, which means the same source code can be used on all operating systems for which a Java platform exists (e.g., Mac OS, Windows, and Linux) and can also be integrated into websites.

→ W.202
Programming language Java

An ever-growing, vital, and supportive online Processing community exists that actively exchanges ideas on the Processing website. The website also contains online references of all language elements and an index of supplementary libraries.

→ W.203
Processing Website

Several of these external libraries are used for the programs in this book. We also developed our own library for this book. The range of functions of the generative design library also includes the support of graphic tablets, the ability to export to Adobe's ASE color palette format, and the transformation of Cartesian coordinates into polar coordinates. The complementary libraries found in the "libraries" folder must be installed for all the programs in this book to work.

→ www.generative-gestaltung.de
→ Generative Design library

Palette exporting
→ Ch.P.1.2
Color palettes

All files required by a program, such as images, texts, or SVG (Scalable Vector Graphics) files, should be saved in a folder called "data" within the sketch folder. This ensures that Processing can find all necessary files, even if the sketch is executed in another operating system or in a web browser.

THE PROCESSING EDITOR As previously mentioned, Processing is based on the programming language Java. Processing is easier to learn than Java because the most important commands are simple, particularly those used for graphic output, and the beginner is not burdened with the confusing constructions Java requires to get a program running.

Processing also provides a development environment that is reduced to the essentials. When Processing is opened, a window like the one shown here appears. The program code is entered in the middle area, the editor. The toolbar above this contains buttons used to start and stop the program or to load, save, or export programs. Information and error messages appear in the console, located at the bottom. Once the program code has been entered, the program starts; if there are no error messages, a display window appears in which the program runs.

The Processing development environment.

The most important language elements and programming concepts are introduced on the following pages. You can immediately enter the presented commands in the editor, press start, and watch what the commands produce. Note, however, that not all printed code examples are functioning stand-alone programs.

P.0.1
Language elements

HELLO, ELLIPSE A first program. Simply type in the following line into the Processing editor and click start.

```
ellipse(50, 50, 60, 60);
```

A circle appears on the display.

Of course, it is possible to have more than one line of code. In this case, each line will be processed sequentially from top to bottom. Processing reads the following commands in this manner:

```
ellipse(50, 50, 60, 60);
strokeWeight(4);
fill(128);
rect(50, 50, 40, 30);
```

Draw an ellipse at the coordinates (50, 50) with a width and height of 60 pixels. Set the line weight to 4 pixels. Set the fill color to a medium gray. Draw a rectangle at the coordinates (50, 50) with a width of 40 and a height of 30.

Processing commands are case sensitive. The command strokeWeight() would not be recognized when written as strokeweight() or Stroke-Weight().

There are commands that draw, such as ellipse, rect, line, etc., and commands that specify how the graphic that follows should be drawn, such as stroke, strokeWeight, noStroke, fill, noFill, etc. Once a drawing mode has been configured, it will apply for all additional drawing commands until the drawing mode is reconfigured.

Most drawing commands require one or more parameters that indicate where something should be drawn and at what size. The unit of measure for this is the pixel. The origin of the coordinate system is located in the upper left corner of the display window.

```
point(60, 50);
```

The pixel generated by the command point(60,50) is thus drawn sixty pixels from the left edge and fifty pixels from the upper edge.

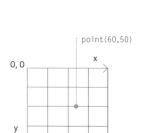

Display window with a width and height of one hundred pixels.

SETUP AND DRAW The short programs just presented stop when the last line has been processed. However, a program usually continues to run until the user stops it. Only in this mode do animation and interaction become possible.

To achieve this, the draw() function has to be implemented. It is called in each drawing step, and all of its commands are processed each time.

```
void draw() { }
```

Although this draw() function contains no commands, it keeps the program running.

```
void draw() {
  println(frameCount);
}
```

A draw() function with one command. The command println() displays text in the console area of the Processing development environment. In this case, it displays the continually increasing number of the actual frame.

The draw() function is displayed with a preset frequency that specifies how many images are shown per second. The standard number is set at sixty images per second, but this can be reset using the command frameRate().

```
frameRate(30);
```

This drawing speed is set at 30 images per second.

However, if the computational effort per frame becomes so high that Processing is unable to execute it within the preset time, the set frame rate decreases automatically.

Some actions should only be performed once when the program is started and not repeatedly in each frame. The setup() function is used for this.

```
void setup() {
  frameRate(30);
}
```

These commands, which should be executed just once when the program is started, appear in the setup() function.

DISPLAY AND RENDERER The display window is the stage for the program's visual output and can be set to any size.

```
size(640, 480);
```

The display is now 640 pixels wide and 480 pixels high.

In addition to the parameters' width and height, using the command `size()` makes it possible to enter which renderer should be used for displaying the image. The renderer is responsible for how the different graphic commands are actually translated into pixels. The following rendering options are available:

```
size(640, 480, JAVA2D);
```

The standard renderer: this is used if nothing else has been specified.

```
size(640, 480, P2D);
```

Processing 2D renderer: this is quicker but less accurate.

```
size(640, 480, P3D);
```

Processing 3D renderer: this is quick and is reliable on the Web.

```
size(640, 480, OPENGL);
```

OpenGL renderer: this uses (and requires) OpenGL-compatible graphic hardware. Here the graphic card and CPU share the computational efforts, making it the fastest renderer.

TRANSFORMATIONS One of Processing's strengths is that it can move, rotate, and scale the coordinate system. All graphic commands thereafter refer to this altered coordinate system.

```
translate(40, 20);
rotate(0.5);
scale(1.5);
```

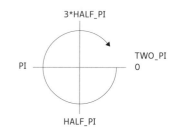

In this example, the coordinate system is moved 40 pixels to the right and 20 pixels downwards, then rotated 0.5 radians (about 30°) and finally scaled by a factor of 1.5.

In Processing, angles are generally shown in radians, in which 180° equals the number pi (\approx 3.14) and the rotation is in a clockwise direction.

VARIABLES AND DATA TYPES In a program, information is stored in variables so that it is available to other parts of the program. These variables can have any name other than the keywords for Processing functions. Keywords can be recognized by their special color in the editor.

```
int myVariable;
myVariable = 5;
```

The variable myVariable is created.
The value 5 is then saved there.

When defining a variable, the user must specify its type, meaning what kind of information it will save. The keyword int in front of the variable's name informs Processing that this variable should hold integers. Processing provides several data types for various kinds of information. The most important are:

```
boolean myBoolean = true;
```

Logic values (Boolean values): true or false

```
int myInteger = 7;
```

Integers: e.g., 50, -532

```
float myFloat = -3.219;
```

Floating point value: e.g., 0.02, -73.1, 80.0

```
char myChar = 'A';
```

A single character: e.g., 'a', 'A', '9', '&'

```
String myString = "This is text.";
```

Character string/text: e.g., "Hello, world"

ARRAYS When working with a large number of values, it is inconvenient to have to create a variable for each value. An array allows a list of values to be managed.

```
String[] planets = {"Mercury", "Venus", "Earth", "Mars",
                    "Jupiter", "Saturn", "Uranus", "Neptune"};

println(planets[0]);
```

The square brackets after String indicate that the variable planets should be created or initialized as an array of strings. This array will immediately be filled with eight values (the planet names).

Values can be accessed by entering an index number in the square brackets following the variable name. The index 0 points to the first entry in the array.

If values are not immediately assigned to an array, the array can be created first and filled later:

```
int[] planetDiameter = new int[8];
planetDiameter[0] = 4879;
planetDiameter[1] = 12104;
planetDiameter[2] = 12756;
planetDiameter[3] = 6794;
...
```

The value 8 in the square brackets initializes an array for eight values.

Values are then assigned to the array. This could also happen later while the program is running.

OPERATORS AND MATHEMATICS Naturally, calculations can also be performed in Processing. This is possible with simple numbers:

```
float a = (4 + 2.3) / 7;
```

After execution the value 0.9 is saved in a.

. . . with strings:

```
String s = "circumference of Jupiter: " + (142984*PI) + " km";
```

The variable s then contains the string "circumference of Jupiter: 449197.5 km".

. . . and with variables:

```
int i = myVariable * 50;
```

The value in myVariable is multiplied by 50 and the result saved in i.

The following computational operators are available: +, -, *, /, % and !.

A whole series of mathematical functions are also available. Here are a few:

```
float convertedValue = map(aValue, 10,20, 0,1);
```

The value in aValue is converted from a number between 10 and 20 to a number between 0 and 1.

```
int roundedValue = round(2.67);
```

Round a number. The roundedValue is then 3.

```
float randomValue = random(-5, 5);
```

Produce a random number between -5 and 5.

```
float cosineValue = cos(angle);
```

Calculate the cosine of the specified angle.

MOUSE AND KEYBOARD There are several ways to access information using the mouse and keyboard as input devices. One option is to query the variables available in Processing.

```
void draw() {
  println("Mouse position: " + mouseX + ", " + mouseY);
  println("Is one of the mouse buttons pressed: " + mousePressed);
  println("Is a key pressed: " + keyPressed);
  println("Last key pressed: " + key);
}
```

The Processing variables mouseX and mouseY always contain the actual position of the mouse; mousePressed is true if one of the mouse buttons is pressed in that moment. For the keyboard, keyPressed indicates if a key is pressed; the key last pressed appears in key.

Another possibility is to implement one of the event handlers. An event handler is called when the corresponding event occurs—i.e., when a mouse button or key on the keyboard is pressed.

```
void mouseReleased() {
  println("The mouse button has been released.");
}
```

The function mouseReleased() is called when the left mouse button is released.

Additional event handlers include mousePressed(), mouseMoved(), keyPressed(), and keyReleased().

CONDITIONS It is often necessary to execute lines of code. The if conditions are used to do this.

```
if (aNumber == 3) {
  fill(255, 0, 0);
  ellipse(50, 50, 80, 80);
}
```

The two lines of code inside the curly brackets are executed only when the condition is met—i.e., when the value of the variable aNumber is 3.

```
if (aNumber == 3) {
  fill(255, 0, 0);
}
else {
  fill(0, 255, 0);
}
```

With else, the if condition is expanded by one code snippet that is executed when the condition is not met.

```
if (aNumber == 3) fill(255, 0, 0);
else fill(0, 255, 0);
```

If a code snippet consists of only one line, as in the previous example, the curly brackets can be eliminated.

Differentiating between multiple values of a variable can usually be achieved by the switch command.

```
switch (aNumber) {
  case 1:
    rect(20, 20, 80, 80);
    break;
  case 2:
    ellipse(50, 50, 80, 80);
    break;
  default:
    line(20, 20, 80, 80);
}
```

The switch command tests if the value of the variable aNumber corresponds to one of the values listed in the case lines, jumps there if it does, and continues code execution until the following break statement.

If no corresponding value exists, program execution continues at default.

LOOPS Loops are used to execute a particular command several times within a program. Here are two versions:

The for loop is used to loop a code snippet for a specific number of repetitions.

```
for (int i = 0; i <= 5; i++) {
  line(0, 0, i*20, 100);
  line(100, 0, i*20, 100);
}
```

The two lines of code inside the curly brackets are executed exactly six times. First the variable i is set to the value 0, then increased by 1 (i++) after each cycle, as long as the value is 5 or less.

A while loop will continue as long as a certain condition is fulfilled.

```
float myValue = 0;
while (myValue < 100) {
  myValue = myValue + random(5);
  println("The value of the variable myValue is " + myValue);
}
```

This while loop will continue as long as the value of the variable myValue is less than 100. A random value between 0 and 5 is added in each new loop cycle.

FUNCTIONS There are often parts of a program that appear in a similar way in different places. In many such cases it is wise to encapsulate these parts in a function. For example:

```
void setup() {
  translate(40, 15);
  line(0, -10, 0, 10);
  line(-8, -5, 8, 5);
  line(-8, 5, 8, -5);
  translate(20, 50);
  line(0, -10, 0, 10);
  line(-8, -5, 8, 5);
  line(-8, 5, 8, -5);
}
```

The coordinate system is moved to another location, where a star is made of three lines. The coordinate system is then moved again, and a star is drawn using the same commands at the new location.

To change the star's appearance in this program, the drawing commands have to be changed in two places. It is therefore better to store the corresponding lines in a function.

```
void setup() {
  translate(40, 15);
  drawStar();
  translate(20, 50);
  drawStar();
}

void drawStar() {
  line(0, -10, 0, 10);
  line(-8, -5, 8, 5);
  line(-8, 5, 8, -5);
}
```

Here a function was defined that contains the drawing commands. This function can be called from anywhere in the program in order to execute the code it contains.

Values can be passed in functions, which can also return a value as a result.

```
void setup() {
  println("The factorial of 5 is 1*2*3*4*5 = " + factorial(5));
}

int factorial(int theValue) {
  int result = 1;
  for (int i = 1; i <= theValue; i++) {
    result = result * i;.
  }
  return result;
}
```

A function factorial() is defined here, in which a value is passed, theValue of type int. When the function is called the parameter, 5 in this case, is passed in the variable theValue.

In the function, various calculations are executed with this value, and the result is returned using the command return. The type classifier in front of the function's name (here int) indicates the type of the return value. Here void indicates when no value will be returned, as in the previous example with the drawStar() function.

P.0.2
Programming beautifully

In programming there are usually many ways to attain a desired result. The fact that a program works, however, is just one part of the solution, albeit a very important one; there are other aspects you should consider.

COMMENTS The more complex and tricky a program is, the harder it is for others—and for you, too, after a short time—to understand it. A program that is not accessible cannot be modified or updated. Comments in the program help to clarify the code.

```
// calculate distance between actual and previous mouse position
// which represents the speed of the mouse
float mouseSpeed = dist(mouseX, mouseY, pmouseX, pmouseY);
```

Text that follows two forward slashes is ignored by Processing and can be used for comments.

The Processing community is spread across the entire world. It is therefore advisable to write comments and variable names in English. This makes it easier for you and others to look for and find suggestions and answers to problems in Internet forums.

USEFUL NAMES AND CLEAR STRUCTURES In addition to the use of comments, sensibly selected variable and function names help users to maintain an overview and to understand what a specific program does.

```
float mixer(float apples, float oranges) {
  float juice = (apples + oranges) / 2;
  return juice;
}
```

In this example it is difficult to recognize just what the function calculates. The fact that the average of two numbers is calculated can only be guessed from the formula.

To this end, it is necessary to structure the program into smaller, logical sections with the help of functions and classes. This encapsulation of functionality also means that the program can be quickly modified and extended.

PERFORMANCE Even though computers are becoming faster and faster, it still takes time to execute a command. Even short periods of time add up noticeably when a command is executed often. Try not to burden the program with unnecessary work.

```
for (int i = 0; i < 10000000; i++) {
  float mouseSpeed = dist(mouseX, mouseY, pmouseX, pmouseY);
  doSomethingWithMouseSpeed(mouseSpeed);
}
```

Here mouseSpeed is calculated in all ten million loops even though the mouse position cannot be changed during this process.

```
float mouseSpeed = dist(mouseX, mouseY, pmouseX, pmouseY);
for (int i = 0; i < 10000000; i++) {
  doSomethingWithMouseSpeed(mouseSpeed);
}
```

Performance is therefore improved enormously when the mouse speed is calculated outside the loop.

With the programs in this book, we have tried to uphold the aforementioned principles. Sometimes, however, clarity and performance contradict one another, meaning that program code optimized for performance can be more difficult to understand. In such cases we have opted for clear structures.

USING OUR PROGRAMS In this chapter we have provided a short overview of the most essential building blocks of the Processing programming language. However, the most important part of programming is to connect these building blocks in such a way that the program does exactly what you want it to do. You will find it helpful to practice using the examples provided.

Learn from the programs in this book—create your own images with them, change the programs, and use them to create something new. We have released the programs under the Apache license. Therefore, you may use, modify, and distribute the programs freely in any context. Naturally, we would be very pleased if you mentioned us in your work.

→ W.204
Apache license

P.1

Color

In contrast to this book, the colors of which we per-
ceive through reflected and filtered light, comput-
ers are true quantum catapults. When we look at a
screen, light is sent directly into our eyes in vari-
ous wavelengths and can be manipulated in real
time. The following examples provide users with the
most important technical features for working with
color and introduce several ways to use color when
designing on the screen.

P.1.0
Hello, color

The ability to directly influence 16,777,216 colors gives users an amazing freedom. Simultaneous contrast—without which it would be impossible to perceive colors—is illustrated here by juxtaposing a number of color combinations. Our perception of a color is affected by its neighboring color and the shifting proportions of that color to its background.

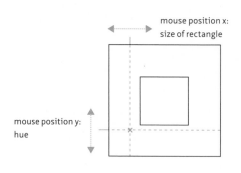

mouse position x:
size of rectangle

mouse position y:
hue

→ P_1_0_01.pde

The horizontal position of the mouse controls the size of the color field. Starting in the center, the colored area is depicted with a height and width of 1 to 720 pixels. The vertical mouse position controls the hue. The background passes through the color spectrum from 0 to 360, while the color field passes through the spectrum in the opposite direction, from 360 to 0.

Mouse: *Position x: Size of rectangle · Position y: Hue*
Keys: *S: Save PNG · P: Save PDF*

→ P_1_0_01.pde

```
void setup() {
  size(720, 720);
  noCursor();
}
```

The setup() function sets the size of the display window and makes the cursor invisible.

```
void draw() {
  ...
  colorMode(HSB, 360, 100, 100);
  rectMode(CENTER);
  noStroke();
  background(mouseY/2, 100, 100);

  fill(360-mouseY/2, 100, 100);
  rect(360, 360, mouseX+1, mouseX+1);
  ...
}
```

The colors should pass through the hue spectrum in this program. For this reason, colorMode() allows users to change the way color value is interpreted. HSB specifies the color model, and the three values following it specify the respective range. Hue, for example, can only be specified by values between 0 and 360.

The y-value of the mouse position is divided by 2 to get values from 0 to 360 on the color wheel.

The halved y-value of the mouse position is subtracted from 360, creating values from 360 to 0.

The size of the color field changes relative to the x-value of the mouse position, with a side length between 1 and 720 pixels.

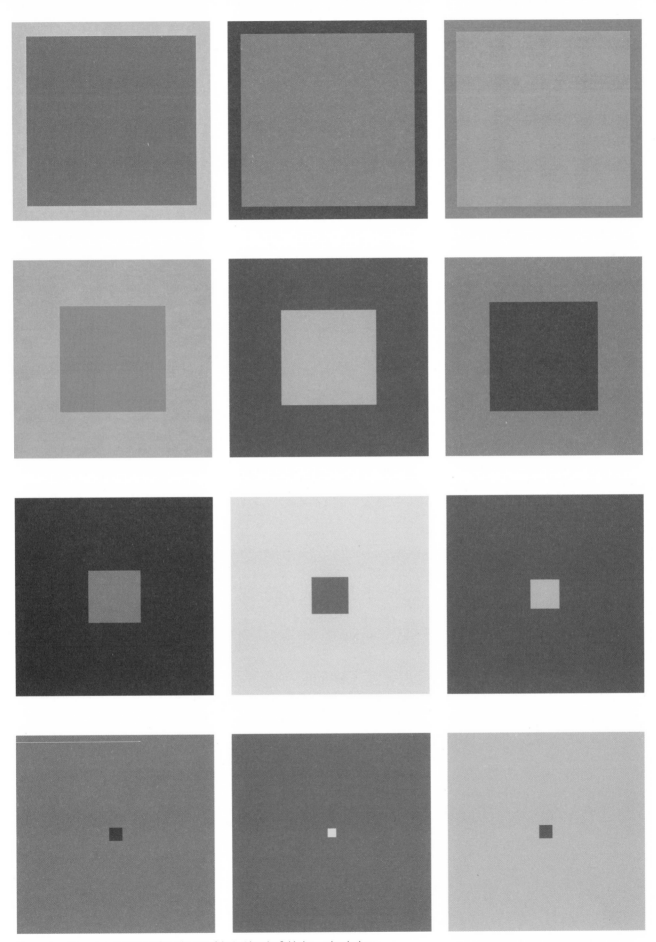

The x-value of the mouse position defines the size of the inside color field, the y-value the hue.
→ P_1_0_01.pde

P.1.1.1
Color spectrum in a grid

This color spectrum is composed of colored rectangles. Each tile is assigned a hue on the horizontal axis and a saturation value on the vertical. The color resolution can be reduced by enlarging the rectangles, so that the primary colors in the spectrum become clearer.

→ P_1_1_1_01.pde

The grid is created by two nested for loops. In the outer loop, the y-position is increased, step by step. The inner loop then draws a line by increasing the value for the rectangle's x-position, step by step, until the entire width is processed. The step size is set by the value of the mouse position and is located in the variables stepX and stepY. It also determines the length and width of the rectangles.

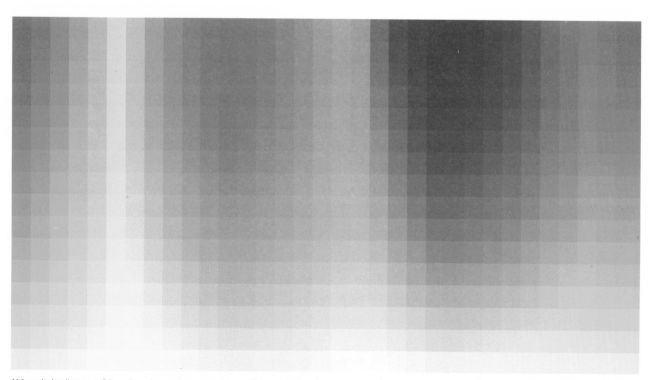

Although the distance of the color values is the same between all the color tiles, the contrasts are perceived as greater in some positions than in others.
→ P_1_1_1_01.pde

```
int stepX;
int stepY;

void setup(){
  size(800, 400);
  background(0);
}

void draw(){
  ...
  colorMode(HSB, width, height, 100);

  stepX = mouseX+2;
  stepY = mouseY+2;

  for (int gridY=0; gridY<height; gridY+=stepY){
    for (int gridX=0; gridX<width; gridX+=stepX){
      fill(gridX, height-gridY, 100);
      rect(gridX, gridY, stepX, stepY);
    }
  }
  ...
}
```

The display size is set using size(). The values defined here can be retrieved at any time using the system variables width and height.

The value range for hue and saturation is set at 800 or 400 using the command colorMode(). Hue is no longer defined as a number between 0 and 360 but rather as one between 0 and 800. The same is true of the saturation value.

The addition of 2 prevents stepX or stepY from being too small, which would lead to longer display times.

With the help of two nested loops, all the positions in the grid will now be processed. The y-position of the rectangle to be drawn is defined by gridY in the outer loop. The value increases only when the inner loop has been processed (i.e., once a complete row of rectangles has been drawn).

The variables gridX and gridY are used not only to position the tile but also to define the fill color. The hue is determined by gridX. Saturation value decreases proportionally to increases in the value gridY.

A soft rainbow effect occurs at full resolution.
→ P_1_1_1_01.pde

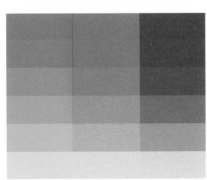

The primary colors of a computer monitor—red, green, and blue—in various gradations.

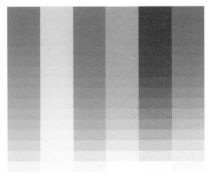

The secondary colors are also visible at this resolution.

P.1.1.2
Color spectrum in a circle

There are numerous models for organizing colors. The color spectrum arranged in a circle (color wheel) is a popular model for comparing harmonies, contrasts, and color tones. You can control the number of circle segments, as well as their brightness and saturation values, allowing you to better understand the color arrangement in HSB mode.

→ P_1_1_2_01.pde

The color-wheel segments are arranged in the shape of a fan. The individual vertices are computed from the cosine and sine values of the corresponding angle. A Processing method mode can be used that makes it especially easy to create the wheel segments. The individual points have to be set in the following order: first the middle point, and then the outer ones sequentially.

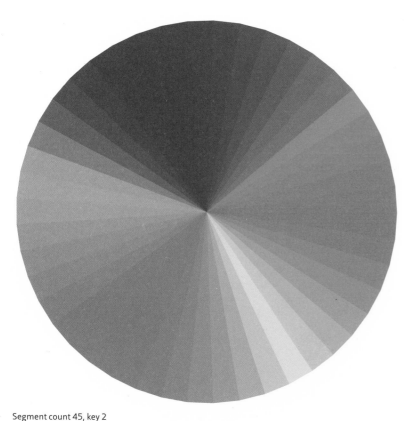

Segment count 45, key 2
→ P_1_1_2_01.pde

Segment count 12, key 4
→ P_1_1_2_01.pde

Segment count 6, key 5
→ P_1_1_2_01.pde

```
void draw(){
  ...
  colorMode(HSB, 360, width, height);
  background(360);

  float angleStep = 360/segmentCount;

  beginShape(TRIANGLE_FAN);
  vertex(width/2, height/2);
  for (float angle=0; angle<=360; angle+=angleStep){
    float vx = width/2 + cos(radians(angle))*radius;
    float vy = height/2 + sin(radians(angle))*radius;
    vertex(vx, vy);
    fill(angle, mouseX, mouseY);
  }
  endShape();
  ...
}
```

The ranges of values for saturation and brightness are adjusted in such a way that mouse coordinates can be taken as their values.

The angle increment depends on how many segments are to be drawn (segmentCount).

The first vertex point is in the middle of the display.

For the other vertices, angle has to be converted from degrees (0–360) to radians (0–2π) because the functions cos() and sin() require the angle be input this way.

The fill color for the next segment is defined: the value of angle as hue, mouseX as saturation, and mouseY as brightness.

The construction of the color segment is ended with endShape().

```
void keyReleased(){
  ...
  switch(key){
  case '1':
    segmentCount = 360;
    break;
  case '2':
    segmentCount = 45;
    break;
  case '3':
    segmentCount = 24;
    break;
  case '4':
    segmentCount = 12;
    break;
  case '5':
    segmentCount = 6;
    break;
  }
}
```

The switch() command checks the last key pressed, which enables easy switching between different cases.

If the key 3 was pressed, for instance, then segmentCount is set at the value 24.

187

P.1.2.1
Color palettes through interpolation

In each color model, colors have their clearly defined place. The direct path from one color to another always has precisely definable gradations, which will vary depending on the specific model. Using this interpolation you can create color groups in every gradation, as well as locate individual intermediate nuances.

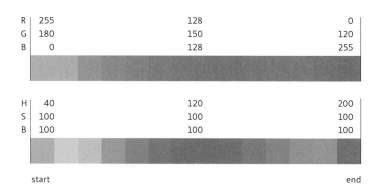

R	255	128	0
G	180	150	120
B	0	128	255

H	40	120	200
S	100	100	100
B	100	100	100

start end

Because a color is not defined by a single number but by several values, it is necessary to interpolate between these values. Depending on the chosen color model, RGB or HSB, the same color is defined by different values, thereby causing the path from one to another to lead past different colors. In the HSB color model, for instance, a detour is made past the color wheel. This difference is due to the characteristics of the color models, both of which can be very useful, depending on the situation. It is therefore important to choose the appropriate color model to solve a specific problem.

Mouse: *Left click: New random color set • Position x: Resolution • Position y: Number of rows*
Keys: *1–2: Interpolation style • S: Save PNG • P: Save PDF • C: Save ASE palette*

```
void draw() {
  ...
  tileCountX = (int) map(mouseX,0,width,2,100);
  tileCountY = (int) map(mouseY,0,height,2,10);
  float tileWidth = width / (float)tileCountX;
  float tileHeight = height / (float)tileCountY;
  color interCol;
  ...
  for (int gridY=0; gridY< tileCountY; gridY++) {
    color col1 = colorsLeft[gridY];
    color col2 = colorsRight[gridY];
    for (int gridX=0; gridX< tileCountX; gridX++) {
      float amount = map(gridX,0,tileCountX-1,0,1);
      ...
      interCol = lerpColor(col1,col2, amount);
      ...
      fill(interCol);
      float posX = tileWidth*gridX;
      float posY = tileHeight*gridY;
      rect(posX, posY, tileWidth, tileHeight);
      ...
    }
  }
}
```

The number of color gradations tileCountX and the number of rows tileCountY are determined by the position of the mouse.

Drawing the grid row by row.

The colors for the left and right columns are set in the arrays colorsLeft and colorsRight.

The intermediary colors are calculated with lerpColor(). This function performs the interpolation between the individual color values. The variable amount, a value between 0 and 1, specifies the position between the start and end color.

In all programs that are described in the color palette chapters, a color palette in ASE format for Adobe applications can be saved using the C key.

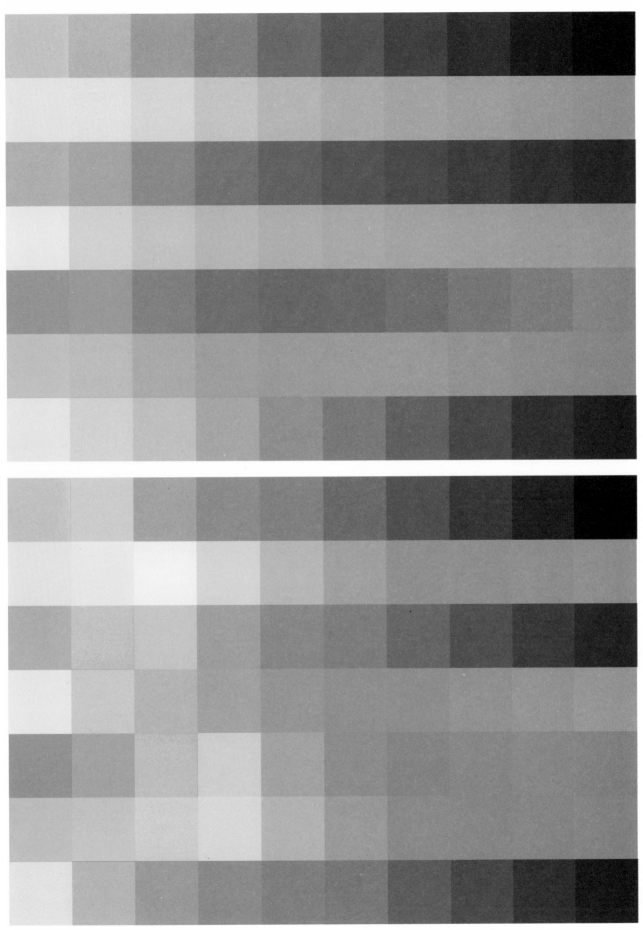

In each row, two colors are interpolated in ten steps: above in the RGB color model and below in the HSB color model.
→ P_1_2_1_01.pde

189

P.1.2.2
Color palettes from images

We constantly are surrounded by color palettes; we need only to record and evaluate them. The colors obtained from the photograph of one individual's wardrobe—a very personal color palette—are selected and sorted using the following program. You can export the resulting color collection and use it as an inspirational color palette.

→ P_1_2_2_01.pde

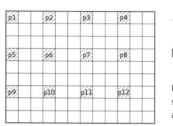

An image is scanned in a specific grid spacing.

[p1, p2, p3, p4, ...]

Pixel values are saved in an array and rearranged.

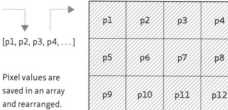

Palette with color fields.

The pixels of a loaded image are scanned using the mouse position in a specific grid spacing, one by one and row for row, in order to define the respective color value. These values are stored in an array and can be sorted by hue, saturation, brightness, or gray value.

Mouse: Position x: Resolution
Keys: 1–3: Change example image • 4–8: Change sort mode • S: Save PNG
P: Save PDF • C: Save ASE palette

→ P_1_2_2_01.pde

```
PImage img;
color[] colors;

String sortMode = null;

void setup(){
  ...
  img = loadImage("pic1.jpg");
}

void draw(){
  ...
  int tileCount = width / max(mouseX, 5);
  float rectSize = width / float(tileCount);
  →
```

The variable img is declared as an image variable.

The currently selected sorting mode is always stored in the variable sortMode. The default is to not sort, and the value is therefore set at null (undefined).

The specified image is loaded and stored in img.

The number of rows and columns in the grid tileCount depends on the x-value of the mouse. The function max() selects the larger of the two given values.

The grid resolution just calculated is now used to define the size of the tiles, rectSize.

```
int i = 0;
colors = new color[tileCount*tileCount];
for (int gridY=0; gridY<tileCount; gridY++) {
  for (int gridX=0; gridX<tileCount; gridX++) {
    int px = (int) (gridX*rectSize);
    int py = (int) (gridY*rectSize);
    colors[i] = img.get(px, py);
    i++;
  }
}
if (sortMode != null) colors = GenerativeDesign.sortColors(
                        this, colors, sortMode);

i = 0;
for (int gridY=0; gridY<tileCount; gridY++) {
  for (int gridX=0; gridX<tileCount; gridX++) {
    fill(colors[i]);
    rect(gridX*rectSize, gridY*rectSize, rectSize, rectSize);
    i++;
  }
}
...
}
```

The colors array is initialized. When the tileCount is 10, for example, the array is set with length 100.

Now the image is scanned, row by row, with the previously calculated grid spacing, rectSize. The color value of the pixel at the position px and py is set with img.get() and written in the color array.

When a sort mode has been selected (i.e., sortMode is not equal to null), the colors are sorted using the function sortColors(). The parameters passed to this function are a reference to the Processing program this, the array colors, and a value for the sorting mode sortMode.

In order to draw the palette, the grid is processed again. The fill colors for the tiles are taken, value by value, from the array colors.

```
void keyReleased(){
  if (key == 'c' || key == 'C') GenerativeDesign.saveASE(this,
                        colors, timestamp()+".ase");
  ...
  if (key == '4') sortMode = null;
  if (key == '5') sortMode = GenerativeDesign.HUE;
  if (key == '6') sortMode = GenerativeDesign.SATURATION;
  if (key == '7') sortMode = GenerativeDesign.BRIGHTNESS;
  if (key == '8') sortMode = GenerativeDesign.GRAYSCALE;
}
```

The function saveASE() allows an array of colors to be saved as an Adobe Swatch Exchange (ASE) file. The palette can then be loaded as a color swatch library, for instance, in Adobe Illustrator.

The keys 4 to 8 control what sorting function is applied to colors. For this the sortMode is set at null (no sorting) or at one of the constants, HUE, SATURATION, BRIGHTNESS or GRAYSCALE, from the Generative Design library.

Original image: *Subway Tunnel.*
→ Photograph: Stefan Eigner

Pixels arranged according to hue.
→ P_1_2_2_01.pde

Pixels arranged according to saturation.

Pixels arranged according to brightness.

Original image: *Wardrobe* (pic4.jpg).

Wardrobe with arrangement according to hue.
→ P_1_2_2_01.pde

 Original image: *Lights at Night* (pic2.jpg).

Lights at Night with arrangement according to hue.
→ P_1_2_2_01.pde

Color palettes from rules

All colors are made up of three components: hue, saturation, and brightness. The value for these color components are defined using a set of rules. By using controlled random functions, you can quickly create different palettes in specific color nuances.

→ P_1_2_3_01.pde

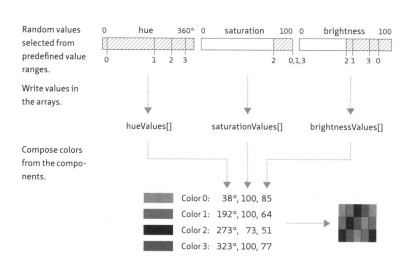

Random values selected from predefined value ranges.

Write values in the arrays.

Compose colors from the components.

Color 0: 38°, 100, 85
Color 1: 192°, 100, 64
Color 2: 273°, 73, 51
Color 3: 323°, 100, 77

Values for hue, saturation and brightness are randomly selected from predefined ranges of values. This combination of rule sets—the definition of value ranges—and random functions means that new palettes are continually created and that they always produce specific color nuances.

Because the perception of color depends on context, the produced colors are drawn in an interactive grid. Even the color nuances emerge more distinctly.

Mouse	*Position x/y: Grid resolution*
Keys:	*0–9: Change color palette · S: Save PNG · P: Save PDF · C: Save ASE palette*

→ P_1_2_3_01.pde

```
int[] hueValues = new int[tileCountX];
int[] saturationValues = new int[tileCountX];
int[] brightnessValues = new int[tileCountX];
```

An individual array is used to save hue, saturation and brightness. Depending on what key is pressed (0–9), the arrays are filled according to different rules.

```
void draw() {
  ...
  int index = counter % currentTileCountX;

  fill(hueValues[index],
      saturationValues[index],
      brightnessValues[index]);
  rect(posX, posY, tileWidth, tileHeight);
  counter++;
  ...
}
```

When the grid is drawn, the colors are selected from the arrays, one by one. The continually incrementing variable counter starts to cycle through the same values because of the modulo operator, %. When currentTileCountX is 3, for instance, index will consecutively hold the values 0, 1, 2, 0, 1, 2 . . . This means only the first colors in the arrays are used in the grid.

```
if (key == '1') {
  for (int i=0; i<tileCountX; i++) {
    hueValues[i] = (int) random(0,360);
    saturationValues[i] = (int) random(0,100);
    brightnessValues[i] = (int) random(0,100);
  }
}
```

When key 1 is pressed, the three arrays are filled with random values from the complete ranges of values. This means any color can appear in the palette.

```
if (key == '2') {
  for (int i=0; i<tileCountX; i++) {
    hueValues[i] = (int) random(0,360);
    saturationValues[i] = (int) random(0,100);
    brightnessValues[i] = 100;
  }
}
```

Here brightness is always set at the value 100. The result is a palette dominated by bright colors.

```
if (key == '3') {
  for (int i=0; i<tileCountX; i++) {
    hueValues[i] = (int) random(0,360);
    saturationValues[i] = 100;
    brightnessValues[i] = (int) random(0,100);
  }
}
```

When the saturation value is set at 100, no pastel tones are created.

```
if (key == '7') {
  for (int i=0; i<tileCountX; i++) {
    hueValues[i] = (int) random(0,180);
    saturationValues[i] = 100;
    brightnessValues[i] = (int) random(50,90);
  }
}
```

Here a restriction occurs in all color components. For instance, the hues are only selected from the first half of the color wheel, creating warmer colors.

```
if (key == '9') {
  for (int i=0; i<tileCountX; i++) {
    if (i%2 == 0) {
      hueValues[i] = (int) random(0,360);
      saturationValues[i] = 100;
      brightnessValues[i] = (int) random(0,100);
    }
    else {
      hueValues[i] = 195;
      saturationValues[i] = (int) random(0,100);
      brightnessValues[i] = 100;
    }
  }
}
```

It is also possible to mix two color palettes. The expression i%2 produces alternately the numbers 0 and 1. When the result is 0, a darker, more saturated color is saved in the array.

Otherwise the second rule is applied, and hue and brightness are set to fixed values. These values produce bright blue tones.

The 0 key creates a color palette in which two preset hues (cyan and violet) alternate. Saturation and brightness are varied randomly.
→ P_1_2_3_01.pde

Randomness plays a larger role here. The rows are divided into tiles of different widths. It is randomly decided which tiles are divided again.

→ P_1_2_3_02.pde

If the tiles are slightly transparent and overlapping, another series of colors is created in addition to those in the color palette.
→ P_1_2_3_03.pde

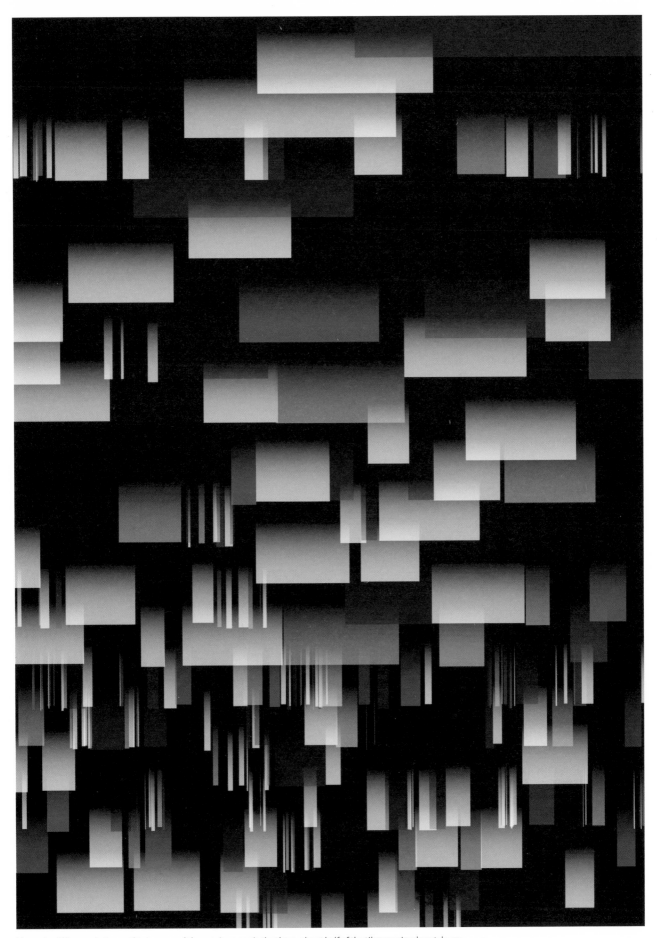

The main difference between this image and the previous one is that here, about half of the tiles are simply not drawn.
→ P_1_2_3_04.pde

P.2

Shape

The previous chapter was primarily devoted to color, with shape playing a lesser role. Since it is possible to control every element of an image, we are able to access, modularize, and automate an enormous variety of not only colors but also shapes. A dialog with form emerges.

P.2.0

Hello, shape

Are point, line, and plane still the holy trinity of every form? Kandinsky's determination of these basic elements is more relevant than ever when viewed in the context of generative design. In keeping with this approach, the pixel is the origin of the small black circle in the image below. Lines are created by a series of pixels and planes by connected lines.

mouse position x

mouse position y

→ P_2_0_01.pde

The shape is reduced to one pixel when the cursor is located in the middle of the upper border of the display window.

The x-value of the mouse position sets the length of the lines. The y-value sets the value and number of the lines.

Mouse: Position x: Line length • Position y: Value and number of lines
Keys: S: Save PNG • P: Save PDF

→ P_2_0_01.pde

```
void draw(){
  ...
  translate(width/2,height/2);

  int circleResolution = (int) map(mouseY, 0,height, 2,80);
  float radius = mouseX-width/2 + 0.5;
  float angle = TWO_PI/circleResolution;

  strokeWeight(mouseY/20);

  beginShape();
  for (int i=0; i<=circleResolution; i++){
    float x = cos(angle*i) * radius;
    float y = sin(angle*i) * radius;
    line(0, 0, x, y);
    // vertex(x, y);
  }
  endShape();
  ...
}
```

The origin of the coordinate system is moved to the center of the display.

The function map() converts the y-value of the mouse position (a number between 0 and height) to a value between 2 and 80.

By subtracting half of the display's width from the x-value of the mouse position, the radius becomes increasingly smaller the more the mouse is moved toward the center. Adding 0.5 to the x-value ensures the diameter of the circle is at least 1.

The increment angle is calculated as the full circle, TWO_PI, divided by the number of lines, circleResolution.

The end points of the line can be connected as a closed vertex by deleting the comment characters //.

In this variation, the end points of the star forms are connected to the closed polygons. In addition, when drawing with the mouse, the transformation tracks are retained because the background is not given a new color.

→ P_2_0_02.pde

In a third variation, it is also possible to change colors with keys 1 to 3.
→ P_2_0_03.pde

P.2.1.1
Alignment in a grid

How can a diagonal with only two possible directions use the strict order of a grid to make complex structures? The direction of the diagonals in every grid is decided randomly. Overlapping, resulting from changes in line width, creates new forms, connections, and interstices.

→ P_2_1_1_01.pde

0 = line A

1 = line B

In a grid, either a line A is drawn from the upper-left to the lower-right corner or a line B is drawn from the lower-left to the upper-right corner. The direction of the diagonals is selected randomly.

Mouse: *Position x: Line value of left diagonals* • *Position y: Line value of right diagonals*
Left click: New random value
Keys: *1–3: Change line endings* • *S: Save PNG* • *P: Save PDF*

→ P_2_1_1_01.pde

```
int tileCount = 20;
```

The value of the variable `tileCount` defines the grid resolution.

```
void draw() {
  ...
  strokeCap(actStrokeCap);
  ...
  for (int gridY=0; gridY<tileCount; gridY++) {
    for (int gridX=0; gridX<tileCount; gridX++) {
      int posX = width/tileCount*gridX;
      int posY = height/tileCount*gridY;
      int toggle = (int) random(0,2);
      if (toggle == 0) {
        strokeWeight(mouseX/20);
        line(posX, posY,
          posX+width/tileCount, posY+height/tileCount);
      }
      if (toggle == 1) {
        strokeWeight(mouseY/20);
        line(posX, posY+width/tileCount,
          posX+height/tileCount, posY);
      }
  ...
```

The command `random(0,2)` creates a random number between 0.000 and 1.999. When converting this into an integer using `(int)`, it is rounded off and the variable `toggle` becomes either 0 or 1.

In this "if" query, the value of the variable `toggle` is compared to 0. When this statement is true, the next two lines of code are executed, drawing line A.

The value of the current mouse position on the x-axis defines the stroke value of line A. It is divided by 20 so the stroke value does not become too large.

The same applies to line B.

```
void keyReleased(){
  ...

  if (key == '1') {
    actStrokeCap = ROUND;
  }
  if (key == '2') {
    actStrokeCap = SQUARE;
  }
  if (key == '3') {
    actStrokeCap = PROJECT;
  }
}
```

Pressing one of the keys 1 to 3 sets the variable actStrokeCap to one of the Processing constants: ROUND, SQUARE, or PROJECT. This parameter can then be used to set how the ends of the lines are drawn using the function strokeCap().

strokeCap(ROUND)

strokeCap(SQUARE)

strokeCap(PROJECT)

The line values of the diagonals are linked to the mouse position, and the types of line endings are switched using keys 1 to 3.
→ P_2_1_1_01.pde

In this variation, additional colors and transparencies are used for both types of diagonals.
→ P_2_1_1_02.pde

Here the elements in the grid are loaded out of the data file SVG graphics, which are always turned toward the mouse position. Using the key C, it is possible to switch between different color modes. The transparency of an element depends on its distance from the mouse position.

→ P_2_1_1_04.pde

Using key D, it is possible to select whether the elements become smaller or larger as they near the mouse.

→ P_2_1_1_04.pde

Additional SVG modules can be selected with the keys 1 to 7. When the SVG graphics are decentralized in position, the grid appears to dissolve, although the modules are drawn strictly within the grid.

→ P_2_1_1_04.pde

The elements can also be rotated (left- and right-arrow keys).

→ P_2_1_1_04.pde

P.2.1.2
Movement in a grid

Tension is highest when order borders on chaos. Individual forms abandon their strict arrangement in the dynamic grid and submit to random configurations. Elements inclined to the grid and those adverse to it fight for visual supremacy. It is the moments of transition that are important.

→ P_2_1_2_01.pde

A fixed number of circles are drawn to the display one by one, line by line. Random values are added to the grid position of a circle, forcing it to move it along the x- and y-axes. The farther the mouse is moved to the right, the greater the circle's movement.

Mouse: Position x: Circle position · Position y: Circle size · Left click: New random values of circle position → P_2_1_2_01.pde
Keys: S: Save PNG · P: Save PDF

```
void draw() {
  translate(width/tileCount/2, height/tileCount/2);
  ...
  strokeWeight(mouseY/60);

  for (int gridY=0; gridY<tileCount; gridY++) {
    for (int gridX=0; gridX<tileCount; gridX++) {

      int posX = width/tileCount * gridX;
      int posY = height/tileCount * gridY;

      float shiftX = random(-mouseX, mouseX)/20;
      float shiftY = random(-mouseX, mouseX)/20;

      ellipse(posX+shiftX, posY+shiftY, mouseY/15, mouseY/15);
    }
  }
  ...
}
```

The origin of the coordinate system is shifted by half a tile width and height to the right and down so the circles are located in the center of their tiles.

The higher the x value of the mouse position mouseX, the greater the range of values for the random numbers.

Adding the values shiftX and shiftY to the grid coordinates posX and posY results in the final shifted positions of the circles.

Transparent circles move in the horizontal grid according to the mouse position. The vertical mouse position determines the size of the circles.

→ P_2_1_2_01.pde

The shifting black circles are situated behind a dense grid of white circles.

→ P_2_1_2_02.pde

A color variation with transparent circles.
→ P_2_1_2_02.pde

In this row, only the violet circles are offset, while the pink ones remain fixed to the grid.
→ P_2_1_2_02.pde

Only the corners of the elements are shifted here, not the elements themselves.
→ P_2_1_2_04.pde

The overlaps and gaps here reveal the grid before it gradually becomes unrecognizable.
→ P_2_1_2_04.pde

Complex modules in a grid

Even more interesting is the nesting of several forms into a complex module. In this illustration, four different clusters of ellipses increase in size in opposite directions and are positioned alternately on the grid. The varied diameters and transparencies of the individual ellipses create an illusion of depth.

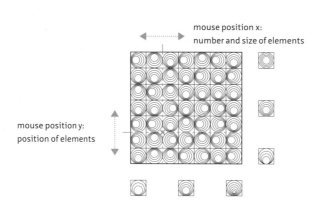

mouse position x:
number and size of elements

mouse position y:
position of elements

→ P_2_1_3_01.pde

The module filling the grid consists of a stack of circles that become smaller and smaller and move in one direction (top, bottom, right, or left), that is decided randomly. The number of circles corresponds to mouse position x, the movement to mouse position y.

Each module in the grid consists of several circles. The mouse position defines their number, size, and position.
→ P_2_1_3_01.pde

Mouse: *Position x: Number and size of circles · Position y: Position of circles* → P_2_1_3_01.pde
 Left click: New random value for position
Keys: *S: Save PNG · P: Save PDF*

```
void draw() {
  ...
  circleCount = mouseX/30 + 1;
  endSize = map(mouseX, 0,width, tileWidth/2.0,0);
  endOffset = map(mouseY, 0,height, 0,(tileWidth-endSize)/2);

  for (int gridY=0; gridY<=tileCountY; gridY++) {
    for (int gridX=0; gridX<=tileCountX; gridX++) {
      pushMatrix();
      translate(tileWidth*gridX, tileHeight*gridY);
      scale(1, tileHeight/tileWidth);

      int toggle = (int) random(0,4);
      if (toggle == 0) rotate(-HALF_PI);
      if (toggle == 1) rotate(0);
      if (toggle == 2) rotate(HALF_PI);
      if (toggle == 3) rotate(PI);

      for(int i=0; i<circleCount; i++) {
        float diameter = map(i, 0,circleCount-1,
                             tileWidth,endSize);
        float offset = map(i, 0,circleCount-1, 0,endOffset);
        ellipse(offset, 0, diameter,diameter);
      }
      popMatrix();
    }
  }
  ...
}
```

The mouse position defines circleCount in a module, the size of the circles, and the offset of the last circle.

The varying rotation of the modules is easier to manage when, before drawing a module, the origin of the coordinate system is temporarily moved to the position where it will be drawn. The command pushMatrix() ensures that the current state of the coordinate system is saved before the origin is moved using translate().

The random number toggle decides between the four rotation directions. The radian angle HALF_PI is a rotation of 90°.

The module is constructed by drawing the circles in succession. The value of diameter ranges between tileWidth and the previously calculated endSize. The value offset comprises the shift from the center. The circles become smaller and smaller thereby shifting farther and farther to the right.

Finally, the previously saved state of the coordinate system is restored using popMatrix().

Complex modules made of straight lines. The consolidation of the lines generates new forms.
→ P_2_1_3_02.pde

The point toward which the lines converge can be shifted diagonally with the mouse.
→ P_2_1_3_03.pde

Consolidation easily creates a three-dimensional effect.
→ P_2_1_3_03.pde

215

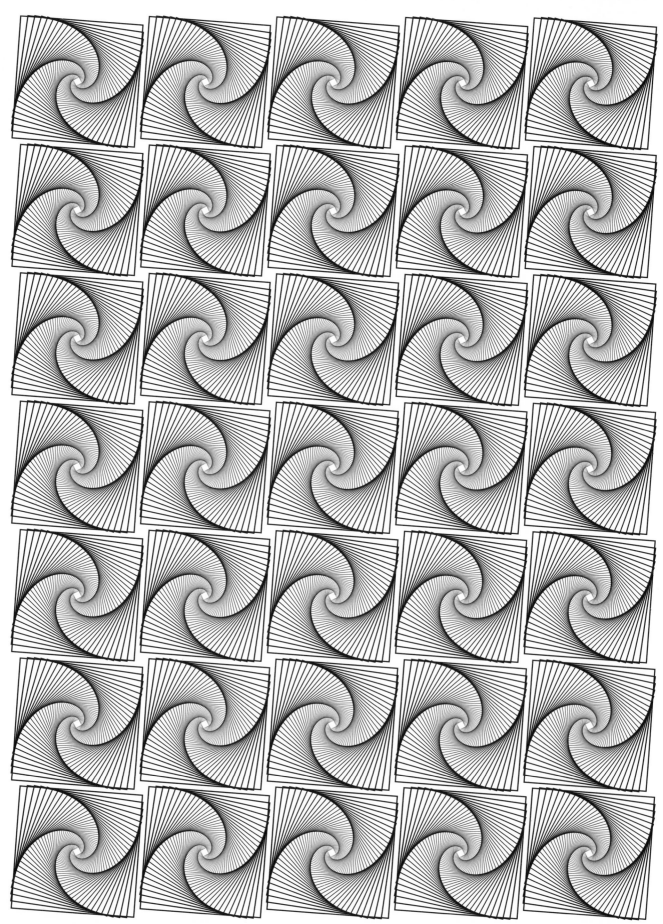

The module consists of rotating squares that become progressively smaller.

→ P_2_1_3_04.pde

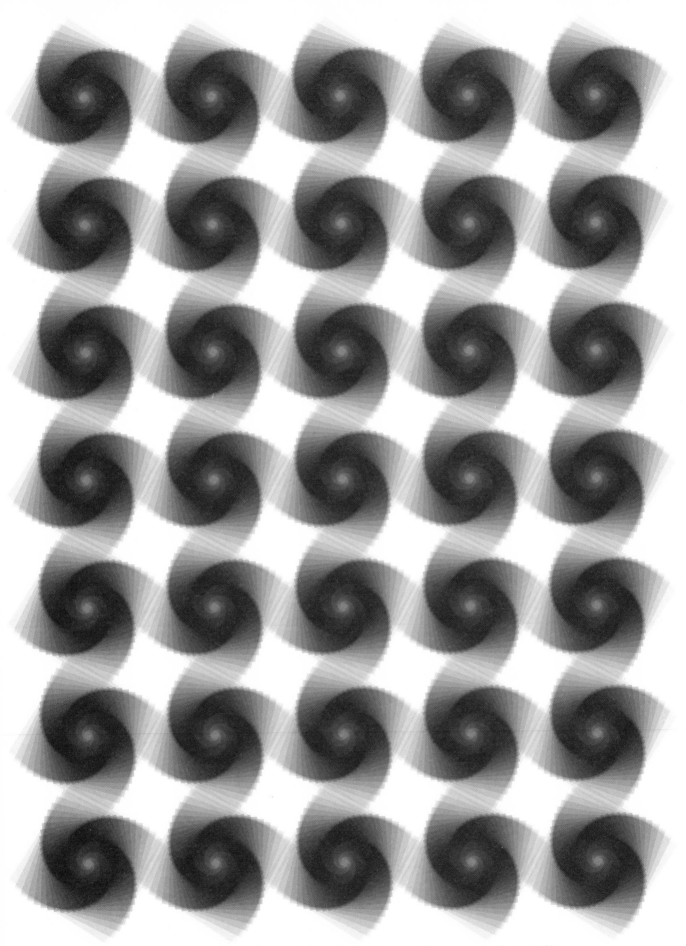

These forms are based on the same principle as the preceding example. Now colored and transparent, the squares are hardly recognizable.

→ P_2_1_3_04.pde

P.2.2.1
Dumb agents

Instead of being rigidly embedded in a grid, the pixel now becomes an agent and can move freely based on different behavioral patterns. With each step the agent advances according to one of eight directions, leaving a trail behind it. It pursues its mission and never gives up.

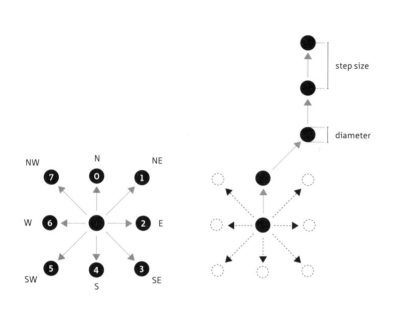

→ P_2_2_1_01.pde

During each drawing operation, one of the eight possible directions is randomly selected for the next step. Steps are made by adding or subtracting a predetermined value (step size) to the current position's coordinates. The circle is finally drawn at the new position.

Mouse: *Position x: Speed of the image construction*
Keys: *DEL: Delete display · R/E: Recording PDF · S: Save PNG*

→ P_2_2_1_01.pde

```
int NORTH = 0;
int NORTHEAST = 1;
int EAST = 2;
int SOUTHEAST = 3;
int SOUTH = 4;
int SOUTHWEST = 5;
int WEST = 6;
int NORTHWEST= 7;
```

Eight constants, each with a different numerical value, are defined.

```
int stepSize = 1;
int diameter = 1;
```

The step size and diameter of the agents can be set by changing the values of stepSize and diameter.

```
void draw() {
  for (int i=0; i<=mouseX; i++) {
    direction = (int) random(0, 8);
    →
```

The command random(0, 8) creates a random number between 0.000 and 7.999. When rounded off, this results in a value between 0 and 7. This, in turn, is stored in direction and determines the next step.

The longer the agents migrate, the denser the cloud structure becomes.
→ P_2_2_1_01.pde

The agents' direction of movement is restricted here.
→ P_2_2_1_02.pde

In this variation, the diameters of the circles are larger and sometimes colored blue.
→ P_2_2_1_02.pde

```
if (direction == NORTH) {
  posY -= stepSize;
}
else if (direction == NORTHEAST) {
  posX += stepSize;
  posY -= stepSize;
}
else if (direction == EAST) {
  posX += stepSize;
}
else if (direction == SOUTHEAST) {
  posX += stepSize;
  posY += stepSize;
}
...

if (posX > width) posX = 0;
if (posX < 0) posX = width;
if (posY < 0) posY = height;
if (posY > height) posY = 0;

fill(0, 40);
ellipse(posX+stepSize/2, posY+stepSize/2, diameter, diameter);
  }
}
```

When the agent's current position extends beyond the right border of the display window, posX is set at 0. This causes the agent to continue its path on the opposite side.

A transparent circle is drawn in the new position. Half the increment size, stepSize/2, is added to this so the circle is not cut off at the border of the display window.

P.2.2.2
Intelligent agents

Behavioral patterns are now far more complex and subject to precise conditions. The agent easily goes astray when it crosses its own path. When it reaches the border of the display window, it changes direction. The straight lines, which are drawn between two points of intersection, change their color and stroke value depending on the traveled distance.

→ P_2_2_2_01.pde

The agent always moves in one of the cardinal directions: north, east, south, or west. It can, however, choose from several possible angles, whereby right angles are not possible. When the agent reaches the border of the display, it turns around and randomly selects one of the possible angles. When it crosses its own path, it maintains its general direction but selects a new angle.

Possible angles of the agents moving north.

The agent reaches the border of the display window.

The agent crosses its own path.

Mouse: Position x: Speed of the image construction
Keys: DEL: Delete display · R/E: Recording PDF · S: Save PNG

→ P_2_2_2_01.pde

```
void draw(){
  for (int i=0; i<=mouseX; i++) {
    if (!recordPDF) {
      strokeWeight(1);
      stroke(180);
      point(posX, posY);
    }

    posX += cos(radians(angle)) * stepSize;
    posY += sin(radians(angle)) * stepSize;

    boolean reachedBorder = false;
    if (posY <= 5) {
      direction = SOUTH;
      reachedBorder = true;
    }
    else if (posX >= width-5) {
      direction = WEST;
      reachedBorder = true;
    }
    ...
    →
```

A point is drawn on the agent's current position (posX, posY). The point can become almost (or completely) invisible when its color matches the background color.

The agent takes a step. In doing so, its position is updated: angle defines the direction and stepSize the length of the step.

Now the agent is checked to determine if it has reached a border of the display window. If, for instance, it is only five pixels or fewer away from the upper border, the main direction is changed to and the variable reachedBorder set to true.

By pressing key R, lines are drawn without tracks in a PDF. The process is ended by pressing key E.
→ P_2_2_2_01.pde

A line's value depends on its distance.
→ P_2_2_2_02.pde

The lines here are colored according to their length (key 2).
→ P_2_2_2_02.pde

```
    int px = (int) posX;
    int py = (int) posY;
    if (get(px, py) != color(360) || reachedBorder == true) {
      angle = getRandomAngle(direction);
      float distance = dist(posX, posY, posXcross, posYcross);
      if (distance >= minLength) {
        strokeWeight(3);
        stroke(0);
        line(posX, posY, posXcross, posYcross);
      }
      posXcross = posX;
      posYcross = posY;
    }
  }
}
```

The function get() checks every time the agent moves to determine whether it is on a pixel that is not white. If this is the case or if the variable reachedBorder is true, then a new random angle step increment in the main direction is selected using the function getRandomAngle().

When changing direction, a line is only drawn when the position of the last direction change (posXcross, posYcross) is at least as far away as the distance defined by minLength.

Finally, the current position is saved in the variables posXcross and posYcross.

```
float getRandomAngle(int theDirection) {
  float a = (floor(random(-angleCount, angleCount)) + 0.5)
          * 90.0/angleCount;
  if (theDirection == NORTH) return (a - 90);
  if (theDirection == EAST) return (a);
  if (theDirection == SOUTH) return (a + 90);
  if (theDirection == WEST) return (a + 180);
  return 0;
}
```

The function getRandomAngle() randomly selects and returns one of the possible angles, which is dependent on the passed main direction, theDirection. When angleCount, for instance, is 3 (i.e., three directions per quadrant) and theDirection is SOUTH, then one of these angles is returned.

Longer lines are opaque in appearance, shorter ones transparent (key 3).
→ P_2_2_2_02.pde

Fixed values are set for hue and saturation: brightness depends on the length of the lines.

→ P_2_2_2_02.pde

P.2.2.3
Shapes from agents

It is only through cooperative efforts that dumb agents become strong. A circle is the source shape in this example. The permutation rule is that every point on the circle is represented by a dumb agent and that movement of the points will cause the circle to gradually change its shape. This produces a surprisingly large repertoire of forms.

→ Ch.P.2.2.1

→ P_2_2_3_01.pde

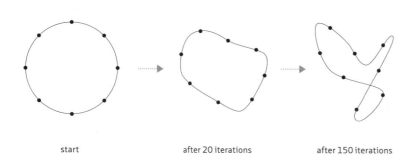

| start | after 20 iterations | after 150 iterations |

The calculation of the points on the circle produces the starting positions of the agents. A flexible curve firmly connects each agent with both its neighbors. The farther away the dumb agents move from their original positions, the more the circular organization dissolves.

Mouse: Left click: New circle • Position x/y: Movement direction
Keys: 1–2: Fill mode • F: Start/stop animation • DEL: Delete display
R/E: Recording PDF • S: Save PDF

→ P_2_2_3_01.pde

```
void setup() {
  ...
  centerX = width/2;
  centerY = height/2;
  float angle = radians(360/float(formResolution));
  for (int i=0; i<formResolution; i++){
    x[i] = cos(angle*i) * startRadius;
    y[i] = sin(angle*i) * startRadius;
  }
  ...
}
```

The agents are drawn later around the position (centerX, centerY). The initial starting point is the center of the display.

The agents' starting positions are calculated as points on the circle and saved in the arrays x and y.

→ Ch.P.1.1.2 Color spectrum in a circle

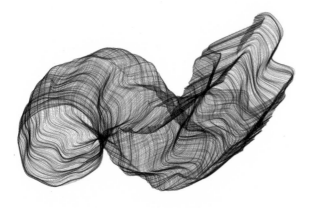

The constantly changing shape always moves toward the mouse and can thereby be controlled by it.
→ P_2_2_3_01.pde

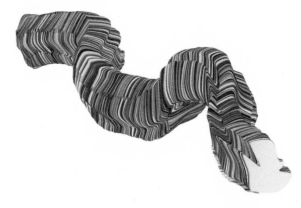

The fill mode can be set using key 2 so that the form is colored with a random and changing gray value.
→ P_2_2_3_01.pde

```
void draw(){
  if (mouseX != 0 || mouseY != 0) {
    centerX += (mouseX-centerX) * 0.01;
    centerY += (mouseY-centerY) * 0.01;
  }

  for (int i=0; i<formResolution; i++){
    x[i] += random(-stepSize,stepSize);
    y[i] += random(-stepSize,stepSize);
    // ellipse(x[i],y[i],5,5);
  }
  ...
  beginShape();
  curveVertex(x[formResolution-1]+centerX,
              y[formResolution-1]+centerY);

  for (int i=0; i<formResolution; i++){
    curveVertex(x[i]+centerX, y[i]+centerY);
  }
  curveVertex(x[0]+centerX, y[0]+centerY);

  curveVertex(x[1]+centerX, y[1]+centerY);
  endShape();
}
```

→ P_2_2_3_02.pde

The mouse follows the position (centerX, centerY). With every frame the difference between the agent position and the mouse position is calculated, multiplied by a small value, and added again to this position.

The addition of random values between -stepSize and stepSize to the agents' current positions results in an up and down movement.

The agents' positions can also be visualized by adding the ellipse command.

Note that when drawing the form, the first and last points set with the curveVertex() serve as control points and are not drawn. These two control points ensure the circle is completed without any bends so the final circle is smooth.

first vertex point = last point in array

second and next-to-last vertex point

third and last vertex point = second point in array

If, for example, curveVertex is replaced with vertex, straight connections are produced. Experiments with the fill color fill also result in interesting variations.

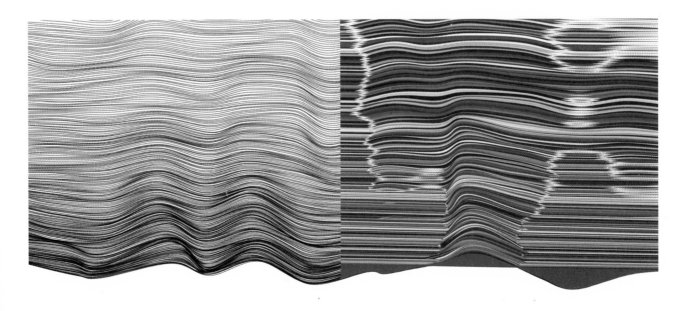

In this version of the program, instead of a circle, a line can be selected as the default (press key 4). This form can also be displayed filled in.
→ P_2_2_3_02.pde

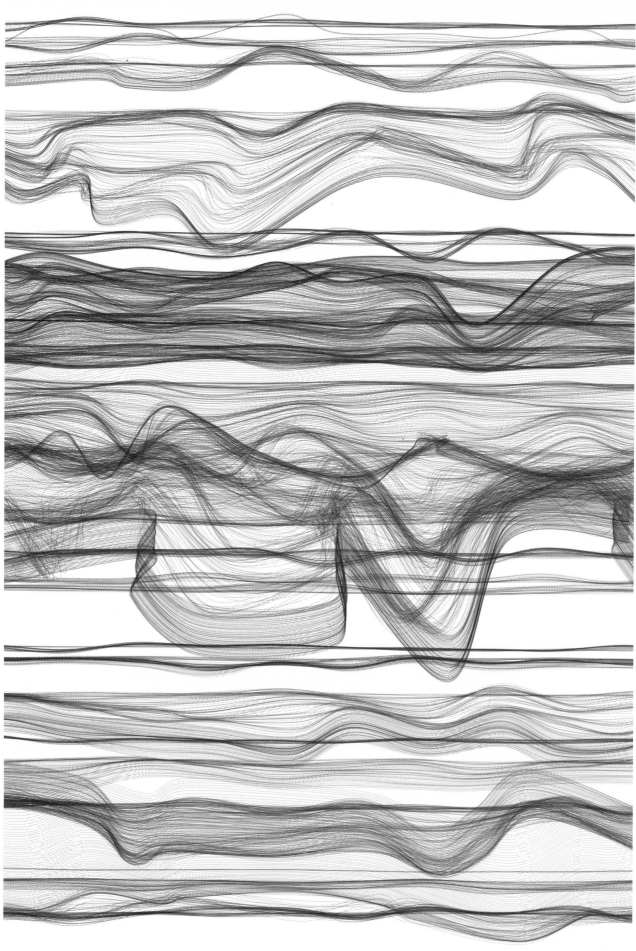

In this version of the program for a pen tablet, the harder the pen is pressed, the more quickly the form changes.

→ P_2_2_3_02_TABLET.pde

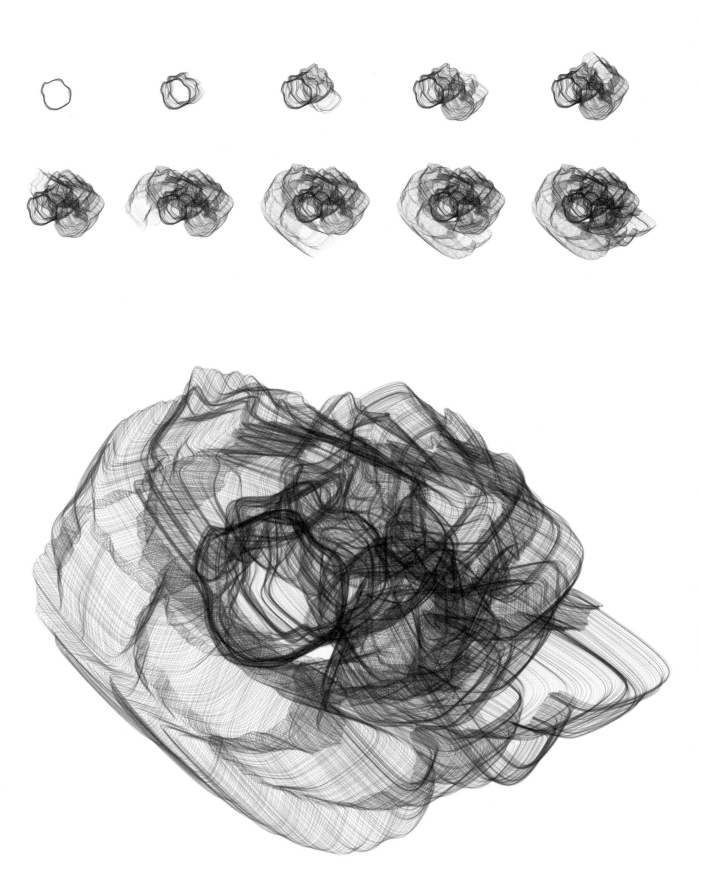

Drawing with a shape that changes its form on its own. When the pen is placed on the circle, the circle's form barely changes. When the pen moves, the form follows the position of the pen and becomes more and more distorted.

→ P_2_2_3_02_TABLET.pde

P.2.2.4
Growth structure from agents

A stable structure results from the convergence of multiple agents based on simple rules. Complex shapes are created out of simple propagation patterns such as: draw a new circle and position it as close as possible to its nearest neighbor. These types of algorithms also describe growth processes in plants and minerals.

→ W.205 Wikipedia: Diffusion limited aggregation

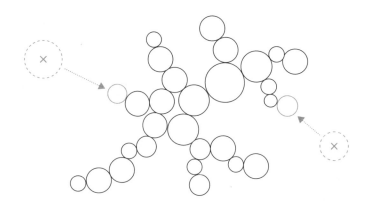

→ P_2_2_4_01.pde

In each frame, a new circle is generated at a random position and with a random radius (dashed circles). It is then determined which of the existing circles lies nearest to the new one. In the final step, the new circle docks with its closest neighbor via the shortest path.

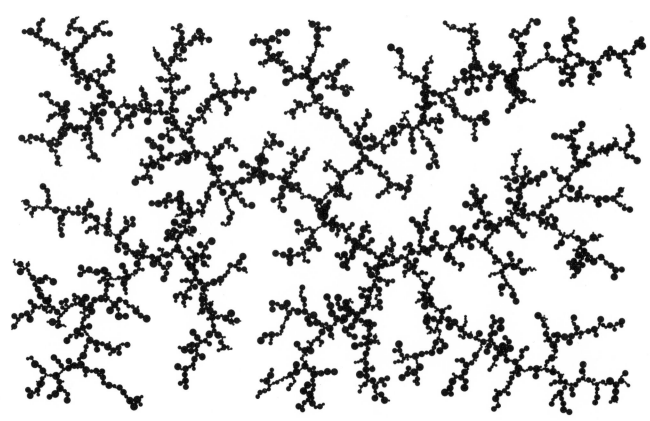

Circles increasingly fill the area and an organic structure evolves.
→ P_2_2_4_01.pde

```
void draw() {
  background(255);
  float newR = random(1, 7);
  float newX = random(0+newR, width-newR);
  float newY = random(0+newR, height-newR);

  float closestDist = 100000000;
  int closestIndex = 0;
  for(int i=0; i < currentCount; i++) {
    float newDist = dist(newX,newY, x[i],y[i]);
    if (newDist < closestDist) {
      closestDist = newDist;
      closestIndex = i;
    }
  }

  // fill(230);
  // ellipse(newX,newY,newR*2,newR*2);
  // line(newX,newY,x[closestIndex],y[closestIndex]);

  float angle = atan2(newY-y[closestIndex],
                      newX-x[closestIndex]);

  x[currentCount] = x[closestIndex] + cos(angle) *
                    (r[closestIndex]+newR);
  y[currentCount] = y[closestIndex] + sin(angle) *
                    (r[closestIndex]+newR);
  r[currentCount] = newR;
  currentCount++;

  for (int i=0 ; i < currentCount; i++) {
    fill(50);
    ellipse(x[i],y[i], r[i]*2,r[i]*2);
  }
  if (currentCount >= maxCount) noLoop();
}
```

→ P_2_2_4_01.pde

The radius newR and the position (newX, newY) for the circle are defined randomly.

The closest neighbor is searched in the for loop. All circles are processed one by one and their distance to the new circle is calculated. If this distance is smaller than all previous distances, a reference to this circle is saved in the variable closestIndex.

By drawing the starting position of the new circle and the connecting line to the circle closest to it, the process just described can be visualized using these three lines of code.

By calculating the angle to the closest neighbor, the new circle can be positioned so the two circles touch.
→ Ch.P.1.1.2 Color spectrum in a circle

angle

The circles are drawn.

When currentCount reaches the defined upper limit, the program is stopped using the function noLoop().

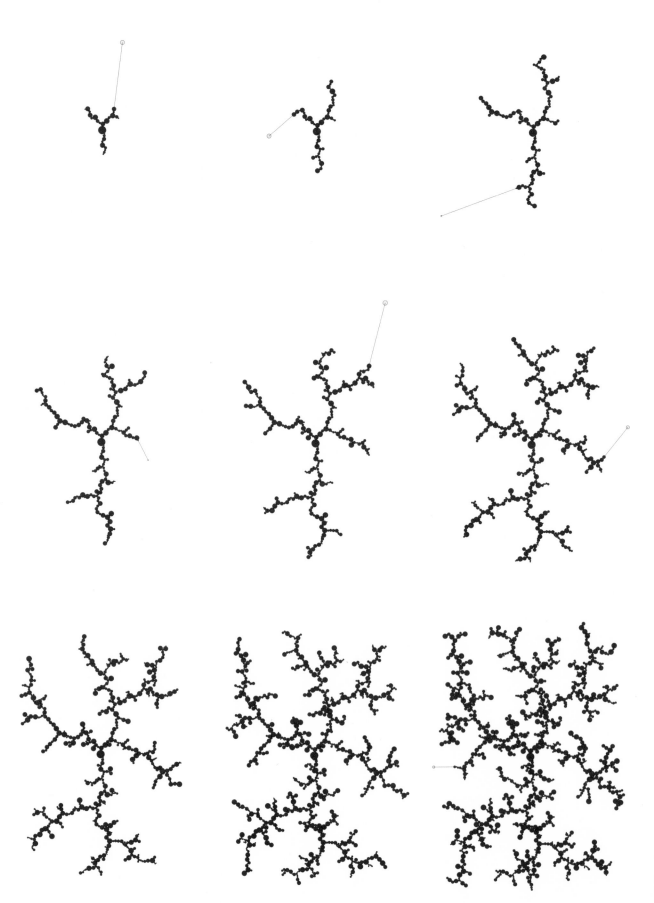

This sequence demonstrates how the structure grows gradually but continually.

→ P_2_2_4_01.pde

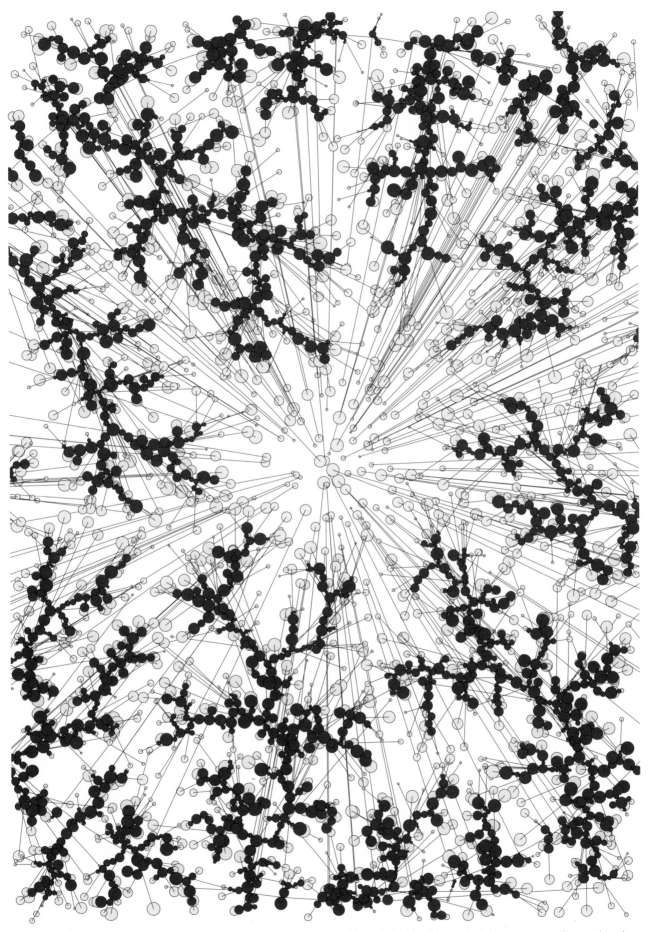

When the source circle is particularly large, the structure grows from the outside in. In addition, the initial positions of the circles and connecting lines are drawn here to their new position.

→ P_2_2_4_02.pde

P.2.2.5
Structural density from agents

In this example an iterative process again serves as a shape-giver: Generate a new circle. If this circle does not intersect with any other circle in the display, make it as large as possible; if it intersects with another circle, start over. The aim of this algorithm is to pack the circles so densely that eventually even the smallest gaps are closed.

Circle position not possible. Start over.

Possible new circle. The radius is maximized until it bumps into its nearest neighbor.

→ P_2_2_5_01.pde

Here, too, a new circle (shown by a dashed yellow outline) with a random position and size is generated in each frame. When this intersects with a pre-existing circle, the algorithm starts over.

Otherwise, it locates the closest circle. The distance to this circle and its radius now defines how large the new circle has to be drawn so that it touches its neighbor and the circles can be packed densely.

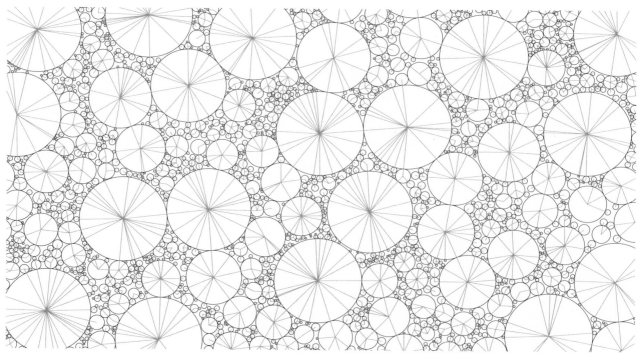

The algorithm fills the area with circles that become smaller and smaller. The yellow lines show on which circles new growths have docked.

→ P_2_2_5_01.pde

```
void draw() {
  ...
  float newX = random(0+maxRadius,width-maxRadius);
  float newY = random(0+maxRadius,height-maxRadius);
  float newR = minRadius;
  if (mousePressed == true) {
    newX = random(mouseX-mouseRect/2,mouseX+mouseRect/2);
    newY = random(mouseY-mouseRect/2,mouseY+mouseRect/2);
    newR = 1;
  }

  boolean intersection = false;
  for(int i=0; i < currentCount; i++) {
    float d = dist(newX,newY, x[i],y[i]);
    if (d < (newR + r[i])) {
      intersection = true;
      break;
    }
  }

  if (intersection == false) {
    float newRadius = width;
    for(int i=0; i < currentCount; i++) {
      float d = dist(newX,newY, x[i],y[i]);
      if (newRadius > d-r[i]) {
        newRadius = d-r[i];
        closestIndex[currentCount] = i;
      }
    }
    if (newRadius > maxRadius) newRadius = maxRadius;
    x[currentCount] = newX;
    y[currentCount] = newY;
    r[currentCount] = newRadius;
    currentCount++;
  }

  for (int i=0 ; i < currentCount; i++) {
    ...
    ellipse(x[i],y[i], r[i]*2,r[i]*2);
    ...
    int n = closestIndex[i];
    line(x[i],y[i], x[n],y[n]);
  }
  ...
}
```

Create a position and radius for a new circle.

By holding down the mouse button, the range for random values is limited, allowing new circles to be positioned selectively and generating an interactive drawing tool.

All existing circles are compared to the new one. When an intersection exists (e.g., when the distance is smaller than the sum of both radii), then the variable intersection is set to true.

When there is no intersection, the next neighbor is determined and its index saved.

The radius of the new circle is made as large as possible (but no larger than the size specified by maxRadius).

All stored circles are drawn in the display.

In addition, each circle is connected with a line to its nearest neighbor. For this purpose, its previously stored index is retrieved from the array closestIndex.

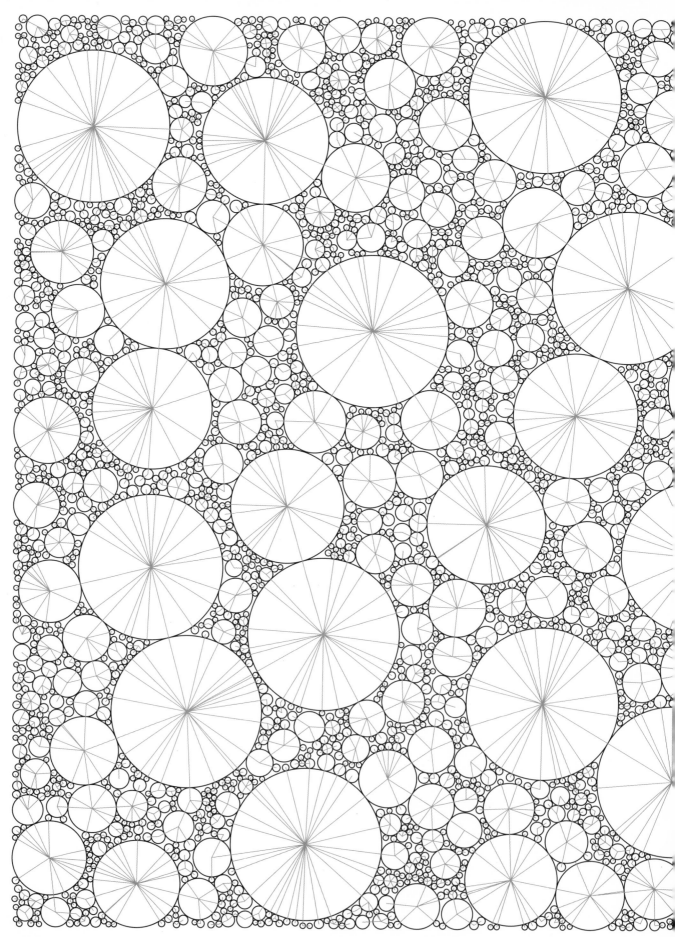

By loading SVG modules, very different images are created. Using keys 1 to 3, it is possible to specify which elements are to be visible:
the SVGs, the connecting lines, or the circles.
→ P_2_2_5_02.pde

P.2.3.1

Drawing with animated brushes

In previous chapters, agents moved autonomously according to predefined rules. In this example, users will interact with an agent, creating an experimental drawing tool that follows its own set of rules. What makes animated brushes so unusual is their ability to be inspired by their own behavior while drawing. This process offers a much greater range of expression, as the act of drawing becomes like a ballroom dance with a partner.

initial
mouse position

current
mouse position

→ P_2_3_1_01.pde

The first drawing tool is an excellent demonstration of how much visual potential can be contained in very simple principles. A line rotates around the mouse position. The lines consolidate in different ways depending on the speed and direction of the mouse's movements. The line changes its color and length with each mouse click. The rotation speed can be set with the right or left arrow keys.

Mouse: Drag: Draw
Keys: 1–4: Change color settings • Space: New random color • DEL: Delete display
D: Change direction and mirror angle • Arrow up/down: Line length +/-
Arrow right/left: Rotation speed +/- • S: Save PNG • R/E: Recording PDF

```
void draw() {
  if (mousePressed) {
    pushMatrix();
    strokeWeight(1.0);
    noFill();
    stroke(col);
    translate(mouseX,mouseY);
    rotate(radians(angle));
    line(0, 0, lineLength, 0);
    popMatrix();

    angle += angleSpeed;
  }
}

void mousePressed() {
  lineLength = random(70, 200);
}
```

The drawing is activated only when the left mouse button is held down.

The line is supposed to rotate around the mouse position. Therefore, the origin of the coordinate system must first be moved to the mouse position using the translate() function. The coordinate system is then rotated with the rotate() function. The horizontal line drawn now becomes a rotating brush.

The rotation angle is increased by a value for the rotation speed.

The length of the line changes with each click.

The mouse was only moved back and forth along the middle of the horizontal line. The animated brush thereby generated different levels of density.
→ P_2_3_1_01.pde

In addition to the mouse movement and the different colors, the step size of the rotating lines is also changed.
→ P_2_3_1_02.pde

Lines of random colors rotate around the mouse position when the mouse button is held down. Even without moving the mouse, a wealth of parameters such as line length, color, line shape, and rotation speed can be influenced with the keys, thereby generating a variety of images.
→ P_2_3_1_02.pde

P.2.3.2
Relation and distance

Since the relation of individual elements to one another is crucial to an overall image, it is important for users to be able to control individual parameters such as distance and angle; this program provides the necessary knowledge.

→ P_2_3_2_01.pde

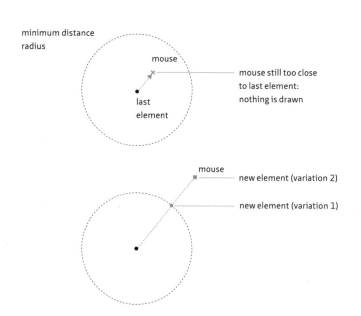

In the previous example, a new element was drawn on the display in each frame when the mouse button was held down. This function is now restricted: a new element is positioned only when it stays a minimum distance from the previously drawn element. There are several ways to do this:

Variation 1: The new element is not placed directly at the mouse position but rather at the exact specified minimum distance from the last element.

Variation 2: The new element is placed at the mouse position, and the minimum distance only serves as a threshold value.

The more quickly the mouse is moved during the drawing process, the longer the lines become.
→ P_2_3_2_01_.pde

Mouse: *Drag: Draw*
Keys: *1–2: Drawing mode • DEL: Delete display • Arrow up/down: Line length +/-*
R/E: Recording PDF • S: Save PNG

→ P_2_3_2_01.pde

```
void draw() {
  if (mousePressed) {
    float d = dist(x,y, mouseX,mouseY);

    if (d > stepSize) {
      float angle = atan2(mouseY-y, mouseX-x);

      pushMatrix();
      translate(x,y);
      rotate(angle);
      stroke(col);
      if (frameCount % 2 == 0) stroke(150);
      line(0,0,0,lineLength*random(0.95,1.0)*d/10);
      popMatrix();

      if (mode == 1) {
        x = x + cos(angle) * stepSize;
        y = y + sin(angle) * stepSize;
      }
      else {
        x = mouseX;
        y = mouseY;
      }
    }
  }
}
```

Holding down the mouse button (i.e., when you want to draw) calculates the distance from the last drawing position (x,y) to the current mouse position.

If this distance is greater than stepSize, a new point is drawn. To do this, the angle to the previous drawing position has to be calculated. This is easily accomplished with the function atan2(), which requires two parameters: the vertical distance between the two points mouseY-y and the horizontal distance between the two points mouseX-x.

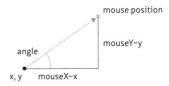

The lines are drawn alternately in different colors: the randomly selected color or a medium gray.

A vertical line is drawn. Since the coordinate system was previously rotated by angle, the line is now perpendicular to the drawing path. The line's length results from the basic length lineLength, a random factor that varies the length slightly, by the factor d/10. This means that the greater the distance between the old and new points, the longer the line is drawn, thereby reflecting the speed of the mouse.

In version 1 (mode == 1), the new point is placed at the distance stepSize from the old position. In version 2, the mouse determines the new position.

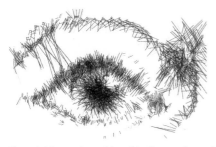
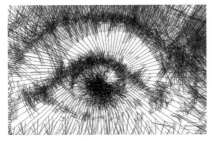

The multiple superimposition of the lines can be used to create fine shading.
→ P_2_3_2_01.pde → Illustration: Victor Juarez Hernandez

241

P.2.3.3
Drawing with type

Who doesn't like to switch brushes while painting? In this application, the position and size of characters are constantly transformed according to the position and speed of the brush. The user can paint random series of letters or even whole novels.

mouse movement

→ P_2_3_3_01.pde

Along the mouse's drawing line, a text appears that is defined in the program and is drawn larger or smaller depending on mouse speed.

Mouse: Drag: Draw text
Keys: DEL: Delete display · Arrow up/down: Distortion angle +/-
R/E: Recording PDF · S: Save PNG

→ P_2_3_3_01.pde

```
void draw() {
  if (mousePressed) {
    float d = dist(x,y, mouseX,mouseY);
    textFont(font, fontSizeMin+d/2);
    char newLetter = letters.charAt(counter);
    stepSize = textWidth(newLetter);

    if (d > stepSize) {
      float angle = atan2(mouseY-y, mouseX-x);

      pushMatrix();
      translate(x, y);
      rotate(angle + random(angleDistortion));
      text(newLetter, 0, 0);
      popMatrix();

      counter++;
      if (counter > letters.length()-1) counter = 0;

      x = x + cos(angle) * stepSize;
      y = y + sin(angle) * stepSize;
    }
  }
}
```

The distance between the mouse and the current writing position (x,y) is calculated. This, in turn, determines the font size for the next character. The value in fontSizeMin ensures that the font will not be smaller than a specified size.

To check whether a new letter can be written, the next character is selected from the string letters and the variable stepSize set to the character's width.

When there is enough space between the mouse and the current writing position, the new letter is written.

The variable counter counts how many letters have already been drawn. This value is used to read the letters in succession from the specified text letters. When counter is greater than the number of letters in the original text, it is reset to 0.

In the tablet version, the pressure on the pen modulates the size of the text. An image can be placed as a template in the background and can be shown or hidden while drawing.

→ P_2_3_3_01_TABLET.pde → Illustration: Pau Domingo



243

P.2.3.4
Drawing with dynamic brushes

A virtual rubber band becomes a dynamic paint brush, as arbitrary basic elements are strung like pearls on a string between brushstrokes and a lazy agent. The tension between the two poles defines the size and position of the elements when drawing.

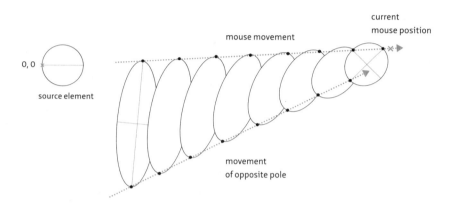

→ P_2_3_4_01.pde

A graphic element is dragged on one end by the mouse. The opposite end moves sluggishly in the direction of the mouse. Depending on the drawing speed and set inertia, the original elements are depicted as stretched to their limits or virtually unchanged. The width of the element remains the same.

Mouse:	Drag: Draw
Keys:	1–9 change module • DEL: Delete display • Arrow up/down: Module size
	Arrow: left/right: Step size • R/E: Recording PDF • S: Save PNG

→ P_2_3_4_01.pde

```
void draw() {
  if (mousePressed) {
    float d = dist(x,y, mouseX,mouseY);

    if (d > stepSize) {
      float angle = atan2(mouseY-y, mouseX-x);

      pushMatrix();
      translate(mouseX, mouseY);
      rotate(angle+PI);
      shape(lineModul, 0, 0, d, modulSize);
      popMatrix();

      x = x + cos(angle) * stepSize;
      y = y + sin(angle) * stepSize;
    }
  }
}
```

In this program, the variables x and y are used for the position of the opposite pole. The distance between these variables and the mouse position determines how much the character element is stretched.

The coordinate system is moved to the mouse position with translate() and turned so it faces the opposite pole; the element is then drawn. The additional angle, PI here, can vary depending on the SVG module. Its length is set at d (the distance to the mouse), the width to modulSize.

The position of the opposite pole is moved by the value stepSize at every step. Since this movement is usually much slower than that of the mouse, a rubber-band effect is produced.

A very subdued opponent to the fast-moving mouse.
→ P_2_3_4_01.pde → Illustrations: Pau Domingo

Quick, regular movements with the mouse generate flowing forms.
→ P_2_3_4_01.pde → Illustration: Pau Domingo

Different movement speeds of the mouse also generate different structures.

→ P_2_3_4_01.pde → Illustration: Pau Domingo

P.2.3.5
Drawing with the pen tablet

Compared to a conventional mouse, a pen tablet puts several more parameters at a user's disposal, including pressure and position. When drawing, the pen movement can be better recorded and interpreted so that the movement of your hand can be reproduced more accurately. When you use a pen tablet you are closer to the generative process.

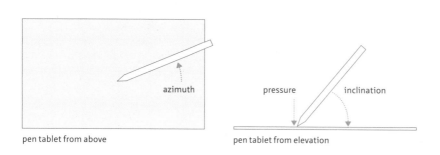

pen tablet from above

pen tablet from elevation

→ P_2_3_5_01_TABLET.pde

The additional parameters provided by a pen tablet are transferred to a basic element (in this case a pen). The azimuth, pressure, and inclination define the rotation, saturation, and length, respectively, of the element. The parameters are read using the tablet classes of the book's Generative Design library.

The form is not loaded from an SVG file but rather drawn as a curve, enabling the individual curve points to be manipulated more easily.

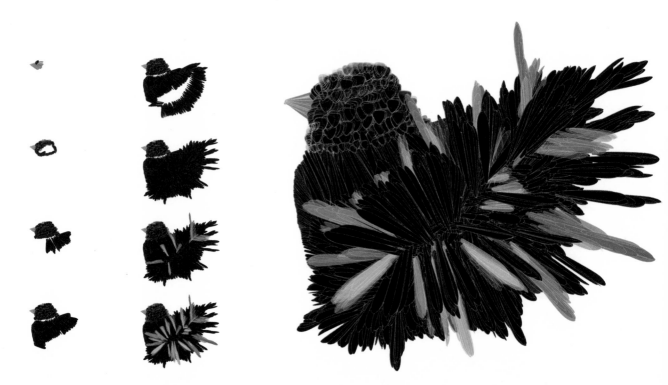

The new elements are always superimposed on the old ones, thereby making it necessary to work from the background to the foreground.
→ P_2_3_5_01_TABLET.pde → Illustration: Jana-Lina Berkenbusch

```
void draw() {
  float pressure = gamma(tablet.getPressure(), 2.5);
  float angle = (tablet.getAzimuth()*-1);
  float penLength = cos(tablet.getAltitude());

  if (pressure > 0.0 && penLength > 0.0) {
    pushMatrix();
    translate(mouseX,mouseY);
    rotate(angle);

    float elementLength = penLenght*250;
    float h1 = random(10)*(1.2+penLenght);
    float h2 = (-10+random(10))*(1.2+penLength);

    ...

    float[] pointsX = new float[5];
    float[] pointsY = new float[5];
    pointsX[0] = 0;
    pointsY[0] = 0;
    pointsX[1] = elementLength*0.77;
    pointsY[1] = h1;
    pointsX[2] = elementLength;
    pointsY[2] = 0;
    pointsX[3] = elementLength*0.77;
    pointsY[3] = h2;
    pointsX[4] = 0;
    pointsY[4] = -5;

    beginShape();
    curveVertex(pointsX[3],pointsY[3]);
    for (int i=0; i< pointsX.length; i++) {
      curveVertex(pointsX[i],pointsY[i]);
    }
    curveVertex(pointsX[1],pointsY[1]);
    endShape(CLOSE);
    popMatrix();
  }
}
```

The pressure and angle information is queried using these three functions.

The elements should only be drawn if the pen is not completely perpendicular to the tablet and the pressure is greater than zero.

Declaration of variables that are needed to describe the shape. Using the random() function, the shapes are varied slightly in their length and width when calculated.

Two arrays, pointsX and pointsY, are created for the shape's contour points and then filled with values.

The shape is drawn.

For drawing the closed curve, see:
→ Ch.P.2.2.3 Shapes from agents

The basic forms, which are superimposed on each other in rapid succession, lead to the creation of complex organic forms.
→ P_2_3_5_01_TABLET.pde → Illustration: Pau Domingo

From birds to mountain ranges to abstract organic forms, the pen tablet inspires the creation of unique illustrations.
→ P_2_3_5_01_TABLET.pde → Illustration: Pau Domingo, Franz Stämmele, and Jana-Lina Berkenbusch

P.2.3.6
Drawing with complex modules

Together they are strong: simple modules become supercharacters. Using combinatorics and complex modules as paint brushes, each module is defined in relation to its four neighbors, generating supercharacters. Depending on the module repertoire and constellation, many different character groups can be generated.

→ P_2_3_6_01.pde

With the mouse, the user draws a grid and positions various SVG modules in its fields. The only information that exists for each field is whether it is empty or filled. When the grid is displayed, the filled or empty state of each field's neighbors becomes apparent; according to this, a specific graphic module is selected.

The sixteen possible states of the four neighbors can be easily summarized in a four-digit binary code. The correct SVG module can be determined simply by converting the binary code into a decimal number, without complicated combinatorics.

→ W.206
Wikipedia: Dual system (binary code)

When drawing in the random mode (by pressing key R), random tiles are selected from eight different tile sets. Using key D, the supplementary information on the tiles is displayed. The resolution of the grid can be changed with the variable tileSize. Key G displays or hides the grid.
→ P_2_3_6_02.pde

Mouse: *Drag: Draw modules* · *Drag right mouse button: Delete modules* → P_2_3_6_01.pde
Keys: *DEL: Delete display* · *G: Show grid on/off* · *D: Show module values on/off*
 S: Save PNG · *P: Save PDF*

```
void draw() {
  ...
  if (mousePressed && (mouseButton == LEFT)) setTile();
  if (mousePressed && (mouseButton == RIGHT)) unsetTile();

  if (drawGrid) drawGrid();
  drawModules();
  ...
}
```

Using the functions setTile() and unsetTile(), the state of a field in the grid is set to 1 or 0.

Using the function drawModules(), all SVG modules are displayed. The underlying grid can be drawn with the function drawGrid().

```
void setTile() {
  int gridX = floor((float)mouseX/tileSize) + 1;
  gridX = constrain(gridX, 1, gridResolutionX-2);
  int gridY = floor((float)mouseY/tileSize) + 1;
  gridY = constrain(gridY, 1, gridResolutionY-2);
  tiles[gridX][gridY] = '1';
}
```

The mouse position is transferred to the corresponding grid field square in the grid (gridX, gridY).

The state of all the fields in the grid is saved in the two-dimensional tiles array. The clicked-on field is set to the value 1.

```
void drawModules() {
  shapeMode(CENTER);
  for (int gridY=1; gridY< gridResolutionY-1; gridY++) {
    for (int gridX=1; gridX< gridResolutionX-1; gridX++) {
      if (tiles[gridX][gridY] == '1') {
        String east = str(tiles[gridX+1][gridY]);
        String south = str(tiles[gridX][gridY+1]);
        String west = str(tiles[gridX-1][gridY]);
        String north = str(tiles[gridX][gridY-1]);
        String binaryResult = north + west + south + east;
        int decimalResult = unbinary(binaryResult);

        float posX = tileSize*gridX - tileSize/2;
        float posY = tileSize*gridY - tileSize/2;
        shape(modules[decimalResult],posX, posY,
            tileSize, tileSize);

        ...
      }
    }
  }
}
```

All tiles are processed. Only fields whose state is 1 (i.e., filled ones) are taken into account.

The state of the four neighbors is queried, converted into strings, and concatenated. Consequently, binaryResult contains a sequence of four zeros or ones.

The coded states of the binary representations are converted into a decimal number using the function unbinary().

The corresponding SVG module is selected with decimalResult and drawn in the display.

Complete characters can be easily drawn with the tiles; the possibilities are endless since new tile sets can always be generated in a vector program.
→ P_2_3_6_02.pde

Patterns are created by filling in adjacent grids.
→ P_2_3_6_02.pde → Illustration: Pau Domingo

The tiles here are used as ornamental structures.
→ P_2_3_6_02.pde → Illustration: Cedric Kiefer

Symmetrical masklike forms.
→ P_2_3_6_02.pde → Illustration: Cedric Kiefer

P.3

Type

In the Shape chapter, we demonstrated how forms can be generated using the principles of repetition (grid), iteration (agents), and interaction (drawing). This chapter is devoted to a special kind of form that is also extremely important in design: typography. Using various methods—from the visual analysis of a text to the outlines of a character—typography will be viewed in the following examples in the context of generative design.

P.3.0

Hello, type

Letters become spaces. In generating a vector-based font, you can directly influence numerous parameters and design with letters in time and space. Traces can be made visible of the emergence of the character and the interactive manipulation of its size and position.

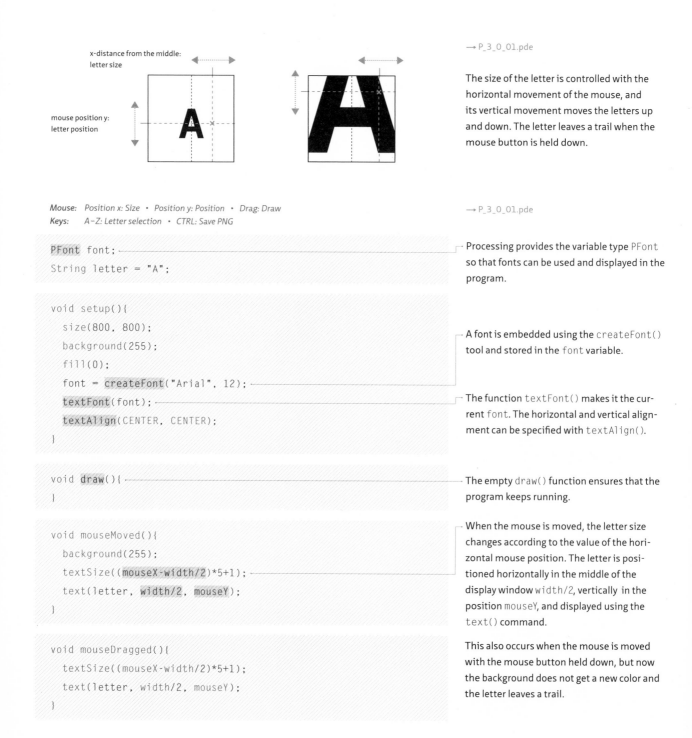

→ P_3_0_01.pde

The size of the letter is controlled with the horizontal movement of the mouse, and its vertical movement moves the letters up and down. The letter leaves a trail when the mouse button is held down.

Mouse: *Position x: Size* • *Position y: Position* • *Drag: Draw*
Keys: *A–Z: Letter selection* • *CTRL: Save PNG*

→ P_3_0_01.pde

```
PFont font;
String letter = "A";
```

Processing provides the variable type PFont so that fonts can be used and displayed in the program.

```
void setup(){
  size(800, 800);
  background(255);
  fill(0);
  font = createFont("Arial", 12);
  textFont(font);
  textAlign(CENTER, CENTER);
}
```

A font is embedded using the createFont() tool and stored in the font variable.

The function textFont() makes it the current font. The horizontal and vertical alignment can be specified with textAlign().

```
void draw(){
}
```

The empty draw() function ensures that the program keeps running.

```
void mouseMoved(){
  background(255);
  textSize((mouseX-width/2)*5+1);
  text(letter, width/2, mouseY);
}
```

When the mouse is moved, the letter size changes according to the value of the horizontal mouse position. The letter is positioned horizontally in the middle of the display window width/2, vertically in the position mouseY, and displayed using the text() command.

```
void mouseDragged(){
  textSize((mouseX-width/2)*5+1);
  text(letter, width/2, mouseY);
}
```

This also occurs when the mouse is moved with the mouse button held down, but now the background does not get a new color and the letter leaves a trail.

The letter leaves the tracks of its changes, then becomes unrecognizable and generates new forms.
→ P_3_0_01.pde

Writing time-based text

Composing text with automatic line breaks is nothing new. But when the vertical mouse position is responsible for the leading (the space between lines), and the elapsed time before entering each letter determines its size, then the rhythm of writing begins to interact with the text.

The more time that passes before a letter is typed, the larger it becomes.

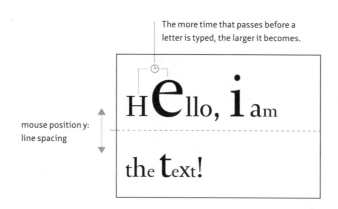

mouse position y:
line spacing

→ P_3_1_1_01.pde

When typing, the virtual "pen tip" moves from left to right across the display. When it reaches the right border, it starts again from the beginning and skips a line. Leading is defined by the vertical mouse position. The time between the individual keystrokes is measured. The greater the time interval, the larger the entered letter.

Mouse: Position y: Line spacing
Keys: Keyboard: Input text · DEL: Delete letters · CTRL: Save PNG and PDF

→ P_3_1_1_01.pde

```
void draw() {
  ...
  spacing = map(mouseY, 0,height, 0,120);
  translate(0, 200+spacing);

  float x = 0, y = 0, fontSize = 20;

  for (int i = 0; i < textTyped.length(); i++) {
    fontSize = fontSizes[i];
    textFont(font, fontSize);
    char letter = textTyped.charAt(i);
    float letterWidth = textWidth(letter) + tracking;

    if (x+letterWidth > width) {
      x = 0;
      y += spacing;
    }

    text(letter, x, y);
    x += letterWidth;

  }
  →
```

The y-coordinate of the mouse is converted into a value between 0 and 120 for spacing.

The variable textTyped contains the entered text. This is now processed letter by letter.

The fontSize is taken from the array fontSizes and the font is set to this size.

Now the character string is selected in the index i and saved in letter. In addition, the letter width textWidth(letter) is increased by the value tracking.

When the current position plus the character width exceeds the width of the display, a line break occurs. Thus x is reset to 0 and the vertical position y is increased by leading.

The letter is drawn at the position x, y.

The vertical mouse position defines the leading (line spacing). Different levels of legibility result.
→ P_3_1_1_01.pde

```
float timeDelta = millis() - pMillis;
newFontSize = map(timeDelta, 0,maxTimeDelta,
                  minFontSize,maxFontSize);
newFontSize = min(newFontSize, maxFontSize);

fill(200, 30, 40);
if (frameCount/10 % 2 == 0) fill(255);
rect(x, y, newFontSize/2, newFontSize/20);
}

void keyPressed() {
  if (key != CODED) {
    switch(key) {
    ...
    default:
      textTyped += key;
      fontSizes = append(fontSizes, newFontSize);
    }
    pMillis = millis();
  }
}
```

After all letters have been drawn, a blinking cursor is displayed. Over time, this is supposed to grow, so timeDelta—the time that has elapsed since the last typing operation—must be determined. The current time is obtained in milliseconds with the millis() function. The value pMillis, which was saved with the last keystroke, is subtracted from this. This time difference can now be converted to the range minFontSize to maxFontSize.

This value is used to draw a rectangle at the current drawing position.

By pressing a key, the typed letter of the character string textTyped is attached and the array fontSizes[] is grown by appending the new letter size in newFontSize.

The current time is saved in pMillis so that the time of the last keystroke is always available.

261

Text as blueprint

In this example, time no longer determines letter size. Rather, certain letters modify, for instance, the text orientation. In this program, every character is translated using a visual rule. The source text thus becomes the blueprint for the composition.

Key	Translation
A	→ Enter A
	→ Shift writing position
B	→ Enter B
	→ Shift writing position
Space	→ Draw graphic image
	→ Turn – 45°
	→ Shift writing position
C	→ Enter C
	→ Shift writing position
Comma	→ Draw graphic image
	→ Turn 45°
	→ Shift writing position

→ P_3_1_2_01.pde

The user can freely enter the text using the keyboard. Every character is translated by a fixed rule in the program that specifies what will be drawn and how position and size are to be altered.

Every entry can be undone using the backspace or delete key.

In this example, some of the characters are replaced by loaded SVG modules.

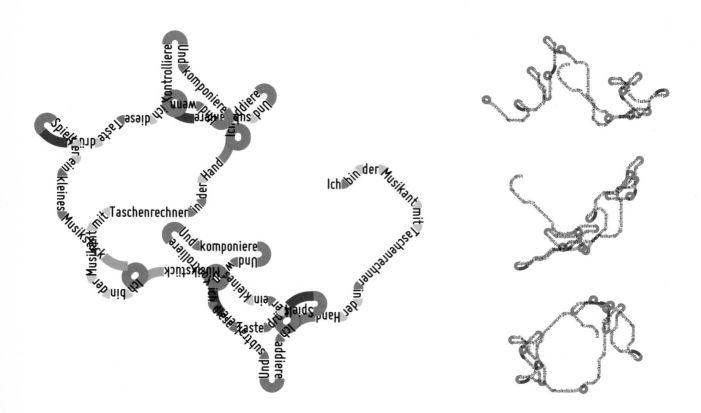

The program interprets a text (here the lyrics of a song by Kraftwerk) as a floor plan. Using the ALT key, different RandomSeeds can be generated that constantly give the text a new appearance, since there are two possible random directions for the space key.
→ P_3_1_2_01.pde

```
void draw() {
  ...
  translate(centerX,centerY);
  scale(zoom);

  for (int i = 0; i < textTyped.length(); i++) {
    float fontSize = 25;
    textFont(font,fontSize);
    char letter = textTyped.charAt(i);
    float letterWidth = textWidth(letter);

    switch(letter) {
    case ' ':
      int dir = floor(random(0, 2));
      if(dir == 0){
        shape(shapeSpace, 0, 0);
        translate(1.9, 0);
        rotate(PI/4);
      }
      if(dir == 1){
        shape(shapeSpace2, 0, 0);
        translate(13, -5);
        rotate(-PI/4);
      }
      break;
    case ',':
      shape(shapeComma, 0, 0);
      translate(34, 15);
      rotate(PI/4);
      break;
    ...
    default:
      fill(0);
      text(letter, 0, 0);
      translate(letterWidth, 0);
    }
  }

  fill(0);
  if (frameCount/6 % 2 == 0) rect(0, 0, 15, 2);
  ...
}
```

The origin of the coordinate system is moved to the point (centerX,centerY) before the text is displayed. This flexible definition allows the point to be moved via mouse interaction.

All typed letters are processed sequentially.

The character width of each letter is calculated so that the writing position can later be offset to the correct distance.

The heart of the program is the set of rules that specifies how the individual characters impact the image and writing behavior. For this purpose, the current letter is distinguished using the switch() command.

A space is translated as follows: depending on the random value dir, one of the two loaded SVG modules shapeSpace or shapeSpace2 is drawn; the writing position is adjusted using translate(); and the writing direction is rotated 45° to either the left or right using rotate().

For other special characters (in this case, the comma), SVGs are also loaded in variables. When one of these characters appears, the corresponding module is drawn, and the writing position and direction are adjusted.

With all other characters the letter is drawn and the writing position shifted by the letterWidth.

Display of the blinking cursor: this construction uses the Processing variable frameCount, which automatically increments in each frame, and the modulo operator % to produce alternately the values 0 and 1. This is used to fade the cursor in and out.

Typed letters are replaced by various elements—e.g., ENTER = "begin new line." The text is completely transformed into an image.
→ P_3_1_2_02.pde → Illustration: Cedric Kiefer

▬▬▬	all keys without special features	
▲	space	
◣	comma, question mark, and excla-mation point	
◟	period	

▼	letters "a" and "u"
◯	letter "o"
Intisca	Intisca (station name, the last seven typed letters)
✈	hyphen

⩘	colon
Ⓐ	letter "x"
Ⓑ	letter "z"
!	plus sign

P.3.1.3
Text image

Which characters appear, and how often? The properties of an analyzed text can generate images. The number of appearances in a text is calculated for each character and determines its appearance. The color of the letters, for instance, corresponds to how frequently they appear. Ultimately we do not even need the letters anymore.

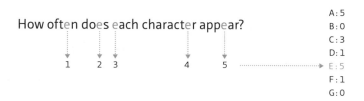

A : 5	A text is processed character by character,
B : 0	and each character's corresponding counter
C : 3	is advanced. That results in a list of counters
D : 1	representing the frequency of each character.
E : 5	These values can now be used as parameters
F : 1	for displaying the text.
G : 0	
...	

Mouse: *Position x: Survivors from the normal and sorted text*
Keys: *1: switch alpha mode · P: Save PDF · S: Save PNG*

```
...
String alphabet = "ABCDEFGHIJKLMNOPQRSTUVWXYZÄÖÜß,.;:!? ";
int[] counters = new int[alphabet.length()];
...
```

The character string alphabet determines which characters are to be counted. The counters array is initialized with the string's length and thereby provides each character with a counter.

```
void setup() {
  size(1200, 800);
  String[] lines = loadStrings("faust_kurz.txt");
  joinedText = join(lines, " ");
  font = createFont("Arial", 10);

  countCharacters();
}
```

The text to be analyzed is loaded with the loadStrings() function. The individual texts are now located in an array of strings. Since it is more practical to work with a continuous text, the lines are joined together using the join() function.

The countCharacters() function is called to determine the frequency.

```
void countCharacters(){
  for (int i = 0; i < joinedText.length(); i++) {
    char c = joinedText.charAt(i);
    String s = str(c);
    s = s.toUpperCase();
    char uppercaseChar = s.charAt(0);
    int index = alphabet.indexOf(uppercaseChar);
    if (index >= 0) counters[index]++;
  }
}
```

The text is processed: a character is taken from the text using charAt(), converted into a string using str(), converted into an uppercase letter using the toUpperCase() function, and then converted back into a character using the uppercaseChar() function.

Using the indexOf() function, it is possible to identify if the character appears within the character string alphabet. If the character is found, the index function is used to increment the corresponding counter.

```
void draw() {
  ...
  posX = 20;
  posY = 200;

  for (int i = 0; i < joinedText.length(); i++) {
    String s = str(joinedText.charAt(i)).toUpperCase();
    char uppercaseChar = s.charAt(0);
    int index = alphabet.indexOf(uppercaseChar);
    if (index < 0) continue;

    if (drawAlpha) fill(87, 35, 129, counters[index]*3);
    else fill(87, 35, 129);
    textSize(18);

    float sortY = index*20+40;
    float m = map(mouseX, 50,width-50, 0,1);
    m = constrain(m, 0, 1);
    float interY = lerp(posY, sortY, m);

    text(joinedText.charAt(i), posX, interY);

    posX += textWidth(joinedText.charAt(i));
    if (posX >= width-200 && uppercaseChar == ' ') {
      posY += 40;
      posX = 20;
    }
  }
  ...
}
```

The variables posX and posY always contain the current writing position.

When drawing, the text is processed from the beginning each time, and, just as in the countCharacters() function, the index of the current character is determined for the counter array. If the character is not found—index < 0—the drawing process for this character is canceled using the continue command.

When the drawing mode drawAlpha is engaged, the transparency of the fill color is dependent on the frequency of the character and set with counters[index].

The variable sortY is introduced to sort the characters. This represents the y-coordinate of the line to which the character should go or migrate. For A, it is 40. For B, the value is 60, etc.

The mouse position is converted into a number m between 0 and 1 that will serve as an interpolation variable. Using the lerp() function, an interpolation between posY and sortY is carried out, and the calculated value interY is used to position the character.

Now only the writing position has to be updated. The value PosX is increased by the character width; if this value approximates the right border of the display and the current character is a space, then the line break takes place. The value posY is increased by the line spacing and posX set back to the left.

Ihr naht euch wieder, schwankende Gestalten, Die früh sich einst dem trüben Blick gezeigt. Versuch ich wohl, euch diesmal festzuhalten? Fühl ich mein Herz noch jenem Wahn geneigt? Ihr drängt euch zu! nun gut, so mögt ihr walten, Wie ihr aus Dunst und Nebel um mich steigt; Mein Busen fühlt sich jugendlich erschüttert Vom Zauberhauch, der euren Zug umwittert. Ihr bringt mit euch die Bilder froher Tage, Und manche liebe Schatten steigen auf; Gleich einer alten, halbverklungnen Sage Kommt erste Lieb und Freundschaft mit herauf; Der Schmerz wird neu, es wiederholt die Klage Des Lebens labyrinthisch irren Lauf, Und nennt die Guten, die, um schöne Stunden Vom Glück getäuscht, vor mir hinweggeschwunden.

The horizontal mouse position controls whether the letters are displayed in the normal text position or sorted.
→ P_3_1_3_01.pde

267

The frequency of the letters in a text are coded here several times and in various combinations: by the size and transparency of the yellow circles, by the length of the purple lines, and by the opacity of the letters themselves.

→ P_3_1_3_03.pde

Ihr naht euch wieder, schwankende Gestalten, Die früh sich einst dem trüben Blick gezeigt. Versuch ich wohl, euch diesmal festzuhalten? Fühl ich mein Herz noch jenem Wahn geneigt? Ihr drängt euch zu! nun gut, so mögt ihr walten, Wie ihr aus Dunst und Nebel um mich steigt; Mein Busen fühlt sich jugendlich erschüttert Vom Zauberhauch, der euren Zug umwittert. Ihr bringt mit euch die Bilder froher Tage, Und manche liebe Schatten steigen auf; Gleich einer alten, halbverklungnen Sage Kommt erste Lieb und Freundschaft mit herauf; Der Schmerz wird neu, es wiederholt die Klage Des Lebens labyrinthisch irren Lauf, Und nennt die Guten, die, um schöne Stunden Vom Glück getäuscht, vor mir hinweggeschwunden.

→ P_3_1_3_04.pde

Identical letters are connected by colored lines; the colors of the lines pass through the color wheel once in alphabetical order. The letters are sorted by their frequency when the mouse is moved to the right.

Any kind of letter can be individually switched on and off, allowing, for example, the frequency of the vowels to be observed separately.

The gray line (see illustration on the right), which can be turned on and off using key 2, connects each letter with the letter directly following it. Although hardly visible in the normal text, when arranged by letter, these gray lines create a striking network structure.

22 A aaaaaaaaaaaaaaaaaaaaaaa
12 B bBbBbbBbbbbb
26 C cccccccccccccccccccccccccc
25 D ddDdddDddddddddDdddDddddd
85 E eee
10 F ffFffffFfff
23 G GggggggggggggggGgggGGggg
44 H hhhhhhhhhhhhhHhhhhhhhhhhhhhhhhhhhhhhhhhhhhhhhhh
43 I IiiiiiiiiiiIiiiiiiiiiIiiiiiiiiiiiiiiiiiiiiiii
2 J jj
6 K kkkKKk
23 L lllllllllllllllllLllLlLl
19 M mmmmmmmMmmmmmmmmmmmm
50 N nnnnnnnnnnnnnnnnnnnNnnnnnnnnnnnnnnnnnnnnnnnnnnnnnnnn
9 O ooooooooo
0 P
0 Q
35 R rrrrrrrrrrrrrrrrrrrrrrrrrrrrrrrrrrr
28 S ssssssssssssssssSsSssSssssssSss
41 T ttttttttttttttttttttttttttttTttttttttttttt
34 U uuuuuuuuuuuuuuuuuuuuuuuUuuuuuuuUuuuuu
5 V VVvVv
11 W wwwWwWwwwww
0 X
1 Y y
7 Z zzzzZZz
2 Ä ää
2 Ö öö
6 Ü üüüüüü
0 ß
13 , ,,,,,,,,,,,,,
3 . .·.·.
3 ; ;·;
0 :
1 ! !
2 ? ??

112

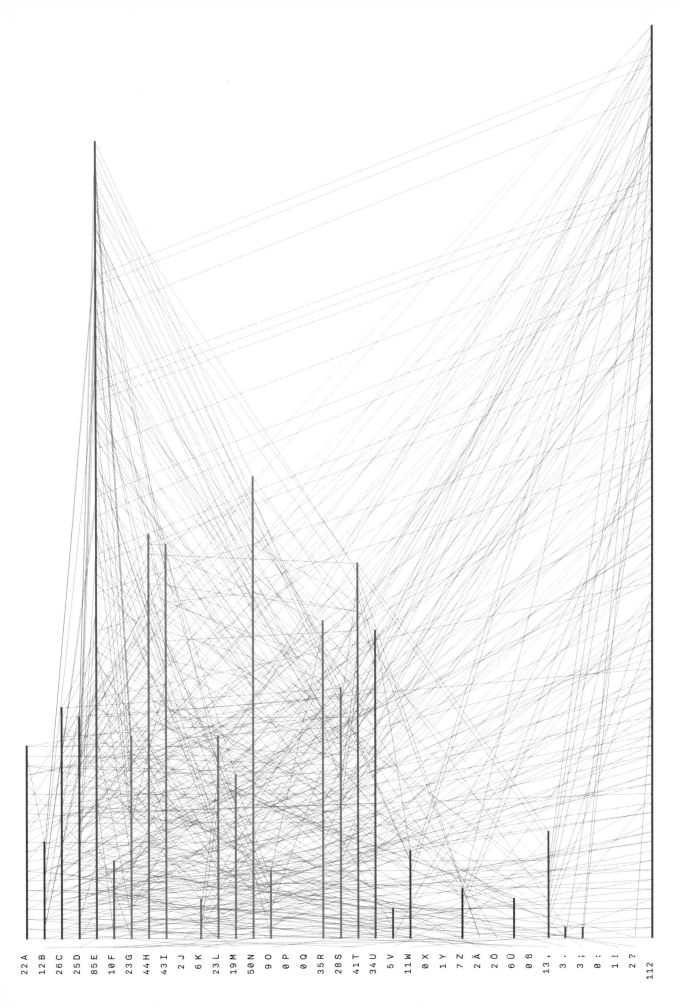

22 A 12 B 26 C 25 D 85 E 10 F 23 G 44 H 43 I 2 J 6 K 23 L 19 M 50 N 9 O 0 P 0 Q 35 R 28 S 41 T 34 U 5 V 11 W 0 X 1 Y 7 Z 2 Ä 2 Ö 6 Ü 0 ß 13 , 3 . 3 ; 0 : 1 ! 2 ? 112

P.3.1.4

Text diagram

What were Melville's, Goethe's, or Dickens's favorite words? The possibility of mechanically reading and processing large amounts of text provides considerable room for experimentation. All the words in Goethe's *Faust*, for instance, can be counted and their frequency represented by elements (in this case, rectangles) of varying sizes to create diagrams that function as static literary criticism.

→ P_3_1_4_01.pde

read words from a text file

Treemap library

Ben Fry's Treemap library allows treemaps to be constructed easily. The aim is to divide up the display window according to the frequency with which each word is used in a text. The complete text of Goethe's *Faust* is read from a text file and passed to the Treemap library for visualization. The treemap's basic layout algorithm can then be selected.

→ W.207
Treemap library by Ben Fry

→ W.208
Wikipedia: Treemapping

→ W.209
Source of *Faust* texts

Keys: 1–5: Treemap layout • P: Save PDF • S: Save PNG

```
void setup() {
  ...
  WordMap mapData = new WordMap();

  String[] lines = loadStrings("faust.txt");
  String joinedText = join(lines, " ");
  joinedText = joinedText.replaceAll("_", "");
  String[] words = splitTokens(joinedText, " .,;::?!\u2014\"");

  for (int i = 0; i < words.length; i++) {
    String word = words[i].toLowerCase();
    mapData.addWord(word);
  }

  mapData.finishAdd();

  map = new Treemap(mapData, 0, 0, width, height);
  ...
}
```

The data container mapData is filled later with the words from *Faust* and passed to the Treemap library. WordMap is a self-defined class here.

The complete text is loaded using loadStrings(). Using the string functions join(), replaceAll(), and splitTokens(), it is possible to split the long, continuous text into individual words.

The array with the words is processed. Each word is initially converted into lowercase letters so the different capitalizations of the same word (e.g., the first letter of a sentence) are still recognized as such. Then, using addWord(), the word is passed to mapData.

Once all the data has been read, it is fixed using finishAdd() and passed to the new treemap to be constructed.

Sections of a treemap in which the rectangles are arranged in strips of random heights (key 5).
→ P_3_1_4_01.pde

```
void draw() {
  ...
  background(255);
  map.setLayout(layoutAlgorithm);
  map.updateLayout();
  map.draw();
  ....
}
```

The treemap class provides several methods such as setLayout() and updateLayout() for configuring and updating the diagram form. The method draw() draws the treemap in the display.

```
void keyPressed() {
  ...
  if (key == '4') layoutAlgorithm = new SliceLayout();
  ...
}
```

The Treemap library offers five different layout algorithms that can be selected here using the keys 1 to 5.

→ P_3_1_4_01/WordItem.pde

```
class WordItem extends SimpleMapItem {
  ...
  void draw() {
    strokeWeight(0.25);
    fill(255);
    rect(x, y, w, h);

    for (int i = minFontSize; i <= maxFontSize; i++) {
      textFont(font,i);
      if (w < textWidth(word) + margin ||
          h < (textAscent()+textDescent()) + margin) {
        break;
      }
    }
    fill(0);
    textAlign(CENTER, CENTER);
    text(word, x + w/2, y + h/2);
  }
}
```

The WordItem class is the building block from which the tree is assembled.

Position, width, and height of the element are automatically available in the variables x, y, w, and h and can be used to draw the element's frame.

After this, the font size of the particular word is increased until the word is either taller or wider than the previously drawn element.

The word is written in the middle of the element.

273

The frequency of all the words in Goethe's *Faust* as a treemap. The algorithm tries to keep the rectangles as square as possible in this arrangement.

→ P_3_1_4_01.pde

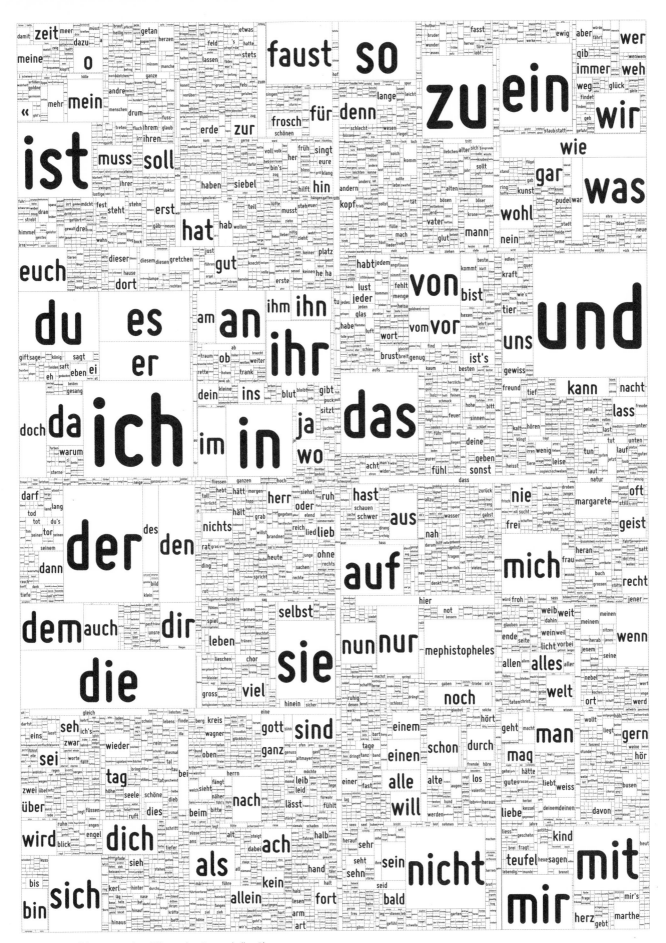

Arrangement of the treemap in a different drawing mode (key 2).
→ P_3_1_4_01.pde

Dissolving the font outline

A text is made up of characters. A character, in turn, is shaped by its outlines. In the following chapters, this outline dissipates into a multitude of points and will establish the basis for generative font manipulation. Individual points are replaced by other elements, thereby disguising the original font.

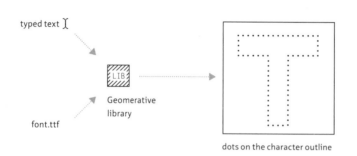

typed text

font.ttf

Geomerative library

dots on the character outline

→ P_3_2_1_01.pde

The starting point is a text and a font file. The Geomerative library, designed by Ricard Marxer, generates a multitude of points onto the font outline. This information can then be used to give the characters new visual identities.

→ W.210
Geomerative library

SVGs are loaded and placed on the character outline in this version of the program. Rotation angles and scaling can be controlled with the mouse.
→ P_3_2_1_02.pde

```
void setup() {
  ...
  RG.init(this);
  font = new RFont("FreeSans.ttf", 200, RFont.LEFT);

  RCommand.setSegmentLength(10);
  RCommand.setSegmentator(RCommand.UNIFORMLENGTH);
}
```

First, the Geomerative library has to be initialized. Then the font file (a TrueType font) is loaded.

Using RCommand, additional settings for the functionality of the library can be configured—e.g., the kind of segmentation and the distance between the dots.

```
void draw() {
  ...
  RGroup grp;
  grp = font.toGroup(textTyped);
  grp = grp.toPolygonGroup();
  RPoint[] pnts = grp.getPoints();

  stroke(255, 132, 8);
  strokeWeight(2);
  for (int i=0; i < pnts.length; i++ ) {
    float l = 5;
    line(pnts[i].x-1, pnts[i].y-1,
         pnts[i].x+1, pnts[i].y+1);
  }

  fill(0);
  noStroke();
  for (int i=0; i < pnts.length; i++ ) {
    float diameter = 18;
    if (i%2 == 0) ellipse(pnts[i].x,pnts[i].y,
                          diameter,diameter);
  }
  ...
}
```

When extracting the dots, the entered characters do not have to be processed individually. The entire text textTyped can be grouped. Then the getPoints() function provides a list of dots comprising the outline lines of the entire text.

The dots are processed. First, short, angled lines are drawn on their positions.

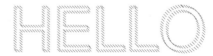

Next, black circles are processed. In this run, only every second position is used.

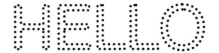

Graphic elements are placed on character outlines.
→ P_3_2_1_01.pde

The appearance of the generated character forms can be regulated by the scaling and rotation of the elements on the character outlines.
→ P_3_2_1_02.pde

my way to learn,
stopped by fools,
foster
earned to speak

Jonathan Harris

279

Varying the font outline

If the font outline is not made up of straight lines or curves but controllable elements instead, then we increasingly free ourselves from the underlying font. All existing base points are joined together with specially formed Bézier curves. This is just one of the myriad ways of quickly creating dozens of new fonts.

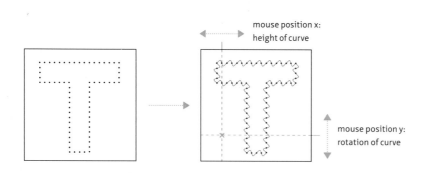

mouse position x:
height of curve

mouse position y:
rotation of curve

→ P_3_2_2_01.pde

The dots on the text outline are connected with Bézier curves. The shape of the curves can be controlled interactively with the mouse.

Different settings for the height and rotation of the Bézier curves.
→ P_3_2_2_01.pde

Mouse: *Position x: Rotation of curve • Position y: Height of curve*
Keys: *Keyboard: Input text • DEL: Delete letters • ALT: Change filling mode*
CTRL: Save PDF and PNG

→ P_3_2_2_01.pde

```
float addToAngle = map(mouseX, 0,width, -PI,+PI);
float curveHeight = map(mouseY, 0,height, 0.1,2);

for (int i = 0; i < pnts.length-1; i++ ) {
  float d = dist(pnts[i].x, pnts[i].y,
                 pnts[i+1].x, pnts[i+1].y);
  if (d > 50) continue;

  float stepper = map(i%2, 0,1, -1,1);
  float angle = atan2(pnts[i+1].y-pnts[i].y,
                      pnts[i+1].x-pnts[i].x);
  angle = angle + addToAngle;

  float cx=pnts[i].x+cos(angle*stepper)*d*4*curveHeight;
  float cy=pnts[i].y+sin(angle*stepper)*d*3*curveHeight;

  bezier(pnts[i].x,pnts[i].y, cx,cy, cx,cy,
         pnts[i+1].x,pnts[i+1].y);
}
```

The variables addToAngle and curveHeight result from the x- and y-coordinates of the mouse position and control the rotation and height of the Bézier curves.

The dots are processed from the first to the next-to-last. The distance from the current dot to the next one is calculated each time.

When the distance is greater than 50, this loop is aborted and no line is drawn. Since the Geomerative library provides the dots for the entire text as a chain of dots, it ensures that the individual letters are not connected.

For the variable stepper, the values −1 and 1 are alternately produced. These are used to calculate the control points for the Bézier curve cx, cy in order to move the curve up and down.

Four points have to be defined when drawing the Bézier curve: the beginning point, the end point, and two control points. The control point just calculated is used twice here.

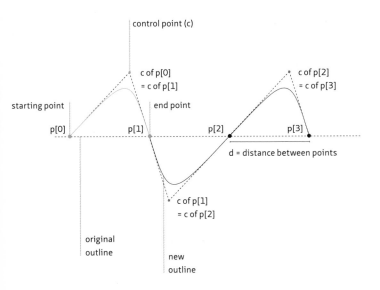

A new outline is produced and moves up and down around the original outline line. It consists of individual Bézier curves that are defined by the beginning and end points and the two control points, which in this case have the same value: c of p[0] = c of p[1].

The mouse position determines the form of the Bézier curves. It is possible to switch to filled curves by using the ALT key.
→ P_3_2_2_01.pde

re creating
shit, man,
sky ain't

Charles Mingus

P.3.2.3

Font outline from agents

How long is a letter recognizable as such? In this example, the outlines of a letter serve as the source shape. Each individual nodal point moves like a dumb agent. Over time, the letter becomes illegible and is transformed into something new.

→ P_3_2_3_01.pde

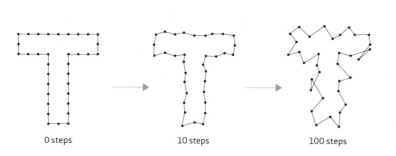

0 steps 10 steps 100 steps

Points are again generated from a font outline. Each point becomes an independent dumb agent but remains connected to its neighbor.

Mouse: Left click + position x: Deformation speed
Keys: Keyboard: Input text · SHIFT: Movement start/stop · DEL: Delete display
CTRL: Start PDF Recording · ALT: Stop PDF Recording · TAB: Save PNG

→ P_3_2_3_01.pde

```
void draw() {
  ...
  translate(letterX,letterY);

  if (mousePressed) danceFactor = map(mouseX, 0,width, 1,3);
  else danceFactor = 1;

  if (grp.getWidth() > 0) {
    for (int i = 0; i < pnts.length; i++ ) {
      pnts[i].x += random(-stepSize,stepSize)*danceFactor;
      pnts[i].y += random(-stepSize,stepSize)*danceFactor;
    }
    ...
    strokeWeight(0.1);
    stroke(0);
    beginShape();
    for (int i=0; i<pnts.length; i++) {
      vertex(pnts[i].x,pnts[i].y);
      ellipse(pnts[i].x,pnts[i].y,7,7);
    }
    vertex(pnts[0].x,pnts[0].y);
    endShape();
  }
  ...
}
```

The origin of the coordinate system is moved to the current writing position before a letter is written.

By keeping the mouse button pressed down, the variable danceFactor is set to a value, which increases proportionally to the value of the mouse's x-coordinate.

Random values are added to a point's position in every iteration. The value danceFactor increases the speed of the movement.

Lines connect the dots.

Finally, another line is drawn to the first point, closing the outline.

The more time that passes without a key being pressed, the more a character becomes deformed.

→ P_3_2_3_01.pde

P.4

Image

In the last chapter, we saw how text can be dissolved and how the resulting elements—words, letters, and even dots on contours—can be used for experimentation. Similarly, images can be manipulated: details can be copied, collages can be produced, and pixels—the digital image's smallest units of information—can become the basis of a new visual world.

P.4.0
Hello, image

A digital image is a mosaic of small color tiles. Dynamic access to these tiny elements allows for the generation of new compositions. It is possible to create your own collection of image tools with the following programs.

→ P_4_0_01.pde

An image is loaded and displayed in a grid defined by the mouse. Each tile in the grid is filled with a scaled copy of the source image.

original image scaled image in the grid

Mouse: *Position x: Number of horizontal tiles* · *Position y: Number of vertical tiles*
Keys: *S: Save PNG*

→ P_4_0_01.pde

```
PImage img;

void setup(){
  size(650, 450);
  img = loadImage("image.jpg");
}
```

The image is loaded.

```
void draw() {
  float tileCountX = mouseX/3+1;
  float tileCountY = mouseY/3+1;
  float stepX = width/tileCountX;
  float stepY = height/tileCountY;
  for (float gridY = 0; gridY < height; gridY += stepY){
    for (float gridX = 0; gridX < width; gridX += stepX){
      image(img, gridX, gridY, stepX, stepY);
    }
  }
}
```

The mouse position determines tileCountX and tileCountY and, thereby, their width stepX and height stepY.

The image is drawn using the function image(). The upper-left corner of the image is located in the grid (gridX, gridY); width and height are determined by tile width stepX and tile height stepY.

The original image (image.jpg) is in the data folder.

Abstract images are created through the repeated copying and extreme scaling of the source image.
→ P_4_0_01.pde

```

```

P.4.1.1
Image cutouts in a grid

The principle illustrated below is almost the same as the one in the previous example, and yet a whole new world of images emerges. An image's details and fine structures become pattern generators when only a portion of it is selected and configured into tiles. The results are even more interesting if these sections are randomly selected.

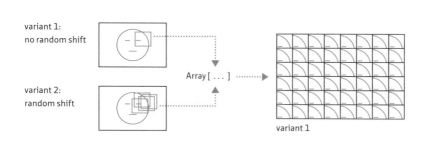

variant 1

→ P_4_1_1_01.pde

Using the mouse, a section of the image is selected in the display window. After releasing the mouse button, several copies of this section are stored in an array and organized in a grid. The program offers two variants. In variant one, all copies are made from the exact same section. In variant two, the section is shifted slightly at random each time.

Mouse: Position x/y: Detail positioning · Left click: Copy detail
Keys: 1–3: Change detail size · R: Random on/off · S: Save PNG

→ P_4_1_1_01.pde

```
void cropTiles(){
  tileWidth = width/tileCountY;
  tileHeight = height/tileCountX;
  tileCount = tileCountX * tileCountY;
  imageTiles = new PImage[tileCount];

  int i = 0;
  for (int gridY = 0; gridY < tileCountY; gridY++){
    for (int gridX = 0; gridX < tileCountX; gridX++){
      if (randomMode){
        cropX = (int) random(mouseX-tileWidth/2,
                             mouseX+tileWidth/2);
        cropY = (int) random(mouseY-tileHeight/2,
                             mouseY+tileHeight/2);
      }
      cropX = constrain(cropX, 0, width-tileWidth);
      cropY = constrain(cropY, 0, height-tileHeight);
      imageTiles[i++] = img.get(cropX, cropY,
                               tileWidth, tileHeight);
    }
  }
}
```

The core of the program is the cropTiles() function. Here the image is fragmented and the copies of the sections are stored in an array.

The array for the image sections imageTiles is initialized with the correct number of tiles.

When version two comes into play (randomMode is true), all the values for cropX and cropY are randomly selected from a value range around the mouse position.

The constrain() function ensures that the cutout section does not extend beyond the image boundaries.

Finally, the section is copied from the image img using get() and stored in the array.

The original image (image.jpg) is in the data folder.

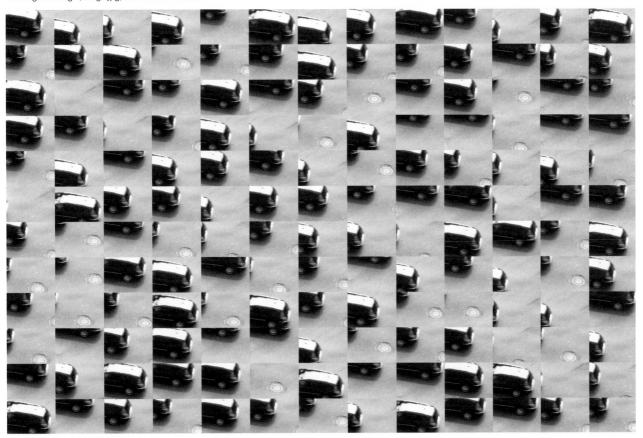

Random variations in the section can be activated and deactivated using the R key.
→ P_4_1_1_01.pde

The multiplication of small image sections creates rhythmic structures that are only recognizable as image sections at a second glance.
→ P_4_1_1_01.pde

Using keys 1 to 3, selections can be made among different portions of the image sections. The motifs are still recognizable in these large, detail-rich excerpts but now have an unsettling perspective.

→ P_4_1_1_01.pde

P.4.1.2
Feedback of image cutouts

A familiar example of feedback: a video camera is directed at a television screen that displays the image taken by the camera. After a short time, the television screen depicts an ever-recurring and distorted image. When this phenomenon is simulated, an image's level of complexity is increased. This repeated overlaying leads to a fragmentary composition.

→ W.211 Wikipedia: Feedback

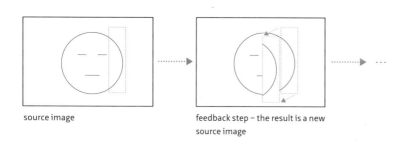

source image

feedback step – the result is a new source image

→ P_4_1_2_01.pde

First, the image is loaded and shown in the display. A section of the image is copied to a new randomly selected position with each iteration step. The resulting image now serves as the basis for the next step—the principle of each and every feedback.

Keys: DEL: Delete display · S: Save PNG

```
void setup() {
  ...
  img = loadImage("pic.png");
  image(img, 0,100);
}
```

When the program is started, the loaded image is offset one hundred pixels downward using the image() command and drawn in the display window.

```
void draw() {
  int x1 = (int) random(0, width);
  int y1 = 0;

  int x2 = round(x1 + random(-7, 7));
  int y2 = round(random(-5, 5));

  int w = (int) random(35, 50);
  int h = height;

  copy(x1,y1, w,h, x2,y2, w,h);
}
```

The x-position of the detail to be copied (x1), the target position (x2, y2), and its width (w) are all determined randomly.

The copying process is executed using the copy() command.

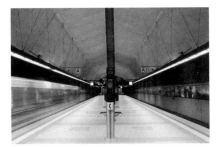

Original image: *Subway Tunnel.*
→ Photograph: Stefan Eigner

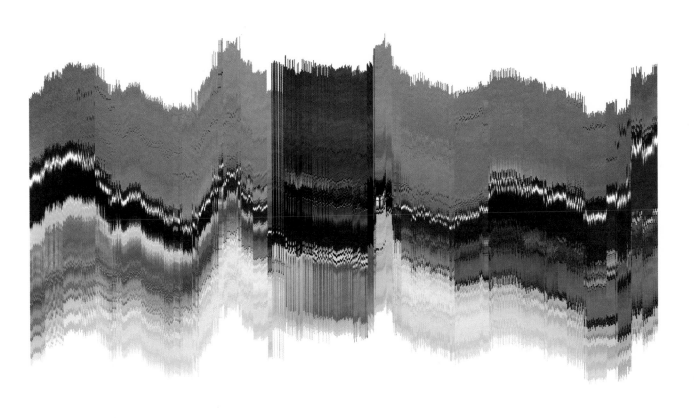

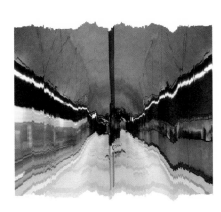

Right after the program starts, the motif is easily recognizable. It then dissolves more and more through the overlapping of copied image strips.
→ P_4_1_2_01.pde

P.4.2.1
Collage from image collection

Your archive of photographs now becomes artistic material. This program assembles a collage from a folder of images. The cropping, cutting, and sorting of the source images are especially important, since only picture fragments are recombined in the collage.

→ P_4_2_1_01.pde

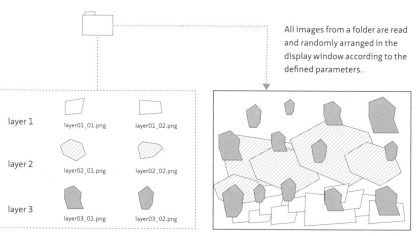

All images from a folder are read and randomly arranged in the display window according to the defined parameters.

All the pictures in a folder are read dynamically and assigned to one of several layers. This allows the semantic groups to be treated differently. The individual layers also have room for experimentation with rotation, position, and size when constructing the collage. Note the layer order; the first level is drawn first and is thus in the background.

The images are assigned to layers according to the filenames (e.g., "layer01_01.png").

Here, only a few large elements are created from the images on layer 2, while many small ones are created from those on layer 3.

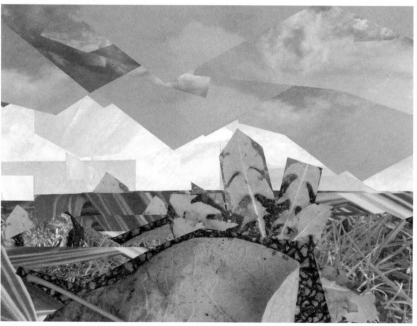

The image consists of three levels: scraps of paper are on layer 1, cutouts of the sky on layer 2, and plants on layer 3.
→ P_4_2_1_01.pde → Footage: Andrea von Danwitz

A new composition is immediately created when the images on a level are switched or the parameters are changed.

```
PImage[] images;
String[] imageNames;
int imageCount;
CollageItem[] layer1Items, layer2Items, layer3Items;

void setup() {
  ...
  File dir = new File(selectFolder("choose a folder ..."));
  if (dir.isDirectory()) {
    String[] contents = dir.list();
    images = new PImage[contents.length];
    imageNames = new String[contents.length];
    for (int i = 0 ; i < contents.length; i++) {
      if (contents[i].charAt(0) == '.') continue;
      else if(contents[i].toLowerCase().endsWith(".png")){
        File childFile = new File(dir, contents[i]);
        images[imageCount] = loadImage(childFile.getPath());
        imageNames[imageCount] = childFile.getName();
        imageCount++;
      }
    }
  }

  layer1Items = generateCollageItems(
                "layer1", 100, width/2,height/2, width,height,
                0.1,0.5, 0,0);
  layer2Items = generateCollageItems(
                "layer2", 150, width/2,height/2, width,height,
                0.1,0.3, -PI/2,PI/2);
  layer3Items = generateCollageItems(
                "layer3", 110, width/2,height/2, width,height,
                0.1,0.85, 0,0);

  drawCollageItems(layer1Items);
  drawCollageItems(layer2Items);
  drawCollageItems(layer3Items);
}

class CollageItem {
  float x = 0, y = 0;
  float rotation = 0;
  float scaling = 1;
  int indexToImage = -1;
}
```

Several arrays are needed to load the images and arrange the layout of the collage pieces. The loaded images are stored in images and their names in imageNames so they can be distributed later onto the different levels (layer1Items, ...).

In this step, all the picture files are loaded from a directory and stored in the array images. First, it is verified that the selected path is a folder. The names of the files in this folder are then identified and processed sequentially, and all those ending in ".png" are loaded and stored in the array.

The generateCollageItems() function fills the layers of the arrays (layer1Items, ...) with collage items. The parameters determine which loaded images are to be used and how many items are to be created, and they specify value ranges for positions, scattering, scaling, and rotation. In this example, images are used whose names begin with "layer1", and one hundred collage pieces are created. All instances are placed in the position (width/2, height/2) with a scattering of width and height. The scaling varies from 0.1 to 0.5 and no rotation is used.

Each time the drawCollageItems() function is run, one of the layers is drawn. The order of the layers' invocation determines the construction of the final composition. The images from layer1Items are located in the background, those from layer3Items in the foreground.

All features of a collage item are summarized in the class CollageItem. In addition to position, rotation, and scaling, a reference to the corresponding image in the image array is stored in the variable indexToImage.

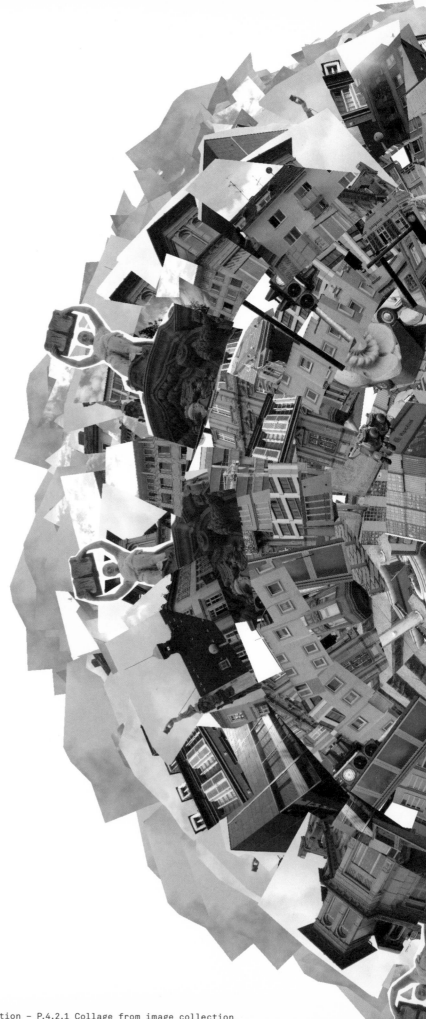

A second version of the program allows the image
details to be arranged radially around a particular
center. The angle at which the images gather and
their distance from the center can be specified for
each layer.

→ P_4_2_1_02.pde
→ Illustration: Andrea von Danwitz

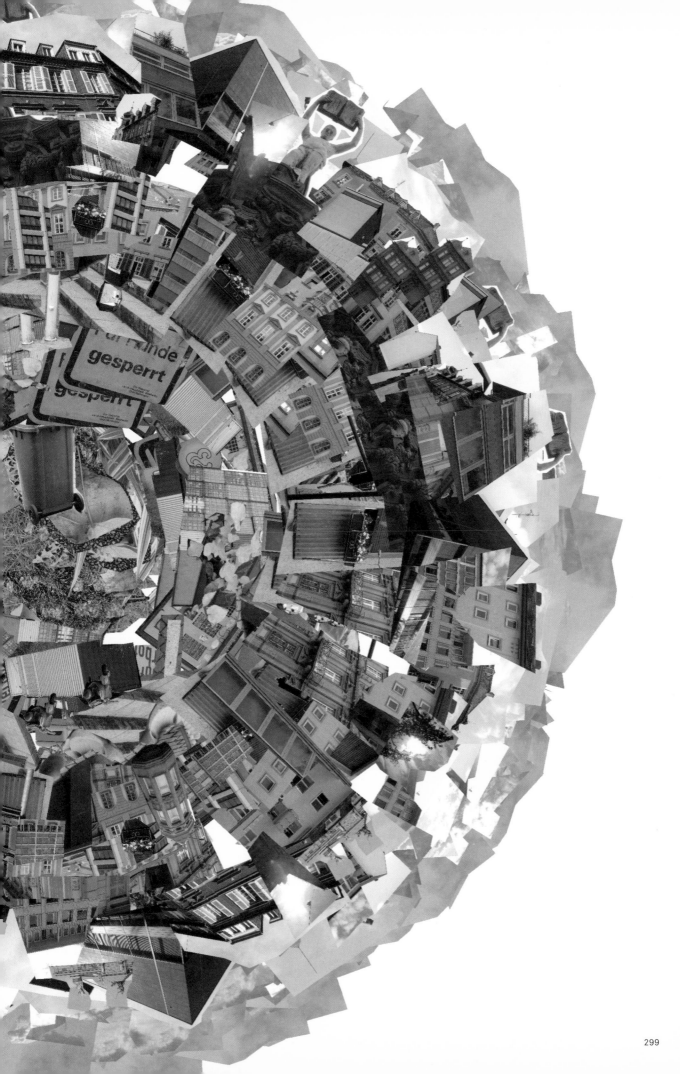

P.4.2.2

Time-based image collection

In this example, the inner structures of moving images are visualized. After extracting individual images from a video file, this program arranges the images in defined and regular time intervals in a grid. This grid depicts a compacted version of the entire video file and represents the rhythm of its cuts and frames.

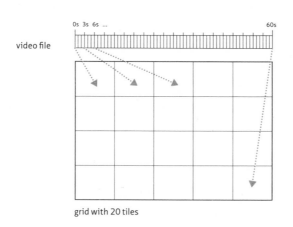

video file

grid with 20 tiles

→ P_4_2_2_01.pde

To fill the grid, individual still images are extracted at regular intervals from the entire length of a video. Accordingly, a sixty-second video and a grid with twenty tiles results in three-second intervals.

Keys: *S: Save PNG*

→ P_4_2_2_01.pde

```
void draw() {
  float posX = tileWidth*gridX;
  float posY = tileHeight*gridY;

  float moviePos = map(currentImage,
                    0,imageCount, 0,movie.duration());
  movie.jump(moviePos);
  movie.read();
  image(movie, posX, posY, tileWidth, tileHeight);

  gridX++;
  if (gridX >= tileCountX) {
    gridX = 0;
    gridY++;
  }

  currentImage++;
  if (currentImage >= imageCount) noLoop();
}
```

Every time the draw() function is run, an image is selected from the video and depicted in the grid. First, the corresponding time in the video is calculated with movie-Pos. The variable currentImage (a number between 0 and imageCount) is converted to a second value between 0 and the entire playing time of the video.

The newly calculated position in the timeline is jumped to with the jump() function. The image at that position is then selected and drawn in the tile.

To define the next tile, gridX is increased by 1. If the end of the line has been reached, the program jumps to the first image of the next line by setting gridX to 0 and increasing gridY incrementally.

The end of the program is reached when all the tiles are filled with images.

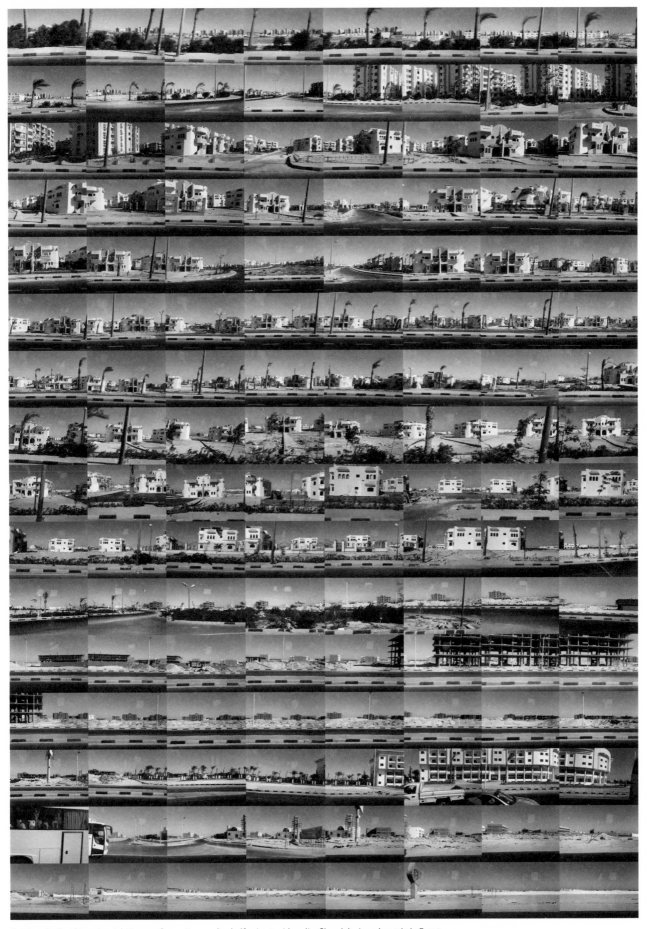

One hundred and twenty-eight images from a two-and-a-half-minute video clip, filmed during a bus trip in Egypt.

→ P_4_2_2_01.pde

Graphic from pixel values

Pixels, the smallest elements of an image, can serve as the starting point for the composition of portraits. In this example, each pixel is reduced to its color value. These values modulate design parameters such as rotation, width, height, and area. The pixel is completely replaced by a new graphic representation, and the portrait becomes somewhat abstract.

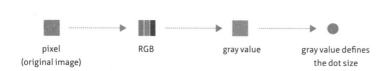

| pixel (original image) | RGB | gray value | gray value defines the dot size |

→ P_4_3_1_01.pde

The pixels of an image are analyzed sequentially and transformed into other graphic elements. The key to this is the conversion of the color values of pixels (RGB) into the corresponding gray values, because—in contrast to the pure RGB values—these can be practically applied to design aspects such as line width. It is advisable to reduce the resolution of the source image first.

→ W.212
Wikipedia: Gray value conversion

Mouse: Position x/y: Different parameters (dependent on drawing mode)
Keys: 1–9: Change drawing mode • P: Save PDF • S: Save PNG

→ P_4_3_1_01.pde

```
for (int gridX = 0; gridX < img.width; gridX++) {
  for (int gridY = 0; gridY < img.height; gridY++) {
    float tileWidth = width / (float)img.width;
    float tileHeight = height / (float)img.height;
    float posX = tileWidth*gridX;
    float posY = tileHeight*gridY;

    color c = img.pixels[gridY*img.width+gridX];
    int greyscale = round(
          red(c)*0.222+green(c)*0.707+blue(c)*0.071);

    switch(drawMode) {
    case 1:
      float w1 = map(greyscale, 0,255, 15,0.1);
      stroke(0);
      strokeWeight(w1 * mouseXFactor);
      line(posX, posY, posX+5, posY+5);
      break;
    case 2:
      ...
    }
  }
}
```

The width and height of the original image determines the resolution of the grid.

The color of the pixels at the current grid position (and thus the image) is defined. Since all the pixels are lined up in a linear array, the pixel index has to be calculated from the grid position (gridX,gridY).

In calculating the gray value, the values for red, green, and blue are weighted differently, whereby there are no absolutely correct weights since colors are both displayed and perceived differently. This gray value is used later to control individual parameters.

The program provides several drawing modes that can also be influenced by the horizontal mouse position. These were previously converted into a value between 0.05 and 1 and are available in the variable mouseXFactor.

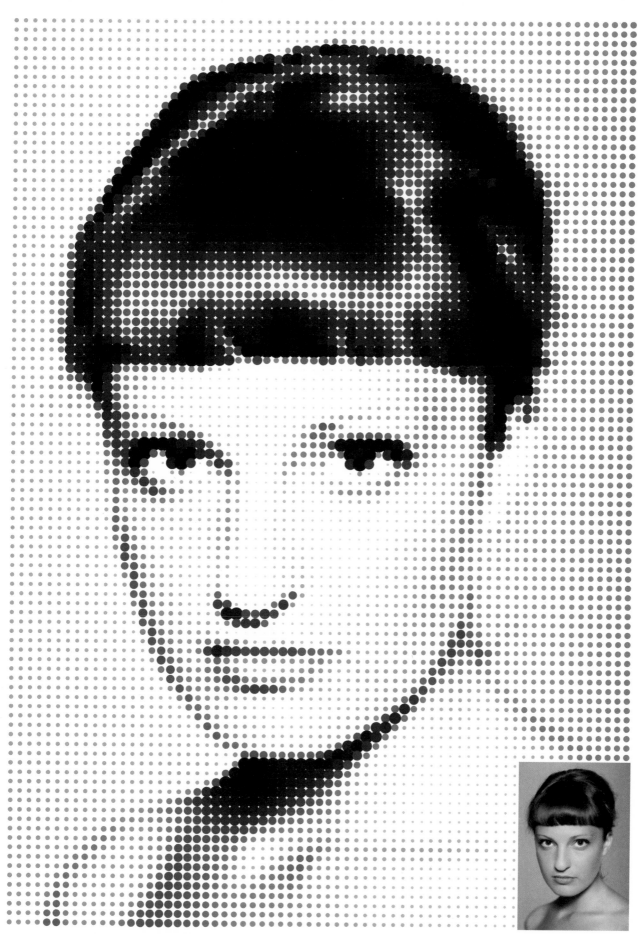

The gray value of each pixel defines the size of its diameter; the pixels' original color values are kept.

→ P_4_3_1_01.pde → Original photograph: Tom Ziora

The gray value defines the size, stroke value, rotation, and position of the elements.
→ P_4_3_1_01.pde

In this drawing mode (key 9), each pixel is represented by several color-distorting elements.

→ P_4_3_1_01.pde

Pixels of various brightness are replaced here by SVG units. The SVG files have been sorted according to brightness using a supplementary program. Note that the files have been renamed (the brightness value forms the beginning of the file name).

→ P_4_3_1_02.pde → P_4_3_1_02_analyse_svg_grayscale.pde

Type from pixel values

The following text image is ambiguous. It can be read for its meaning, or viewed at a distance and perceived as a picture. The pixels from the image control the configuration of the letters. The size of each letter depends on the gray values of the pixels in the original image and thereby creates an additional message.

→ P_4_3_2_01.pde

A character string is processed letter by letter → Ch.P.3.1.1/P.3.1.2 and constructed row by row in the normal writing direction.

Before a character is drawn, its position in display coordinates is matched to the corresponding position in the original image in pixel coordinates. Only a subset of the original pixels is used—merely those for which a corresponding character position exists. The color of the selected pixel can now be converted into its gray value and the gray value used to modulate the font size, for example.

Ihr naht euch wieder, schwankende Gestalten, Die früh sich einst d em trüben Blick gezeigt. Versuch ich wohl, euch die smal festzuhalten? Fühl ich mein Herz n och jenem Wahn geneigt? Ihr dräng t euch zu! nun gut, so mögt ihr w ...

pixel (original image) → RGB → gray value → gray value defines font size

The color of a pixel can define the size or color of the letters, or both.
→ P_4_3_2_01.pde

Keys: 1: Switch character size mode • 2: Switch character color mode
 Arrow up/down: Maximum character size +/– • Arrow right/left: Minimum character size +/–
 P: Save PDF • S: Save PNG

```
void draw() {
  ...
  float x = 0, y = 10;
  int counter = 0;

  while (y < height) {
    int imgX = (int) map(x, 0,width, 0,img.width);
    int imgY = (int) map(y, 0,height, 0,img.height);
    color c = img.pixels[imgY*img.width+imgX];
    int greyscale = round(red(c)*0.222 + green(c)*0.707 +
                          blue(c)*0.071);

    pushMatrix();
    translate(x, y);

    if (fontSizeStatic) {
      textFont(font, fontSizeMax);
      ...
    } else {
      float fontSize = map(greyscale, 0,255,
                           fontSizeMax,fontSizeMin);
      fontSize = max(fontSize, 1);
      textFont(font, fontSize);
      ...
    }

    char letter = inputText.charAt(counter);
    text(letter, 0, 0);
    float letterWidth = textWidth(letter) + kerning;
    x = x + letterWidth;
    popMatrix();

    if (x+letterWidth >= width) {
      x = 0;
      y = y + spacing;
    }

    counter++;
    if (counter > inputText.length()-1) counter = 0;
  }
}
```

The writing process continues as long as the y-coordinate of the current writing position y is still less than the height of the display.

Using the map() function, the display coordinates are converted into image coordinates.

For example, the x-coordinate x is proportionally converted from a value between 0 and the display width to a corresponding value between 0 and the width of the image img.width.

Depending on the selected mode fontSizeStatic (key 1 or 2), the font size is set to a fixed value fontSizeMax or is varied by the gray value. The value fontSize cannot be zero or negative, as this would cause problems. Therefore, the function max() ensures this value is at least 1.

The value of the variable x is increased by the character width.

The line is broken if x is greater than or equal to the display width. The y value is then increased by the leading (line spacing) value, and x starts again from 0, the far left of the display.

309

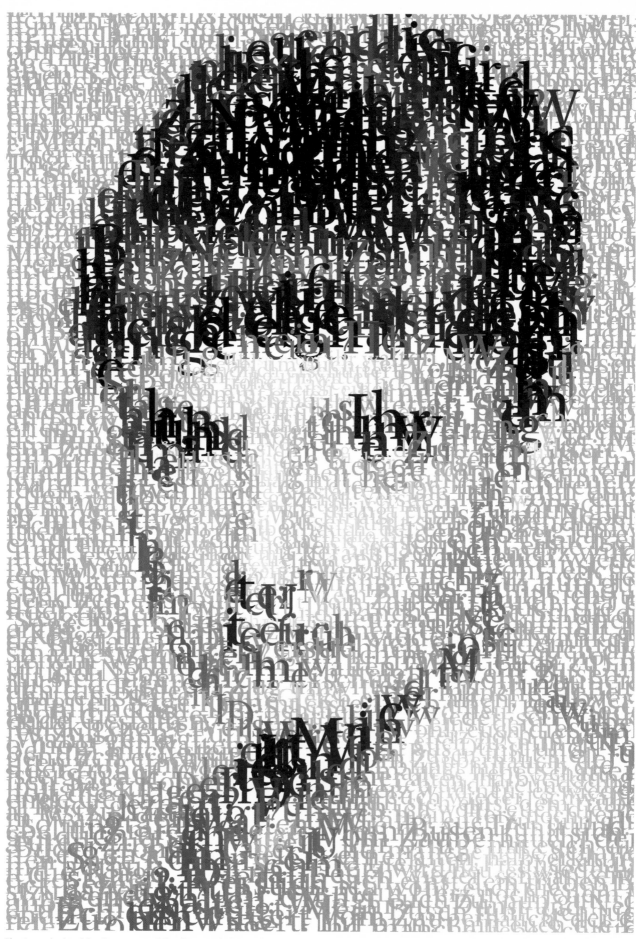

The size and color of the characters are defined by an underlying image.
→ P_4_3_2_01.pde

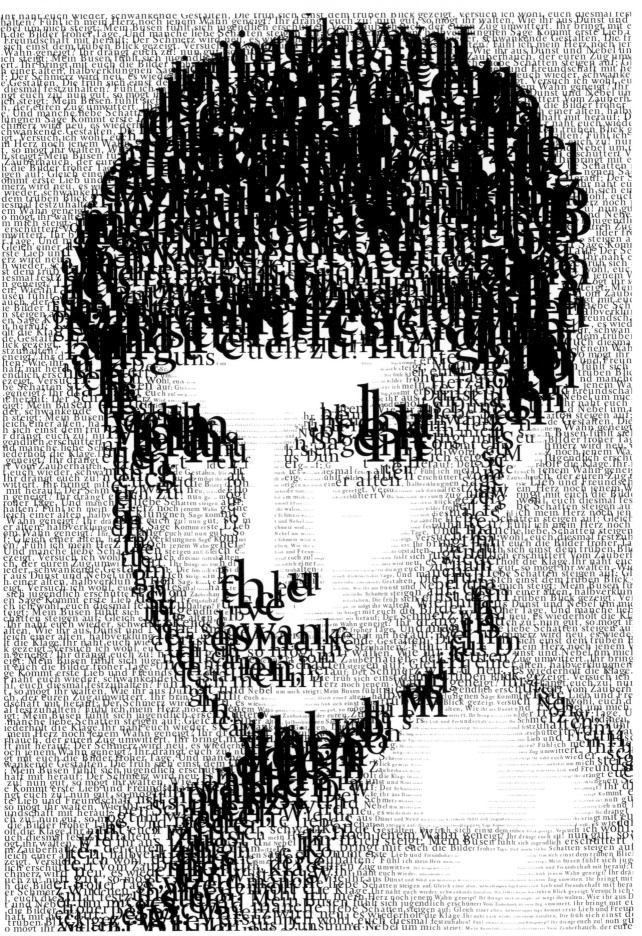

Here the gray value of the pixels determines font size.

→ P_4_3_2_01.pde

P.4.3.3
Real-time pixel values

The color values of pixels can again be translated into graphic elements, but with two important differences: first, the pixels are constantly changing because the images come from a video camera, and second, pixels are translated sequentially by dumb agents that are constantly in motion rather than simultaneously. The motion captured by the camera and the migration of the agents thus can paint a picture right before our eyes.

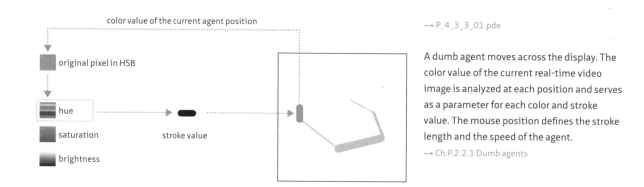

color value of the current agent position

original pixel in HSB

hue → stroke value

saturation

brightness

→ P_4_3_3_01.pde

A dumb agent moves across the display. The color value of the current real-time video image is analyzed at each position and serves as a parameter for each color and stroke value. The mouse position defines the stroke length and the speed of the agent.

→ Ch.P.2.2.1 Dumb agents

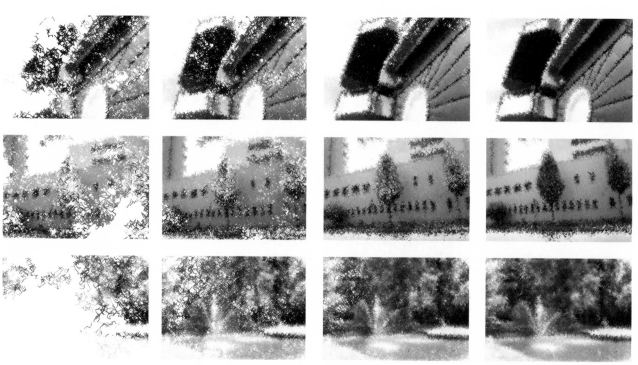

The agent's path gradually creates an image.
→ P_4_3_3_01.pde

Mouse: *Position x: Drawing speed* • *Position y: Direction*
Keys: *Arrow up/down: Number of curve points +/–* • *Q: Stop drawing*
W: Continue drawing • *R/E: Recording PDF* • *S: Save PNG*

→ P_4_3_3_01.pde

```
import processing.video.*;
...
Capture video;
```

A corresponding library has to be imported in order to work with video images. The capture class from this library provides the necessary functionality for live videos.

```
void setup() {
  ...
  video = new Capture(this, width, height, 30);
  video.start();
}
```

The variable video is initialized: the live video images from the connected video camera are converted to the size of the display and drawn with a frame rate of thirty images per second. (Display size and frame rate have to be adapted to the hardware specifications of the camera as necessary.)

```
void draw() {
  ...
  for (int j=0; j<=mouseX/50; j++) {
    if (video.available()) video.read();
    video.loadPixels();

    int pixelIndex = ((video.width-1-x) + y*video.width);
    color c = video.pixels[pixelIndex];
    strokeWeight(hue(c)/50);
    stroke(c);

    diffusion = map(mouseY, 0,height, 5,100);

    beginShape();
    curveVertex(x, y);
    curveVertex(x, y);
    for (int i = 0; i < pointCount; i++) {
      int rx = (int) random(-diffusion, diffusion);
      curvePointX = constrain(x+rx, 0, width-1);
      int ry = (int) random(-diffusion, diffusion);
      curvePointY = constrain(y+ry, 0, height-1);
      curveVertex(curvePointX, curvePointY);
    }
    curveVertex(curvePointX, curvePointY);
    endShape();

    x = curvePointX;
    y = curvePointY;

  }
}
```

If the video signal is available, the pixels of the current video image are loaded.

As in a static pixel image, the pixels in a video image are also numbered row by row. Therefore, the pixel index has to be calculated from the current writing position (x, y). When using webcams directed at the user, it is useful to mirror the video image horizontally using the calculation video.width-1-x.

The stroke value is set so it is defined by the hue of the pixel.

The line element can now be drawn. The first curve point is placed on the current drawing position. This is done twice because the first and last points are not drawn when drawing lines with curveVertex().

The variable pointCount now specifies how many curve points are to be drawn. The default value is 1, so only one line is drawn. The curve points are placed in random positions around the drawing position. The value diffusion specifies how large this area is.

The last curve point is specified as the new drawing position.

313

The people leave tracks in the image with their movements. The length of the lines varies throughout the drawing process, whereby the image is sometimes more detailed and sometimes more abstract.

→ P_4_3_3_01.pde

Three agents move around the display in this version of the program. The first agent's stroke value is defined by the pixel's hue; the second's by the pixel's saturation; and the third's by the pixel's brightness.

→ P_4_3_3_02.pde

When the subject also moves in front of the camera, random (but not completely arbitrary) scribbles are created.

M.///

Complex Methods

Each chapter in the Basic Principles section addressed one relatively simple programming feature. The level of complexity will increase in the following chapters. We will demonstrate how the previously presented methods can be varied and combined, using increasingly sophisticated techniques that yield a wide range of effects. But do not worry: these applications are created using easy steps, so that you can employ the programs—or parts of them—as the basis for your own experiments. You can also leave them as they are presented and simply modify their numerous parameters, using built-in controls to create a wealth of new images.

M.1

Randomness and noise

M.1.0
Randomness and noise—an overview

An algorithm that allows the creation of random values is called a "random generator." The main differences between the two most important random generators, randomness and noise, are presented with practical examples in this chapter, thereby making it clear for which visual fields each is best suited.

→ M_1_5_02_TOOL.pde
→ M_1_5_03_TOOL.pde
→ M_1_5_04_TOOL.pde
→ M_1_6_01_TOOL.pde
→ M_1_6_02_TOOL.pde

The generated values are random but uniformly distributed over time. The same is true, for instance, when rolling dice.

The values are not completely random but are always close to those of their neighbors. This kind of randomness occurs in nature when the interactions within a system are so complex that things cannot always be exactly predicted, as with cloud formation or ripples on the water's surface.

The random values can be used in different ways: to color objects . . .

. . . to set the height position of the points in a grid . . .

. . . or to control the movement of a swarm of agents, for example.

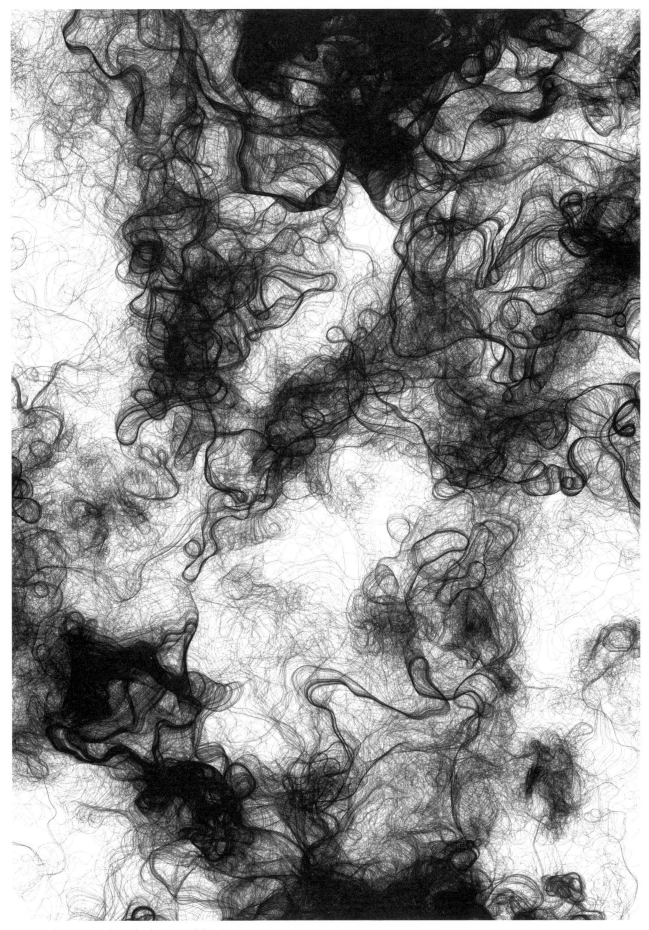

A swarm of agents moves in randomly generated directions.
→ M_1_5_03_TOOL.pde

M.1.1 **Randomness and starting conditions**

In Processing the random generator is the function random(). The term "random" usually signifies an unpredictable event. A random generator created with the help of a computer, however, will never be able to create truly random events or actions because the seemingly random sequence of numbers has always been generated by an algorithm. This is called "determinism" in computer science, meaning that the sequence of values is determined by the initial condition. This initial condition can be set using the randomSeed() function. The command randomSeed(42) therefore generates an identical sequence of values when working with the same random generator, which here are 0.72, 0.05, 0.68, etc. In many programming languages the initial condition is set unnoticed in the background, thereby creating the illusion that real random values are created each time the program is started.

The y-coordinate of each point is generated by the random() function and all points are connected to a line.

Mouse: *Left click: New random values*

→ M_1_1_01.pde

```
void draw() {
  ...
  randomSeed(actRandomSeed);
  beginShape();
  for (int x = 0; x < width; x+=10) {
    float y = random(0, height);
    vertex(x,y);
  }
  endShape();
  ...
}
```

Every time draw() is run, the initial condition is reset using the randomSeed() function, forcing random() to produce the same random numbers in the same order each time. Without randomSeed(), the line would change continually.

The parameters of random() function do not influence the sequence of the numerical values. The parameter merely scales the result of a certain interval. An identical line could therefore be generated as follows:
float y = random(1)*height;

M.1.2 Randomness and order

The random function is not a panacea for a weak visual composition. Although an excess of randomness may sometimes create a surprisingly complex visual effect, on closer inspection this effect will simply appear arbitrary. On the other hand, random processes are indispensable tools that can be used to break up the extreme and sometimes rigid regularity of computer-generated work. Since no rule of thumb exists, two extremes should be tested individually for each new composition. The following program attempts to illustrate the two opposing positions.

Mouse: Position x: Transition between randomness and circular organization → M_1_2_01.pde

```
void draw() {
    ...
    float faderX = (float)mouseX/width;

    randomSeed(actRandomSeed);
    float angle = radians(360/float(count));

    for (int i=0; i<count; i++){
        float randomX = random(0,width);
        float randomY = random(0,height);
        float circleX = width/2 + cos(angle*i)*300;
        float circleY = height/2 + sin(angle*i)*300;

        float x = lerp(randomX,circleX, faderX);
        float y = lerp(randomY,circleY, faderX);

        fill(0,130,164);
        ellipse(x,y,11,11);
    }
}
```

The x-position of the mouse is converted to the range value of 0 to1.

The same sequence of values is created until the actRandomSeed variable changes.

The positions are calculated for the two poles—random distribution and static circle.

A smooth transition between the two poles is generated using the lerp() function and the faderX variable.

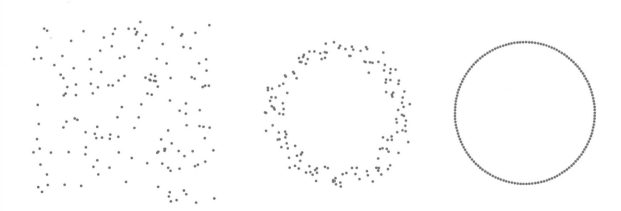

The mouse position defines the degree of the random arrangement of the dots. On the far left the points are arranged completely randomly, while on the right they form a circle.
→ M_1_2_01.pde

M.1.3 Noise vs. randomness

Until now, only the `random()` function was used to create random values. The only way to control randomness was to set the initial conditions with `randomSeed()`. This method, however, simply reproduces or sets a specific sequence of random values; over time, a uniform distribution of values always results. This is not sufficient to mimic natural phenomena such as clouds, water, mountains, hair, smoke, etc. The random generator "Perlin noise" is needed to produce these kinds of effects. In Processing this function is implemented using the `noise()` function. In contrast to `random()`, `noise()` generates sequences of values with smooth transitions—i.e., the values increase and decrease in a seemingly natural way. In Processing the `noise()` function can be used to create one-, two-, or three-dimensional noise.

→ W.401
Processing reference: Noise

→ W.402
Website: Ken Perlin

→ W.403
Wikipedia: Noise

A juxtaposition of the two random generators `noise()` and `random()`:

The y-values of the points in the first curve are created using the one-dimensional `noise()` function.

The y-values of the points in the first curve are created using the one-dimensional `random()` function.

Mouse: *Position x: Value range for noise · Left click: New noise seed*

→ M_1_3_01.pde

```
void draw() {
  ...
  int noiseXRange = mouseX/10;

  beginShape();
  for (int x = 0; x < width; x+=10) {
    float noiseX = map(x, 0,width, 0,noiseXRange);
    float y = noise(noiseX) * height;
    vertex(x,y);
  }
  endShape();
  ...
}
```

In contrast to `random()`, the `noise()` function requires one (or up to three) parameters that select a value from the random curve. Using the `noiseXRange` function, the area from the random curve that is to be displayed is defined. The mouse can control this operation.

The x values of the display are processed in steps of ten. These are passed as values ranging from 0 to `noiseXRange` using the `map()` function.

The result of `noise()` always lies between 0.0 and 1.0 and therefore must be multiplied by the display height.

What was just demonstrated with random curves can also be applied to areas. The results are textures rather than curves.

TEXTURE FROM RANDOMNESS Every pixel in the display is assigned a random gray value between black and white. Since random() distributes the random values evenly, the visual result is always a medium gray. This does not change even if the randomSeed() function is used to generate other random values.

→ M_1_3_02.pde

```
randomSeed(actRandomSeed);
loadPixels();
for (int x = 0; x < width; x++) {
  for (int y = 0; y < height; y++) {
    float randomValue = random(255);
    pixels[x+y*width] = color(randomValue);
  }
}
updatePixels();
```

A random value between 0 and 255 is generated for each pixel and its gray value set with it.

TEXTURE FROM NOISE The gray value of each pixel in the display is determined by its position in relation to the two-dimensional version of the noise() function. Since the random values change only slightly in the vertical and horizontal direction in relation to their neighbors, the result is a cloud-like texture.

→ M_1_3_03.pde

```
noiseDetail(octaves,falloff);
int noiseXRange = mouseX/10;
int noiseYRange = mouseY/10;
loadPixels();
for (int x = 0; x < width; x++) {
  for (int y = 0; y < height; y++) {
    float noiseX = map(x, 0,width, 0,noiseXRange);
    float noiseY = map(y, 0,height, 0,noiseYRange);
    float noiseValue = 0;
    if (noiseMode == 1) {
      noiseValue = noise(noiseX,noiseY) * 255;
    } else if (noiseMode == 2) {
      float n = noise(noiseX,noiseY) * 24;
      noiseValue = (n-(int)n) * 255;
    }
    pixels[x+y*width] = color(noiseValue);
  }
}
updatePixels();
```

The noise type can be configured using the noiseDetail() function.
→ W.404
Processing reference: noiseDetail

All pixels are processed and their position (x,y) translated into the values from 0 to noiseXRange or 0 to noiseYRange. The resulting values noiseX and noiseY are used later in the noise() function.

In addition to the simple method—multiplying the noise() value by 255 and using this directly as the gray value—the program offers another interesting alternative: if the random value is first multiplied by a number and only the result's fractional digits are used, a whole new visual effect emerges.

→ W.405
Detailed information on Perlin noise

Texture comprised of random gray values.
→ M_1_3_02.pde

Texture comprised of gray values created with noise.
→ M_1_3_03.pde

M.1.4 **Noisy landscapes**

The preceding example of cloud textures is easily expanded to include pseudo-realistic landscapes with mountains and valleys. Rather than coloring pixels in levels of gray, the height position of the points on a grid is modulated using the same principles.

The resulting grid is only sketched here and is examined in more detail in the chapter "Formulated bodies." → Ch.M.3

Mouse: *Drag: Noise input area • Drag right mouse button: Camera view*
Keys: *L: Lines on/off • +/–: Zoom in/zoom out • Space: New noise seed*
 Arrow up/down: Noise decrease +/– • Arrow right/left: Noise octave +/–

→ M_1_4_01.pde

```
void draw() {
  ...
  if (mousePressed && mouseButton==LEFT) {
    noiseXRange = mouseX/10;
    noiseYRange = mouseY/10;
  }
  ...
  float tileSizeY = (float)height/tileCount;
  float noiseStepY = (float)noiseYRange/tileCount;

  for(int meshY=0; meshY<=tileCount; meshY++) {
    beginShape(TRIANGLE_STRIP);
    for(int meshX=0; meshX<=tileCount; meshX++) {

      float x = map(meshX, 0,tileCount, -width/2,width/2);
      float y = map(meshY, 0,tileCount, -height/2,height/2);

      float noiseX = map(meshX, 0,tileCount, 0,noiseXRange);
      float noiseY = map(meshY, 0,tileCount, 0,noiseYRange);
      float z1 = noise(noiseX,noiseY);
      float z2 = noise(noiseX,noiseY+noiseStepY);

      ...
      fill(interColor);

      vertex(x, y, z1*zScale);
      vertex(x, y+tileSizeY, z2*zScale);
    }
    endShape();
  }
  ...
}
```

The resolution of the grid `tileCount` defines both the tile height `tileSizeY` and the step size in which the random values are selected.

The grid coordinate (`meshX`, `meshY`) is converted into the display coordinate (x, y).

The same is true of the parameters `noiseX` and `noiseY` for the `noise()` function. Finally, the height position `z1` is generated. The second height position `z2` is necessary because the coordinates of the next row of tiles are needed to draw the first row of tiles.

In the omission, the fill color of the grid points is calculated depending on its vertical position.

The grid is made up of individual strips. Here, the drawing method `TRIANGLE_STRIP` requires that the points are positioned in pairs.

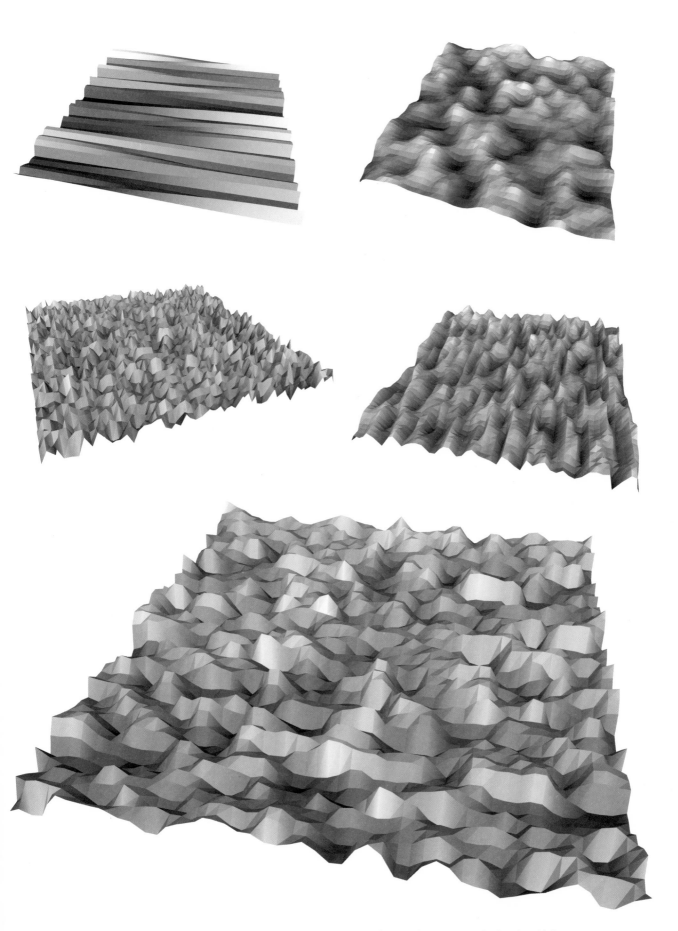

Noise-generated values serve as the z-coordinates for the points on the grids. The user can fine-tune the noise in x- and y-direction with the mouse.
→ M_1_4_01.pde

M.1.5 **Noisy motion**

As you can see, the possibilities of the `noise()` function's character are diverse. Until now, the generated values were always applied directly to a visual parameter (curve point, pixel color, or height position of the grid points). In the following examples the noise function is used to control dynamic parameters. The generated values now define the direction of movement of a swarm of agents.

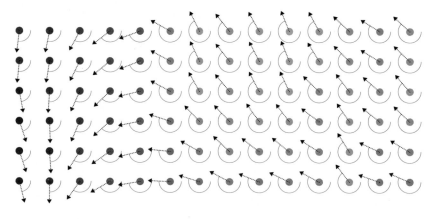

This example uses the same principle employed in the previous programs. The only difference is that `noise()` is applied to the rotation of the grid elements. In the following programs, the arrows are no longer drawn but are used to control the movement of the elements.

Mouse: *Position x/y: Noise input area*
Keys: *D: Show circle brightness • Space: New noise seed*
 Arrow up/down: Noise decrease +/- • Arrow right/left: Noise octave +/-

→ M_1_5_01.pde

```
float noiseValue = noise(noiseX,noiseY);
float angle = noiseValue*TWO_PI;
```

The random value `noiseValue` returned from the `noise()` function is used as the angle value.

AGENTS IN TWO-DIMENSIONAL SPACE In order to animate a swarm of agents in this way, all the agents are moved in the direction defined by the `noise()` function to assume their positions. The only remaining consideration is what to do with the agents that migrate out of the display window.

Keys: *M: Menu • 1–2: Switch noise mode • Backspace: Empty screen*

→ M_1_5_02_TOOL/Agent.pde

```
class Agent {
  PVector p, pOld;
  float stepSize, angle;
  boolean isOutside = false;

  Agent() {
    p = new PVector(random(width), random(height));
    pOld = new PVector(p.x, p.y);
    stepSize = random(1, 5);
  } →
```

The functionality of the agents is encapsulated in a class.

Variables for the current position, the previous position, step size, direction, and a Boolean value, which specifies whether an agent is located outside the display.

In the beginning, all agents are randomly dispersed throughout the display and the step size is varied slightly.

```
void update1(){
  angle = noise(p.x/noiseScale,p.y/noiseScale) * noiseStrength;
  p.x += cos(angle) * stepSize;
  p.y += sin(angle) * stepSize;

  if (p.x < -10) isOutside = true;
  else if (p.x > width+10) isOutside = true;
  else if (p.y < -10) isOutside = true;
  else if (p.y > height+10) isOutside = true;

  if (isOutside) {
    p.x = random(width);
    p.y = random(height);
    pOld.set(p);
  }

  strokeWeight(strokeWidth*length);
  line(pOld.x,pOld.y, p.x,p.y);
  pOld.set(p);
  isOutside = false;
  }
}
```

An angle is calculated using the agent's current position via the noise() function. In addition, the angle properties can be influenced using the variables noiseScale and noiseStrength.

When an agent is located outside the display, the variable isOutside becomes true and the agent is again set to a random location on the display.

A short line in the display depicts the difference between the agent's previous position and its current position.

→ W.406
Wikipedia: Polar coordinate system

The agent class can be used as follows:

→ M_1_5_02_TOOL.pde

```
Agent[] agents = new Agent[10000];
...
void setup(){
  ...
  for(int i=0; i<agents.length; i++) {
    agents[i] = new Agent();
  }
}
```

Create an array for the agents.

Generate the instances.

```
void draw(){
  ...
  if (drawMode == 1) {
    for(int i=0; i<agentsCount; i++) agents[i].update1();
  } else {
    for(int i=0; i<agentsCount; i++) agents[i].update2();
  }
}
```

The positions of the agents are updated and drawn in each frame iteration. It is possible to switch between two types of drawing modes using the variable drawMode.

A typical image produced when randomly generated values control the direction of a swarm of agents. The agents are displayed as points and leave tracks, which are continually drawn over the old image.

→ M_1_5_02_TOOL.pde

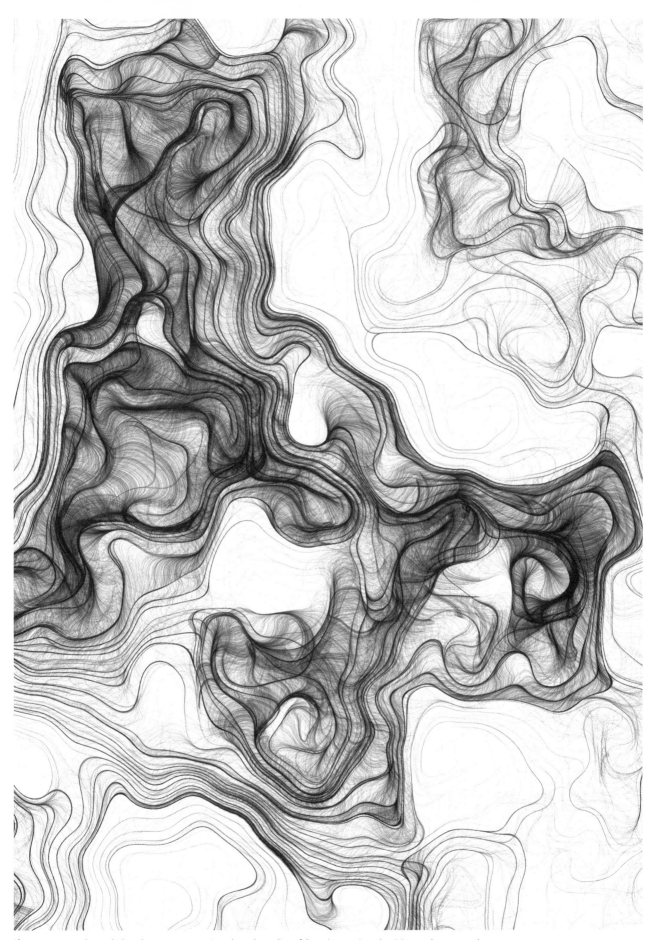

If parameters are changed when the agents are moving—here the scaling of the noise—various densities overlap one another.
→ M_1_5_02_TOOL.pde

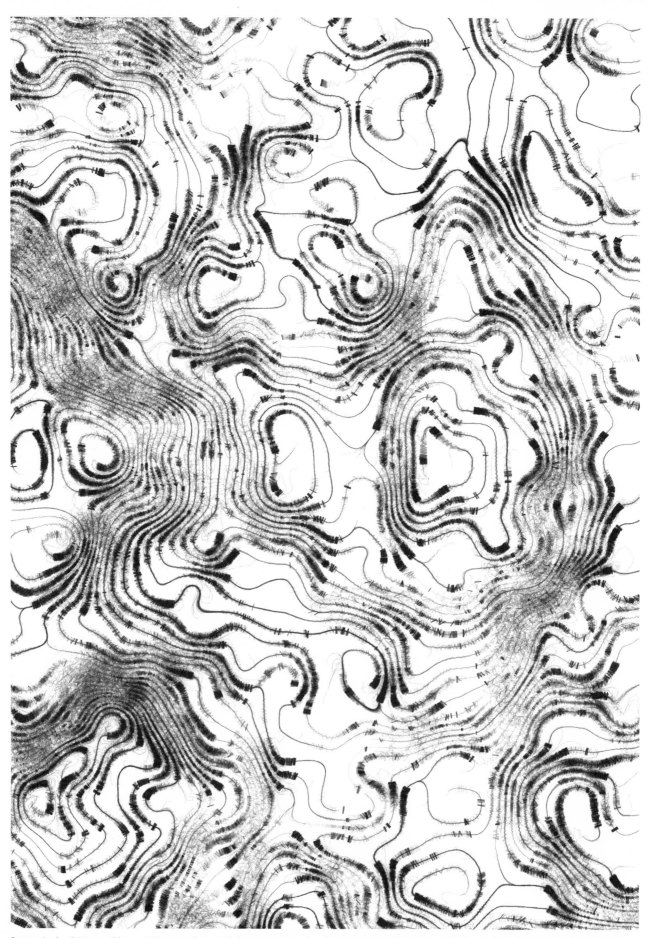

By pressing key 2 it is possible to switch to a mode in which the movement angles of the agents are subjected to an additional calculation step, thereby making the density more graduated. →M_1_5_02_TOOL.pde

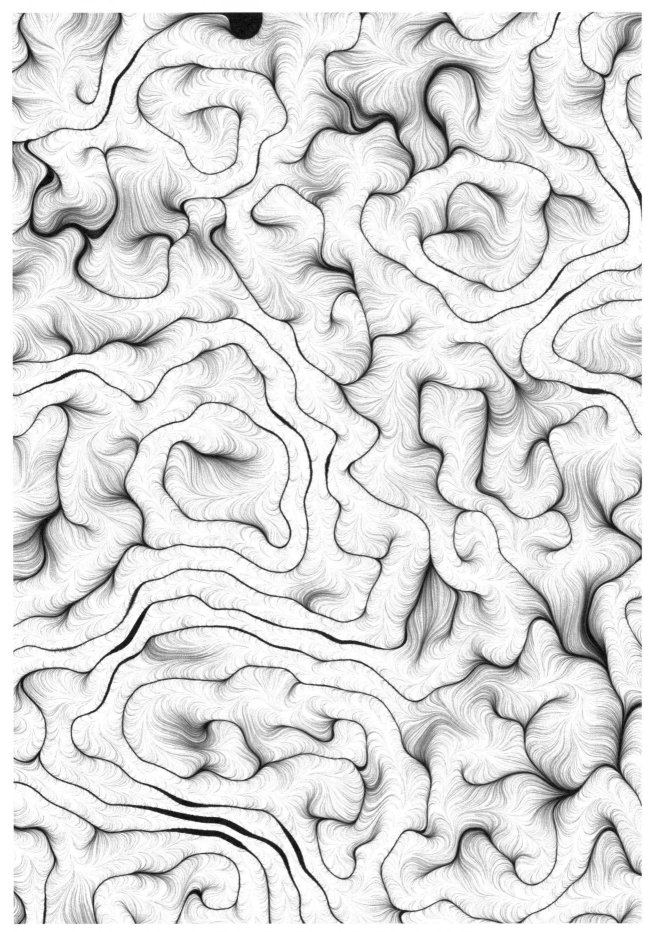

A large swarm of agents whose tracks have overlapped for a longer time period generates dramatically contoured densities.
→ M_1_ 5_02_TOOL.pde

THREE-DIMENSIONAL NOISE The complexity of the agents' behavior can be further increased when the three-dimensional variation of the `noise()` function is used to generate angle values. This three-dimensional noise can be thought of as a large cube of random numbers in which the individual values differ only slightly from their neighbors.

If the agents still move about in the area, but the random numbers for their movement are selected from the different layers of this random number cloud, they are no longer bound to the same paths.

The closer these virtual z-coordinates lie to each other, the more they cluster together. The image becomes even more dynamic when the z-coordinates are changed slightly but continuously. The agent class has to be modified slightly to perform this new function.

Keys: *M: Menu drop down/flip up · 1–2: Switch noise mode · Backspace: Empty screen* → M_1_5_03_TOOL/Agent.pde

```
class Agent {
  PVector p, pOld;
  float noiseZ, noiseZVelocity = 0.01;
  float stepSize, angle;
  ...
  void update1(){
    angle = noise(p.x/noiseScale, p.y/noiseScale, noiseZ)
          * noiseStrength;
    ...
    noiseZ += noiseZVelocity;
  }
  ...
  void setNoiseZRange(float theNoiseZRange) {
    noiseZ = random(theNoiseZRange);
  }
}
```

Two new variables for the z-coordinates and their speed of change.

The angle value is now generated depending on the z-coordinates.

This is slightly increased with every update.

The value that is passed to `setNoiseZRange()` specifies how close the agents' z-coordinates are to each other. The smaller the distance, the more uniform the paths the agents follow.

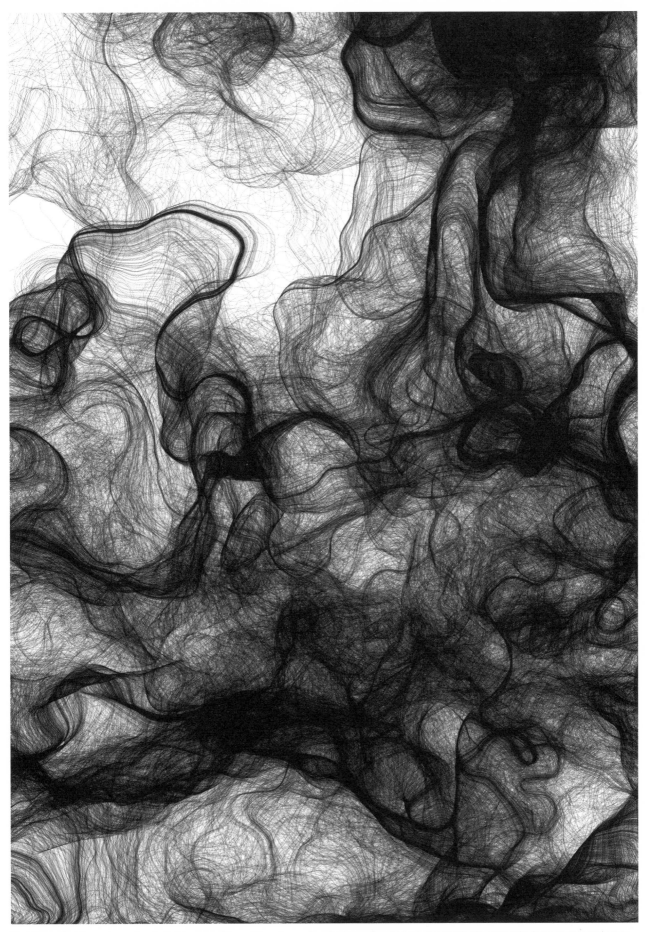

The agents select the random values for their movement from different, ever-changing layers of random-number clouds. This causes the dense structure to become more blurred and to change continually.

→ M_1_5_03_TOOL.pde

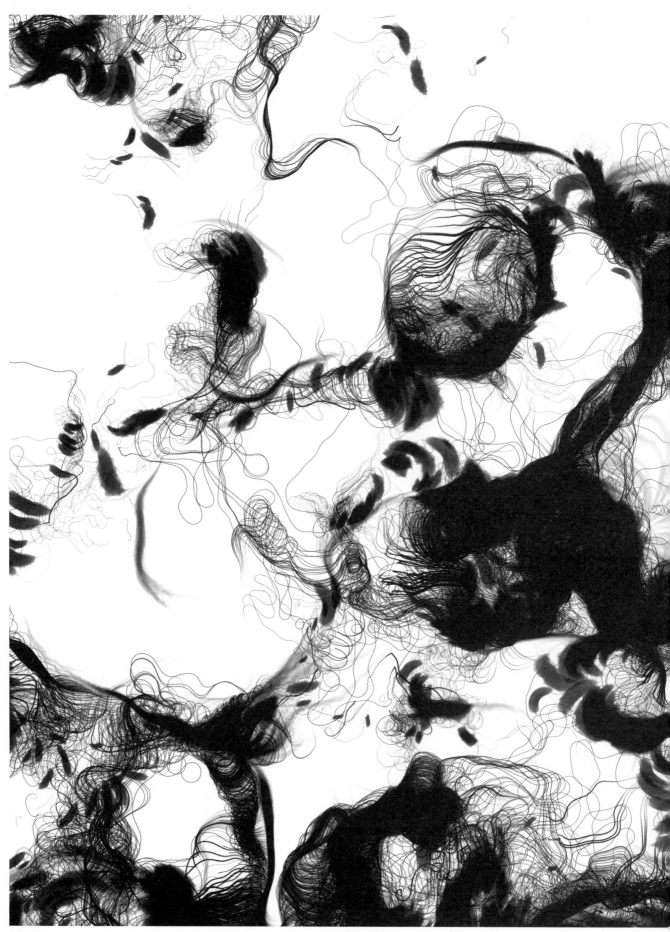

Parameters that continuously change during the drawing process create images in which disparate structures mingle.
→ M_1_5_03_TOOL.pde

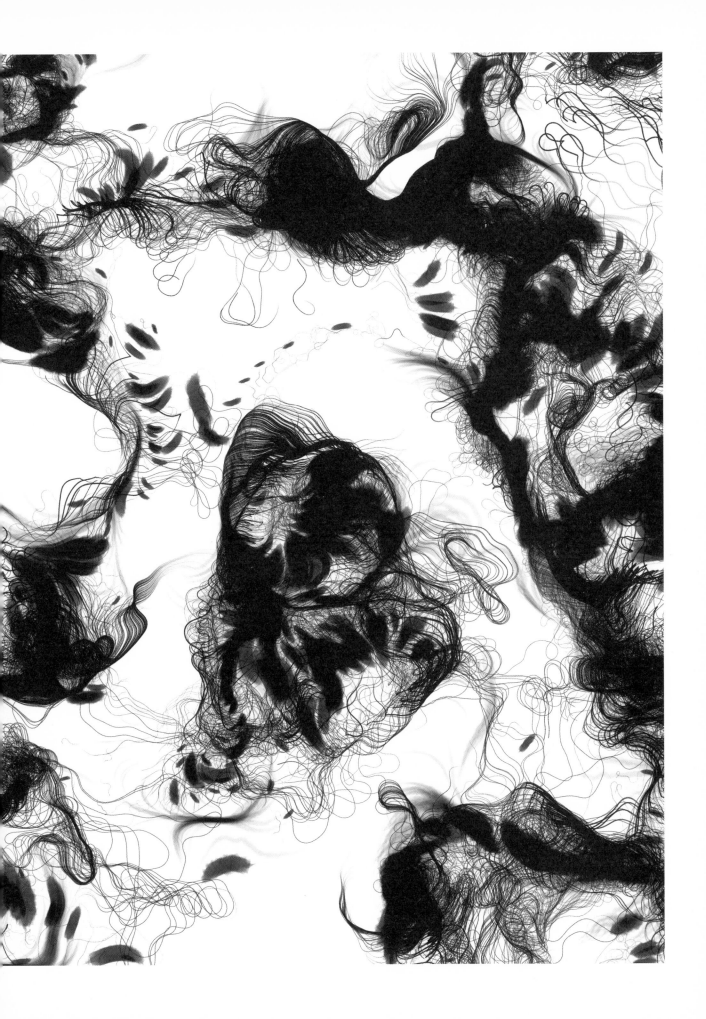

M.1.6 Agents in space

For the last example in this chapter, the use of the `noise()` function as a way to determine the direction of agents' movement is carried into the third dimension. The swarm of agents leaves the flat area and moves in three-dimensional space. An agent is represented by a ribbon composed of its previously executed positions. The agent class is adjusted in the following manner:

Mouse: *Drag right mouse button: Camera view*
Keys: *M: Menu fold in/fold out • Space: New noise seed • F: Stop animation*
 Arrow up/down: Zoom in/zoom out

→ M_1_6_01_TOOL / Agent.pde

```
class Agent {
  boolean isOutside = false;
  PVector p;
  float offset, stepSize, angleY, angleZ;
  Ribbon3d ribbon;

  Agent() {
    p = new PVector(0, 0, 0);
    setRandomPostition();
    offset = 10000;
    stepSize = random(1, 8);
    ribbon = new Ribbon3d(p, (int)random(50, 150));
  }

  void update(){
    angleY = noise(p.x/noiseScale, p.y/noiseScale,
                   p.z/noiseScale) * noiseStrength;
    angleZ = noise(p.x/noiseScale+offset, p.y/noiseScale,
                   p.z/noiseScale) * noiseStrength;

    p.x += cos(angleZ) * cos(angleY) * stepSize;
    p.y += sin(angleZ) * stepSize;
    p.z += cos(angleZ) * sin(angleY) * stepSize;

    if (p.x<-spaceSizeX || p.x>spaceSizeX ||
        p.y<-spaceSizeY || p.y>spaceSizeY ||
        p.z<-spaceSizeZ || p.z>spaceSizeZ) {
      setRandomPostition();
      isOutside = true;
    }

    ribbon.update(p, isOutside);
    isOutside = false;
  }
  →
```

The functionality of the ribbon, which represents the agent's path, is stored in the class Ribbon3d.

An instance of it is created and saved in the ribbon variable.

A second, random angle is needed for an agent to move in all three dimensions. To produce this angle, the point at which the random number is selected is simply shifted by the value of offset.

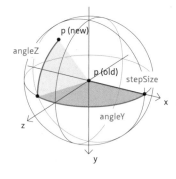

→ W.407
Wikipedia: Spherical coordinates

The new point of the agent is defined by the two angles angleY and angleZ.

The ribbon is updated. In doing so, the current position and the information about whether the position has just reached the edge is passed.

```
void draw() {
  ribbon.drawLineRibbon(agentColor, 1.0);
} ...
```

The draw command is passed to the ribbon. Finally, the ribbon represents the agent in the display.

The functionality of the ribbon is summarized in the class Ribbon3d:

→ M_1_6_01_TOOL / Ribbon3d.pde

```
class Ribbon3d {
  int count;
  PVector[] p;
  boolean[] isGap;

  Ribbon3d (PVector theP, int theCount) {
    count = theCount;
    p = new PVector[count];
    isGap = new boolean[count];
    for(int i=0; i<count; i++) {
      p[i] = new PVector(theP.x,theP.y,theP.z);
      isGap[i] = false;
    }
  }

  void update(PVector theP, boolean theIsGap){
    for (int i=count-1; i>0; i--) {
      p[i].set(p[i-1]);
      isGap[i] = isGap[i-1];
    }
    p[0].set(theP);
    isGap[0] = theIsGap;
  }
  ...
  void drawLineRibbon(color theStrokeCol, float theWidth) {
    noFill();
    strokeWeight(theWidth);
    stroke(theStrokeCol);
    beginShape(QUAD_STRIP);
    for(int i=0; i<count; i++) {
      vertex(p[i].x, p[i].y, p[i].z);
      if (isGap[i] == true) {
        endShape();
        beginShape(QUAD_STRIP);
      }
    }
    endShape();
  }
}
```

The variable count determines how many previous positions are saved. The two arrays isGap and p are initialized with this length.

The positions are stored according to the principle of a queue using the update() function. In each step, the values shift one step to the right in the two arrays to make room for the new value. In doing this, the oldest value is overwritten and thereby erased.

→ W.408
Wikipedia: Queue

Since an agent is placed back in a random position when leaving the defined space, additional information is required for each saved agent position that indicates whether this random position represents a so-called new beginning. Such a point should not be connected to the point on the previous position. This information is available in the array isGap[] and is requested when drawing the ribbon in order to produce a gap.

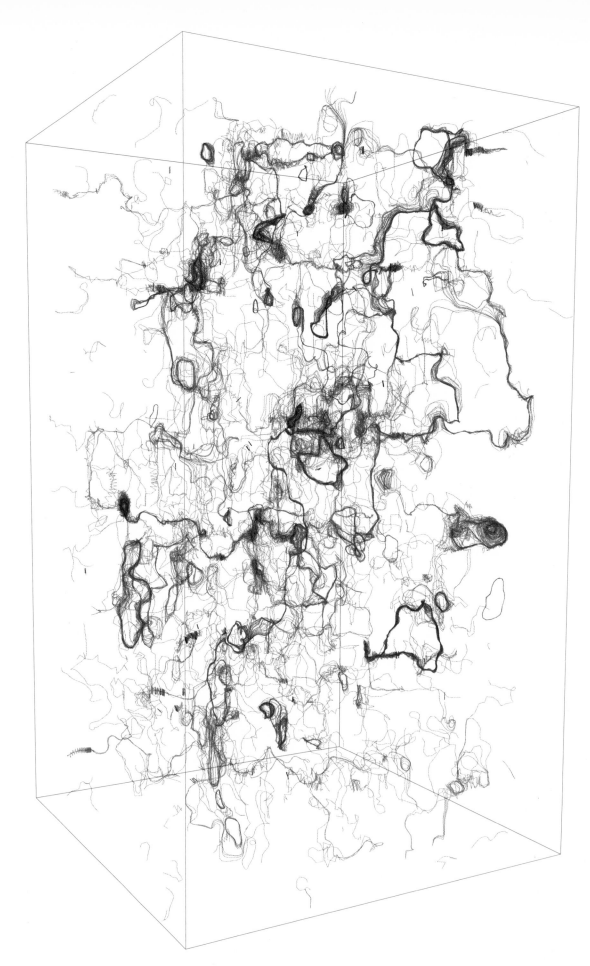

In the three-dimensional version of the program, the agents' tracks are represented as line ribbons.
→ M_1_6_01_TOOL.pde

A version of the program in which the agents are represented as colored ribbons. Their width can be controlled in the menu.
→ M_1_6_02_TOOL.pde

M.2

Oscillation figures

M.2.0
Oscillation figures—an overview

The superimposition of different sine waves results in a class of variably formed curves. This chapter demonstrates how these so-called Lissajous figures can be generated and modified. Starting with a very simple principle—in this case the sine function—a program can gradually be made more complex and altered to create a variety of images.

→ M_2_5_02_TOOL.pde
→ M_2_6_01_TOOL.pde
→ M_2_6_01_TOOL_TABLET.pde

harmonic oscillation

modulated oscillation

The starting point is the harmonic oscillation. If points are set in such a way that their x-coordinates are determined by one oscillation and their y-coordinates by another, Lissajous figures are created.

The shape of the oscillations can be changed by superimposing different frequencies. These modulated oscillations expand the varying range of figures generated.

The figures can be drawn not only in two-dimensional space but can also be easily transferred to the third dimension.

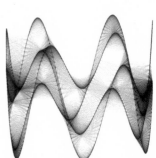

Another experimental field opens up when the generated points are not connected in the conventional way but rather by a mesh network structure in which each point is connected to all others (based on an idea of Keith Peters).
→ W.409
Website: Keith Peters

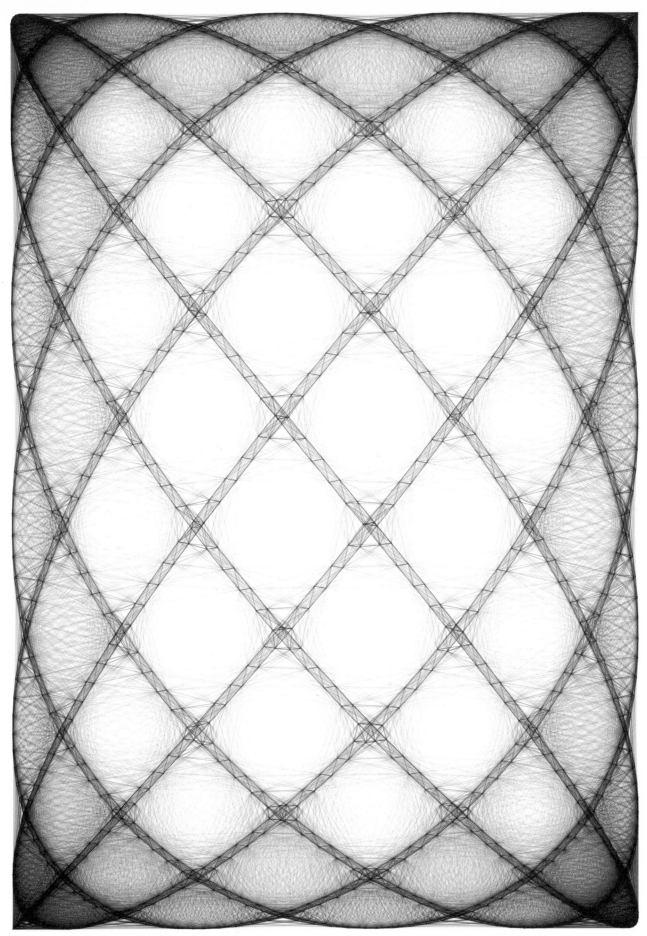

The points of these Lissajous curves are connected to one another.
→ M_2_5_02_TOOL.pde

M.2.1 Harmonic oscillations

The basis of all Lissajous figures is harmonic oscillation. In the physical world, a harmonic oscillation is created when, for example, a weight suspended from a spring is pulled down and then released. If the loss of energy through friction is disregarded and the position of the weight over time is recorded, the following oscillation curves are created. The frequency tells us how many oscillations occur per time period.

harmonic oscillations with frequency 1

harmonic oscillations with frequency 3

These oscillation systems can easily be described mathematically with a sine curve. This can be imagined as a point that moves along a circular path. If one now measures for each angle the vertical distance between the point and the horizontal axis (this segment is defined as the sine of the angle) and plots this in a coordinate system, a sine curve is created:

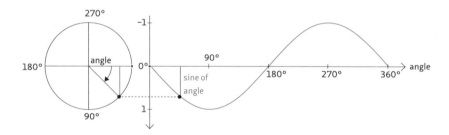

Here, the frequency can be increased. The point just has to move more quickly around the circle, thereby completing more rotations in the same time period.

The curve can be moved horizontally by using a point at an angle other than 0°. This offset angle is commonly referred to as "phi" and the shift of the curve is referred to as a phase shift.

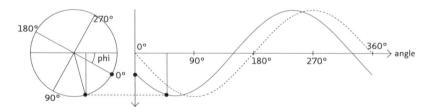

An oscillation with a phase shift of 30°. The curve thereby begins at the corresponding sine value of 30°, or 0.5.

The following program draws oscillation curves that better describe these relationships.

```
int pointCount;
int freq = 1;
float phi = 0;
```
Variables for the number of points to be drawn (pointCount), the frequency (freq), and the phase shift (phi).

```
void draw() {
  ...
  pointCount = width;
  translate(0, height/2);

  beginShape();
  for (int i=0; i<=pointCount; i++) {
    angle = map(i, 0,pointCount, 0,TWO_PI);
    y = sin(angle*freq + radians(phi));
    y = y * 100;
    vertex(i, y);
  }
  endShape();
  ...
}
```

Draw as many points as the display is wide.

When processing the points, first the index i of the current point (a number between 0 and pointCount) is translated to the corresponding value between 0 and 360°.

The point's y value is now calculated by using the sin() function, which passes this angle after it is multiplied with the frequency and increased by the phase shift angle phi. The result of this function is a number between –1 and 1 and must therefore be scaled by multiplication. Otherwise, the curve would be drawn too flat.

M.2.2 Lissajous figures

The step from harmonic oscillations to Lissajous figures is very easy now. Instead of one oscillation, two are calculated, one of which defines the y-coordinates of the point to be drawn (as demonstrated) and the other its x-coordinates. The adjacent image depicts an oscillation with frequency 2, an oscillation with frequency 1, and a 90° phase shift, which together result in a Lissajous figure in the shape of a reclining 8.

This only requires the following adjustment in the program:

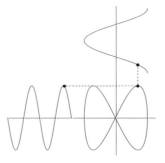

Lissajous figure made of two superimposed oscillations.

```
x = sin(angle*freqX + radians(phi));
y = sin(angle*freqY);
```

The variables freqX and freqY define the frequencies of the two oscillations. It is not necessary to enable a phase shift phi for both oscillations, since all possible Lissajous figures can already be generated.

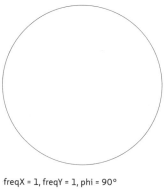

freqX = 1, freqY = 1, phi = 90°
→ M_2_2_01.pde

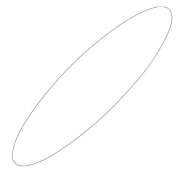

freqX = 1, freqY = 1, phi = 150°
→ M_2_2_01.pde

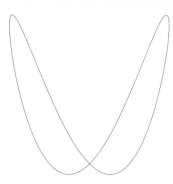

freqX = 1, freqY = 2, phi = 120°
→ M_2_2_01.pde

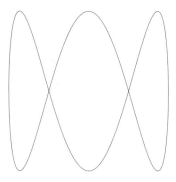

freqX = 1, freqY = 3, phi = 75°
→ M_2_2_01.pde

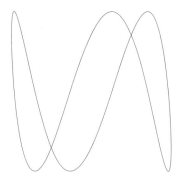

freqX = 1, freqY = 3, phi = 195°
→ M_2_2_01.pde

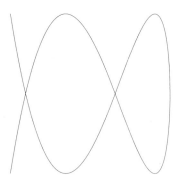

freqX = 2, freqY = 5, phi = 90°
→ M_2_2_01.pde

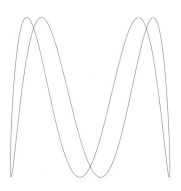

freqX = 1, freqY = 4, phi = 150°
→ M_2_2_01.pde

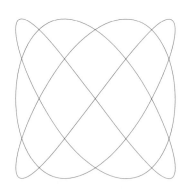

freqX = 6, freqY = 8, phi = 90°
→ M_2_2_01.pde

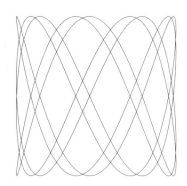

freqX = 4, freqY = 9, phi = 195°
→ M_2_2_01.pde

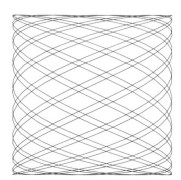

freqX = 19, freqY = 9, phi = 75°
→ M_2_2_01.pde

freqX = 11, freqY = 13, phi = 90°
→ M_2_2_01.pde

freqX = 13, freqY = 23, phi = 75°
→ M_2_2_01.pde

M.2.3 Modulated figures

The variation of Lissajous figures can be greatly increased by modulating the oscillations. The concept of modulation is used in telecommunications, in which oscillations are used to transmit signals. In order to make simultaneous transmissions possible—for instance, many different radio programs—broadcasters need to combine each information signal (e.g. music and speech) with a carrier signal.

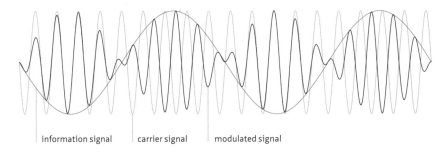

information signal carrier signal modulated signal

An information signal is combined with a carrier signal. The result is a curve in which the amplitude of the carrier signal is modulated by the information signal. One therefore also speaks of amplitude modulation.
→ M_2_3_01.pde

For the implementation of the program, the curve is composed of two oscillations:

Keys: *I: Draw information signal on/off • C: Draw carrier signal on/off*
 1-2: Information signal frequency –/+ • Arrow left/right: Information signal phase shift –/+ 15°
 7-8: Carrier signal frequency (modulation frequency) –/+

→ M_2_3_01.pde

```
for (int i=0; i<=pointCount; i++) {
  angle = map(i, 0,pointCount, 0,TWO_PI);

  float info = sin(angle * freq + radians(phi));
  float carrier = cos(angle * modFreq);
  y = info * carrier;

  y = y * (height/4);
  vertex(i, y);
}
```

The first oscillation is calculated in the usual way and saved in `info`.

The oscillation of the carrier signal `carrier` is defined by the second frequency `modFreq`. The oscillation is calculated here with cosine. The modulation can be shut off easily by setting `modFreq` to 0. The value `carrier` is thereby always 1.

Now the two values only have to be multiplied.

Just as we saw with the unmodulated Lissajous figures, two modulated oscillations can be used to define the point's x- and y-coordinates.

→ M_2_3_02.pde

Mouse: *Position x: Number of points*
Keys: *D: Drawing mode • 1-2: Frequency x –/+ • 3-4: Frequency y –/+*
 Arrow left/right: Phase shift –/+ 15° • 7-8: Modulation frequency x –/+
 9-0: Modulation frequency y –/+

```
x = sin(angle * freqX + radians(phi)) * cos(angle * modFreqX);
y = sin(angle * freqY) * cos(angle * modFreqY);
```

The calculation and multiplication of the information and the carrier signals are in one line of code.

M.2.4 Three-dimensional Lissajous figures

An obvious step is to extend these representation into the third dimension. This requires only the addition of a sine wave to control the movement of the points on the z-axis. Many new possibilities arise through the addition of this new axis.

The following is an inspiring example in which triangular planes span between the coordinate origin and the Lissajous path. The two outer corner points lie on the Lissajous path; the triangle's third point is the origin. The plane does not span between all points but rather only between every third point and its second neighbor to the right. In order to access the points more easily, it is advisable to calculate them first and save them in an array.

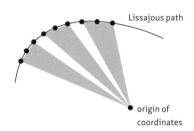

→ M_2_4_01.pde

Mouse: Drag right mouse button: Control display
Keys: 1/2: Frequency x –/+ · 3/4: Frequency y –/+ · 5/6: Frequency z –/+
Arrow left/right: Phase shift x –/+ · Arrow up/down: Phase shift y –/+

```
void calculateLissajousPoints(){
  lissajousPoints = new PVector[pointCount+1];
  float f = width/2;

  for (int i = 0; i <= pointCount; i++){
    float angle = map(i, 0,pointCount, 0,TWO_PI);
    float x = sin(angle*freqX+radians(phiX)) * sin(angle*2) * f;
    float y = sin(angle*freqY+radians(phiY)) * f;
    float z = sin(angle*freqZ) * f;
    lissajousPoints[i] = new PVector(x, y, z);
  }
}
```

The points are calculated in the calculateLissajousPoints() function and saved in the lissajousPoints array.

A scaling factor f is set based on the display size.

The Lissajous points are calculated as usual. The oscillation for x and y can be offset using phiX and phiY. Additionally, the oscillation for x is modulated with the frequency 2.

The calculated point is saved.

The areas can be calculated as follows:

```
beginShape(TRIANGLE_FAN);
for(int i=0; i<pointCount-2; i++) {
  if (i%3 == 0) {
    fill(50);
    vertex(0, 0, 0);
    fill(200);
    vertex(lissajousPoints[i].x, lissajousPoints[i].y,
           lissajousPoints[i].z);
    vertex(lissajousPoints[i+2].x, lissajousPoints[i+2].y,
           lissajousPoints[i+2].z);
  }
}
endShape();
```

The points are processed but a plane is only drawn at every third point (when i%3 is 0).

The point of origin has a darker color than the outer points, creating a gradient.

The outer points are set. The current point i and the point after the next i+2 are taken from the array.

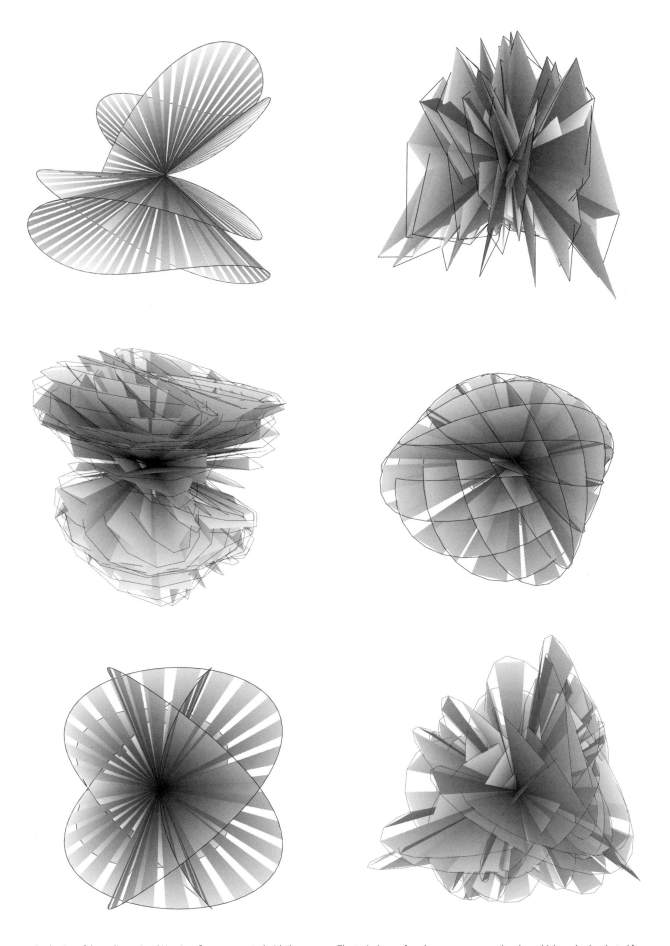

A selection of three-dimensional Lissajous figures generated with the program. The typical curve form becomes more angular when a higher value is selected for the frequency.

→ M_2_4_01.pde

M.2.5 Drawing Lissajous figures

Extremely attractive forms are created when the points on the Lissajous curve are not connected in the usual manner (i.e. one point only to the next point) but rather when each point is connected with all others. To avoid black clump—after all, many lines have to be drawn—it is necessary to ensure that the farther apart the points are, the more transparent the lines become, as Keith Peters demonstrates in "Random Lissajous Webs" on his website.

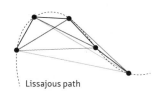

Lissajous path

→ W.409
Website: Keith Peters

A formula is needed to transform the distance d of two points into a transparency value a. This could be done as follows:

$$y = \frac{1}{x+1}$$

$$a = \frac{1}{\frac{d}{r}+1}$$

$$a = \left(\frac{1}{\frac{d}{r}+1}\right)^6$$

The starting point is the above formula, which fulfills the requirement: the smaller the result, the greater the input value. When x = 0, the formula calculates the value 1. When x = 1, the formula result is 0.5.

This is easily adapted to distance and transparency. In order for the curve to retain the property that its radius r yields the value 0.5, d has to be divided by r.

The result would be unattractive, however, if the lines still had half the opacity at distance r. The curve is therefore pushed down using exponentiation.

Keys: 1–2: Frequency x –/+ • 3–4: Frequency y –/+ • Arrow left/right: Phase shift –/+
7–8: Modulation frequency x –/+ • 9–0: Modulation frequency y –/+

→ M_2_5_01.pde

```
for (int i1 = 0; i1 < pointCount; i1++) {
  for (int i2 = 0; i2 < i1; i2++) {
    PVector p1 = lissajousPoints[i1];
    PVector p2 = lissajousPoints[i2];

    d = PVector.dist(p1, p2);
    a = pow(1/(d/connectionRadius+1), 6);

    if (d <= connectionRadius) {
      stroke(lineColor, a*lineAlpha);
      line(p1.x, p1.y, p2.x, p2.y);
    }
  }
}
```

In the drawLissajous() function, the two for-loops ensure that each point is connected to all other points. The variable i1 passes through all points and i2 passes through the points of index 0 to index i1-1. This ensures lines are not drawn more than once.

The distance between the two points is calculated and used in the aforementioned formula to calculate the transparency value a.

The line is only drawn when the distance is less than the specified radius. The variable a contains a value between 0 and 1. Multiplied by the maximum value for the opacity lineAlpha, this results in a value between 0 and lineAlpha.

THE LISSAJOUS TOOL All the possible ways of working with two-dimensional Lissajous figures can be combined in one program, which also contains additional parameters used to modify the figures. The value `randomOffset` offsets the x- and y-coordinates of all points by a random value between `-randomOffset` and `+randomOffset`.

The parameters `modFreq2X`, `modFreq2Y`, and `modFreq2Strength` are a bit more difficult to understand. These parameters modulate the frequencies of the harmonic oscillations. This means the frequencies `freqX` and `freqY` are no longer constant, but sometimes higher or lower.

frequency modulation

→ M_2_5_02_TOOL.pde

```
float fmx = sin(angle*modFreq2X) * modFreq2Strength + 1;
float fmy = sin(angle*modFreq2Y) * modFreq2Strength + 1;

x = sin(angle * freqX * fmx + radians(phi))
    * cos(angle * modFreqX);
y = sin(angle * freqY * fmy) * cos(angle * modFreqY);
```

The oscillation values `fmx` and `fmy` are calculated from the parameters `modFreq2X`, `modFreq2Y`, and `modFreq2Strength`.

These values are used to modulate the main frequencies `freqX` and `freqY`.

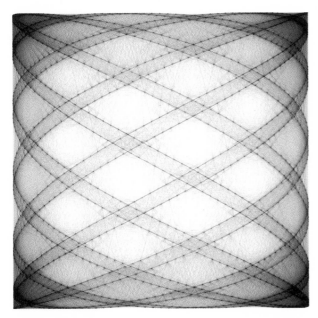

Shadowing is generated using this new method of connecting Lissajous figures.
→ M_2_5_02_TOOL.pde

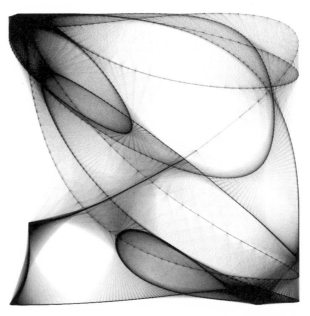

The frequency modulation causes the regular paths to be abandoned, creating a seemingly random curve structure.
→ M_2_5_02_TOOL.pde

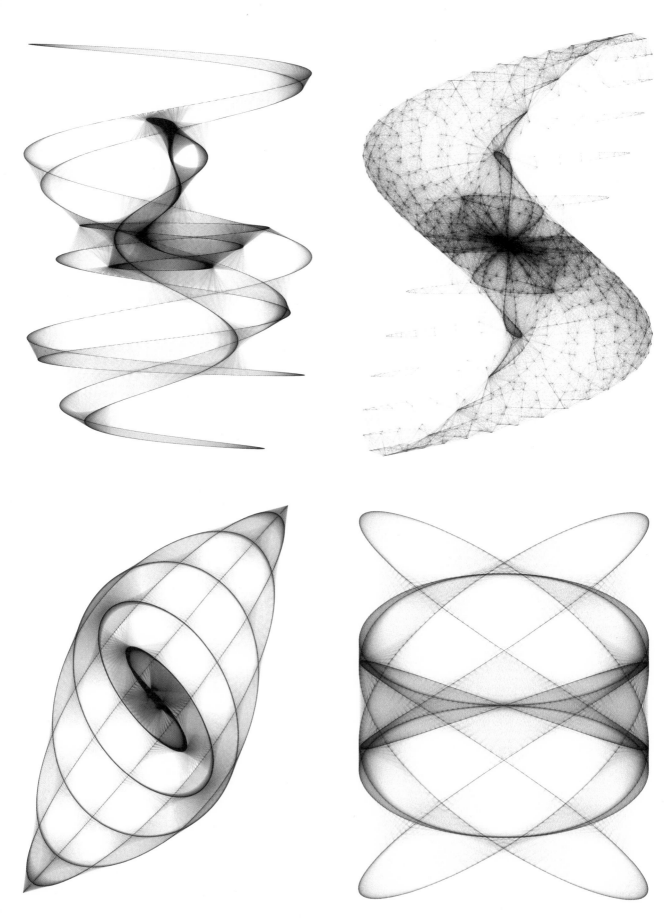

These forms experiment with amplitude modulation modFreqX and modFreqY.
→ M_2_5_02_TOOL.pde

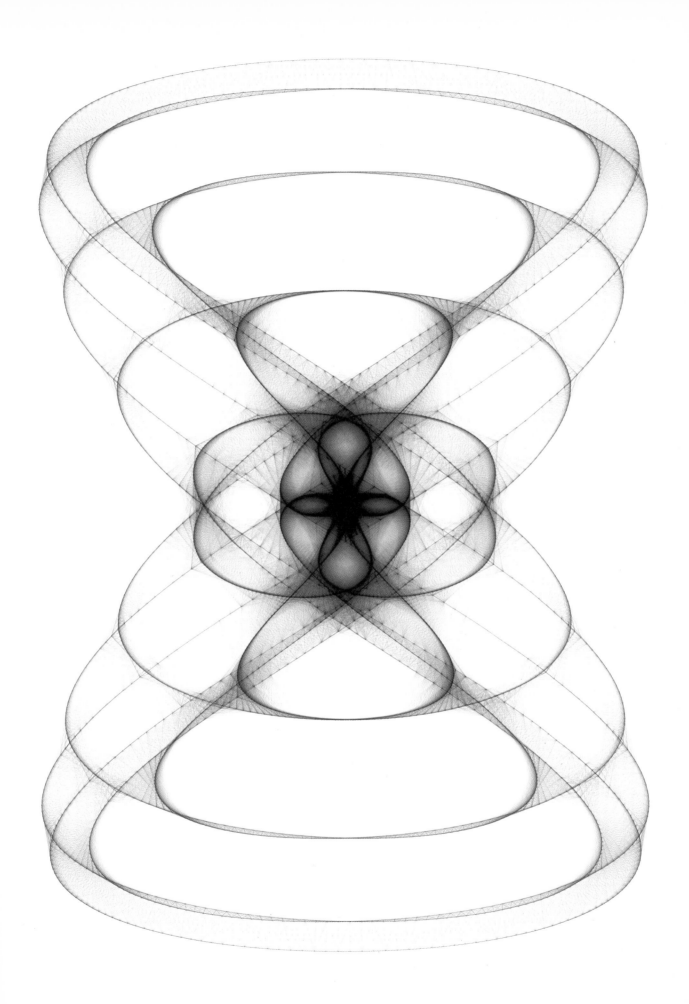

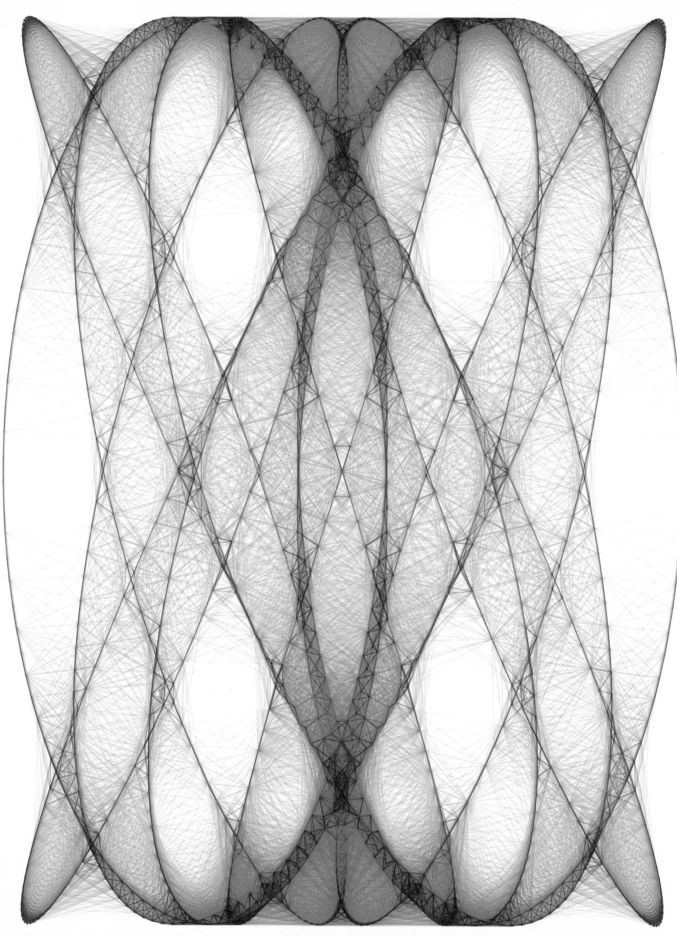

In Tool, it is possible to create colored grid lines. The set value range for hues hueRange is assigned to the length of the lines. This means that short lines are colored with the hue from the beginning of the value range and long lines with the hue from the end of the value range.

→ M_2_5_02_TOOL.pde

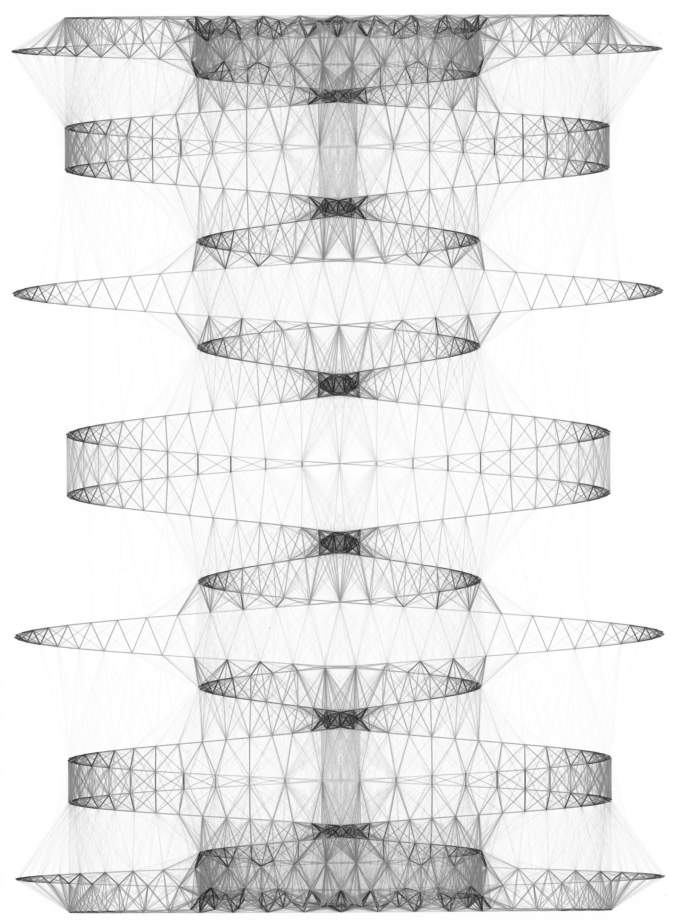

The color arrangement can be reversed with the button "Invert Hue Range."
→ M_2_5_02_TOOL.pde

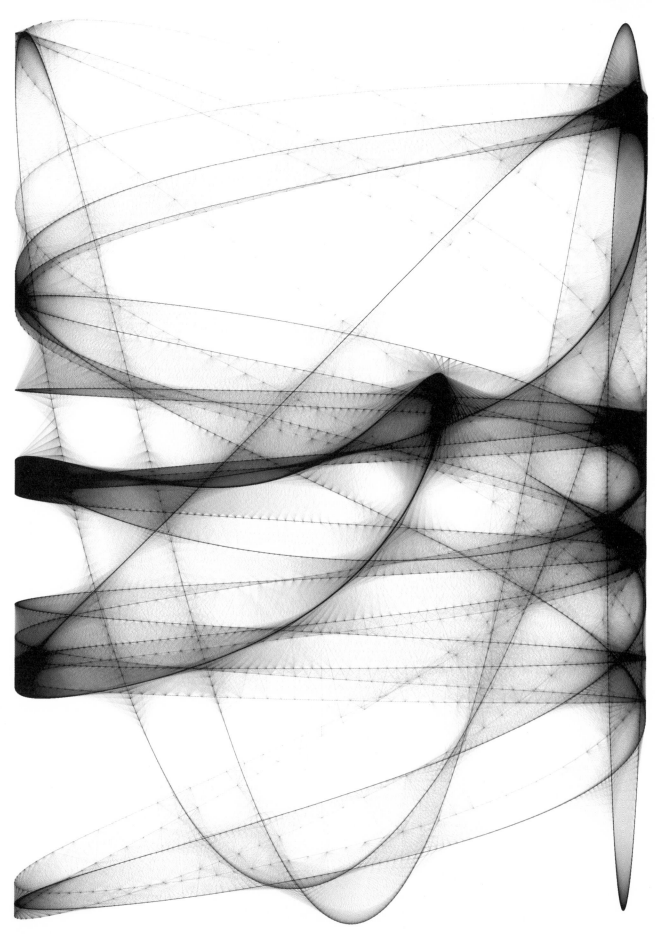

This irregular form is not generated by random function but by the overlapping and modulation of several oscillations.
→ M_2_5_02_TOOL.pde

A smaller value of the parameter modFreq2Strength causes irregularities in an otherwise ordered form.
→ M_2_5_02_TOOL.pde

M.2.6 A drawing tool

The aforementioned method of connecting points is not limited to Lissajous figures but can be applied to any set of points, regardless of how they were generated. It therefore makes sense to create a small drawing tool to connect points drawn with the mouse in this manner.

Mouse: Left click: Draw · Shift + left click: Erase · Drag right mouse button: Move
Keys: DEL: Delete display

→ M_2_6_01_TOOL.pde

```
ArrayList pointList = new ArrayList();

void draw() {
  ...
  if (drawing) {
    ...
    float x = (mouseX-width/2) / zoom - offsetX + width/2;
    float y = (mouseY-height/2) / zoom - offsetY + height/2;

    if (pointCount > 0) {
      PVector p = (PVector) pointList.get(pointCount-1);
      if (dist(x,y, p.x,p.y) > (minDistance)) {
        pointList.add(new PVector(x, y));
      }
    }
    else {
      pointList.add(new PVector(x, y));
    }
    pointCount = pointList.size();
  }
  ...
}
```

The drawn points are saved in the ArrayList pointList because new values can be added to it more quickly than to an array.

By clicking the mouse, the Boolean value drawing is set to true. A point is placed in each frame when this is the case.

The mouse position has to be converted into the corresponding position on the drawing area, since the drawing area can be moved and enlarged.

If points have already been set, the last drawn point is retrieved from pointList and the distance to this calculated. The new point is only set when this distance exceeds a specified minimum distance minDistance.

The new point is added to the ArrayList using the add() function.

The length of pointList is determined using the size() function and used to update pointCount.

Although this drawing tool no longer has anything to do with oscillation figures, the example demonstrates how easily a method used in one context can be translated into another to expand its design repertoire in a novel way.

Two versions of this drawing tool are available: one for mouse operation and the other for a pen tablet. With the tablet version, the pressure with which a point is drawn determines how this point is connected to the other points, allowing for far more differentiated shading.

→ Ch.P.2.3.5
Drawing with the pen tablet

The targeted placement of the individual points generates the grid structure typical of works made with this particular drawing tool.
→ M_2_6_01_TOOL.pde → Illustration: Markus Schattmaier

An existing form can be varied later using various parameters.
→ M_2_6_01_TOOL.pde → Illustration: Ben Reubold

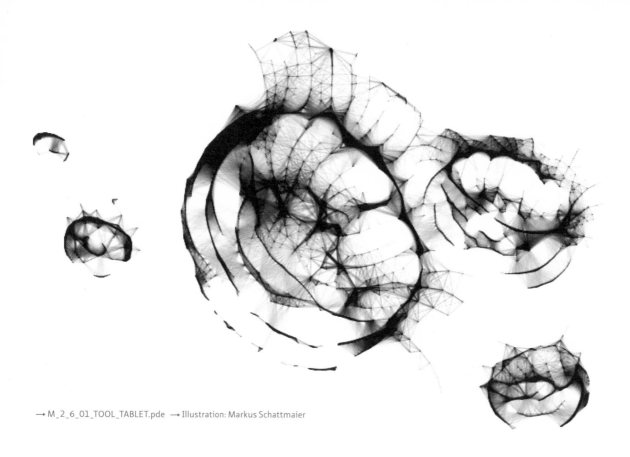

→ M_2_6_01_TOOL_TABLET.pde → Illustration: Markus Schattmaier

Fine shadows can be drawn using the pen tablet version of the program.
→ M_2_6_01_TOOL_TABLET.pde → Illustration: Franz Stämmele

→ M_2_6_01_TOOL_TABLET.pde → Illustration: Markus Schattmaier

M.3

Formulated
bodies

M.3.0
Formulated bodies—an overview

Generating three-dimensional objects like spheres, cylinders, or other complex forms is most easily done using mathematical formulas. Here, the starting point is a two-dimensional grid of points. A mathematical formula is applied to each point with the result drawn in three-dimensional space. This chapter demonstrates how this works and how the resulting mesh can be deconstructed with random numbers.

→ M_3_4_01_TOOL.pde
→ M_3_4_03_TOOL.pde

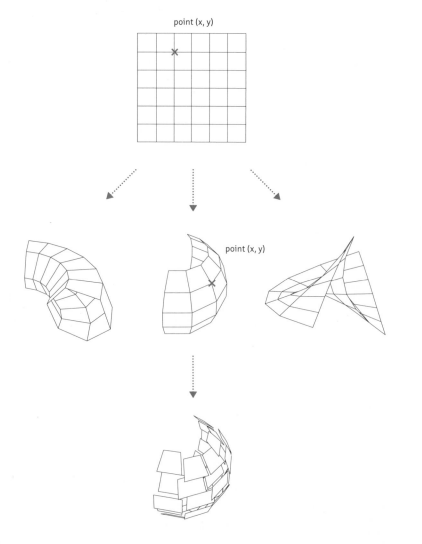

point (x, y)

The basis is a set of points arranged in a two-dimensional grid.

These two-dimensional points are transformed into three-dimensional space using mathematical functions.

point (x, y)

Differently shaped surfaces arise depending on which formulas are applied.

These surfaces can be dissolved in a further step by moving individual points away from their computed locations using random numbers.

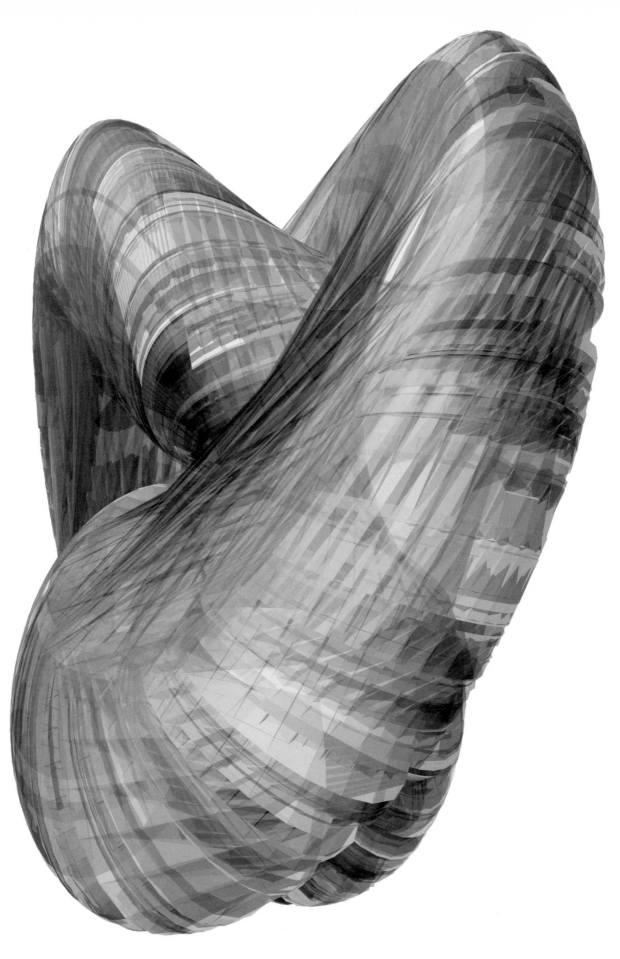

The three-dimensional forms generated in this chapter can be represented in many different ways; this is just one possibility for how such a mesh can look.
→ M_3_4_03_TOOL.pde

M.3.1 Creating a grid

Before a three-dimensional object can be created, we need a grid of points in a two-dimensional plane to be "bent" to form closed areas. The easiest way to do this is to arrange the points in a regular grid. The first step is to find the most flexible way to draw such a grid. Processing enables tiles to be drawn with QUAD_STRIP or TRIANGLE_STRIP. This is a reasonable choice since the grid points should be individually movable later on.

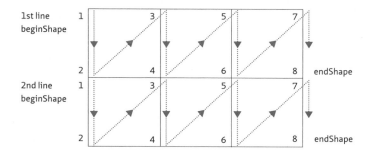

Two strips, each with three tiles, are drawn to form a grid with three tiles in the horizontal and two tiles in the vertical direction.

Both QUAD_STRIP and TRIANGLE_STRIP require that the points be entered in the order presented here.

Mouse: *Drag: Rotate*

→ M_3_1_01.pde

```
int xCount = 3;
int yCount = 2;
```

Number of tiles in the horizontal and vertical direction

```
void draw() {
  ...
  scale(40);

  for (int y = 0; y < yCount; y++) {
    beginShape(QUAD_STRIP);
    for (int x = 0; x <= xCount; x++) {
      vertex(x, y, 0);
      vertex(x, y+1, 0);
    }
    endShape();
  }
}
```

In the y-direction the precise number of tiles is processed, two in this example.

In the x-direction the number of grid points is processed. In this case, there are four iterations.

Using the two vertex() commands, the two superjacent points are set in pairs.

The meshes generated with this program always begin at the origin of the coordinate system and evolve downward and to the right.

xCount = 3, yCount = 2 xCount = 4, yCount = 4

M.3.2 Bending the grid

The next step to creating a three-dimensional form is easy. The values of x and y are used to find a value for the z-position—the grid point is now transferred into the third dimension. This kind of transformation is an "elevation contour" since the x- and y-coordinates of the grid points are not altered.

Mouse: Drag: Rotate

→ M_3_2_02.pde

```
for (int y = 0; y < yCount; y++) {
  beginShape(QUAD_STRIP);
  for (int x = 0; x <= xCount; x++) {

    float z = sin(sqrt(x*x+y*y));
    vertex(x, y, z);

    z = sin(sqrt(x*x+(y+1)*(y+1)));
    vertex(x, y+1, z);
  }
  endShape();
}
```

The z-value is calculated from x and y using the following formula: $z = \sin(\sqrt{x^2+y^2})$.

The further the point (x, y) is from the origin, the greater the expression in brackets. This generates a wave shape when combined with the sine function.

The z-value for the lower point is calculated using the same formula, whereby every y must be replaced with $(y+1)$. Finally, the lower points of the current strip have to correspond to the upper points of the next strip.

Two examples of the effects of two different formulas. The sine function is used in both: in the example on the right, only the x-coordinate served as the parameter; on the left, the x- and y-coordinates were converted into a single value.

The formula z=sin(x) was used here; thus only the x-coordinate of the grid point is used to calculate the z-value.
→ M_3_2_01.pde

This is the result of the formula shown above.
→ M_3_2_02.pde

It is also possible to use formulas for the x- and y-coordinates in order to move a point to an arbitrary location in space. But first, some slight improvements to the code will make things easier later on.

A SECOND COORDINATE SYSTEM Especially with complicated formulas, it's easiest to keep track of the original grid and the three-dimensional form using two different coordinate systems: one for the original two-dimensional grid and another for the positions in the three-dimensional space.

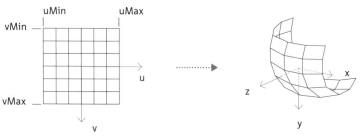

coordinate system of the grid coordinate system of the 3D space

From now on, u and v will be used to represent the axes of the grid coordinate system. x, y, and z will continue to be used for the three-dimensional space.

The values uMin, uMax, vMin, and vMax are used to define the value range for u and v.

The introduction of a second coordinate system becomes especially noticeable in the source code, in the new names for some variables.

Mouse: Drag: Rotate → M_3_2_03.pde

```
int uCount = 40;
float uMin = -10;
float uMax = 10;

int vCount = 40;
float vMin = -10;
float vMax = 10;

for (float iv = 0; iv < vCount; iv++) {
  beginShape(QUAD_STRIP);
  for (float iu = 0; iu <= uCount; iu++) {
    float u = map(iu, 0, uCount, uMin, uMax);
    float v = map(iv, 0, vCount, vMin, vMax);

    float x = u;
    float y = v;
    float z = cos(sqrt(u*u + v*v));
    vertex(x, y, z);

    v = map(iv+1, 0, vCount, vMin, vMax);
    y = v;
    z = cos(sqrt(u*u + v*v));
    vertex(x, y, z);
  }
  endShape();
}
```

The variables iu and iv are converted to the value range uMin to uMax (or vMin to vMax).

The values u and v can continue to be used as the values for x and y. The formula for z is the same as in the preceding example. A different image is generated because the value range of u and v are now controlled by the variables uMin, uMax, vMin, and vMax.

Obtaining the values of x and y becomes much simpler if they are calculated using a formula rather than taken directly.

→ M_3_2_04.pde

Mouse: Drag: Rotate
Keys: 1–2: uMin –/+ • 3–4: uMax –/+ • 5–6: vMin –/+ • 7–8: vMax –/+
Arrow left/right: Value range for u • Arrow up/down: Value range for v

```
for (float iv = vCount-1; iv >= 0; iv--) {
  beginShape(QUAD_STRIP);
  for (float iu = 0; iu <= uCount; iu++) {
    float u = map(iu, 0, uCount, uMin, uMax);
    float v = map(iv, 0, vCount, vMin, vMax);

    float x = 0.75*v;
    float y = sin(u)*v;
    float z = cos(u)*cos(v);
    vertex(x, y, z);

    v = map(iv+1, 0, vCount, vMin, vMax);
    x = 0.75*v;
    y = sin(u)*v;
    z = cos(u)*cos(v);
    vertex(x, y, z);
  }
  endShape();
}
```

u and v serve as the basis for the calculation of the x, y, and z values.

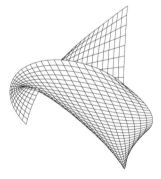

These shapes were generated using the same formulas and are also rotated the same way in space. The different value ranges for u and v ensure that a different part of the formula's entire surface is drawn.

uMin=5, uMax=57, vMin=0, vMax=15
→ M_3_2_04.pde

uMin=7, uMax=39, vMin=-4, vMax=15
→ M_3_2_04.pde

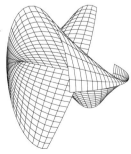

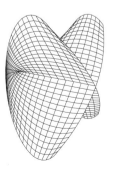

uMin=-6, uMax=25, vMin=-11, vMax=4
→ M_3_2_04.pde

uMin=0, uMax=50, vMin=-10, vMax=10
→ M_3_2_04.pde

uMin=10, uMax=52, vMin=-10, vMax=10
→ M_3_2_04.pde

OPTIMIZING THE CODE Generally speaking, all three-dimensional forms defined by mathematical functions can be generated with the last version of the program. Since rendering with complicated functions or a very large number of grid points can be very CPU-intensive, a simple optimization of the code should be performed.

At the moment, all the grid points are newly calculated for each frame (i.e., each time the grid is drawn). It would suffice, however, to calculate the x-, y-, and z-coordinates just once at the beginning. In addition, almost all points are calculated twice: the lower points of a tile row correspond in the end to the upper tiles of the next row.

It is therefore better to calculate the points at the beginning and to store them in a two-dimensional array.

→ M_3_2_05.pde

```
PVector[][] points = new PVector[vCount+1][uCount+1];

...

void setup() {

  ...

  for (int iv = 0; iv <= vCount; iv++) {
    for (int iu = 0; iu <= uCount; iu++) {
      float u = map(iu, 0, uCount, uMin, uMax);
      float v = map(iv, 0, vCount, vMin, vMax);

      points[iv][iu] = new PVector();
      points[iv][iu].x = v;
      points[iv][iu].y = sin(u)*cos(v);
      points[iv][iu].z = cos(u)*cos(v);
    }
  }
}
```

Initialization of the two-dimensional array. The number of grid points is always one more than the number of tiles.

Calculate points and store in the array.

The calculated points can then be used when drawing. The corresponding drawing routine is as follows:

```
for (int iv = 0; iv < vCount; iv++) {
  beginShape(QUAD_STRIP);
  for (int iu = 0; iu <= uCount; iu++) {
    vertex(points[iv][iu].x, points[iv][iu].y, points[iv][iu].z);
    vertex(points[iv+1][iu].x, points[iv+1][iu].y,
           points[iv+1][iu].z);
  }
  endShape();
}
```

Using saved point coordinates: the indices iu and iv refer to the upper points of the strip and iu and iv+1 to the lower points.

M.3.3 Mesh class

The calculation and rendering of the grids for the rest of the additional examples in this chapter are encapsulated in a class. This means that all the parameters for the mesh and the functions for calculating and drawing it are summarized in a separate part of the program, making it easier to generate the mesh; the code is also clearer. In addition, many standard forms are predefined in the class.

→ W.410
Website: Paul Bourke: geometry

The following two lines, for example, suffice to generate and draw a mesh. Here is an example of the "Steinbach screw," a form that features 100 tiles in the u and v directions, a value range for u from −3 to 3, and a value range for v from −PI to PI:

→ M_3_3_01.pde

```
Mesh myMesh = new Mesh(Mesh.STEINBACHSCREW,
                       100,100, -3,3,-PI,PI);
myMesh.draw();
```

The mesh class is also contained in the Generative Design library documented in detail at www.generative-gestaltung.de. A short reference for the mesh class is located at the end of this chapter.

Steinbach screw
→ M_3_3_01.pde

shell
→ M_3_3_02.pde

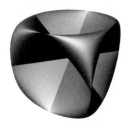

sine
→ M_3_3_03.pde

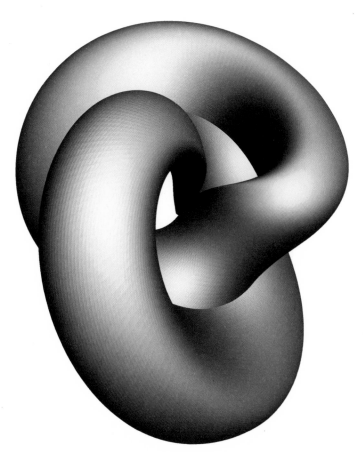

figure-8 torus
→ M_3_3_04.pde

M.3.4 Deconstructing the mesh

Admittedly, the forms generated up to now (at least the simple ones) can be produced more quickly in any 3D program. The effort involved in calculating and drawing your own mesh pays off when you want to go beyond the usual representation methods. Below are two simple methods that demonstrate how the mesh classes can be modified or used differently to expand on their visual possibilities.

A SINGLE GRID Until now we have generated contiguous connected grids. The variety of shapes can be expanded when the random function comes into play to dissolve the mesh. It is already laid out in the mesh class: a value can be set using setMeshDistortion(), ensuring that the mesh points will not be not drawn on their calculated positions, but rather at a random distance from them.

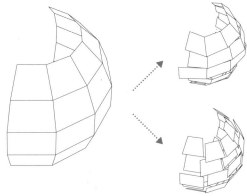

After the grid points are transformed into three-dimensional space, random values are added to the x-, y- and z-values. If the mesh continues to be drawn using QUAD_STRIP, individual strips remain connected.

If the draw mode QUADS is used instead, the mesh dissolves completely.

Mouse: *Drag right mouse button: Rotate*
Keys: *M: Menu · D: 3D export (DXF format)*

→ M_3_4_01_TOOL/Mesh.pde

```
float r1 = meshDistortion * random(-1, 1);
float r2 = meshDistortion * random(-1, 1);
float r3 = meshDistortion * random(-1, 1);

vertex(points[iv][iu].x + r1,
       points[iv][iu].y + r2,
       points[iv][iu].z + r3);
vertex(points[iv+1][iu].x + r1,
       points[iv+1][iu].y + r2,
       points[iv+1][iu].z + r3);
```

When drawing the mesh, three random numbers are generated before the points are set, one each for the points' x-, y-, and z-coordinates. The greater the value of meshDistortion, the greater the random displacement of the individual points from their actual position.

It is important to generate the same sequence of random numbers with randomSeed() before drawing so that this does not change (and thereby cause flickering) in each drawing operation.

→ Ch.M.1.1
Randomness and starting conditions

→ M_3_4_01_TOOL.pde

```
randomSeed(123);
myMesh.draw();
```

A menu was added to this example that makes it possible to manipulate many of the parameters directly. The variables `uMin`, `uMax`, `vMin`, and `vMax`, for instance, are set using the range sliders uRange and vRange. The shape of the grid is modified with `paramExtra`.

A few drawing modes ("No Blend," "Blend on White," "Blend on Black") and parameters ("meshAlpha," "meshSpecular," "hueRange," "saturationRange," and "brightnessRange") affect the color and transparency of the mesh and have been added to the list of main parameters.

Using the mode "Draw Strip," each row of the mesh is connected as a strip.
→ M_3_4_01_TOOL.pde

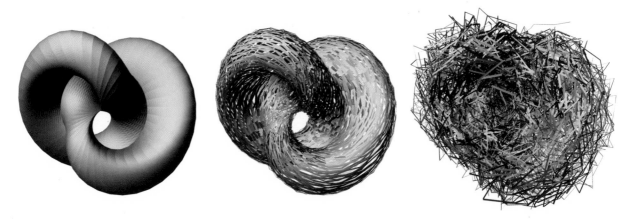

The parameter "meshDistortion" specifies how much the grid points are displaced by a random vector.
→ M_3_4_01_TOOL.pde

Form: Bow. Forms like these are generated when one of the two values uCount and vCount is very large and the other very small.
→ M_3_4_01_TOOL.pde

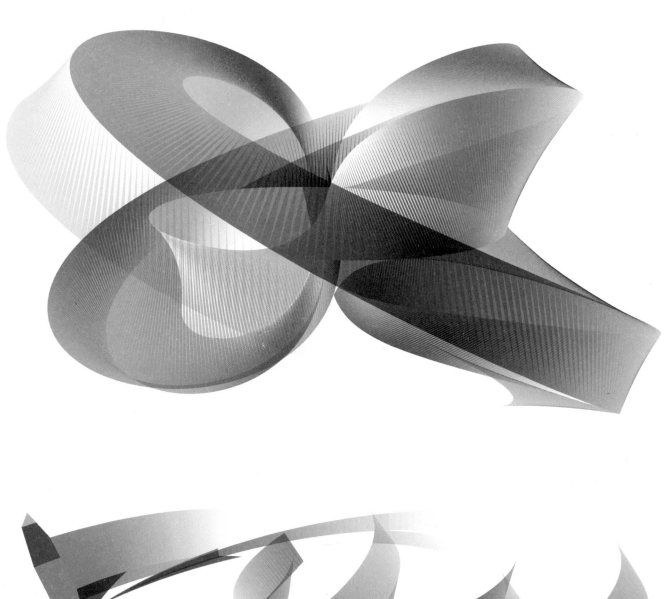

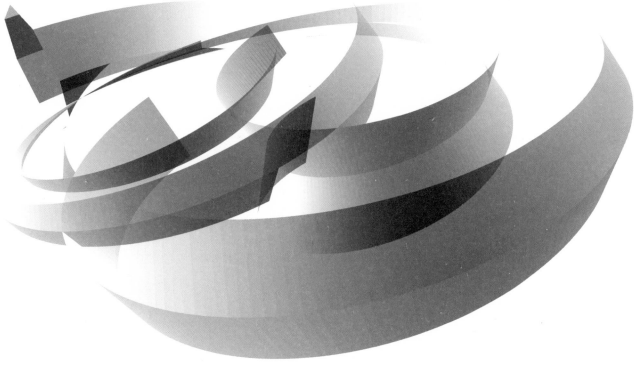

Form: Figure-8 torus. The mesh is represented by intersecting layers of color using the mode "Blend on White."
→ M_3_4_01_TOOL.pde

MULTIPLE GRID SECTIONS A second way to dissolve the grid is to generate a number of grids but only display them in sections on the mesh's surface.

In the following example, six instances of the mesh class are generated using the sphere formula. A mesh would generate an entire sphere if the value range for u and v extended from −Pi to Pi. If smaller random value ranges are now selected for each mesh, a kind of patchwork is generated as the overall shape. It is relatively easy to implement this in the program. Here, again, it is convenient that the entire functionality for the calculation and drawing of the mesh is encapsulated in the mesh class.

The shape of the mesh is no longer drawn in one piece but results from a large number of grid sections that can also overlap with each other.

→ M_3_4_02.pde

```
int meshCount = 6;
Mesh[] myMeshes;

int form = Mesh.SPHERE;
int uCount = 100;
int vCount = 30;
```

The variable meshCount defines how many meshes are to be generated. The meshes are saved in the array myMeshes.

Sets the mesh parameters that will apply to all generated meshes.

```
void setup() {
  ...
  myMeshes = new Mesh[meshCount];

  randomSeed(35976);
  for (int i = 0; i < meshCount; i++) {
    float uMin = random(-6, 6);
    float uMax = uMin + random(2, 3);

    float vMin = random(-6, 6);
    float vMax = vMin + random(1, 2);

    myMeshes[i] = new Mesh(form, uCount,vCount,
                      uMin,uMax, vMin,vMax);
    myMeshes[i].setDrawMode(QUAD_STRIP);

    float col = random(160, 240);
    myMeshes[i].setColorRange(col,col,50,50,100,100,100);
  }
}
```

Initializes the array for the meshes.

The meshes are created in a loop. The u-v section is defined randomly. Since the value range for u is larger than that for v, strips are generated.

The meshes are generated as usual except that here the generated instances are stored in an array.

```
void draw() {
  ...
  for (int i = 0; i < meshCount; i++) {
    pushMatrix();
    scale(random(0.9, 1.2));
    myMeshes[i].draw();
    popMatrix();
  }
}
```

Scaling in the draw() routine is set at a random value between 90% and 120% before drawing a grid. This usually prevents the tiles of different meshes from overlapping in an unattractive way.

A tool is also available for this kind of deconstruction with which the form can be changed using a few controls and buttons. What is new here is the parameter "randomScaleRange" that defines how much the individual grid sections are scaled.

Using the sliding control for "randomURange" and "randomUCenter-Range" (or "randomVRange" and "randomVCenterRange"), the random values are set that specify how wide the grid sections can be and where these are placed.

A torus made of several meshes. When "randomScaleRange" is increased, some meshes become smaller and migrate inward while others become larger and migrate outward.
→ M_3_4_03_TOOL.pde

 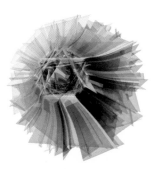 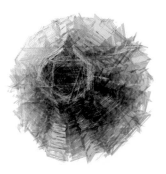 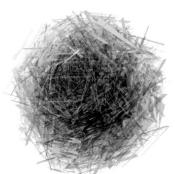

Form: Limpet torus; first "randomScaleRange" was increased then "meshDistortion."
→ M_3_4_03_TOOL.pde

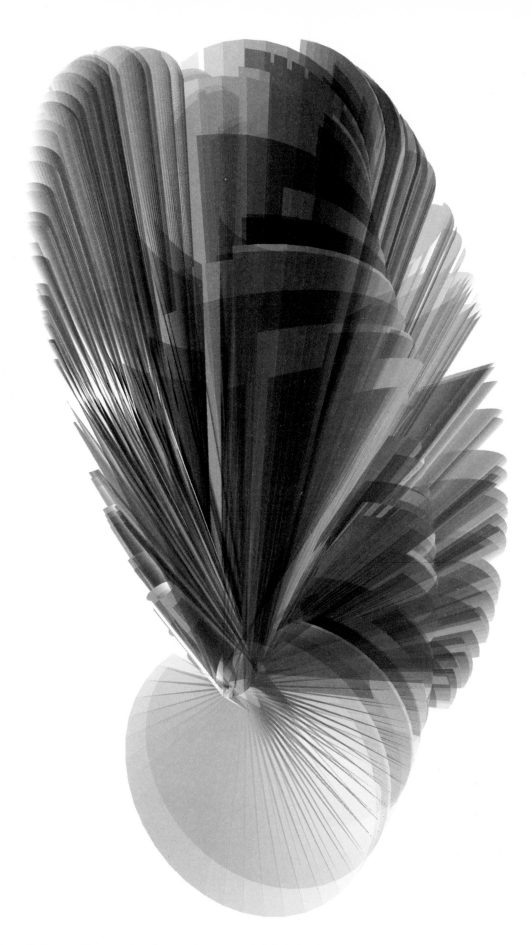

Form: Figure-8 torus. The forms on this page consists of many mesh sections, each of which is composed of very few individual areas.
→ M_3_4_03_TOOL.pde

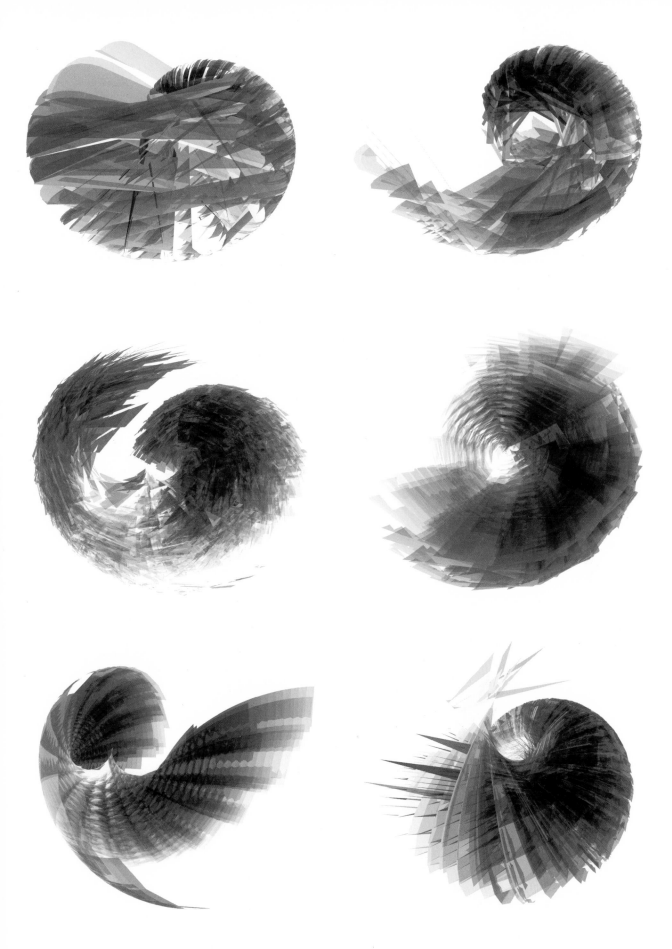

Form: Corkscrew. Here, the variety of forms is generated by parameter changes in the random areas for u and v through the rotation of the mesh.
→ M_3_4_03_TOOL.pde

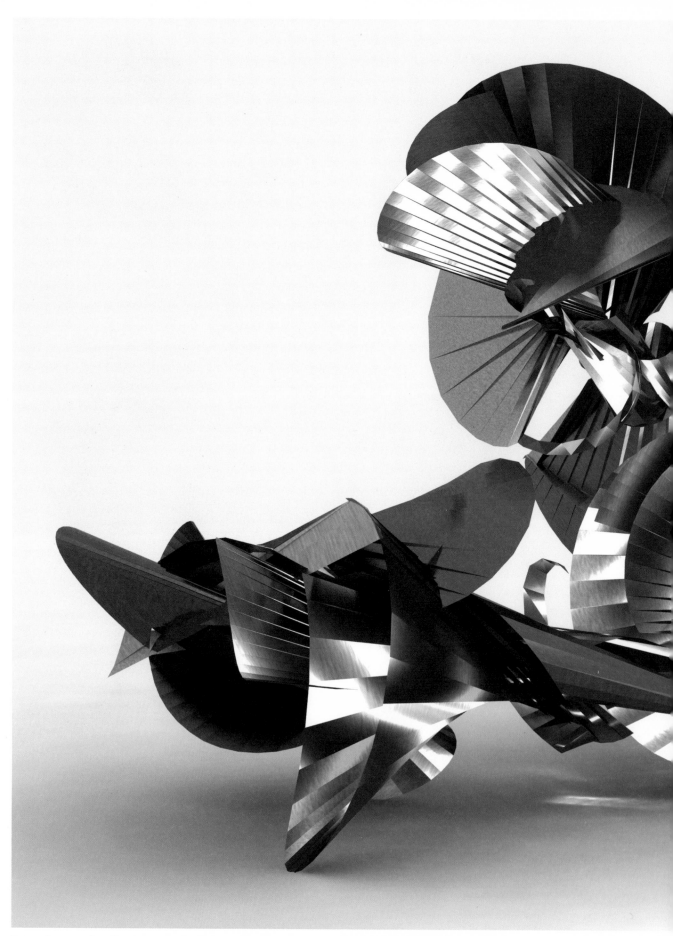

Data can be exported to a 3D program using the DSF format, which allows even more impressive rendering effects to be generated.
→ M_3_4_03_TOOL.pde and Autodesk 3ds Max → Rendering: Cedric Kiefer

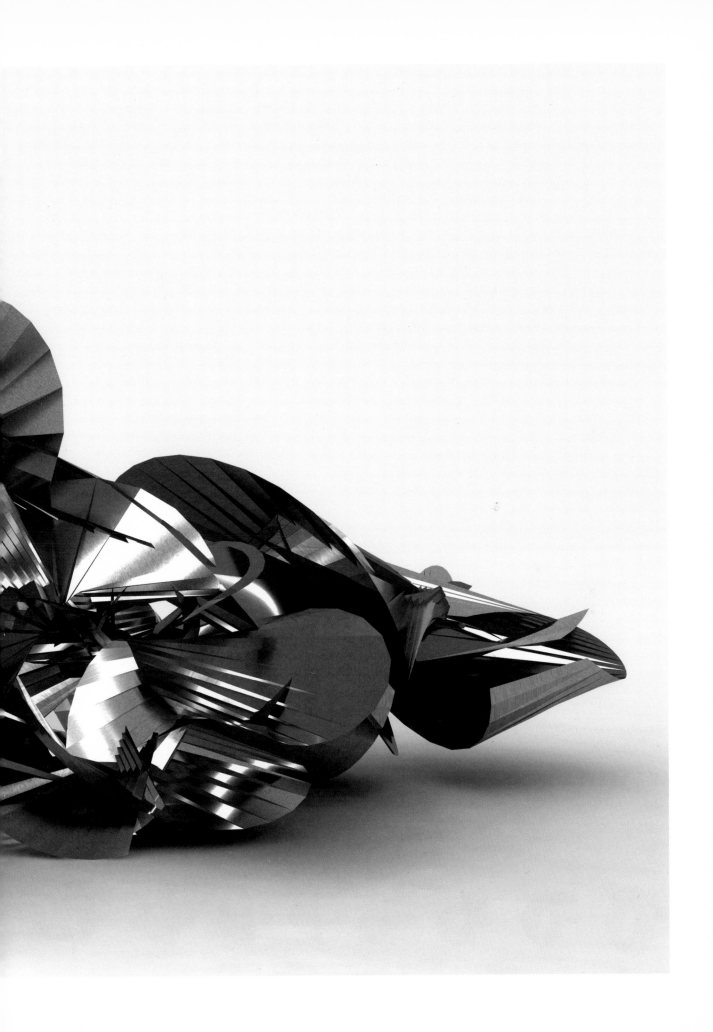

M.3.5 Defining custom shapes

Various forms are already implemented in the mesh class. For instance, a sphere can be generated using setForm(Mesh.SPHERE). The mesh class can be easily expanded to define new forms. In the following script, a class MyOwnMesh is generated that extends the existing class. All methods are then derived from the mesh class. Only the method calculatePoints() has to be replaced, in which x, y, and z are calculated from the values u and v, allowing either the creation of completely new formulas or the modification of pre-existing ones to generate new forms.

→ M_3_5_01.pde

```
class MyOwnMesh extends Mesh {
  PVector calculatePoints(float u, float v) {
    PVector p1 = SteinbachScrew(u, v);
    PVector p2 = Bow(u, v);

    float x = lerp(p1.x, p2.x, params[1]);
    float y = lerp(p1.y, p2.y, params[1]);
    float z = lerp(p1.z, p2.z, params[1]);

    return new PVector(x, y, z);
  }
}
```

The method calculatePoints is redefined.

An interpolation should be performed between the predefined formulas SteinbachScrew and Bow.

The array params in the mesh class provides twelve memory locations that can be used freely. The first value in the params[0] array, however, is already used in the predefined formulas. Here, params[1] is used to control the cross-blending of the two forms.

The class can now be used as follows:

```
void setup() {
  ...
  myMesh = new MyOwnMesh();
  myMesh.setUCount(100);
  myMesh.setVCount(100);
  myMesh.setColorRange(193, 193, 30, 30, 85, 85, 100);
}

void draw() {
  ...
  myMesh.setParam(1, float(mouseX)/width);
  myMesh.update();
  myMesh.draw();
}
```

An instance of the new class is generated and various parameters are set.

Using the method setParam(), the value for an individual parameter can be set. Since params[1] is used in the self-generated class, it is precisely this parameter that is modified here.

When parameters change that affect the shape of the mesh (as in this case), the points must be recalculated with update() before drawing.

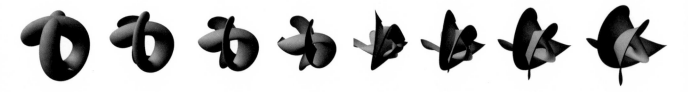

The mouse's horizontal position controls the parameter that dissolves one form into another.
→ M_3_5_01.pde

M.3.6 Mesh class—a short reference

PROPERTIES

form	int	Defines the shape of the mesh. One of the constants. PLANE, TUBE, SPHERE, TORUS, PARABOLOID, STEINBACHSCREW, SINE, FIGURE8TORUS, ELLIPTICTORUS, `CORKSCREW, BOHEMIANDOME, BOW, MAEDERSOWL, ASTROIDALELLIPSOID, TRIAXIALTRITORUS, LIMPETTORUS, HORN, SHELL, KIDNEY, LEMNISCAPE, TRIANGULOID, SUPERFORMULA
uMin	float	Minimal value for u
uMax	float	Maximum value for u
uCount	int	Number of tiles in direction u
vMin	float	Minimal value for v
vMax	float	Maximum value for v
vCount	int	Number of tiles in direction v
params	float[]	Array of parameters that change the appearance of some shapes. Usually only param[0] is used in the formulas.
drawMode	int	Defines how the tiles are drawn. TRIANGLES, TRIANGLE_STRIP, QUADS, QUAD_STRIP
meshDistortion	float	Distortion of the mesh
minHue	float	Minimal value for hue (0–360)
maxHue	float	Maximum value for hue (0–360)
minSaturation	float	Minimal value for saturation (0–100)
maxSaturation	float	Maximum value for saturation (0–100)
minBrightness	float	Minimal value for brightness (0–100)
maxBrightness	float	Maximum value for brightness (0–100)
meshAlpha	float	Opacity (0–100)

METHODS

update()	Recalculate the mesh points.
draw()	Draw the mesh.

CONSTRUCTORS

Mesh()
Mesh(form)
Mesh(form, uCount, vCount)
Mesh(form, uMin, uMax, vMin, vMax)
Mesh(form, uCount, vCount, uMin, uMax, vMin, vMax)

M.4

Attractors

M.4.0
Attractors—an overview

Attractors are virtual magnets: imagined—and programmed—points in space that either attract or repel other objects. Their function is time-based; each time a program is iterated, they have a minimal effect on the environment. Forms gradually emerge that cannot be generated any other way (or only with great difficulty). They are also useful when a large quantity of objects are to be gathered in one place or kept away from a place.

→ M_4_3_01_TOOL.pde
→ M_4_4_01_TOOL.pdes

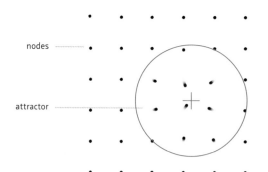

nodes

attractor

The starting points for all the graphics in this chapter are nodes (points that can move) and attractors that attract or repel these nodes. This attracting or repelling force is recalculated in each frame and then applied to the nodes. The starting structure is gradually deformed by this iterative process.

Different structures are generated depending on the parameters for the points' movement and the representation method. Nodes represented as points . . .

. . . nodes connected with horizontal lines, gradually distorted and superimposed . . .

. . . or a three-dimensional grid of nodes in which the attractor repelled all the grid points into all spatial dimensions.

The originally horizontal lines were gradually deformed by an attractor. Although no three-dimensional operations were applied here, packing generates a three-dimensional appearance.

→ M_4_3_01_TOOL.pde

M.4.1 Nodes

When creating a virtual world in which attractive forces are simulated, at least two kinds of objects are needed: attractors (points that attract) and nodes (objects that are attracted). In principle, both attractors and nodes are simple points in space. The most important information is their position: x-, y-, and (in the event that they move in three-dimensional space) z-coordinates. They also have other properties and functions, which will be examined in more detail in the following pages.

The first examples are based on a two-dimensional space, but it will be easy to shift into the third dimension later.

An object that can move is now needed as the node. In addition to its position in the world (x, y), it is also assigned a velocity vector that specifies by how many pixels the position is offset in each frame.

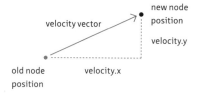

In the following example, a simple node class is created and a few instances from it are placed on the stage.

Keys: *R: Reset nodes* → M_4_1_01/Node.pde

```
class Node extends PVector {
  PVector velocity = new PVector();
  float minX=5, minY=5, maxX=width-5, maxY=height-5;
  float damping = 0.1;

  Node(float theX, float theY) {
    x = theX;
    y = theY;
  }

  void update() {
    x += velocity.x;
    y += velocity.y;

    →
```

As a supplement to the PVector class, the node class adopts all their properties and methods, especially the properties for the x and y positions.

Velocity.

Position boundary.

Damping the motion (0–1). The higher this number is, the more quickly the node stops moving.

When the update() method is called, the velocity values are added to the position first.

```
    if (x < minX) {
      x = minX - (x - minX);
      velocity.x = -velocity.x;
    }
    if (x > maxX) {
      x = maxX - (x - maxX);
      velocity.x = -velocity.x;
    }
    ...

    velocity.x *= (1-damping);
    velocity.y *= (1-damping);
  }
}
```

When the position (here the x-coordinate) lies outside of the permitted area, the x-value is reflected and the border and velocity value is inverted, thereby preventing a rebound reaction.

What was shown for the x-coordinate must be applied in the same way to the y-coordinate.

Finally, the velocity vector is shortened depending on the damping value. A higher damping value causes velocity.x and velocity.y to be multiplied by a number close to zero, reducing those values quickly.

The node class can then be applied as follows:

→ M_4_1_01.pde

```
int nodeCount = 20;
Node[] myNodes = new Node[nodeCount];

void setup() {
  ...
  for (int i = 0; i < nodeCount; i++) {
    myNodes[i] = new Node(random(width), random(height));
    myNodes[i].velocity.x = random(-3, 3);
    myNodes[i].velocity.y = random(-3, 3);
    myNodes[i].damping = 0.01;
  }
}
```

Create the node array.

Generate the instances with random position values and a random velocity vector.

```
void draw() {
  ...
  for (int i = 0; i < myNodes.length; i++) {
    myNodes[i].update();
    fill(0, 100);
    ellipse(myNodes[i].x, myNodes[i].y, 10, 10);
  }
}
```

The node positions are updated and drawn each time with each frame.

The other examples are based on the node class, which is integrated into the Generative Design library. → p.408 This is basically identical to the aforementioned class except for a few small changes, including expansion by one function. The node class is also used in the chapter "Dynamic data structures," in which this additional functionality is required.

→ Ch.M.6

M.4.2 Attractor

An attractor simulates attracting forces. As with magnets, the closer the objects (in this case the nodes) are to the attractor, the more strongly they are attracted to it.

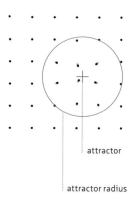

attractor

attractor radius

An attractor functions iteratively, meaning that with each calculation step, the velocity vectors of all the nodes within a defined radius around the attractor are modified so that they move toward it. This occurs as follows:

1. Measure distance (d) between the node and attractor.

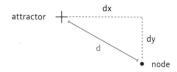

2. Define a function to calculate the attractive force (f).

A function is now required that will return a large number if the distance is close to zero, and that will return zero if the distance is as large as the radius. It is first useful to convert d from the value range between 0 and radius (r) into a value s between 0 and 1 and use this in the adjacent function.

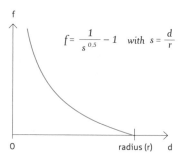

$$f = \frac{1}{s^{0.5}} - 1 \quad \text{with} \quad s = \frac{d}{r}$$

3. Apply force to the node's velocity vector.

Now one just has to decide how this value f is applied to the nodes. The easiest way is to multiply f by the original distance vector (this generates the curve illustrated on the right), and add the result to the node's motion vector. Although this is not quite physically correct, it prevents unpleasant effects from occurring when a node gets very close to the attractor.

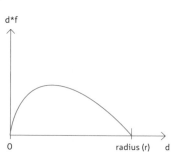

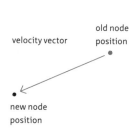

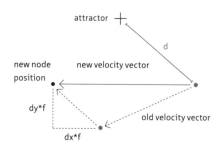

As with nodes, it is useful to summarize attractor function.

Mouse: *Draw: Attraction of nodes*
Keys: *R: Reset nodes*

→ M_4_2_01/Attractor.pde

```
class Attractor {
  float x=0, y=0;                                          Variables for the position.

  float radius = 200;                                      Attractor radius.

  Attractor(float theX, float theY) {
    x = theX;
    y = theY;
  }
                                                           The attract() method is passed a node to
                                                           be influenced by the attractor and carries out
  void attract(Node theNode) {                             the following steps:
    float dx = x - theNode.x;
    float dy = y - theNode.y;
    float d = mag(dx, dy);                                 1. Calculate distance d.

    if (d > 0 && d < radius) {
      float s = d/radius;                                  2. Calculate force f and then divide by
      float f = 1 / pow(s, 0.5) - 1;                       the radius to prevent undesirable strong
      f = f / radius;                                      effects.

      theNode.velocity.x += dx * f;                        3. Exert the force to the node's velocity
      theNode.velocity.y += dy * f;                        vector.
    }
  }
}
```

This class can be applied as follows:

→ M_4_2_01.pde

```
int xCount = 200;
int yCount = 200;
float gridSize = 500;

Node[] myNodes = new Node[xCount*yCount];
Attractor myAttractor;

                                                           For the purpose of clarity, the generation of
void setup() {                                             nodes was outsourced here to a subroutine.
  ...

  initGrid();
  myAttractor = new Attractor(0, 0);                       Create an attractor instance.

}
  →
```

397

```
void draw() {
  ...
  myAttractor.x = mouseX;
  myAttractor.y = mouseY;

  for (int i = 0; i < myNodes.length; i++) {
    if (mousePressed) {
      myAttractor.attract(myNodes[i]);
    }

    myNodes[i].update();

    fill(0);
    rect(myNodes[i].x, myNodes[i].y, 1, 1);
  }
}
```

→ M_4_2_01.pde

The attractor is set at the mouse position.

The attractor should only influence the node when the mouse button is pressed.

Here, too, the nodes are updated with each frame iteration.

When the node damping is set to a very small value (here, 0.02), the nodes maintain their velocity for a long time, thereby generating such an image.

ATTRACTOR-TUNING In order to have more control over certain attractor properties, it is useful to introduce two other parameters in addition to the radius.

It is easy to introduce a parameter for the strength of the attraction. The force f is simply multiplied by an additional value, strength. If a negative value is used for this, then the attractor will have the effect of not only attracting other objects but also repelling them.

→ M_4_2_02/Attractor.pde

```
f = strength * f/radius;
```

When calculating the force, the formula contains the fixed number 0.5, which is multiplied by a new parameter. In order to name this parameter appropriately, one needs to examine how this multiplication changes the curve. Obviously, the more quickly the curve reaches its highest point, the greater the value. The parameter could therefore be called ramp. The corresponding line in the attractor class could be as follows:

0.6 1.2 1.8

Shape of the curve for various values of ramp.

```
float f = 1 / pow(s, 0.5*ramp) - 1;
```

When examined closely, a bend in the curve at the radius is visible, meaning that an unattractive kink would occur on the graphs as well. This kink is eliminated when the following formula is used to calculate the force:

→ M_4_2_03/Attractor.pde

```
float s = pow(d/radius, 1/ramp);
float f = s*9*strength * (1/(s+1) + ((s-3)/4)) / d;
```

Transition with bend

Smooth transition

It is also fairly easy to change the attractor so the force f no longer has an attracting or repelling effect but rather leads to a vortex effect:

Mouse: Draw: Attraction of nodes
Keys: R: Reset nodes

→ M_4_2_04/Attractor.pde

```
class Attractor {
  ...
  void attract(Node theNode) {
    ...
    theNode.velocity.x += dy * f;
    theNode.velocity.y -= dx * f;
  }
}
```

When the two values are switched in a vector (x, y) and one of the values is negated, a vector (y, -x) is generated that is perpendicular to the original. If this principle is applied in the attractor class, the attractor generates a vortex.

Like the node class, this attractor class can be found in a slightly expanded form in the Generative Design library. → p.409 The attractor functions just discussed can be configured using the property mode, the value of which is one of the constants: BASIC (the function that was explained at the beginning of the chapter), SMOOTH (the curve with the smooth transition), or TWIRL (vortex). A short summary of the properties and methods of the attractor class is located at the end of the chapter.

Twirl
→ M_4_2_04.pde

M.4.3 The attractor tool

The previously discussed ways of dealing with nodes and attractors have been combined into one tool, which can be used to investigate the individual parameters. In addition, there are more setting options installed in the tool, some of which will be explained in more detail here.

In previous examples, a grid consisting of nodes was always generated in which each node was represented as a point. The tool contains additional ways to manipulate and draw the grid.

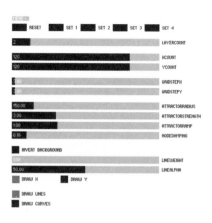

As many as nine grids can be superimposed using "layerCount" and each of these can be influenced separately. Keys 1 through 9 can be used to define which of the layers is to be manipulated. All the displayed grids are changed simultaneously by pressing key 0. Different colors can be used to indicate the individual layers in the following line of code:

```
color[] defaultColors = {color(0, 130, 164),
            color(181, 157, 0), color(90, 144, 82)};
```

By using the buttons "Draw X" and "Draw Y" it is possible to specify which grid points are connected by lines, or—if nothing is selected—if points are drawn at all. The buttons "Lock X" and "Lock Y" are used to limit the nodes' directions of movement. All this greatly expands the repertoire of possible shapes. If "Draw Curves" is selected the individual grid points are not connected by straight lines but by curves.

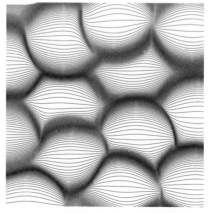

Several layers can be superimposed and influenced individually.
→ M_4_3_01_TOOL.pde

Depending on how the step sizes of the node grid are configured (in this case, the nodes' directions of movement were restricted when drawing with the attractor), or how the lines were ultimately drawn (above as curves, below as lines), completely different structures are created.

→ M_4_3_01_TOOL.pde

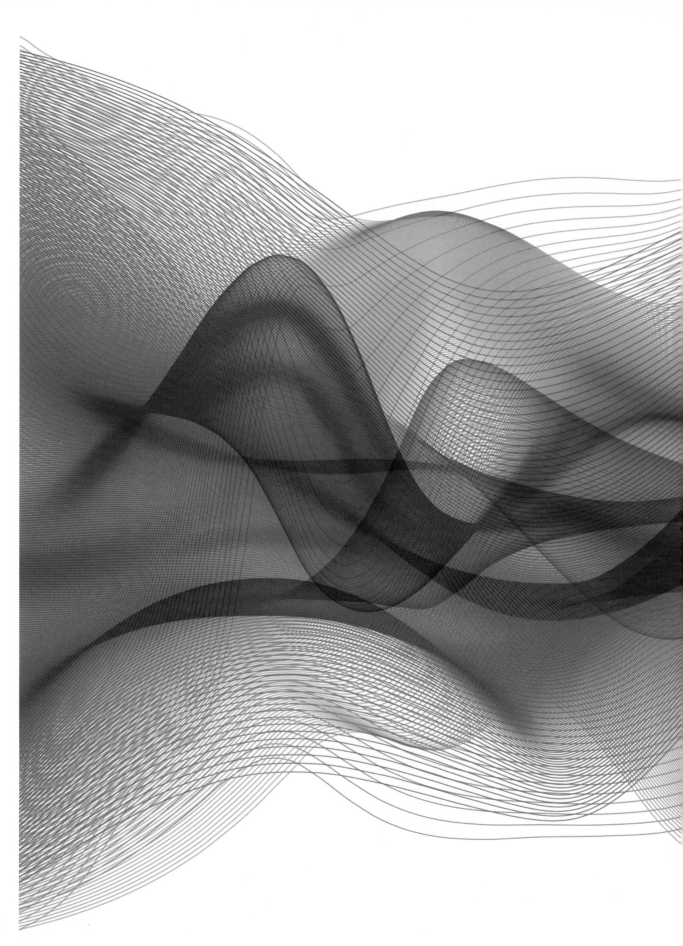

Several two-dimensional node layers, each of which was individually formed and later superimposed with the color multiplying effect.
→ M_4_3_01_TOOL.pde

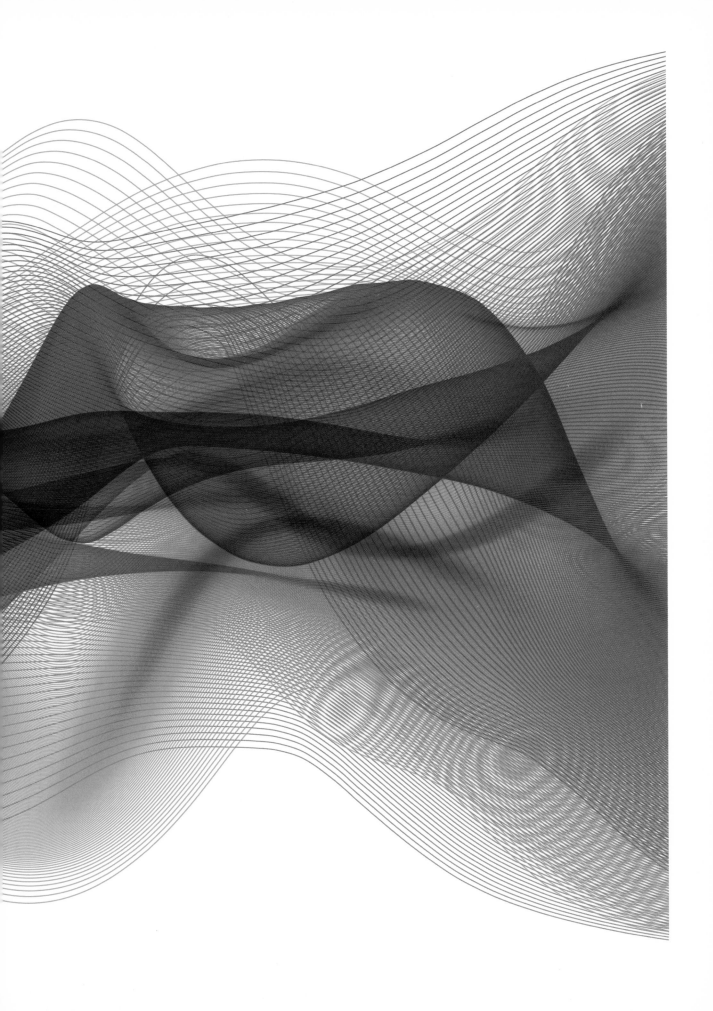

M.4.4 Attractors in space

As stated at the beginning of the chapter, it is easy to use attractors and nodes in three-dimensional space. To do this, everywhere in the sketches where calculations with x and y appear, an additional line needs to be added that does the same with z. This addition is included in the classes in the Generative Design library.

However, a small problem has to be solved if the 2D tool is to be extended into the third dimension. In the 2D tool, the mouse position is used to control the position of the attractor. In a three-dimensional grid of nodes, however, it is no longer clear how an interaction can be designed so the mouse can influence all the nodes. The solution is to ensure that the attractor is always located on the screen's x-y layer. If the nodes are rotated in space, the position of the attractor has to be rotated in the opposite direction so that it influences those nodes that are located on the screen plane.

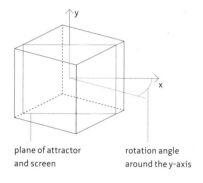

plane of attractor
and screen

rotation angle
around the y-axis

The following has to be contained in the code:

→ M_4_4_01_TOOL.pde

```
rotateX(rotationX);
rotateY(rotationY);
...
myAttractor.x = (mouseX-width/2);
myAttractor.y = (mouseY-height/2);
myAttractor.z = 0;

myAttractor.rotateX(-rotationX);
myAttractor.rotateY(-rotationY);
```

The view of the node grid is rotated here.

The attractor is initially set on the corresponding position in three-dimensional space, depending on the mouse position.

The position of the attractor is then rotated in the opposite direction. The rotation functions are implemented for this action in the attractor class.

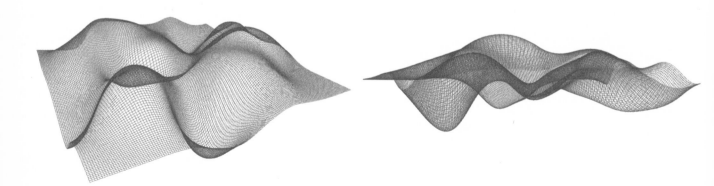

Here, the starting point was a two-dimensional mesh grid of the node. An attractor in space can move the node in all spatial directions, thereby creating these waves.
→ M_4_4_01_TOOL.pde

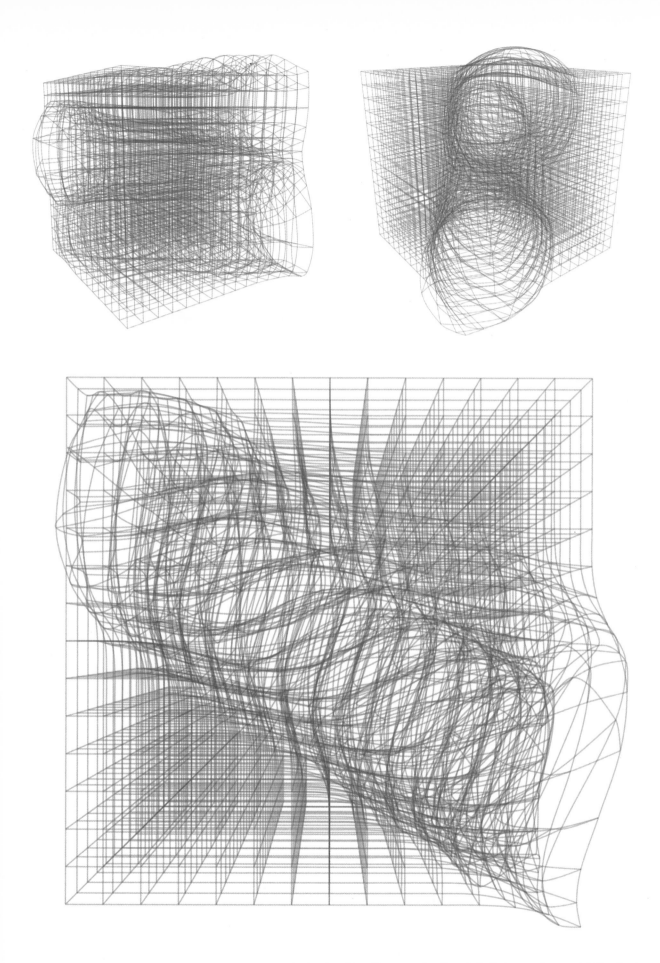

These images show how one can draw in space with the attractor. The elevation of the grid was rotated, as illustrated in the image on the upper left. The attractor was then moved, and the nodes were repelled. The two other images show that the attractor has moved on only one level layer.

→ M_4_4_01_TOOL.pde

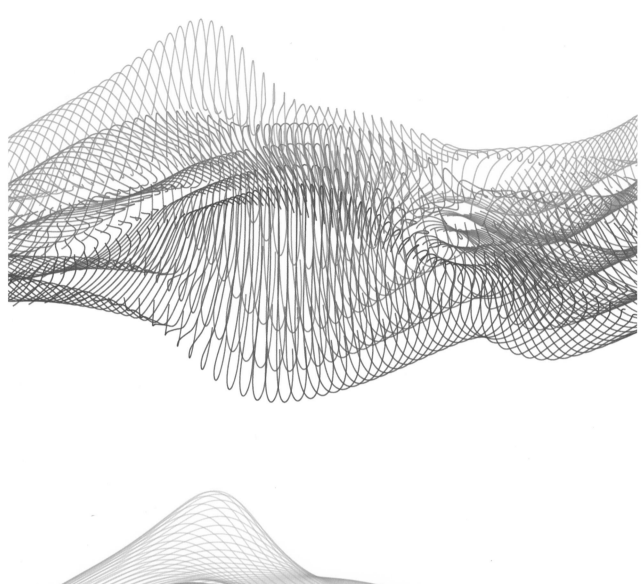

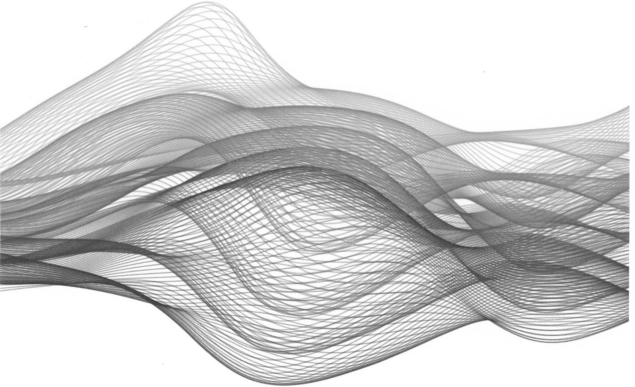

Three images of the same three-dimensionally deformed mesh grid; in the elevation view, the nodes are connected in different ways with lines.
→ M_4_4_01_TOOL.pde

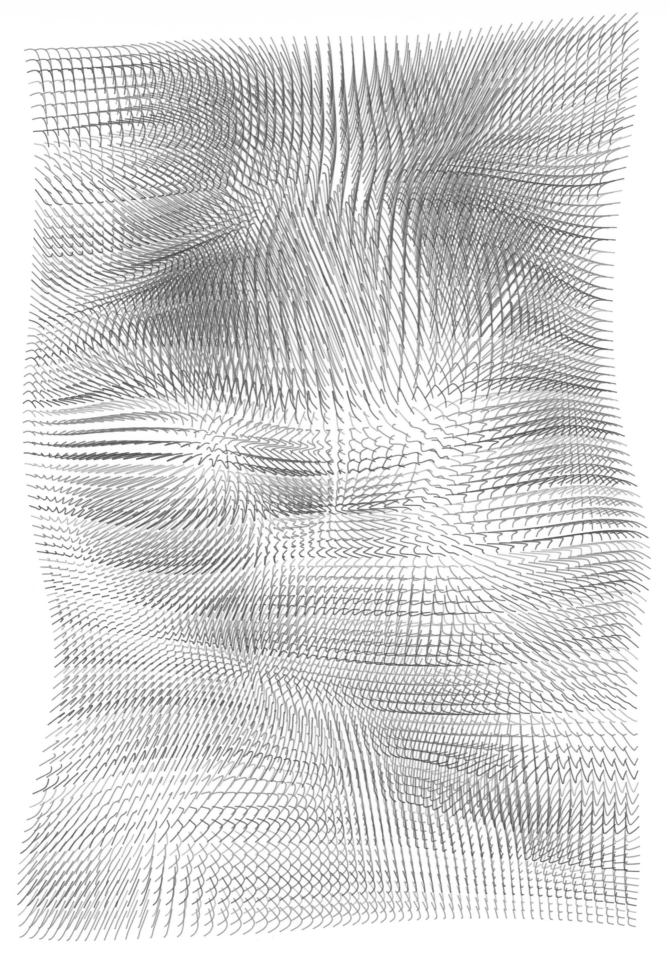

Different colors can be assigned to each layer in the program. When there are more layers than preset configured colors, the colors are repeated.

→ M_4_4_01_TOOL.pde

M.4.5 Node class—a short reference

PROPERTIES

x, y, z	float	Position of the nodes
minX, maxX, minY, maxY, minZ, maxZ	float	Minimum and maximum for x, y, and z
velocity	PVector	Motion vector
maxVelocity	float	Maximum velocity
damping	float	Damping the motion vector (0 – 1)

METHODS

update()	Updates the position
setBoundary(minX, minY, maxX, maxY)	Sets the boundary (x and y)
setBoundary(minX, minY, minZ, maxX, maxY, maxZ)	Sets the boundary (x, y, and z)

CONSTRUCTORS

Node()
Node(x, y)
Node(x, y, z)
Node(PVector(x, y, z))

M.4.6 Attractor class—a short reference

PROPERTIES

x, y, z	float	Position of the attractor
mode	int	One of the constants BASIC, SMOOTH, TWIRL
radius	float	Radius for attraction and repulsion (0 or larger)
strength	float	Strength of the attraction (a negative number indicates repulsion)
ramp	float	Curve gradient for attraction and repulsion (0–2)
nodes	Node[]	Array of nodes that are attracted or repelled when the attract() function is called

METHODS

rotateX(float theAngle)	Rotates the position by the angle around the x-axis
rotateY(float theAngle)	Rotates the position by the angle around the y-axis
rotateZ(float theAngle)	Rotates the position by the angle around the z-axis
attachNode(Node theNode)	Adds the passed node to the nodes array
attract()	Applies attraction/repulsion to the nodes specified in nodes
attract(Node theNode)	Applies attraction/repulsion to theNode
attract(Node[] theNodes)	Applies attraction/repulsion to theNodes

CONSTRUCTORS

Attractor()
Attractor(x, y)
Attractor(x, y, z)
Attractor(PVector(x, y, z))

M.5

Tree diagrams

M.5.0
Tree diagrams—an overview

Tree structures are graphic representations of hierarchically structured data. In this chapter, we will be using an example of a nesting structure: a folder on the hard drive. Data is read recursively and transformed into a special, radially structured tree—a so-called sunburst diagram. The advantages of such a visualization over a list presentation are obvious: the size distribution and nesting structure of thousands of files can be viewed at a glance.

→ M_5_5_01_TOOL.pde

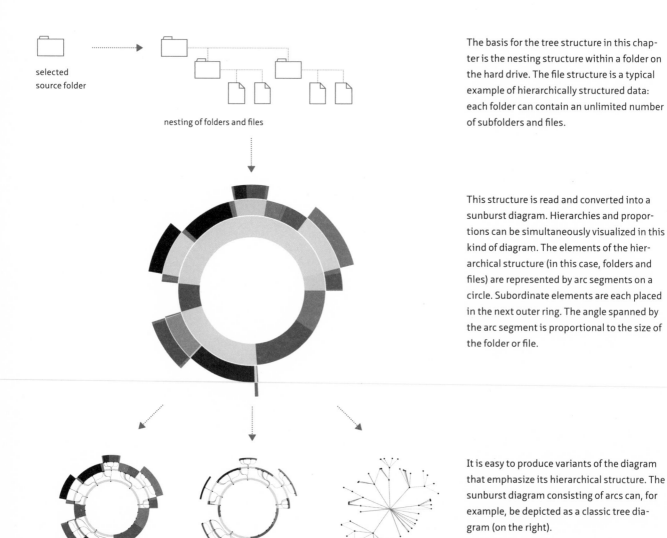

selected
source folder

nesting of folders and files

The basis for the tree structure in this chapter is the nesting structure within a folder on the hard drive. The file structure is a typical example of hierarchically structured data: each folder can contain an unlimited number of subfolders and files.

This structure is read and converted into a sunburst diagram. Hierarchies and proportions can be simultaneously visualized in this kind of diagram. The elements of the hierarchical structure (in this case, folders and files) are represented by arc segments on a circle. Subordinate elements are each placed in the next outer ring. The angle spanned by the arc segment is proportional to the size of the folder or file.

It is easy to produce variants of the diagram that emphasize its hierarchical structure. The sunburst diagram consisting of arcs can, for example, be depicted as a classic tree diagram (on the right).

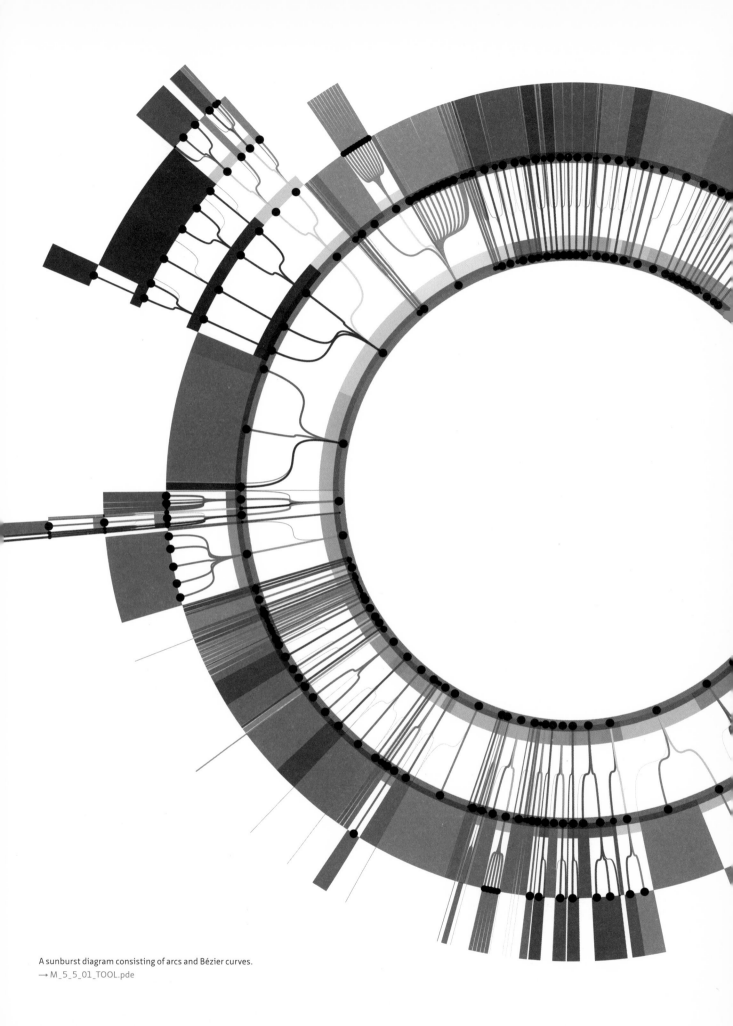

A sunburst diagram consisting of arcs and Bézier curves.
→ M_5_5_01_TOOL.pde

M.5.1 Recursion

The principle of iteration—the repetition of parts of a program—is a popular way to tackle complex tasks. The use of for-loops in almost all of this book's programs reflects this approach. Sometimes, however, this simple method of repetition does not suffice. When processing information or generating structures that are hierarchically nested—such as tree structures—recursion is often the only practical method. Recursion makes use of a function's ability to be called (again) from within itself. Of course, it is necessary to ensure that at some point the function is no longer called, to avoid an endless loop. In the following program, a "branch" is drawn by a function repeatedly calling itself.

→ W.411
Wikipedia: Recursion

The nesting of parentheses in mathematical formulas is a common example of recursion. The following equation has to be calculated recursively down to the innermost set of parentheses to come to the result:
$((2+5)*(4:(3-1)))=14$

Keys: *1–9: Recursion depth*

→ M_5_1_01.pde

```
int recursionLevel = 6;
float startRadius = 200;

void draw() {
  ...
  drawBranch(0,0, startRadius,recursionLevel);
  ...
}

void drawBranch(float x, float y, float radius, int level) {
  strokeWeight(level*2);
  stroke(0, 130, 164, 100);
  noFill();
  arc(x,y, radius*2,radius*2, -PI,0);

  fill(0);
  noStroke();
  ellipse(x,y,level*1.5,level*1.5);

  if (level > 0) {
    drawBranch(x-radius, y+radius/2, radius/2, level-1);
    drawBranch(x+radius, y+radius/2, radius/2, level-1);
  }
}
```

The function drawBranch() draws a downwardly open semicircle with the corresponding center point. The variable recursionLevel specifies how many hierarchical levels are generated.

The nesting level defines the line width.

A branch is drawn in the display using the arc() and ellipse() functions.

When additional sub-branches are to be drawn (i.e., if level>0), the function calls itself again twice with modified parameters.

M.5.2 **Reading data from the hard drive**

The files in a folder on your hard drive serve as the data basis for the tree structures in this chapter. In the section "Collage from collection," we demonstrate how several files from one folder could be loaded. → Ch.P.4.2.1 This exercise differs from that example in two ways. First, the "tree structure" within a folder is required for visualization, meaning that for each folder, all subordinated files and folders have to be traversed recursively. Second, we are no longer interested in the actual file contents but rather only in information about the files, such as their size. In order to load and display a folder structure, a new class `FileSystemItem` is created. Each instance of this class can contain any number of `FileSystemItem` instances.

→ The recursive concept of the FileSystemItem class is based on codes and ideas from Ben Fry's *Visualizing Data*, Ch.7.

→ M_5_2_01/FileSystemItem.pde

```
class FileSystemItem {
  File file;
  FileSystemItem[] children;
  int childCount;

  FileSystemItem(File theFile) {
    this.file = theFile;

    if (file.isDirectory()) {
      String[] contents = file.list();
      if (contents != null) {
        contents = sort(contents);
        children = new FileSystemItem[contents.length];
        for (int i = 0 ; i < contents.length; i++) {
          if (contents[i].equals(".")||contents[i].equals("..")
              || contents[i].substring(0,1).equals(".")) {
            continue;
          }
          File childFile = new File(file, contents[i]);
          try {
            String absPath = childFile.getAbsolutePath();
            String canPath = childFile.getCanonicalPath();
            if (!absPath.equals(canPath)) continue;
          } catch (IOException e) {}
          FileSystemItem child = new FileSystemItem(childFile);
          children[childCount] = child;
          childCount++;
        }
      }
    }
  ...
}
```

Each instance of `FileSystemItem` represents a folder or a file. The reference to the represented folder or file is saved in the variable `file`. References to the sub-objects (in the event that there are any) are stored in the array `children`.

`FileSystemItem` expects a file or a folder in `theFile`'s constructor. When `theFile` is a folder, its content is processed and new instances of `theFileSystemItem` class are then generated for all files and folders.

The included files and folders are sorted alphabetically.

Special files and folders are skipped—e.g., when the file name is "." or ".." or it begins with a period (hidden files).

A check is made to see if the current child element actually exists, excluding aliases (or shortcuts) to files or folders, which could lead to infinite loops in the hierarchical structure.

A new instance of `FileSystemItem` is created for all examined files and folders, recursively continuing the process until no subfolders or files are left.

415

An output method in the `FileSystemItem` class is needed for an initial simple presentation of the processed tree structure. The `printDepthFirst()` function recursively processes and displays the entire tree structure in the Processing console with line indentation, which indicates the depth. The tree is processed according to the principle of depth-first search: the algorithm first goes into the depth of the leaves and then branch by branch into the width. The principle of depth-first search is the "natural" way that a recursively defined function processes a hierarchical structure.

Example of a tree structure that is processed with a depth-first search. The sequence follows the numbers from lowest to highest.

→ W.412
Wikipedia: Depth-first search

```
void printDepthFirst(int depth, int indexToParent) {
  for (int i = 0; i < depth; i++) print("    ");
  println(fileCounter+" "+indexToParent+"<-->"+fileCounter+
          " ("+depth+") "+file.getName());

  indexToParent = fileCounter;
  fileCounter++;
  for (int i = 0; i < childCount; i++) {
    children[i].printDepthFirst(depth+1,indexToParent);
  }
}
```

The greater the value `depth`, the more spaces are added to the line, resulting in the respective indentation.

The variable `fileCounter` is defined globally and is incremented each time this function is called. In this way, all items are numbered and therefore possess a unique identification number.

The `printDepthFirst()` function is called again for each child: `depth` is increased by 1 and the children are given a reference to the parent element through `indexToParent`.

The `FileSystemItem` class and the output method can then be used in the main code as follows:

Keys: O: Choose input folder

```
String defaultFolderPath = "/Users/xyz/Desktop";
int fileCounter = 0;
```

The path specified in `defaultFolderPath` is searched when the program is launched and its contents sent to the output.

```
void setup() {
  size(128,128);
  setInputFolder(defaultFolderPath);
}
```

```
void setInputFolder(String theFolderPath) {
  ...
  FileSystemItem selectedFolder = new FileSystemItem(
                            new File(theFolderPath));
  selectedFolder.printDepthFirst();
  ...
}
```

An instance of `FileSystemItem` is created by giving the constructor a folder on the hard drive as a starting point; as illustrated above, the entire structure of subfolders and files is displayed in it.

This can then be sent to the console output using the `printDepthFirst()` method.

M.5.3 Sunburst diagrams

A sunburst is a visualization technique that simultaneously depicts hierarchical structures and proportions in a radial diagram. The entire diagram is composed of arcs. The farther out the arc lies, the lower the object it represents is in the hierarchy. The size of the object is visualized by the angle the arc spans. In the example of data from a hard drive, this means that each arc represents a file or folder, the angle the arc spans represents the file or folder size, and the distance from the center represents the hierarchical depth. It is also ensured that the inner arcs span the entire 360°. Instead of (or in addition to) file size, other properties such as file age can be coded in the arc depiction (as color, line value, etc.).

→ W.413
Several articles by John Stako on sunbursts

Juxtaposition of a file structure from the hard drive in a tree and sunburst representation. The numbers represent the size of each element.

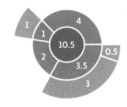

The arcs of the sunburst diagram are generated by the SunburstItem class.

→ M_5_3_01/SunburstItem.pde

```
class SunburstItem {
  ...
  void update(int theMappingMode) {
    ...
    percent = norm(fileSize, fileSizeMin, fileSizeMax);
    if (isDir) {
      float bright = lerp(folderBrightnessStart,
                          folderBrightnessEnd, percent);
      col = color(0,0,bright);
    } ...
  }

  void drawArc(float theFolderScale, float theFileScale) {
    float arcRadius;
    if (depth > 0 ) {
      if (isDir) {
        strokeWeight(depthWeight * theFolderScale);
        arcRadius = radius + depthWeight*theFolderScale/2;
      } else {
        strokeWeight(depthWeight * theFileScale);
        arcRadius = radius + depthWeight*theFileScale/2;
      }

      stroke(col);
      arc(0,0, arcRadius,arcRadius, angleStart, angleEnd);
    }
  }
}
```

Depending on the type of representation, the update() method calculates arc color, arc width, radius, etc. The calculation of the values required for the presentation is executed once, greatly reducing the computational effort.

For example, here fileSize is converted to a percentage value percent between a minimum and maximum size, from which the color of the arc is calculated.

With the drawArc() function, arcs can be drawn in the display. The parameters theFolderScale and theFileScale are used to set the arc width and radius independently for folders and files.

The variable isDir is true when the element is a folder.

The arc is drawn using the arc() command.

In addition, the class `FileSystemItem` has to be expanded so corresponding instances of `SunburstItem` can be created for the loaded tree structures. The expansion is performed by three new methods: `getFileSize()` recursively determines the total size of a folder; `getNotModifiedSince()` finds the date of the last change to the file or folder; and `createSunburstItems()` is used as the main method for creating the instances of `SunburstItem`. This produces an instance of `SunburstItem` for each instance of `FileSystemItem` and translates the folder structure into a sunburst representation. It is easiest to construct the sunburst diagram layer by layer, from the inside out, which is why the tree structure has to be processed according to the principle of breadth-first search.

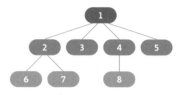

Example of a tree structure processed with a breadth-first search

→ W.414
Wikipedia: Breadth-first search

1. Define a FileSystemItem starting element and save it in a list.
2. Introduce an `index` variable that points to a position in this list.
3. Check if `index` is still found in the list. When this is the case:
 4. Extract a FileSystemItem at this position.
 5. If this is a folder, add all its children to the list.
 6. Create a new SunburstItem from the values of the current FileSystemItems and save it.
 7. Increase `index` by one.
8. When the end of the array has been reached, return all saved SunburstItems.

For the adjacent example of a tree structure, the array is constructed as follows:

↑ index

Create starting element and index.

Add the four children belonging to the current element.

Examine the next element.

Add the two children to the current element.

 ...

End of operation.

Keys: O: Choose input folder · 1–3: Color-coding mode

→ M_5_3_01/FileSystemItem.pde

```
class FileSystemItem {

  ...

  SunburstItem[] createSunburstItems() {
    float megabytes = this.getFileSize();
    float anglePerMegabyte = TWO_PI/megabytes;

    ArrayList items = new ArrayList();
    ArrayList depths = new ArrayList();
    ArrayList indicesParent = new ArrayList();
    ArrayList sunburstItems = new ArrayList();
    ArrayList angles = new ArrayList();

    →
```

The variable `anglePerMegabyte` specifies which angle equals a megabyte.

Creation of necessary lists for processing the tree structure with breadth-first search. Here the type `ArrayList()` is used because this can be expanded by new entries more quickly.

```
items.add(this);
depths.add(0);
indicesParent.add(-1);
angles.add(0.0);

int index = 0;
float angleOffset = 0, oldAngle = 0;

while (items.size() > index) {
    FileSystemItem item = (FileSystemItem) items.get(index);
    int depth = (Integer) depths.get(index);
    int indexToParent = (Integer) indicesParent.get(index);
    float angle = (Float) angles.get(index);

    if (oldAngle != angle) angleOffset = 0.0;

    if (item.file.isDirectory()) {
        for (int ii = 0; ii < item.childCount; ii++) {
            items.add(item.children[ii]);
            depths.add(depth+1);
            indicesParent.add(index);
            angles.add(angle+angleOffset);
        }
    }

    sunburstItems.add(new SunburstItem(index, indexToParent,
                item.childCount, depth, item.getFileSize(),
                getNotModifiedSince(item.file),
                item.file, (angle+angleOffset)%TWO_PI, item.
                getFileSize()*anglePerMegabyte,
                item.folderMinFilesize,
                item.folderMaxFilesize) );

    angleOffset += item.getFileSize()*anglePerMegabyte;
    index++;
    oldAngle = angle;
}

return (SunburstItem[]) sunburstItems.toArray(
        new SunburstItem[sunburstItems.size()]);
}
...
}
```

1. Add the starting element to the list.

2. Initialize the index variable.

3. As long as the end of the list has not been reached . . .

4. an element is extracted from the list on the current index.

If the angle offset of the previously examined element is different from that of the current element (i.e., if you are in a new folder), angle is reset to 0.

5. If the current item is a folder, all its children are added to the list. Additional required information, such as hierarchy level, reference to the current index, and angle of the current element, is stored in separate lists.

6. An instance of SunburstItem() is created for the current FileSystemItem() and saved in sunburstItems.

The current angleOffset is increased depending on the size of the file or folder.

7. The index is incremented.

8. When all elements of the tree structure have been processed, all saved instances of SunburstItem are translated into an array and returned.

The class `SunburstItem` and the new functionalities are used as follows to create a sunburst diagram:

Keys: O: Choose input folder · 1–3: Color-coding mode → M_5_3_01.pde

```
SunburstItem[] sunburst;
```
All arcs for the sunburst diagram are saved in the sunburst array.

```
void draw() {
  ...
  for (int i = 0 ; i < sunburst.length; i++) {
    sunburst[i].drawArc(folderArcScale,fileArcScale);
  }
  ...
}
```
Process and draw all arcs.

```
void setInputFolder(String theFolderPath) {
  ...
  FileSystemItem selectedFolder = new FileSystemItem(
                                  new File(theFolderPath));
  sunburst = selectedFolder.createSunburstItems();
  ...
  for (int i = 0 ; i < sunburst.length; i++) {
    sunburst[i].update(mappingMode);
  }
}
```
The setInputFolder() function is called when the program is launched or a new folder is selected.

A new instance of FileSystemItem is created for the passed folder to generate the arcs, using the aforementioned createSunburstItems() function. The arcs are saved in the sunburst array.

Calculation of arc color, arc value, radius, etc.

Sunburst diagrams are special because hierarchical nesting and relative proportions can be displayed and read simultaneously. The legibility of sunburst diagrams can be increased when the areas of the individual rings are identical. This ensures that the arcs situated on different rings remain comparable. Otherwise, the appearance of the arcs would be emphasized more the farther out they are.

Comparison of equal thickness of the arcs on the left versus equal areas on the right.

→ Three-Dimensional Foundations in Medial Space, HFG Schwäbisch Gmünd, summer semester 2008, Professor Franklin Hernandez-Castro and Benedikt Groß

→ M_5_3_01.pde

Using the following function, a circle with a defined radius (here half the display height `height/2`) is divided up into the number of rings defined by `theDepthMax` function:

```
float calcEqualAreaRadius (int theDepth, int theDepthMax){
  return sqrt(theDepth * pow(height/2, 2) / (theDepthMax+1));
}
```
Depending on theDepth, the number of depth levels theDepthMax, and the height of the display height, the function calc-EqualAreaRadius() returns the radius of the ring's inner edge.

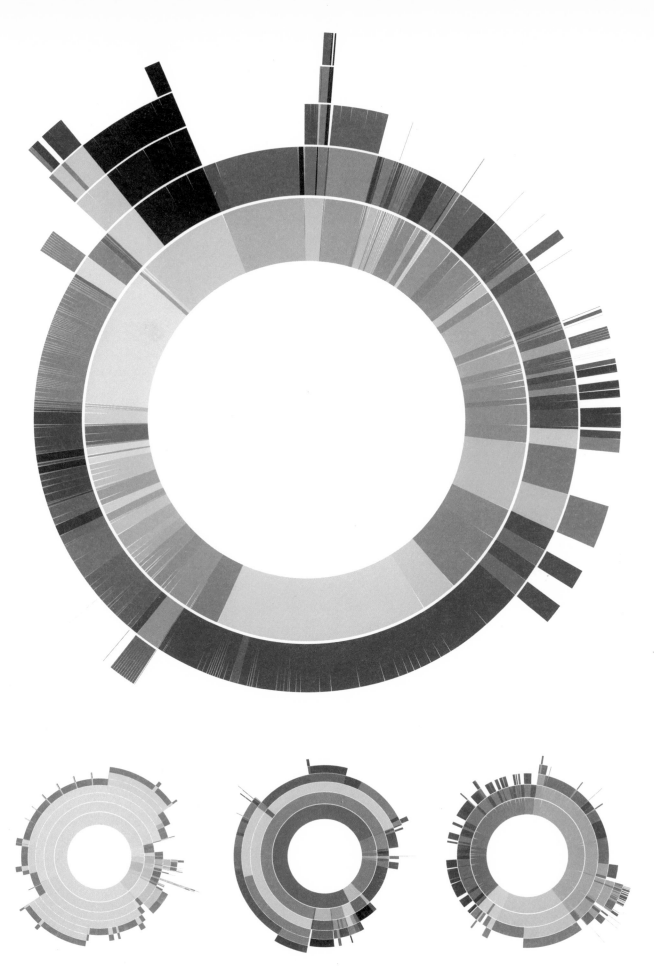

Different folders, each with the same settings, represented as sunburst diagrams. The darker the circle elements, the longer it has been since the represented files or folders have been modified.

→ M_5_3_01.pde

M.5.4 **Sunburst trees**

Thanks to the preparatory work in the two classes FileSystemItem and
SunburstItem, it is now easy to create a networked and tree-like representation based on the sunburst diagram. Only the SunburstItem class
needs to be extended by the ability to draw a connecting line to the parent element. Bézier anchor points are also required to connect the two
instances of SunburstItem with curved lines.

Keys: O: Choose input folder · 1–3: Color-coding mode · B: Curves/lines

→ M_5_4_01/SunburstItem.pde

```
class SunburstItem {
  ...
  int indexToParent;
  ...
  void update(int theMappingMode) {
    ...
    c1X = cos(angleCenter);
    c1X *= calcEqualAreaRadius(depth-1, depthMax);

    c1Y = sin(angleCenter);
    c1Y *= calcEqualAreaRadius(depth-1, depthMax);

    c2X = cos(sunburst[indexToParent].angleCenter);
    c2X *= calcEqualAreaRadius(depth, depthMax);

    c2Y = sin(sunburst[indexToParent].angleCenter);
    c2Y *= calcEqualAreaRadius(depth, depthMax);
  }
  ...
  void drawRelationLine() {
    if (depth > 0) {
    stroke(col);
    strokeWeight(lineWeight);
    line(x,y,
        sunburst[indexToParent].x,sunburst[indexToParent].y);
    }
  }
  void drawRelationBezier() {
    if (depth > 1) {
    stroke(col);
    strokeWeight(lineWeight);
    bezier(x,y, c1X,c1Y, c2X,c2Y,
        sunburst[indexToParent].x,sunburst[indexToParent].y);
    }
  }
}
```

The variable indexToParent ensures
the children elements can access the values
of the parent elements. The radius of the parent element, for instance, can be determined
with sunburst[indexToParent].radius.

The connecting lines are drawn from the
child to the parent element. Two additional control points are needed to generate
a Bézier connecting line. The first lies on
the radius of the next lower hierarchy level
depth-1, the second on the hierarchy level of
the children element depth.

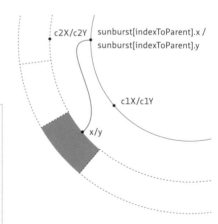

Either drawRelationLine() or
drawRelationBezier() is drawn
depending on the drawing mode.

→ M_5_4_01.pde

```
void draw() {
  ...
  for (int i = 0 ; i < sunburst.length; i++) {
    if (useBezierLine) sunburst[i].drawRelationBezier();
    else sunburst[i].drawRelationLine();
  }
  ...
}
```

Instead of the function drawArc(), one of the new functions can be called and used to draw the diagram.

M.5.5 The sunburst tool

The sunburst tool is a convenient way to access many important parameters when generating sunburst diagrams and demonstrates all the code in this chapter.

In addition, information on folders and files is displayed when the mouse moves over the sunburst diagram. For this purpose it must be determined on which object the mouse is located (i.e., on which ring), and which arc is displayed at this angle. This is complicated by the fact that the rings are drawn with different widths using the calcEqualAreaRadius() function.

Mouse: Position x/y: Rollover for additional information
Keys: O: Choose input folder • 1–3: Color-coding mode • M: Menu

→ M_5_5_01_TOOL.pde

```
void draw() {
  ...
  int mDepth = floor(pow(mRadius,2) * (depthMax+1) /
                     pow(height*0.5,2));
  ...
  for (int i = 0 ; i < sunburst.length; i++) {
    ...
    if (sunburst[i].depth == mDepth) {
      if (mAngle > sunburst[i].angleStart &&
          mAngle < sunburst[i].angleEnd) hitTestIndex = i;
    }
  }
  ...
}
```

The depth level mDepth is calculated from the distance between the mouse and the center of the diagram mRadius.

This loop, in which all the sunburst arcs are drawn, checks if the hierarchy level of the current sunburst item corresponds with the ring over which the mouse is located. When the mouse angle is still within the arc's start and end angles, the index of the current element is saved in the variable hitTestIndex and can be used to display the information on the folder or file.

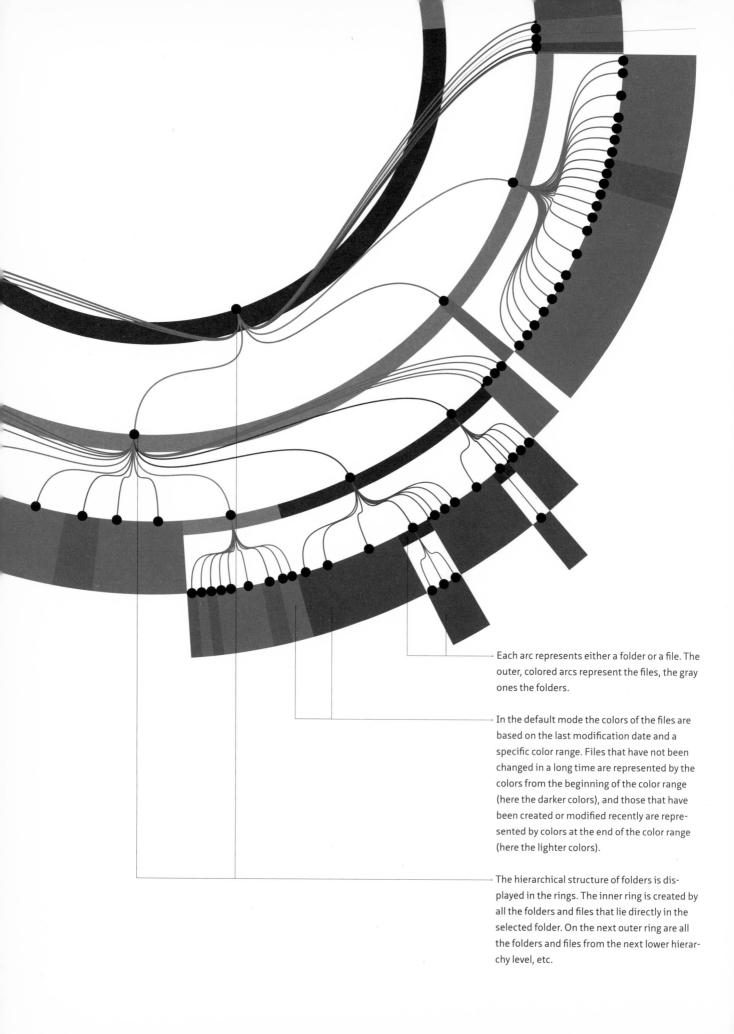

Each arc represents either a folder or a file. The outer, colored arcs represent the files, the gray ones the folders.

In the default mode the colors of the files are based on the last modification date and a specific color range. Files that have not been changed in a long time are represented by the colors from the beginning of the color range (here the darker colors), and those that have been created or modified recently are represented by colors at the end of the color range (here the lighter colors).

The hierarchical structure of folders is displayed in the rings. The inner ring is created by all the folders and files that lie directly in the selected folder. On the next outer ring are all the folders and files from the next lower hierarchy level, etc.

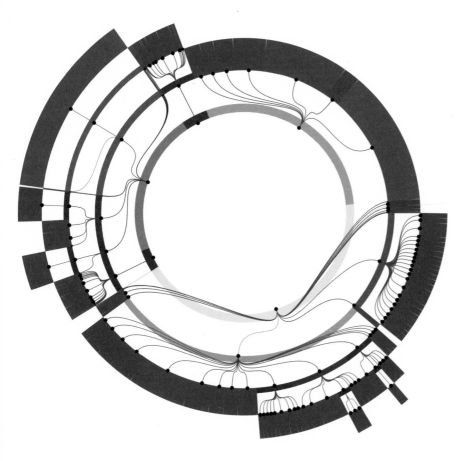

Key 2 changes to another color mode. Now it is no longer a file's age that is transferred to the color of the arc but rather the file's size. Here large files are luminous, smaller ones are darker. The size of the file is apparent from the size of the arc; it can, however, be more easily identified thanks to the double coding.

→ M_5_5_01_TOOL.pde

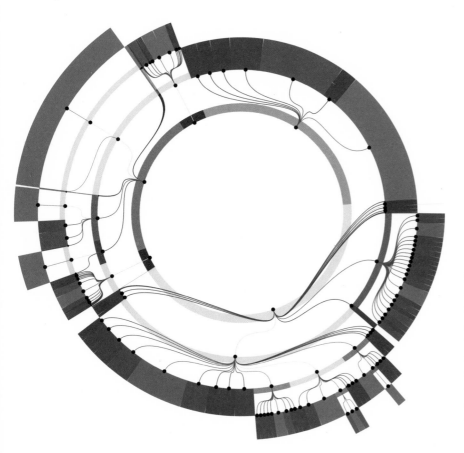

Key 3 changes the definition of the colors again. The file size also determines the color here, although each folder is regarded separately. This means that the largest file in a folder is represented by the color at the end of the preset color spectrum (here the light colors) and the smallest file by the color at the beginning of the spectrum (here the dark colors).

→ M_5_5_01_TOOL.pde

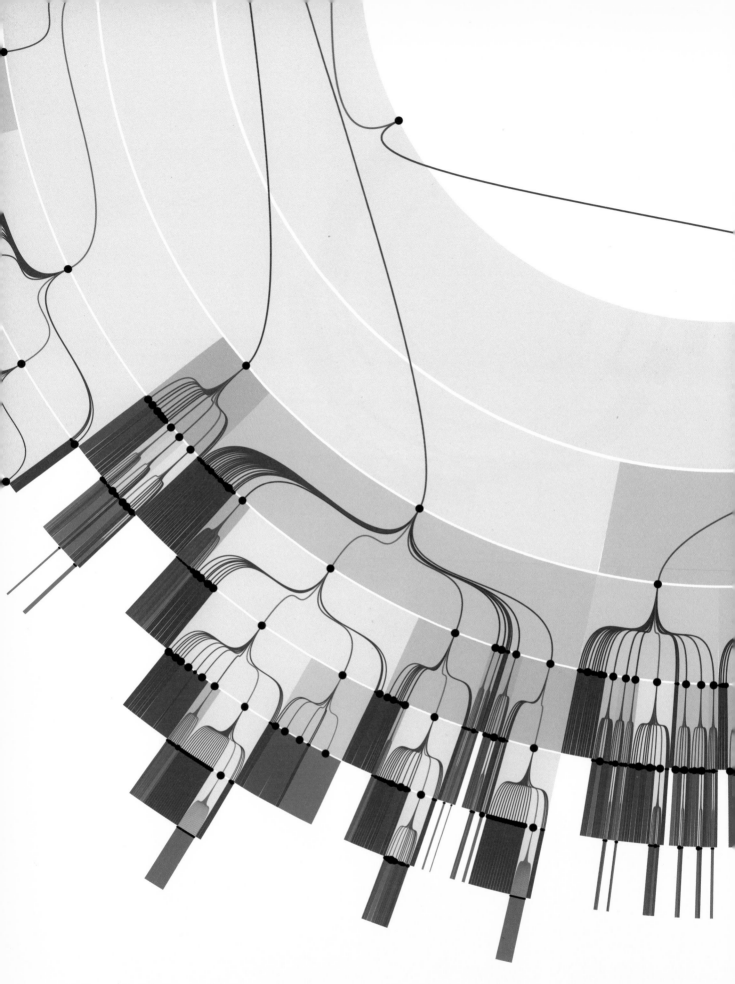

A section of a sunburst diagram with many differently nested folders and files.
→ M_5_5_01_TOOL.pde

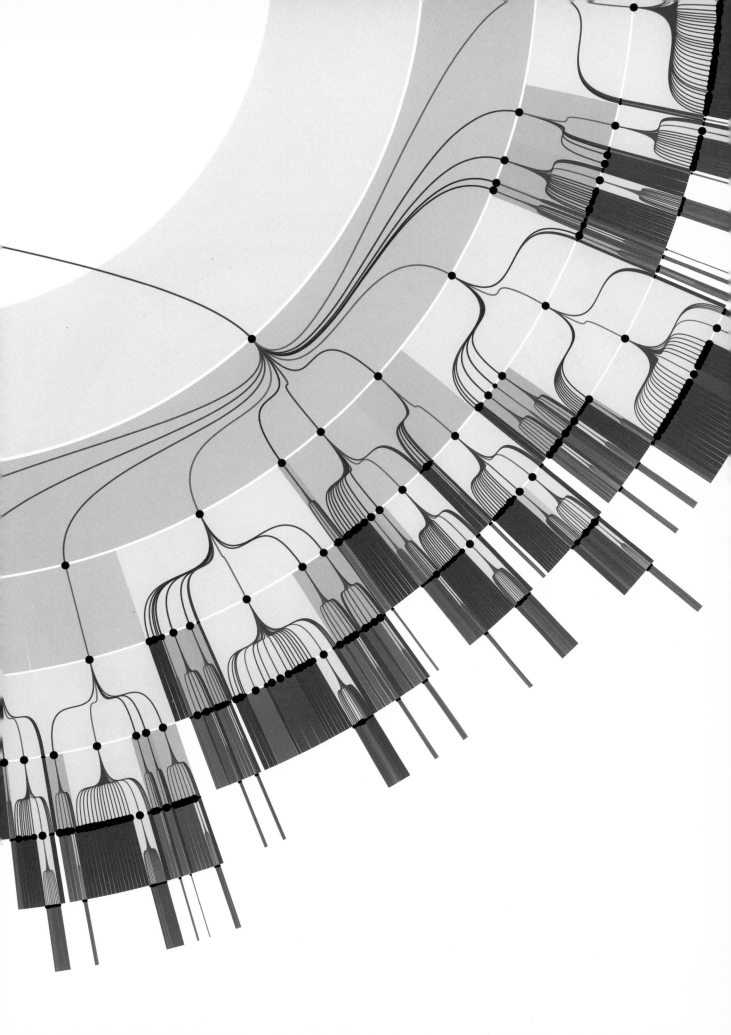

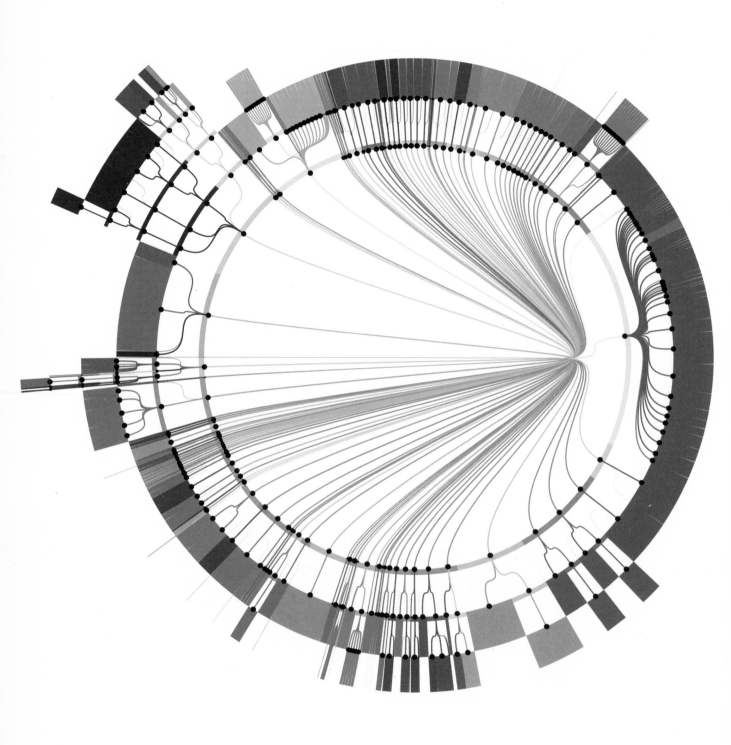

Bézier curves like these are generated when the selected folder initially contains just one other folder that itself contains a large number of folders or files. Incidentally, this is the folder that we used to exchange program files while working on this book.

→ M_5_5_01_TOOL.pde

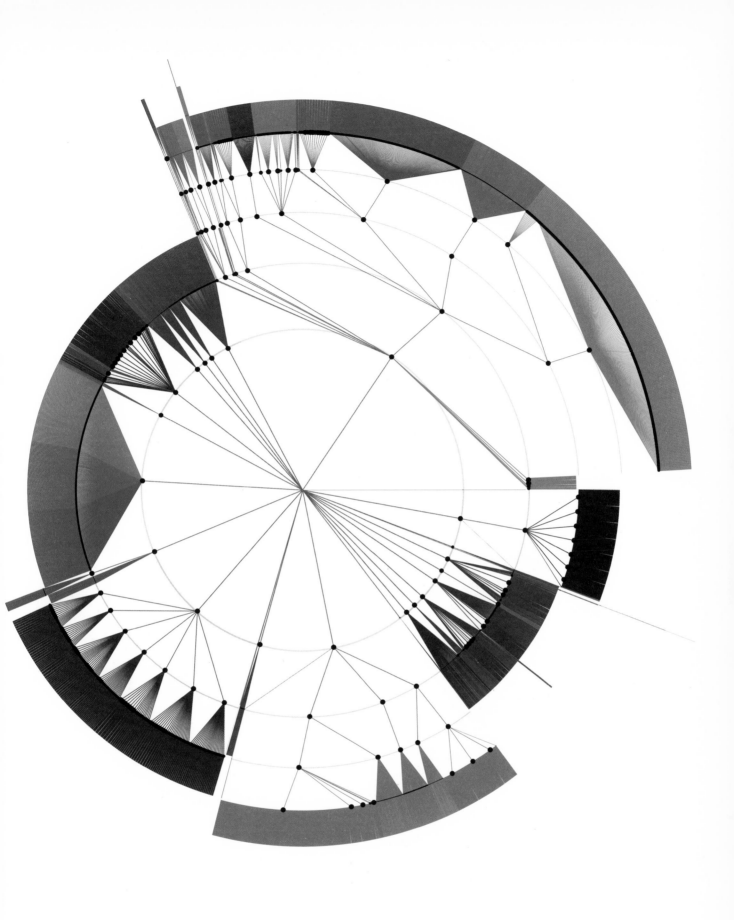

A sunburst diagram that represents a folder of images. The uniform branching shows a folder filled with similarly sized files. Moreover, in most folders the files are the same color, indicating that they were created about the same time.
→ M_5_5_01_TOOL.pde

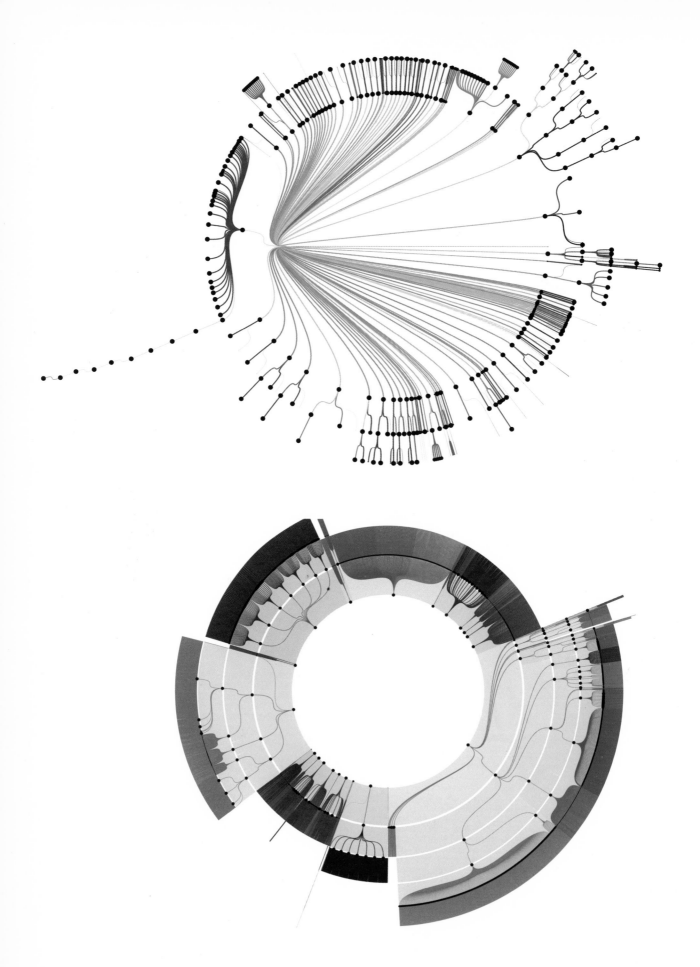

The controls "folderArcScale" and "fileArcScale" control how wide the arcs for the files and folders are depicted. If both are set to 0 (top illustration), it is primarily the hierarchical structure that is emphasized. By contrast, in the bottom illustration, the size distribution is easier to recognize in the size of the arcs.

→ M_5_5_01_TOOL.pde

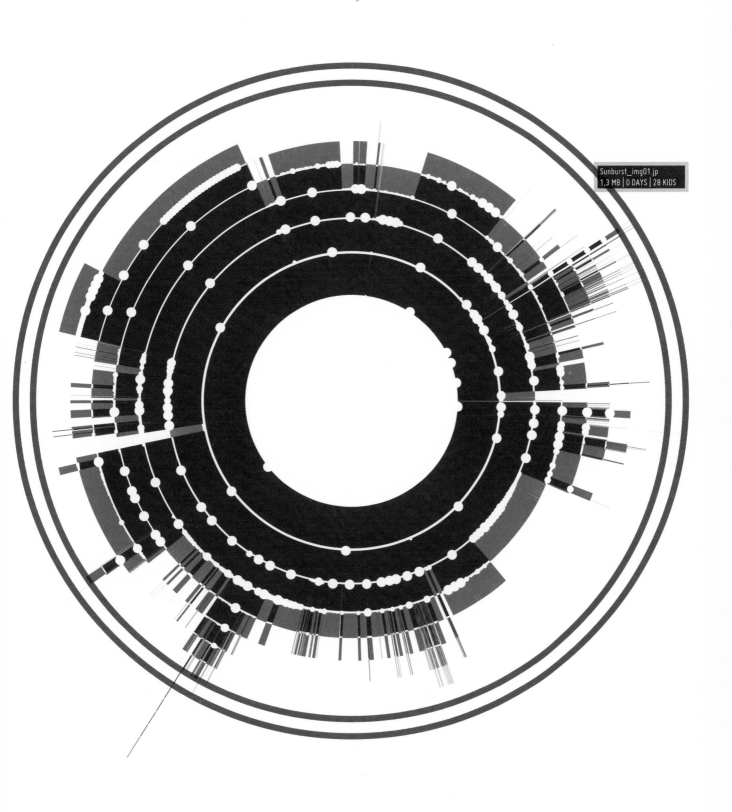

Sunburst_img01.jp
1,3 MB | 0 DAYS | 28 KIDS

With the rollover function, additional information is displayed on a folder or file.

→ M_5_5_01_TOOL.pde

M.6

Dynamic data structures

M.6.0

Dynamic data structures—an overview

Different kinds of data require different visualizations. The sunburst structures we just explored are well suited for presenting proportions in hierarchical data. However, if the data is not hierarchically organized, a different form of representation is required. In this chapter we will demonstrate how to load data from the Internet (in this example, we use the link structure of Wikipedia articles) and how this can be translated into a suitable visualization—a force-directed layout.

→ M_6_4_01_TOOL.pde

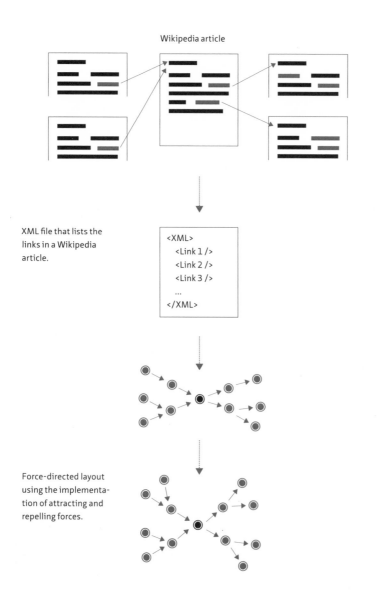

Wikipedia article

A simple application will be created to examine an article from the online encyclopedia Wikipedia to find what other articles it links to and vice versa.

XML file that lists the links in a Wikipedia article.

```
<XML>
  <Link 1 />
  <Link 2 />
  <Link 3 />
  ...
</XML>
```

To do this, one has to find out how such articles are linked. Wikipedia makes available an interface for this purpose that delivers an XML text. XML is a standardized language syntax used for the exchange of data, which is why most programming languages (including Processing) provide libraries for it.

The information attained in this way can then be translated into a diagram. The articles are symbolized by dots, the links by arrows.

Force-directed layout using the implementation of attracting and repelling forces.

The question remains: at which location should a point be drawn? One possibility is to let attracting and repelling forces operate between the dots so they can find an empty spot independently. This algorithm is also called force-directed layout.

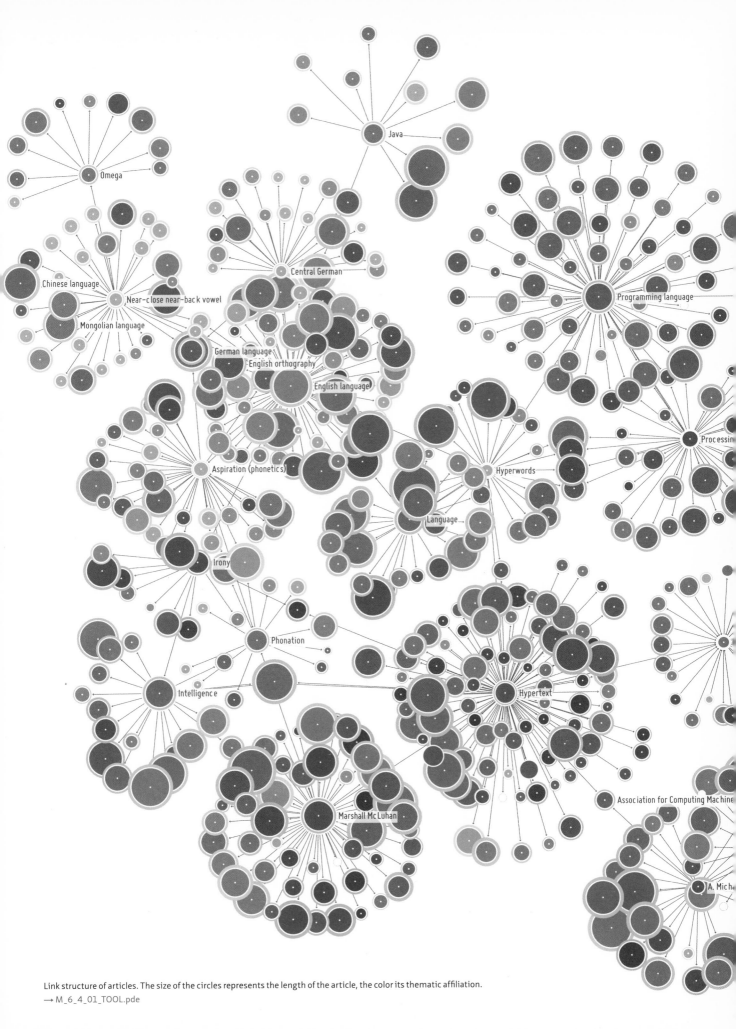

Link structure of articles. The size of the circles represents the length of the article, the color its thematic affiliation.
→ M_6_4_01_TOOL.pde

M.6.1 Force-directed layout

Mathematically speaking, the result of this chapter is a graph—i.e., a set of nodes (the representations of Wikipedia articles) that are sometimes connected. A directed graph is even more precise because the connecting lines between the nodes are depicted as arrows.

A fundamental challenge in the depiction of graphs is finding the best possible position in the space for the nodes. Ideally, there will be enough space around each node that few lines will overlap and space will be left for labeling. A force-directed layout (also called a force-directed graph) elegantly solves this problem.

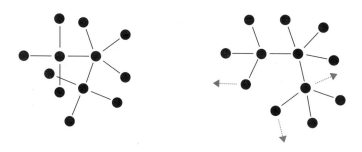

When the connected dots around the node are distributed evenly, overlapping quickly occurs. The overlaps usually dissipate on their own when the nodes that are close together repel each other without the connecting lines becoming too long.

Two opposing forces are needed for force-directed layout: the repulsion of the nodes among themselves, and the attraction of the connections. When these forces are simulated through an iterative process, the grid optimizes itself over time.

REPULSION OF THE NODES Until now, we have spoken of nodes in a more-or-less abstract manner. Now, we have to think about how this abstract concept can be translated into a program. In this example, we will build on the familiar node class in the chapter "Attractors," which already contains the most important properties, such as position and velocity. → Ch.M.4 All that needs to be added is the ability for individual nodes to repel each other.

```
class Node extends PVector {
  ...
  void attract(Node[] theNodes) {
    for (int i = 0; i < theNodes.length; i++) {
      Node otherNode = theNodes[i];
      if (otherNode == null) break;
      if (otherNode == this) continue;

      this.attract(otherNode);
    }
  }

  void attract(Node theNode) {
    float d = PVector.dist(this, theNode);

    if (d > 0 && d < radius) {
      float s = pow(d / radius, 1 / ramp);
      float f = s * 9 * strength * (1/(s+1) + ((s-3)/4)) / d;
      PVector df = PVector.sub(this, theNode);
      df.mult(f);

      theNode.velocity.x += df.x;
      theNode.velocity.y += df.y;
      theNode.velocity.z += df.z;
    }
  }
  ...
}
```

Since a node often does not repel just other individual nodes but all existing ones, it is convenient to have a function that can pass an array of nodes, theNodes, which is then processed.

A node, however, must be prevented from attracting or repelling itself. The current iteration loop is aborted with continue when otherNode is the same node as this.

The calculation of the attracting and repelling forces is executed in the attract() function, to which another node theNode is passed. This calculation is executed just as it is with attractors. → Ch.M.4.2

With nodes, the value of strength is always set by default at a negative value, and the nodes repel each other.

The force has no immediate effect on the position of a node and initially will only adapt to the velocity vector of the other nodes.

In a simple program, these functions can be used as follows:

→ M_6_1_01.pde

```
Node[] nodes = new Node[200];

void setup() {
  ...
  for (int i = 0 ; i < nodes.length; i++) {
    nodes[i] = new Node(width/2+random(-1, 1),
                        height/2+random(-1, 1));
    nodes[i].setBoundary(5, 5, width-5, height-5);
  }
}
```

An array for 200 nodes is created.

The array is filled with instances from the node class; the starting position is the middle of the display, although with a slight random offset so that the nodes do not lie directly on top of one another.

A boundary for the node positions can be set using setBoundary().

437

```
void draw() {
  ...
  for (int i = 0 ; i < nodes.length; i++) {
    nodes[i].attract(nodes);
  }
  for (int i = 0 ; i < nodes.length; i++) {
    nodes[i].update();
  }
  fill(0);
  for (int i = 0 ; i < nodes.length; i++) {
    ellipse(nodes[i].x, nodes[i].y, 10, 10);
  }
}
```

The node array is processed and all other nodes are repelled using the `attract()` function.

The repelling force has only affected the velocity vectors until now. The positions of the nodes are updated with the `update()` function.

The node is depicted as a circle.

200 nodes that repel each other.
→ M_6_1_01.pde

SPRINGS AS CONNECTIONS After repelling nodes, the connections between linked nodes are the second important element of a force-directed layout. Since these connections should attempt to limit themselves to a certain length, the concept of a spring is usually used for this purpose.

→ W.415
Wikipedia: Force-directed layout

Therefore, the algorithm used to translate this model into practice must enable the connected nodes to move toward one another when they are far apart and to repel each other when they come too close. The following steps are one way to meet these demands. These can then be easily transferred to the corresponding vector functions in the program (in the new class `Spring`).

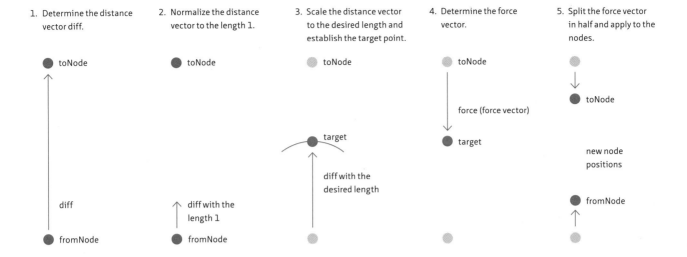

1. Determine the distance vector diff.

 toNode

 diff

 fromNode

2. Normalize the distance vector to the length 1.

 toNode

 ↑ diff with the length 1

 fromNode

3. Scale the distance vector to the desired length and establish the target point.

 toNode

 target

 ↑ diff with the desired length

4. Determine the force vector.

 toNode

 force (force vector)

 target

5. Split the force vector in half and apply to the nodes.

 ↓

 toNode

 new node positions

 fromNode

 ↑

Mouse: *Drag: Move the nodes*

→ M_6_1_02/Spring.pde

```
class Spring {
  Node fromNode;
  Node toNode;

  float length = 100;
  float stiffness = 0.6;
  float damping = 0.9;

  Spring(Node theFromNode, Node theToNode) {
    fromNode = theFromNode;
    toNode = theToNode;
  }
  ...
  void update() {
    PVector diff = PVector.sub(toNode, fromNode);
    diff.normalize();
    diff.mult(length);
    PVector target = PVector.add(fromNode, diff);

    PVector force = PVector.sub(target, toNode);
    force.mult(0.5);
    force.mult(stiffness);
    force.mult(1 - damping);

    toNode.velocity.add(force);
    fromNode.velocity.add(PVector.mult(force, -1));
  }
  ...
}
```

A spring always spans the two nodes `fromNode` and `toNode`.

The desired length of the spring.

The calculations are executed in the `update()` function and the forces applied to the nodes:

1. Determine the distance vector `diff`.
2. Normalize `diff` to length 1.
3. Scale `diff` to the desired length and determine the point `target`.

4. Determine the vector `force`.
5. Split the vector `force` in half and apply to the velocity vectors of the two nodes. With `fromNode`, the vector `force` is first reversed by multiplying it by -1.

In this example, two nodes are connected by a spring:

```
void setup() {
  ...
  spring = new Spring(nodeA, nodeB);
  spring.setLength(100);
  spring.setStiffness(0.6);
  spring.setDamping(0.3);
}

void draw() {
  ...
  spring.update();
  nodeA.update();
  nodeB.update();
  ...
}
```

→ M_6_1_02.pde

A spring is created between nodeA and nodeB. The parameters Length, Stiffness, and Damping are set using the three functions that follow. For stiffness and damping, values between 0 and 1 can be passed, but extreme values will cause the springs to tremble.

The draw() function is used to ensure the spring forces are applied, and update() is used to ensure that the positions of the nodes are updated.

Both classes (the node class → p.408 and spring class) are contained in the Generative Design library, which can be downloaded at www.generative-gestaltung.de. In the following programs, those classes are also imported from this library. An HTML reference of the classes in the Generative Design library is included in the library packet.

Nodes connected with springs.
→ M_6_1_03.pde

M.6.2 Data from the Internet

In principle, all data that can be seen in a browser can also be loaded with another program and used for other purposes. If an HTML text from a web page is not required, but the data is needed in a more structured way, it is more convenient to have this information available in XML format. Luckily, this is now often the case. RSS feeds, for example, are a special XML format, and many Internet pages provide programming interfaces (so-called APIs) with which information in XML format can be specifically queried.

→ W.416
Wikipedia: XML

THE WIKIPEDIA API Wikipedia offers a comprehensive programming interface that allows the user to both query the Wikipedia database and edit articles.

→ W.417
Wikipedia: API

A query can simply be typed in, for example, as a web address. It will appear as follows:

```
http://en.wikipedia.org/w/api.php?action=query&prop=links&titles=Superegg
```

The result of this query is the following text:

```xml
<?xml version="1.0"?>
<api>
  <query>
    <pages>
      <page pageid="10405346" ns="0" title="Superegg">
        <links>
          <pl ns="0" title="Aluminum" />
          <pl ns="0" title="Curvature" />
          <pl ns="0" title="Egg of Columbus" />
          <pl ns="0" title="Executive" />
          <pl ns="0" title="Exponent" />
          <pl ns="0" title="Geometry" />
          <pl ns="0" title="Glasgow" />
          <pl ns="0" title="Implicit function" />
          <pl ns="0" title="Kelvin Hall" />
          <pl ns="0" title="Martin Gardner" />
        </links>
      </page>
    </pages>
  </query>
  <query-continue>
    <links plcontinue="10405346|0|Piet Hein (Denmark)" />
  </query-continue>
</api>
```

The result of the query is delivered in a standard format, an XML text. The format allows data to be structured hierarchically because each element can contain any number of sub-elements.

All content-bearing elements surround this content with a start tag (such as `<links>`) and an end tag (such as `</links>`). Each XML file contains exactly one root element that encompasses everything (with Wikipedia queries this is called api). Additional attributes can be defined in a start tag that describes the element more precisely. The element page is defined here, for example, with pageid, ns (name space), and title. Elements without content can do without an end tag but must then end in `/>`.

In the adjacent Wikipedia query, links are listed that appear in the article "Superegg". These were listed in the element links, where pl stands for page link. Since not all results are listed (the default quantity is 10), the query can be continued with the element query-continue.

In a Processing program this XML can be loaded and evaluated as follows:

```java
XML myXML;
XML[] links;
String query;

void setup() {
  query = "http://en.wikipedia.org/w/api.php?titles=Superegg&
          format=xml&action=query&prop=links&pllimit=500";
  myXML = new XML(this, query);
  links = myXML.getChildren("query/pages/page/links/pl");

  for (int i = 0; i < links.length; i++) {
    String title = links[i].getString("title");
    println("Link " + i + ": " + title);
  }
}
```

→ M_6_2_01.pde

In the URL for the database query, various parameters are given—e.g., that the result should be in XML format or that a maximum of 500 links should be returned.

The XML is loaded by creating a new XML with this query.

A list of XML elements can be created using the getChildren() function, in this case all the entries in XML under the specified path with the tag `<pl>`.

The list of XML elements obtained this way is processed and the attribute title read and displayed.

441

ASYNCHRONOUS LOADING OF AN XML TEXT Loading a file, especially from the Internet, usually takes much more time than the duration of a frame. However, when the XML is loaded while the program is running, program execution is interrupted during that time. This is especially annoying when something is supposed to move continually on the display.

In order to avoid this, a function is included in the Generative Design library with which the XML can be loaded asynchronously (i.e., without interrupting the program flow).

Mouse: *Left click: Links for clicked on nodes are loaded*

→ M_6_2_02.pde

```
void mousePressed() {
  query = "http://en.wikipedia.org/w/api.php?titles=Superegg&
          format=xml&action=query&prop=links&pllimit=500";
  myXML = GenerativeDesign.loadXMLAsync2(this, query);
}
```

In this program, an animation is running. By clicking the mouse, the loading process is started using the loadXMLAsync2() function.

```
void draw() {
  ...
  if (myXML != null) {
    if (myXML.getChildCount() == 0) {
      println("not loaded yet");
    }
    else {
      links = myXML.getChildren("query/pages/page/links/pl");
      ...
    }
  }
}
```

The draw() routine must continually check if the loading process has already been launched.

When the XML to be loaded does not contain any sub-objects (i.e., the function getChildCount() returns 0), the XML has not yet been loaded.

When it does contain sub-objects, the XML is available in the myXML variable and can be evaluated as previously demonstrated.

M.6.3 Force-directed layout with data

The plan is now to begin with a Wikipedia article and, each time it is clicked, reveal a specific number of links, thereby enabling the linking structure to be gradually expanded. In order to maintain legibility in the increasingly complex program, it is useful to summarize a part of the functionality with classes. The `WikipediaNode` class expands the node class so that it can load the data as independently as possible. These, and the linked springs, are administered in the class `WikipediaGraph`.

Mouse: *Left click: Links for clicked-on nodes are loaded* • *Left click + shift: Delete node*
 Drag right mouse button: Drag node • *Right double click: Open article in browser*
Keys: *M: Menu* • *Arrow up/down: Zoom +/–*

→ M_6_3_01/WikipediaNode.pde

```
class WikipediaNode extends Node {
  WikipediaGraph graph;
  XML linksXML;
  XML backlinksXML;
  ...
  void setID(String theID) {
    ...
  }

  void loaderLoop() {
    ...
  }
  ...
}
```

The `WikipediaNode` class extends the node class. In order to retrieve the information from the graph, the variable `graph` will later receive a reference to the graph. In `linksXML` and `backlinksXML` the XML files are loaded for the linking articles.

The title of the Wikipedia article is passed to the `setID()` function. The XML file can then begin loading.

Since the XML files were asynchronously loaded, `loaderLoop()` must constantly check if the data is already loaded.

→ M_6_3_01/WikipediaGraph.pde

```
class WikipediaGraph {
  HashMap nodeMap = new HashMap();
  ArrayList springs = new ArrayList();
  ...
  Node addNode(String theID, float theX, float theY) {
    Node findNode = (Node) nodeMap.get(theID);
    if (findNode == null) {
      Node newNode = new WikipediaNode(this, theX, theY);
      newNode.setID(theID);
      nodeMap.put(theID, newNode);
      return newNode;
    }
    else {
      return null;
    }
  }
  →
```

The class `WikipediaGraph` administers the nodes and springs. The nodes are stored in a HashMap, which facilitates access via their ID. An arrayList is preferable for the springs since it can be expanded more quickly than an array.

Before adding a node with `addNode()`, we check whether a node with this ID is already in `nodeMap`. If not, a new instance is created with this ID and saved in `nodeMap`.

```
Spring addSpring(String fromID, String toID) {
  WikipediaNode fromNode, toNode;
  fromNode = (WikipediaNode) nodeMap.get(fromID);
  toNode = (WikipediaNode) nodeMap.get(toID);
  if (fromNode==null) return null;
  if (toNode==null) return null;

  if (getSpring(fromNode, toNode) == null) {
    Spring newSpring = new Spring(fromNode, toNode,
                         springLength, springStiffness, 0.9);
    springs.add(newSpring);
    return newSpring;
  }
  return null;
}
...
}
```

A spring is created by passing the IDs of two nodes. Then it is verified that the respective nodes are in nodeMap. If they are not, the process is aborted.

If they are in nodeMap, it is verified that a connection already exists between these two nodes. If none exists, one will be created and stored in the ArrayList springs.

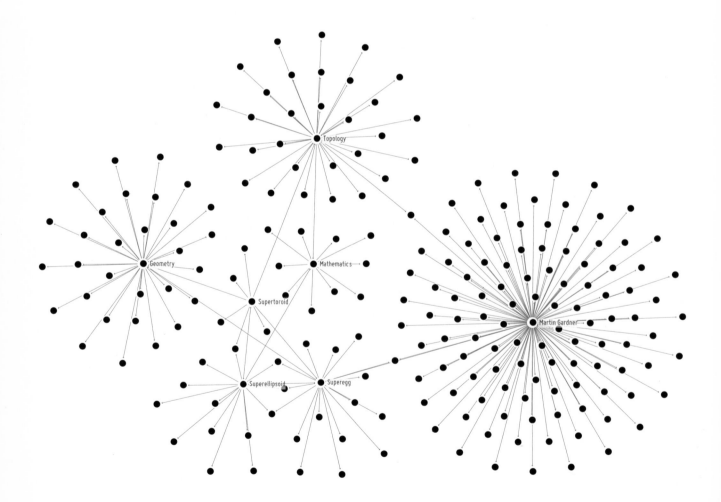

The connecting structure of some Wikipedia articles in a force-directed layout.
→ M_6_3_01.pde

M.6.4 **Visualizing proportions**

Until now the nodes have all looked the same, although they represent completely different Wikipedia articles. For instance, it is not apparent if a represented article is long or short, how many links in it refer to other articles, or if the article itself is referred to. It would make sense to draw the nodes larger when the articles are longer. It must be noted that the quantitative information is recognized by the area of the graphic element and not by its radius. A ring is drawn around the node with a width indicating how many links have yet to be displayed with arrows originating from the node.

Double surface area

 1 1.414

In order for a circle to appear twice as large as another, its radius only has to be approximately 1.414 (= square root of 2) times as large.

→ M_6_4_01_TOOL/WikipediaNode.pde

Mouse: Left click: Load links • Left double click: New node • Left click + shift: Delete node
Drag right mouse button: Drag node • Right double click: Open article in browser
Keys: Arrow up/down: Zoom +/− • 1: Color nodes on/off • 2: Fish-eye view on/off

```
void setID(String theID) {
  ...
  htmlLoaded = false;
  htmlString = "";
  String url = encodeURL("http://en.wikipedia.org/wiki/"+id);
  htmlList = GenerativeDesign.loadHTMLAsync(thisPApplet,
                    url, GenerativeDesign.HTML_CONTENT);
  ...
}

...

void update() {
  ...
  float l = max(htmlString.length()-1500, 0);
  l = sqrt(l/10000.0);
  diameter = graph.minNodeDiameter +
            graph.nodeDiameterFactor * l;

  int hiddenLinkCount = availableLinks.size() - linkCount;
  hiddenLinkCount = max(0, hiddenLinkCount);
  ringRadius = 1 + sqrt(hiddenLinkCount / 2.0);
  diameter += 6;
  diameter += ringRadius;
}

Spring addSpring(String fromID, String toID) {
  ...
  fromNode.linkCount++;
  toNode.backlinkCount++;
  ...
}
```

In order to evaluate the length of an article, the text of the article has to be loaded. This is not a problem since the name of the page the node represents is saved in the ID.

In the loadHTMLAsync() function, it is possible to load the complete source text (with the constant HTML_PLAIN) or, as illustrated here, the text as it appears in the browser.

The length of the loaded HTML text is now used to define the radius of the node diameter. First 1,500 characters are subtracted from the length, which is about the number of characters that are not part of the article. The result is then adjusted with the square root function sqrt() so the surface area of the circle grows proportionally to the length of the article.

The entire number of links is available in the array availableLinks. The linkCount is the number of links already depicted. The radius of the ring is defined depending on the difference.

→ M_6_4_01_TOOL/WikipediaGraph.pde

Each time a new connection is created, the variables linkCount and backlinkCount have to be increased accordingly in the corresponding nodes.

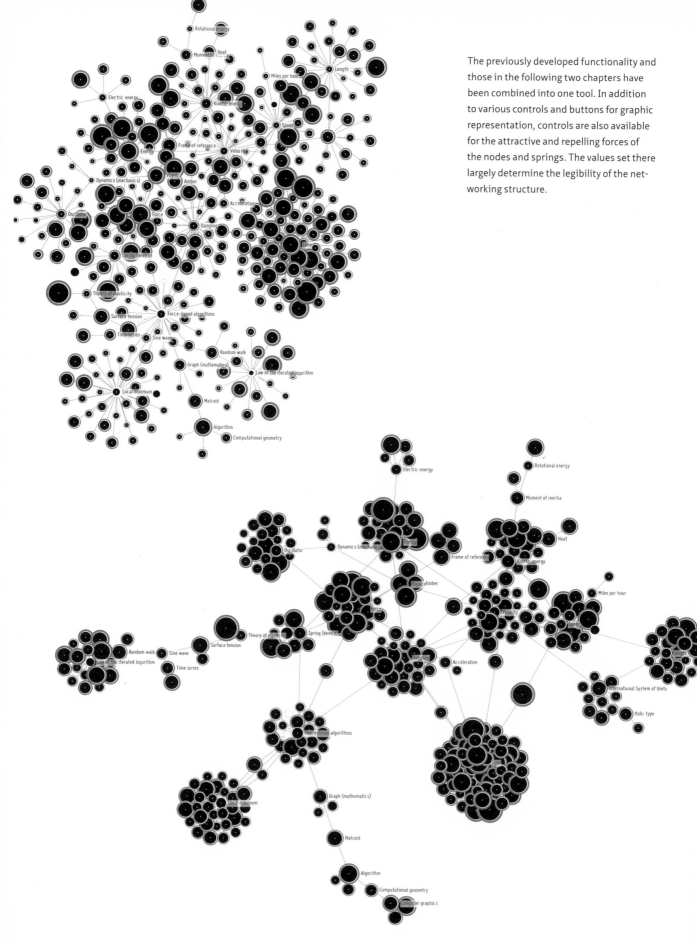

The previously developed functionality and those in the following two chapters have been combined into one tool. In addition to various controls and buttons for graphic representation, controls are also available for the attractive and repelling forces of the nodes and springs. The values set there largely determine the legibility of the networking structure.

The parameter settings chosen here for the attracting and repelling behavior of nodes and springs generate structures that are difficult to read. Above the nodes are too dispersed. Below they are too crowded.
→ M_6_4_01_TOOL.pde

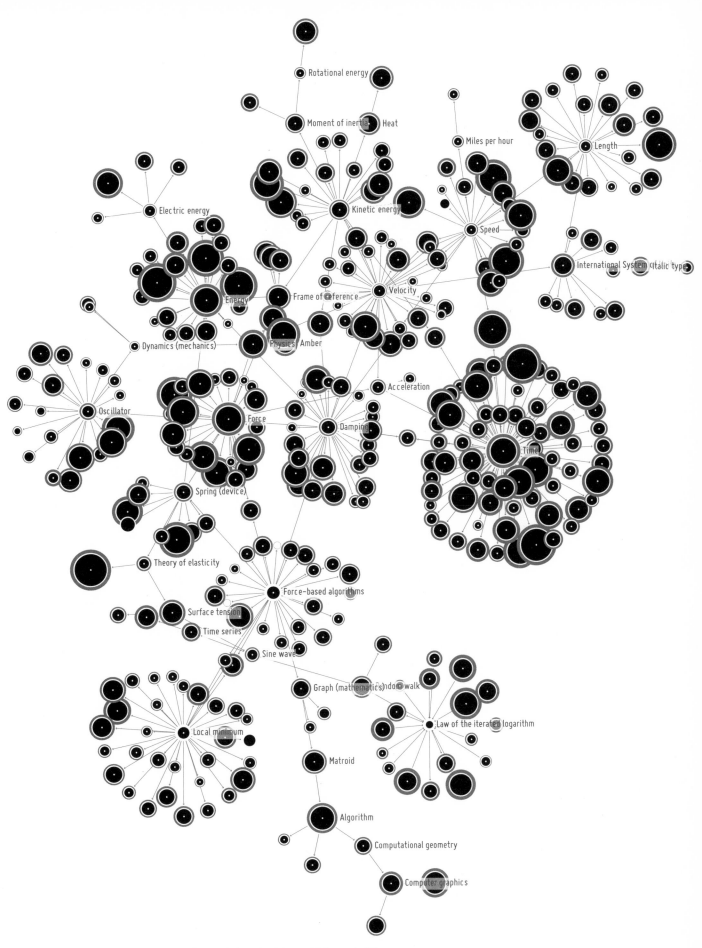

Here the relation of node size and repelling forces is balanced and the graphic is more legible.

→ M_6_4_01_TOOL.pde

M.6.5 Semantic text analysis

Now the nodes can tell us how significant a Wikipedia article is. Other than the title, there is still no way to infer the content of the article. It would be useful when, for example, the color of the node reflected its thematic affiliation—if the article is about science, art, or culture or if it concerns geographic or political subjects.

Unfortunately, Wikipedia does not supply this information. It is possible, however, to implement a simple semantic text analysis. This means that keywords in the text are defined and counted. The more often the keywords of a particular subject appear and the less frequently others do, the more likely it is that the article is about that one subject. If colors are assigned to subjects, then the frequency of the keywords can be used to interpolate between these colors.

The frequency with which keywords appear in an article is used to determine the color of the nodes.

```
Pattern[] patterns = new Pattern[0];
color[] colors = new color[0];
...
WikipediaGraph() {
  ...
  String s;
  s = "model|theory|structur|component|element|concept|
      experiment|mathematic|chemi|device|biology|engineer|
      physic|scientific|science";
  patterns = (Pattern[]) append(patterns, Pattern.compile(s));
  colors = append(colors, color(0, 130, 164));

  s = "climate|histor|planet|plant|population|ethnic|politic|
      atmosphere|treaty";
  patterns = (Pattern[]) append(patterns, Pattern.compile(s));
  colors = append(colors, color(181, 157, 0));

  s = "design|jazz|sculpture|culture|music|opus|period|
      composer|perform|literature|author|drama|poet|genre|
      fiction|theatre|style";
  patterns = (Pattern[]) append(patterns, Pattern.compile(s));
  colors = append(colors, color(89, 34, 131));

}
```

→ M_6_4_01_TOOL/WikipediaGraph.pde

For counting the keywords in a text, it is convenient to resort to Java classes that were developed for working with regular expressions. With regular expressions, strings can be analyzed and manipulated in various ways. Pattern is a class for a search pattern. A specific search pattern is needed for each subject.

→ W.418
Regular expressions

In string s, the regular expression with the keywords for the subject science are defined. This string is then compiled with Pattern.compile() and added to the patterns array. The array colors is extended by the corresponding color.

The same is done for the other two subjects, "nature/society" and "art/culture."

For the interpolation of the colors, a few more considerations need to be made. It is very easy to interpolate between two colors. When there are more than two colors, however, this process has to be extended.

→ Ch.P.1.2.1
Color palettes through interpolation

Example – Hits for the three subjects:

Step 1:
Interpolation between the first two colors

Step 2:
Interpolation between the result and the third color

counters[0]: 3
counters[1]: 12
counters[2]: 5

colors[0] result colors[1]

result

12 hits
12 / (3+12) = 80%

colors[2]

5 hits
5 / (3+12+5) = 25%

When more than two colors are to be interpolated, several interpolation steps must take place.

```
color textToColor(String theText) {
  int i;
  int len = patterns.length;
  int[] counters = new int[len];
  int[] counterSums = new int[len];

  Matcher m;
  for (i = 0; i < len; i++) {
    m = patterns[i].matcher(theText.toLowerCase());
    while (m.find() == true) {
      counters[i]++;
    }
  }

  counterSums[0] = counters[0];
  for (i = 1; i < len; i++) {
    counterSums[i] = counterSums[i-1] + counters[i];
  }

  if (counterSums[len-1] == 0) {
    return color(0);
  }

  color result = colors[0];
  for (i = 1; i < len; i++) {
    float amount = counters[i]/float(counterSums[i]);
    result = lerpColor(result, colors[i], amount);
  }
  return result;
}
```

When a node has loaded the text of its Wikipedia article, this calls the textToColor() function, which evaluates the text and returns a color. The function is flexible with regard to the number len of the subjects; in this example it is three, but the number could be higher.

Matcher is the class that contains the result of the evaluation of a regular expression. In the loop, the search pattern is evaluated with the matcher() function. This result must be processed as long as more hits are encountered. The corresponding counter[i] is incremented.

For the interpolation of the colors, the sum of the counter values counterSums is needed. This means when counters contains the values {3, 12, 5}, then counterSums will contain {3, 15, 20}.

When the last value in the array counterSums is 0, then not a single keyword was found in the text, and the colors are returned as black.

The interpolation steps are executed in the loop. It is interpolated between the last interpolation result and the current color. The variable amount results in the current counter value counter[i] and the running total of all counter values until this point.

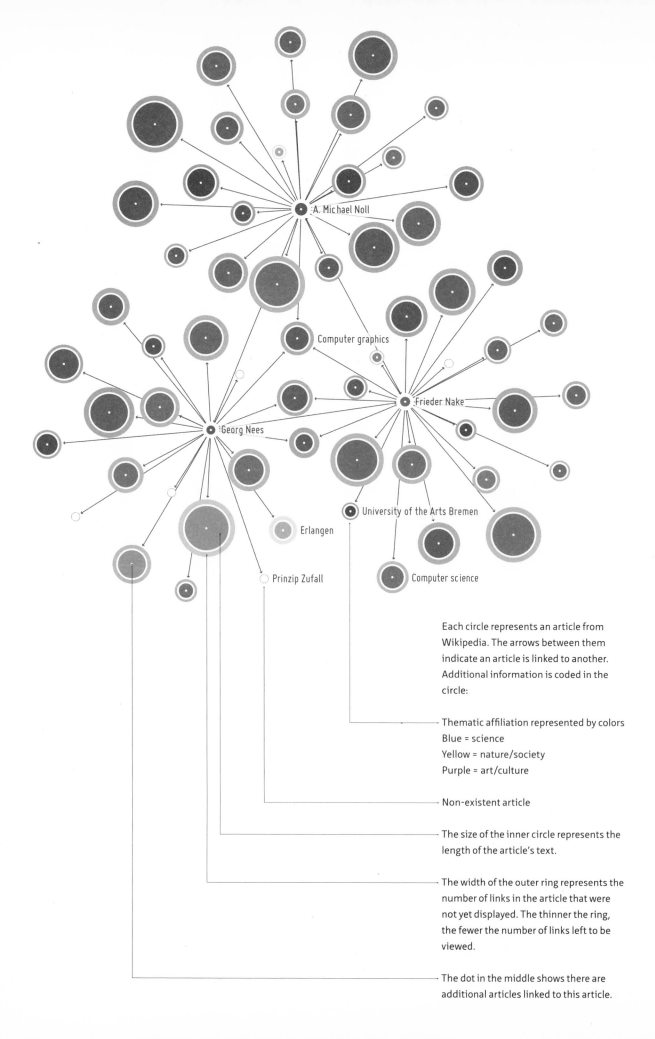

A. Michael Noll

Computer graphics

Frieder Nake

Georg Nees

University of the Arts Bremen

Erlangen

Computer science

Prinzip Zufall

Each circle represents an article from Wikipedia. The arrows between them indicate an article is linked to another. Additional information is coded in the circle:

Thematic affiliation represented by colors
Blue = science
Yellow = nature/society
Purple = art/culture

Non-existent article

The size of the inner circle represents the length of the article's text.

The width of the outer ring represents the number of links in the article that were not yet displayed. The thinner the ring, the fewer the number of links left to be viewed.

The dot in the middle shows there are additional articles linked to this article.

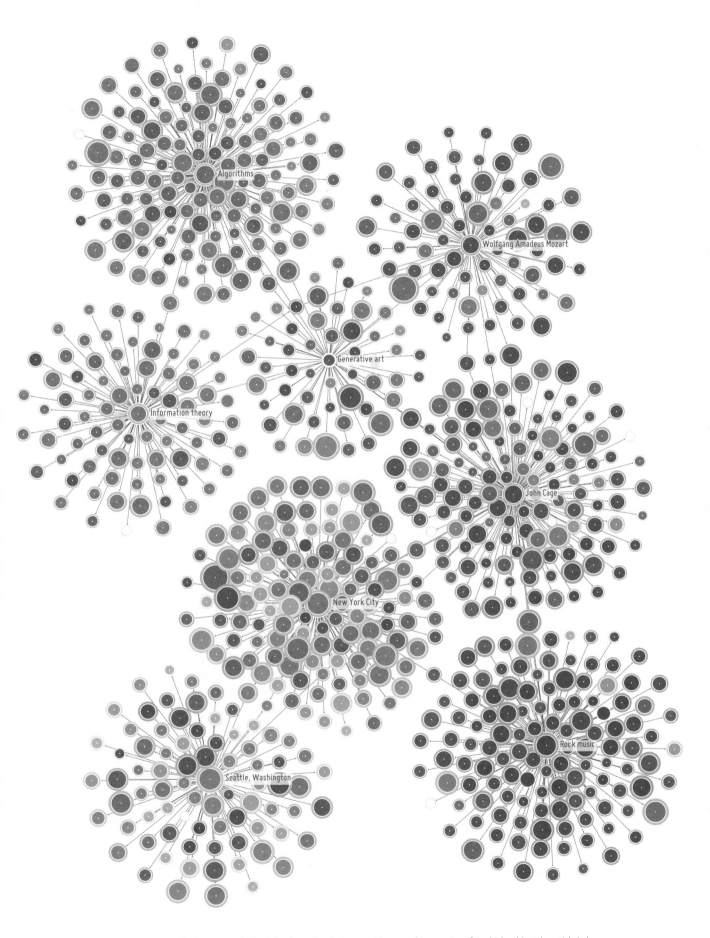

Algorithms

Wolfgang Amadeus Mozart

Information theory

Generative art

John Cage

New York City

Seattle, Washington

Rock music

The simple semantic text analysis, which serves as the basis for the node coloring, provides a good impression of to which subject the article belongs.
→ M_6_4_01_TOOL.pde

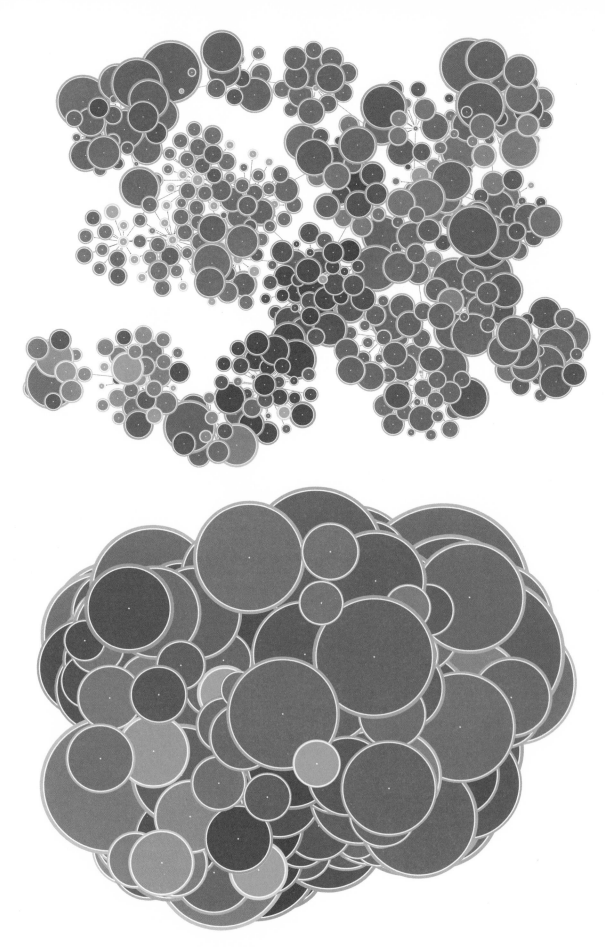

The size of the node can be set using the controls "nodeDiameter" and "nodeDiameterFactor." The value nodeDiameter defines the minimum radius and nodeDiameterFactor defines the size increase.

→ M_6_4_01_TOOL.pde

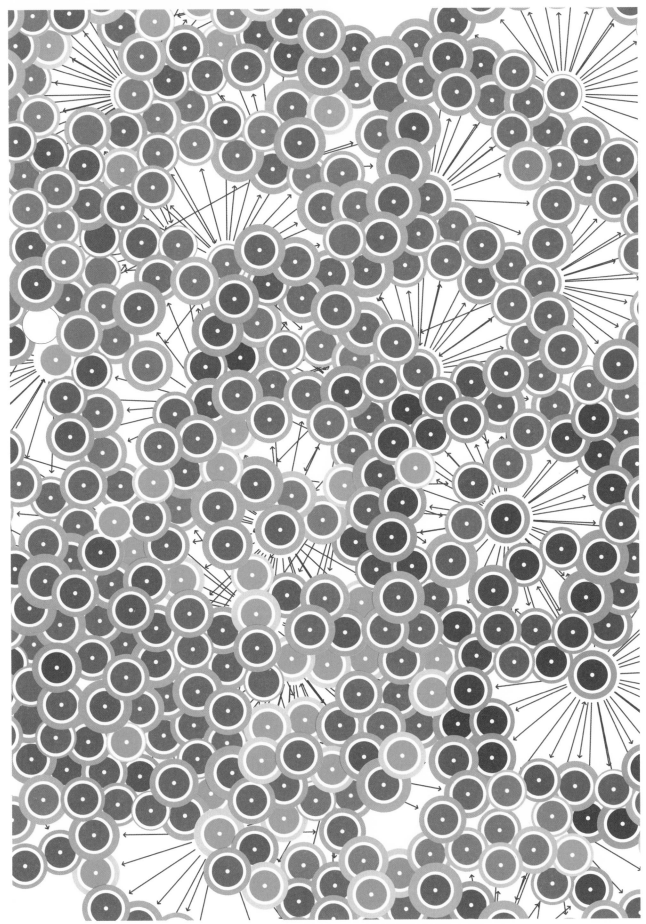

When `nodeDiameterFactor` is set to 0, all nodes have the same size. It then becomes particularly clear that the repulsion of the nodes from one another ensures a uniform distribution.

→ M_6_4_01_TOOL.pde

M.6.6 Fish-eye view

The more nodes added to the graph, the more the network expands in all directions. One can zoom out in order to gain an overview, but the nodes, and especially their inscriptions, lose their legibility.

To resolve this discrepancy, the area in which the graph is displayed can be distorted with a fish-eye projection. This functions like a wide-angle lens with a 180° angle. The elements in the middle of the display are still depicted at their original size, but the farther the elements are from the center, the smaller they are drawn—although they remain visible in the display. This kind of distortion can help maintain perspective without distorting information, especially with representations like force-directed layouts, in which the linking structure of the nodes is more important than their exact position.

→ W.419
Wikipedia: Fish-eye lens

Projection always means taking the original coordinates of the points to be displayed (in this case the coordinates of the nodes) and calculating new coordinates. Only the latter coordinates are used to draw the object in the display. The following shows schematically the sequence of steps:

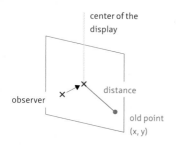

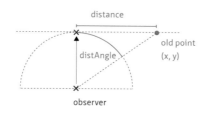

1. Calculate the distance between the center of the display and the points to be displayed.

2. The viewing angle is calculated from this distance by means of the arctan function.

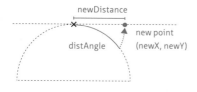

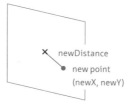

3. The viewing angle is then used as the basis for the distance of the new point's coordinates. One can imagine this as a convolution of the circle.

4. Finally the result, the new distance, is again marked in the same direction in which the old point lay.

This construction demonstrates that, thanks to this projection, all points on the plane—even those that are infinitely far apart—are always depicted.

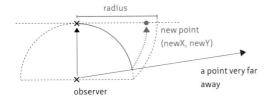

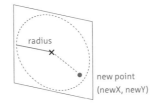

Regardless of how far a point is from the center, in a fish-eye projection it is always located within a specific radius.

In the program, the calculation of the projection is implemented with a function in the WikipediaGraph class.

→ M_6_4_01_TOOL / WikipediaGraph.pde

```
PVector screenPos(PVector thePos) {
  if (drawFishEyed) {
    float x = thePos.x + offset.x / zoom;
    float y = thePos.y + offset.y / zoom;
    float[] pol = GenerativeDesign.cartesianToPolar(x, y);
    float distance = pol[0];

    float radius = min(width, height)/2;
    float distAngle = atan(distance/(radius/2)*zoom) / HALF_PI;
    float newDistance = distAngle * radius / zoom;

    float[] newPos = GenerativeDesign.polarToCartesian(
                            newDistance, pol[1]);
    float newX = newPos[0]-offset.x;
    float newY = newPos[1]-offset.y;
    float newScale = min(1.2-distAngle, 1);
    return new PVector(newX, newY, newScale);
  }
  else {
    return new PVector(thePos.x, thePos.y, 1);
  }
}
```

The screenPos() function is called by the nodes before they are drawn in the display. The position thePos is passed and converted, and a new PVector is returned.

1. The passed position must first be corrected since offset and zoom affect where the coordinates are located in the display. This position (x, y) can be transformed in polar coordinates—i.e., in a distance pol[0] and an angle pol[1].

2. Calculation of the viewing angle distAngle with the atan() function. The result of this function is a number between 0 and HALF_PI. By dividing it by HALF_PI, distAngle is thus a value between 0 and 1.

3. The unfolding of the viewing angle requires only taking the viewing angle distAngle and multiplying it by the desired radius.

4. The new point newPos can now be calculated using newDistance and the old direction angle pol[1].

In the z-coordinate of the returned vector, the information (a number between 0 and 1) about how much the node should be scaled is transmitted with newScale.

In the view enabled with fish-eye projection, the area of the drawing that is close to the center of the display is given more space than the rest of the structure. This way, one part of the visualization is always legible.

→ M_6_4_01_TOOL.pde

Each of these images depicts the same network structure but with different centers and parameter settings. The exaggeration of the three-dimensional fish-eye effect is not intentional but rather the result of the compaction of the structure toward the edges.

→ M_6_4_01_TOOL.pde

A.///

Appendix

A.0
Reflections

The two main parts of this book, Basic Principles and Complex Methods, focus on practically demonstrating how graphic images can be generated. By experimenting with the sample programs, it is possible to gain a sense of what generative design is all about. On the following pages, we reflect on the ideas behind the sample programs and put what has been learned into context. This part also has a referential character—it identifies related topics and connections.

STATUS QUO In design we all use the universal machine—the computer—as a matter of course. Yet the most popular tools today, such as Adobe Creative Suite, AutoCAD, and 3ds Max, only have a representative and illustrative function. The computer's triumphal march has simply virtualized existing tools, such as the paintbrush, scissors, or photo lab, and made these more efficient. As a result, everything has become quicker and easier to use. However, the most essential aspect, the design process, has not undergone any substantial changes. Whether an image has been produced with a mouse or a paintbrush, the concept of creating a line, for instance, remains the same. Generative design is different from conventional methods; the design process is unique and fundamentally results in new possibilities.

Painting with a mouse on the computer screen has a high entertainment value, but…drawing a stroke with a pen is no different from drawing a stroke with a mouse. The real challenge is to discover the intrinsic properties of the new medium and to find out how the stroke you draw via computation is one you could never draw, or even imagine, without computation.
→ John Maeda, *Design by Numbers*, page 175

THE NEW DESIGN PROCESS The main change in the design process achieved by using generative design is that traditional craftmanship recedes into the background, and abstraction and information become the new principal elements. The relevant question is no longer "How do I draw?" but rather "How do I abstract?" This is because the process that leads from the idea to the final image can only take place via a set of rules—a systematic intermediate layer—that the computer interprets and processes. Before appearing in the display, each generated image must first be described completely using a set of rules. This poses two challenges for the designer: how to abstract a vague idea, and how to enter an idea into the computer in a formalized way. No set rules exist for how to abstract an idea; for a complex idea to be implemented, the problem must be broken down into smaller chunks. This problem-solving strategy is also known as "divide and conquer." For instance: a surface is to be filled with as many circles with random diameters as possible, without any overlapping. The first step is to convert the vague idea into a concrete and simple "recipe." Draw a new circle. If this circle does not intersect with any other on the display, make this circle as large as possible. If the circle intersects another, start over. → P.2.2.5

In addition to "divide and conquer" there are many other problem-solving strategies, such as top-down and bottom-up, etc. In this context, the "pattern" idea (analyzing problems in recurring patterns and solving these systematically) can be very helpful.
→ Christopher Alexander, *A Pattern Language*

→ W.501
Wikipedia: Divide and conquer algorithm

→ W.502
Wikipedia: Top-down and bottom-up design

Only through this decomposition is it possible to formulate the individual steps in a programming language, thereby making it executable for the computer. A programming language offers the elementary building blocks with which to do this, such as *repetition, randomness logic*, which will be explained more precisely in the following pages.

→ Example: Structural density from agents

Idea: Generate a density structure of circles that are similar in structure to foam bubbles.

Establish abstracted rules:
1. Generate a new circle.
2. If this does not intersect with any other circle in the display, make it as large as possible.
3. If an intersection exists, start over.

Formalization in code syntax:
```
for(int i=0; i < currentCount; i++) {
    float d = dist(newX,newY, x[i],y[i]);
    if (newRadius > d-r[i]) {
        newRadius = d-r[i];
        closestIndex[currentCount] = i;
    }
}
```

→ Ch.P.2.2.5
Structural density from agents

Diagram labels:
- idea
- abstraction
- rule/ algorithm
- change rules
- formalization (repetition, randomness, logic)
- create (start) parameters
- source code
- change source code or parameter
- designer
- interpretation by the computer and generation of the image/simulation
- image/ simulation
- user evaluates image

Repetition allows the computer to work on a problem until it has solved it or to manipulate multiple objects. The importance of repetition is reflected by how often the for-loop is used in the programs in this book or by the fact that the draw-loop is the central function of Processing.

Randomness is used to create variations to break up the strict regularity of the computer. True randomness rarely produces compositionally interesting results. These are created instead when randomness is limited and applied in measured doses. → Ch.M.1.2 In Processing randomness is represented by the keywords "random" and "noise."

Logic, in the sense of control structures, is used to guide the generative process. Conditions can be established with which the program flow can be diverted into different directions. In "Text as blueprint" → Ch.P.3.1.2, for example, a switch/case structure is used to perform different parts of the program depending on the text input: all letters are written in the usual manner, but every time a punctuation mark appears, the writing direction changes and the punctuation mark is replaced by a curved element. The most common keywords for control structures are "if," "else," "switch," and "case."

→ Ch.P.3.1.2
Text as a blueprint

If a creative idea is translated into code, it can be interpreted by the computer and an image generated from scratch without the hand ever drawing a line. Very rarely, however, does the computer immediately generate completely satisfactory results. The result must be looked at and evaluated, and it is this evaluation that is the basis for improvement. In contrast to a conventional approach, the hand does not manipulate the image; instead the underlying abstraction is modified or individual parameters in the program are changed. Through the interaction between result and creator, the generative system is refined with each iteration, and a final product develops.

Interaction helps accelerate this reciprocal effect. A generative system in itself is not necessarily interactive, and this book does not deal explicitly with interaction. The extra effort involved in installing control elements (buttons, sliders, etc.) is worthwhile, however, so that each parameter can be manipulated in real time. We therefore included an interactive tool at the end of each chapter in the "Complex Methods" section.

→ M_3_4_03_TOOL.pde

NEW POSSIBILITIES IN DESIGN Since programming languages are now part of the design process, the possibilities available to the designer have fundamentally changed and multiplied. Conceptual competence still lies with the designer; the computer assumes only the role of the tireless helper. It is a given in today's automated and digital world that designs can be executed quickly and easily and that it is possible to generate a composition with thousands of elements. It is more interesting to look at the new possibilities of generative design in terms of *emergence, simulation,* and *tools.*

In the context of generative design, processes are emergent when their results are not predetermined and when the interaction of all the elements leads to more than is obvious from their individual properties. A common example of *emergence* is the swarming behavior of birds: simple rules result in highly complex, unpredictable behavior. In the section "Growth structure from agents," completely unexpected organic structures result from a very simple algorithm that consists of only two steps (see also boids and automata). → Ch.P.2.2.4

The *simulation* of natural processes is another important method in generative design. In "Dynamic data structures"we use, for instance, a force-directed layout to visualize the linking structure of Wikipedia articles. → Ch.M.6 A force-directed layout evenly arranges a structure diagram using the simulation of a physical model, in this case a spring and repulsive force. → Ch.M.4 All elements influence each other until the entire structure, in accordance with the laws of physics, reaches a balanced state of tension. Particularly impressive is the fact that diversion from the extended use of the two physical formulas solves the problem. As is often the case, the transfer of knowledge from one field to another leads to astonishing results. What is certain is that there are many more models in nature that can reasonably be transferred to a generative system.

→ Ch.P.2.2.4
Growth structure from agents

→ W.503
Boids

→ W.504
Wikipedia: Automata

→ Ch.M.6
Dynamic data structures

→ Ch.M.4
Attractors

→ W.505
Library MSAFluid (fluid simulation)

Perhaps the most important aspect of this increase in possibilities is that the designer is now the creator of individualized *tools*, since each generative program is also a customized software tool. This allows the designer to explore new paths that would not have been available using existing software, leading to a wider range of visual design mediums. It is astonishing how much designers can accomplish with tools they develop themselves, as is evident in "Drawing." → Ch.P.2.3 Even these simple tools greatly increase a designer's options, and, because such tools can be refined constantly, they become perfectly tailored work instruments. In addition, it is usually not a large step from a generative program to a developed tool with its own user interface (see tool variations in the "Complex Methods" section).

→ Ch.P.2.3
Drawing

LOOKING AHEAD When the German edition of this book was first published in 2009, it was already apparent that the use of generative design would soon be a given. The "Project Selection" that opens this book clearly demonstrates that generative design is already used in many fields, as the basis for information visualization, artwork, media installations, architectural models, video clips, fonts, and even generative lamp design.

The amount of information with which we are confronted daily will continue to increase further thanks to ubiquitously accessible computer networks. Helping society deal with this flood of information in the form of data visualization is an important task for designers. Generative design will be indispensible in coping with this challenge.

The expansion of technological possibilities is a constant source of stimulation for generative design. Just a few years ago, for example, it was nearly impossible to generate complex, three-dimensional worlds—something that is now possible even on a mobile phone. This technical potential will continue to be a driving force in generative design.

The ability to take data—to be able to understand it, to process it, to extract value from it, to visualize it, to communicate it—that's going to be a hugely important skill in the next decades, not only at the professional level but even at the educational level for elementary school kids, for high school kids, for college kids. Because now we really do have essentially free and ubiquitous data. So the complimentary scarce factor is the ability to understand that data and extract value from it.
→ Hal Varian (Google Chief Economist)

Equally important is the community of collaborators, which in almost no other design field is so vital. It is astounding how many net-based communities have provided libraries, tutorials, sample programs, articles, forum contributions, wikis, etc. This is certainly in part because creating code—generative design's underlying design medium—is well suited to team work, as software development has demonstrated. One advantage of code is that it can easily be exchanged and spread, in contrast to other media such as video files.

It should not be forgotten, however, that designers who program are still the absolute minority. This has historical and cultural reasons—universities and colleges, for example, have not traditionally provided training in both design and programming, although this strict separation is being abolished in some situations. In addition, learning this new design process—using mathematical-analytical source code to transform an idea into a visual result—is an insurmountable obstacle for many. Overcoming this obstacle is one of this book's main objectives.

→ Steven Johnson, *Interface Culture*, Chapter 9

We look with great optimism toward the future of generative design. Fortunately, the greatest hurdles—the creation of good developmental tools and the improvement of computer performance—are behind us. Generative design will lead to a new self-perception in dealing with the potential of computers. We agree that programming—and thus generative design—like photography and film in the twentieth century, will quickly become an established form that is essential to our culture of technology. The possibilities are there; we just need to take advantage of them.

→ Georg Trogemann and Jochen Viehoff, *CodeArt*, foreword

A.1

Index

A

Abstraction → 460f
Agent → 076, 100, 120, 218ff, 284, 332ff
Alexander, Christopher → 460
Algorithms → 461
Ammer, Ralph → 124, 128
Angle → 172, 186, 241
Architecture → 052, 060
Array → 173f
ASE format → 017, 188
Attractor → 064, 396ff

B

Bergstrom, Carl → 152
Berkenbusch, Jana-Lina → 248, 251
Bézier curve → 280
Bourke, Paul → 377

C

Color contrast → 182
Color model → 182, 186, 188
Color space
→ Color model
Comments → 178
Conditions → 175f
Coordinate system → 172
Corporate design → 128, 144
Cosines → 186, 353

D

Danwitz, Andrea von → 296, 298
Data folder → 016, 169
Data type → 173
Design process → 460ff
Dessens, David → 024
Display → 172
Distance → 240, 396f
Divide and conquer → 461
Domingo, Pau → 243, 246f, 250f, 255
Dumb agent
→ Agent

E

Edge bundling → 152
Eigner, Stefan → 191, 295
Emergence → 463

F

Feather
→ Spring

Feedback → 104, 294
FELD → 028
FIELD → 032
Fischer, Andreas → 036, 040
Fish-eye view → 454ff
Flash → 140, 152
Fleisch, Thorsten → 044
Force-directed graph
→ Force-directed layout
Force-directed layout → 100, 436ff
For-loop
→ Loop
Fornes, Marc → 048, 052
Fractal → 044
Frequency → 266, 3350ff
Fry, Ben → 168, 272
Function → 176f

G

Generative Design library → 017, 018, 168, 191, 248, 377, 395, 404, 440
Genetic algorithm → 140, 144
Geomerative library → 276
Grid
→ Mesh
Growth → 052, 076, 228f

H

Hansmeyer, Michael → 056, 060
Harris, Jonathan → 278f
Henze, Eno → 064, 068, 072
Hernandez-Castro, Franklin → 420
Hierarchy → 412
HSB
→ Color model

I

IDE
→ Processing editor
Image filter → 302
Installation → 016
Intelligent agent
→ Agent
Interaction → 014, 175, 462
Interpolation → 188

J

Java → 168
Juarez Hernandez, Victor → 241

K

Keyboard → 175
Kiefer, Cedric → 076, 255, 264
Koller, Andreas → 080
Kyttänen, Janne → 084

L

Levin, Golan → 088, 092
Library → 016, 168
License → 179
Lieberman, Zachary → 092
Lissajous figure → 351ff
Logic → 175f, 462
Loop → 176

M

Maeda, John → 460
Marxer, Ricard → 276
Maus, Benjamin → 036
Mesh → 024, 032, 160, 330, 370ff
Mingus, Charles → 282f
Modulation → 353ff
Mouse → 175, 236
Müller, Boris → 096

N

Node → 394f, 436ff
Noise
→ Perlin noise

O

onformative → 100
OpenFrameworks → 092
OpenGL → 172
Operator → 174
Oscillation → 346ff

P

Pen tablet → 248f
Performance → 179
Perlin noise → 068, 326ff
Peters, Keith → 348
Pfeffer, Florian → 096
Polar coordinates → 333
Processing → 016, 168ff
Processing editor → 016, 169
Prudence, Paul → 104
Puckey, Jonathan → 108, 112

R

Randomness → 194, 206, 218, 322ff, 462

Rapid prototyping → 036, 040, 048, 132

Reas, Casey → 116, 168

Recursion → 052, 056, 100, 414

References → 015

Renderer → 172

Repetition → 176, 462

Reubold, Ben → 365

RGB
 → Color model

RhinoScripting → 048

Riecke, Tim → 120

Roswall, Martin → 152

Routine
 → Function

Rule system
 → Algorithms

S

Sagmeister, Stefan → 124, 128

Sanch
 → Dessens, David

Schattmaier, Markus → 365ff

Schmidt, Karsten → 132, 136

Schmitz, Michael → 140, 144

Scriptographer → 108, 112

Seidel, Robert → 148

Simulation → 092, 124, 392, 436, 463

Sine → 186, 350

Sketch → 018, 168

Sketchbook → 018

Source code → 461

Spherical coordinates
 → Polar coordinates

Spring → 438f

Stämmele, Franz → 251, 366

Stefaner, Moritz → 152

Steinweber, Philipp → 080

Sunburst → 417ff

Superformula → 024

SVG format → 252

T

Tablet
 → Pen tablet

Text analysis → 448ff

Texture → 327ff

Tibbits, Skylar → 048

Tool → 017, 464

Tracking → 092

Transformation → 172

Treemap → 152, 272

Typography → 140, 256ff

V

Variable → 173

Varian, Hal → 464

Vector → 394, 396

Verostko, Roman → 156

Voronoi algorithm → 088

vvvv → 024, 072, 080, 104

W

Watz, Marius → 160

Website → 018

Wikipedia → 440ff

X

XML format → 441

Z

Ziora, Tom → 303

A.2
Bibliography

General

→ Flake, Gary William. *The Computational Beauty of Nature: Computer Explorations of Fractals, Chaos, Complex Systems, and Adaptation*. Cambridge: MIT Press, 1998.
 Generative design looked at from a (very) mathematical viewpoint
→ Noble, Joshua. *Programming Interactivity, Second Edition*. Sebastopol: O'Reilly Media, 2012.
→ Reas, Casey, Chandler McWilliams, and Jeroen Barendse. *Form+Code in Design, Art, and Architecture*. New York: Princeton Architectural Press, 2010.

A comprehensive list of all website references in this book and additional links can be found on the website www.generative-gestaltung.de
→ www.generative-gestaltung.de

Processing

→ Glassner, Andrew. *Processing for Visual Artists: How to Create Expressive Images and Interactive Art*. Natick: A K Peters, 2010.
→ Reas, Casey, and Ben Fry. *Getting Started with Processing*. Sebastopol: O'Reilly Media, 2010.
 The perfect handbook for beginners
→ ——. *Processing: A Programming Handbook for Visual Designers and Artists*. Cambridge: MIT Press, 2007.
 The "official" Processing handbook
→ Shiffman, Daniel. *Learning Processing: A Beginner's Guide to Programming Images, Animation, and Interaction*. Boston: Morgan Kaufmann, 2008.
→ ——. The Nature of Code. http://www.shiffman.net/teaching/nature/
 Online tutorials

Data graphics

→ Bertin, Jacques. *Semiology of Graphics: Diagrams, Networks, Maps*. Translated by William Berg. Madison: University of Wisconsin Press, 1983.
→ Fry, Ben. *Visualizing Data*. Sebastopol: O'Reilly Media, 2007.
 Advanced data graphic programming with Processing
→ Klanten, Robert, and Nicolas Bourquin. *Data Flow: Visualising Information in Graphic Design*. Berlin: Gestalten, 2008.
 A wide range of data graphic projects
→ Klanten, Robert, Sven Ehmann, Nicolas Bourquin, and Thibaud Tissot. *Data Flow 2: Visualizing Information in Graphic Design*. Berlin: Gestalten, 2010.
 Additional data graphic projects
→ Lima, Manuel. *Visual Complexity: Mapping Patterns of Information*. New York: Princeton Architectural Press, 2011.
 Overview of complex visualizations
→ Segaran, Toby. *Programming Collective Intelligence: Building Smart Web 2.0 Applications*. Sebastopol: O'Reilly Media, 2007.
 Algorithms for the analysis and use of collectively generated data; only recommended for experienced users with good computer-science skills
→ Tufte, Edward R. *Envisioning Information*. Cheshire: Graphics Press, 1990.
→ ——.*The Visual Display of Quantitative Information*. Cheshire: Graphics Press, 2001.

Aesthetics

→ Albers, Josef. *Interaction of Color*. New Haven: Yale University Press, 1975.

→ Gerstner, Karl. *Designing Programmes*. Zürich: Lars Müller, 2007.

Originally published in 1964; its title is somewhat misleading in our computer age—if it were published for the first time today, it would be called something like Inventing Design Rules.

→ Kandinsky, Wassily. *Point and Line to Plane*. Edited by Hilla Rebay. Translated by Howard Dearstyne and Hilla Rebay. New York: Dover Publications, 1979.

Originally published in 1925; theoretical musings on abstract painting by the Bauhaus master

→ Leborg, Christian. *Visual Grammar*. Translated by Diane Oatley. New York: Princeton Architectural Press, 2006.

Visual syntax abstract in overview; very clear and well illustrated

History and context

→ Brown, Paul, Charlie Gere, Nicholas Lambert, and Catherine Mason, eds. *White Heat Cold Logic: British Computer Art, 1960–1980*. Cambridge: MIT Press, 2008.

→ Burnham, Jack. *Software: Information Technology: Its New Meaning for Art*. New York: The Jewish Museum, 1970.

→ Franke, Herbert W. *Computer Graphics, Computer Art*. New York: Phaidon, 1971.

→ Leavitt, Ruth, ed. *Artist and Computer*. New York: Harmony Books, 1976.

→ Lee, Pamela M. *Chronophobia: On Time in the Art of the 1960s*. Cambridge: MIT Press, 2004.

→ Maeda, John. *Design by Numbers*. Cambridge: MIT Press, 2001.

First popular book that showed the design world how it was done, using the programming language DBN

→ ——. *Maeda@Media*. New York: Rizzoli, 2000.

Autobiography and retrospective of John Maeda's major contribution to generative design

→ McCollough, Malcom. *Abstracting Craft*. Cambridge: MIT Press, 1998.

→ Paul, Christiane. *Digital Art*. New York: Thames & Hudson, 2003.

→ Reichardt, Jasia. *Cybernetic Serendipity: The Computer and the Arts*. New York: Praeger, 1968.

Catalog of the first major exhibition on computer art in London

→ Rosen, Margit, ed. *A Little-Known Story about a Movement, a Magazine, and the Computer's Arrival in Art: New Tendencies and Bit International, 1961–1973*. Cambridge: MIT Press, 2011.

→ Shanken, Edward A. *Art and Electronic Media*. New York: Phaidon Press, 2009.

→ Wardrip-Fruin, Noah, and Nick Montfort, eds. *The New Media Reader*. Cambridge: MIT Press, 2003.

→ Whitelaw, Mitchell. *Metacreations: Art and Artificial Life*. Cambridge: MIT Press, 2004.

→ Wilson, Mark. *Drawing with Computers*. New York: Perigree Books, 1985.

→ Wood, Debora. *Imaging by Numbers: A Historical View of the Computer Print*. Chicago: Northwestern University Press, 2008.

A.3
The authors

Julia Laub

Born in 1980 in Bavaria. 2003: studies communication design at the HfG Schwäbisch Gmünd. Studies abroad at the HGK Basel. 2007: master's thesis "Generative Systeme," with Benedikt Groß. Since 2008: independent graphic designer specializing in book design, corporate design, and generative design. 2010: establishes the design agency onformative (a studio for generative design) in Berlin with Cedric Kiefer. Lecturer and teacher of generative design at various colleges and universities.

Claudius Lazzeroni

Born in 1965 in Bavaria. 1984: trains to become a photographer with Raoul Manuel Schnell. 1987: tutor at Mass College of Art in Boston. 1992: earns degree in media design at the BILDO Academy in Berlin. Until 1996: creative director at Pixelpark. Until 2001: founder, director, and creative director of the design agency IM STALL in Berlin. Since 1999: professor of interface design at the Folkwang Kunsthochschule in Essen. Since 2005: exploration, development, and construction of solographs. Since 2007: expansion of academic department to include physical computing.

Benedikt Groß

Born in 1980 in Baden-Württemberg. 2002: studies geography and computer science. Discontinues these studies and becomes interested in visual design. 2003: studies information and media at the HfG Schwäbisch Gmünd. 2005: internship at Meso in Frankfurt. 2007: master's thesis, "Generative Systeme," with Julia Laub. 2007–2009: academic assistant and lecturer in the department of interaction design at the HfG Schwäbisch Gmünd. 2009–2011: IX and UX Designer at Intuity Media Lab in Stuttgart. Since 2011: MA Design Interactions student at the Royal College of Art, London, UK.

Hartmut Bohnacker

Born in 1972 in Baden-Württemberg. Following discontinued studies in mathematics and a degree in economics, studies communication design at the HfG Schwäbisch Gmünd. Since completing studies in 2002: independent designer in Stuttgart. Specializes in conception, design, and prototypical implementation of projects in the field of interface and interaction development. Since end of 2002: teacher of digital media. Since 2009: professor of interaction design at the HfG Schwäbisch Gmünd.

How this book was created

It happened in the foothills of the Pyrenees: four authors looking for seclusion in which to fuse their capabilities into a common idea. Benedikt Groß and Julia Laub had their master's thesis on generative design in their backpacks. Hartmut Bohnacker brought his extensive experience helping students understand algorithms, and Claudius Lazzeroni, in addition to sharing his extensive knowledge of design fundamentals, made sure our palates were pampered. For several weeks we worked on our vision for a book and then went our separate ways to work together, from that point on, almost exclusively at a distance. Everything written, programmed, and designed was developed and optimized over the following fourteen months through continuous iterative steps based on conversations via the Internet and occasional intensive workshops. Had it not been for our enthusiastic publishers, Karin and Bertram Schmidt-Friderichs, we would still be writing. . . .

A.4
We thank

→ All artists, designers and architects for their contributions to the project collection
→ Cedric Kiefer. Problem solving, programming, consultation, illustration, and emotional and moral support during the long working nights
→ Intuity Media Lab, Stuttgart. Consultancy, support, and use of their office
→ Dany Schmid and Stefan Landsbek of 47 Nord, Stuttgart. SVN- and Wiki hosting, office use, Java help (ASE Export), and realization of the website www.generative-gestaltung.de
→ Christopher Warnow. Programming and support
→ Matthias Wagler. Help with the Processing library and consultation
→ Joreg, Sebastian Gregor and their assistants Roman Grasy, Igne Degutyte, Anton Mezhiborskiy, Anna-Luise Lorenz and others. Translation of all sketches into vvvv patches
→ Sojamo. Modification controlP5
→ Casey Reas, Ben Fry. Prompt Processing bug removal. And Casey for his initial support for this English-language edition and assistance with the bibliography.
→ Processing community. Help in the forum
→ FreeSans.ttf GNU Project, Mårten Nettelbladt (MISO), FontShop. Sharing of fonts
→ François Wunschel, Exyzt Paris. Office use
→ Frank Weiprecht. Help with InDesign scripting
→ Andres Colubri. Library ProTablet
→ Pau Domingo, Markus Schattmaier, Franz Stämmele, Andrea von Danwitz, Jana-Lina Berkenbusch, Ben Reubold, Victor Juarez Hernandez. Illustrations
→ Tom Ziora, Stefan Eigner. Sharing photographs
→ Vanessa Schomakers. Texts in the project selection
→ Nicole Schwarz, Linda Hintz. Advice on layout and typography
→ Florian Stötzler. Feedback and ideas
→ Sebastian Oschatz. Comments and quotations
→ Kristijan Kolak, Marc Guntow. Help with cinema ray tracing
→ Everyone at the Hermann Schmidt Mainz publishing house (especially Brigitte Raab)
→ Marie Frohling. Translation into English and great support
→ Amos Confer. Review of the English translation

And our sincerest thanks to the people around us, without whose support this book would never have been possible:
→ Hartmut Bohnacker thanks: all friends, colleagues, and relatives for their understanding that so little time was left over for them.
→ Benedikt Groß thanks: Sabrina, my parents and brothers, the Fischer family, and Michael Götte for the time together in the IG basic courses.
→ Julia Laub thanks: Cedric, Johannes, my family, my grandparents, and all those who supported me with their encouragement and understanding.
→ Claudius Lazzeroni thanks: Hu Hohn, Anna Heine, Thomas Born, my parents, and my inspiring and supportive wife, Daniela von Heyl.

A.5
Address index

Generative design team
→ info@generative-gestaltung.de

Hartmut Bohnacker
→ hartmut.bohnacker@generative-gestaltung.de

Benedikt Groß
→ benedikt.gross@generative-gestaltung.de

Julia Laub
→ julia.laub@generative-gestaltung.de

Claudius Lazzeroni
→ claudius.lazzeroni@generative-gestaltung.de

A.6
Copyright

Published by
Princeton Architectural Press
37 East Seventh Street
New York, New York 10003

Visit our website at www.papress.com.

Originally published by Verlag Hermann Schmidt Mainz
© 2012 Verlag Hermann Schmidt Mainz and the authors
All rights reserved
English translation © 2012 Princeton Architectural Press
Printed and bound in China
15 14 13 4 3 2

TRANSLATED BY
Marie Frohling

FOR PRINCETON ARCHITECTURAL PRESS
Project editor: Sara E. Stemen

Special thanks to: Bree Anne Apperley, Sara Bader,
Janet Behning, Nicola Bednarek Brower, Fannie Bushin,
Megan Carey, Carina Cha, Andrea Chlad, Russell
Fernandez, Will Foster, Jan Haux, Diane Levinson,
Jennifer Lippert, Gina Morrow, Katharine Myers,
Margaret Rogalski, Elana Schlenker, Dan Simon,
Andrew Stepanian, Paul Wagner, and Joseph Weston
of Princeton Architectural Press
—Kevin C. Lippert, publisher

Library of Congress Cataloging-in-Publication Data
Bohnacker, Hartmut, 1972–
[Generative Gestaltung. English]
Generative design : visualize, program, and create with
processing / Hartmut Bohnacker, Benedikt Gross, Julia
Laub ; editor, Claudius Lazzeroni ; translated by Marie
Frohling.
 p. cm.
Includes bibliographical references and index.
ISBN 978-1-61689-077-3 (hardcover : alk. paper)
1. Computer art. 2. Computer drawing. 3. Graphic arts—
Data processing. 4. Generative programming (Computer
science) I. Gross, Benedikt, 1980– II. Laub, Julia, 1980–
III. Lazzeroni, Claudius. IV. Title.
N7433.8.B6313 2012
702.85—dc23
 2012004343

Website
www.generative-gestaltung.de

Contact
info@generative-gestaltung.de

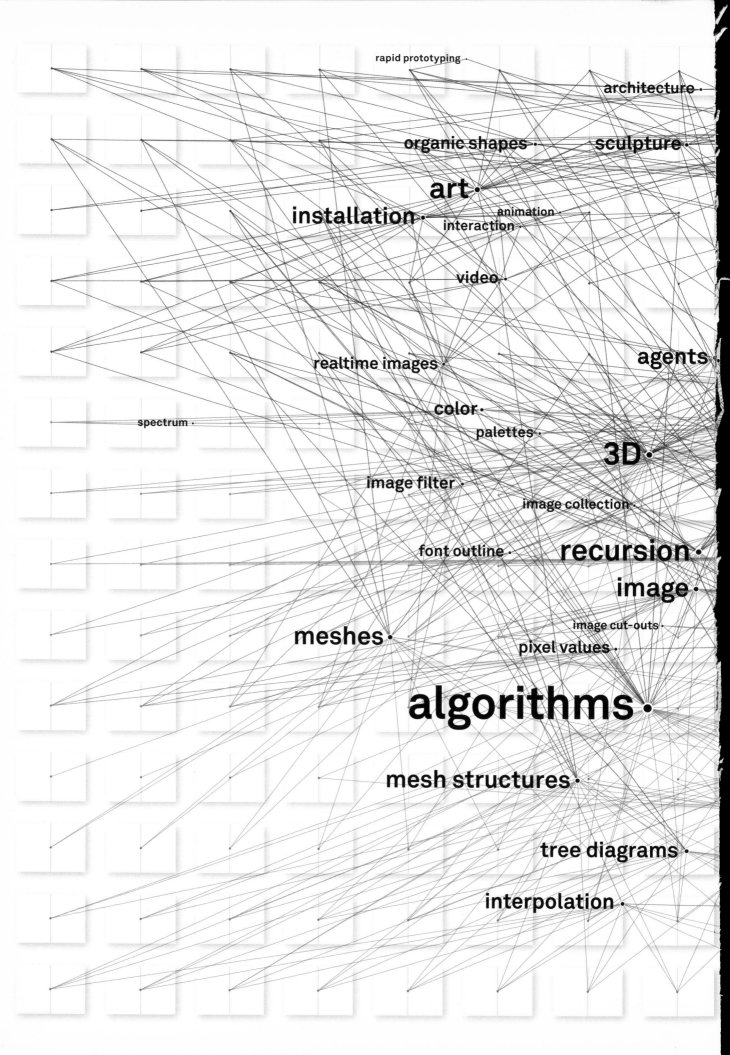

rapid prototyping ·

architecture ·

organic shapes · sculpture ·

art ·

installation · animation ·
interaction ·

video ·

agents ·

realtime images ·

color ·

spectrum · palettes ·

3D ·

image filter ·

image collection ·

font outline · recursion ·

image ·

image cut-outs ·
meshes · pixel values ·

algorithms ·

mesh structures ·

tree diagrams ·

interpolation ·

RhinoScripting

vvvv

processing

scriptographer

corporate design

genetic algorithm

typography

shape **grid** **text**

noise and randomness

drawing **line structures**

visualization

data graphics

attractors

oscillation figures

Keywords are assigned to each double page of the book's three main sections and superimposed as force-directed layout → Ch.M.6 . The elastic connections and repulsion forces create a map of the book giving an idea of how strongly a given topic is represented.
→ Force-Directed-Tags.pde

→ p.020 → p.022 → p.024 → p.026 → p.028 → p.030 → p.032 → p.034

→ p.052 → p.054 → p.056 → p.058 → p.060 → p.062 → p.064 → p.066

→ p.084 → p.086 → p.088 → p.090 → p.092 → p.094 → p.096 → p.098

→ p.116 → p.118 → p.120 → p.122 → p.124 → p.126 → p.128 → p.130

→ p.148 → p.150 → p.152 → p.154 → p.156 → p.158 → p.160 → p.162

→ p.180 → p.182 → p.184 → p.186 → p.188 → p.190 → p.192 → p.194

→ p.212 → p.214 → p.216 → p.218 → p.220 → p.222 → p.224 → p.226

→ p.244 → p.246 → p.248 → p.250 → p.252 → p.254 → p.256 → p.258

→ p.276 → p.278 → p.280 → p.282 → p.284 → p.286 → p.288 → p.290

→ p.308 → p.310 → p.312 → p.314 → p.316 → p.318 → p.320 → p.322

→ p.340 → p.342 → p.344 → p.346 → p.348 → p.350 → p.352 → p.354

→ p.372 → p.374 → p.376 → p.378 → p.380 → p.382 → p.384 → p.386

→ p.404 → p.406 → p.408 → p.410 → p.412 → p.414 → p.416 → p.418

→ p.436 → p.438 → p.440 → p.442 → p.444 → p.446 → p.448 → p.450